MARK WARNER
the Dealmaker

From Business Success to the Business of Governing

By August—nearly two months into the general election—both sides were preparing for a Labor Day blitz of media and outreach efforts. While the Democrats looked outside Virginia for key campaign team spots, the Obenshain camp built a homegrown structure that had been years in the making. Obenshain manager Judy Ford Wason, then Judy Peachee, employed many of the staff members from John Dalton's winning gubernatorial campaign. "A lot of things done in the Dalton campaign were done in the Ford and Godwin campaigns," said Wason. "Once you develop a winning strategy you build on that."[59] Just after the Obenshain team launched a series of party unity radio spots around the state, featuring John Warner, John Dalton, Mills Godwin and Congressman Caldwell Butler, tragedy struck.

"Jinks and I were awakened by our telephone at about 3:00 a.m. on August 2, 1978," recalled Governor Holton. "Kathleen Lawrence, a major member of my former Senate campaign staff, gave us the sad news that Dick Obenshain and two others including the pilot had been killed when their plane was attempting to land at the Chesterfield airport while returning from a campaign trip to Winchester."[60] John Warner saw the devastating news while watching the *Today Show* with Elizabeth Taylor in a New York hotel hours before he was to give a speech to the Navy League. "They were running that message about every fifteen minutes," recalled Warner, "and I remember Elizabeth just burst into tears."[61] The sudden loss of Obenshain left not only a family in grief but also a party in turmoil. GOP chairman George McMath, in an attempt to quash political opportunism and speculation, joined Governor Dalton in declaring "a moratorium on public political assessments" until after Obenshain's funeral.[62]

Dick Obenshain, a forty-two-year-old father of three, was eulogized in Richmond's Second Presbyterian Church before a crowd of family, friends, colleagues and supporters. Just three days after the tragic plane crash, the native Botetourt son was laid to rest beside his great-uncle on land the family had owned dating back to 1849.[63] Reverend Albert Winn directed his comments to Obenshain's young children—Mark, Anne Scott and Kate—in saying, "Your Daddy died pursuing a dream, he tried to do what he thought was right. You can hold your heads high when you remember that."[64]

A party in mourning over the loss of its leader nevertheless had to forge ahead. Chairman McMath called for a special meeting a week later of the state central committee, the party's governing body, to pick the new nominee. John Warner was an obvious successor, having lost to Obenshain by such a narrow margin. Yet with the power of selection in the hands of a

relatively small group of the party's most entrenched members, finishing in second place did not automatically make him the body's preference. Besides, Warner respected the Obenshain family too much to be an opportunist. "The press was all over me," he remembers. "I decided that Elizabeth and I weren't going to do a thing. We weren't going to answer any calls."[65] After instructing his old staff to stand down in kind, the couple returned home.

Holton, the other possible candidate, indicated that he was not interested in being considered for the job.[66] In the days that followed, rumors flew over the potential candidates under consideration. Insiders pleaded with two of Virginia's congressmen, Representatives Caldwell Butler of Roanoke and Winchester native Kenneth Robinson, to consider a run. There was even an attempt to recruit Governor Godwin, who dismissed the idea of a return to public life.[67]

While others were rushing to find a replacement, John Warner did not rush to throw his name into the hat. A delicate situation called for skilled hands. In the midst of consulting Governor Dalton, Obenshain's campaign leadership and the party's rank and file members, Warner took the approach that unity and continuity were more important than personal aspirations. "The essential thing for all of us is to preserve the coalition and the party unity which Dick Obenshain put together," said Warner when asked whether he was up for a second try at the nomination.[68] The same mentality was not exactly the case for many of the state central committee members, who questioned Warner's ability to pass a Republican purity test. Warner's wealth, his celebrity status tied to Elizabeth Taylor and his Washington upbringing gave pause to many activists who feared he was not a bona fide Virginia conservative.[69]

The party operatives more or less handling the effort to secure a nominee, including Wason, Republican state party finance chairman Robert Russell and Delegate Wyatt Durrette, had been unsuccessful up to this point. "We were [searching] for the name of someone who could pick up Dick's mantle and step right into the campaign—someone already known around the state as a conservative," said Durrette.[70] Facing being turned down by their top five choices, the trio took a road trip to see Warner at his Fauquier County farm to buy some time. At that moment, Godwin and Robinson were considering the notion but leaning toward not running. Holton and Butler had already said no, and Chairman McMath was still an option. "This was partly a courtesy call," said Durrette. "We wanted to keep John informed of what we were doing. No commitments of any sort were either asked for or given."[71] The three were sensitive to Warner, given his history with the party

and his second-place showing at the summer convention. "We didn't want him to think we were going behind his back," added Robinson. "We wanted to be open and candid about it…Godwin was our first choice."[72]

A couple days later, Warner made the pilgrimage to Richmond. "I said I think it's very important that I go down and see what the attitude of Obenshain's staff would be and that of his principal supporters. They cross-examined me pretty thoroughly."[73] Later that night, in a private meeting downtown, party insiders grilled Warner at the John Marshall Hotel. The next day, after having taken the high ground and submitting himself to a thorough scrutiny, Warner threw his hat in the ring.

That weekend, on Saturday, August 12, 1978, Warner was chosen by acclamation in less than an hour following Governor Dalton's enthusiastic nomination speech, which celebrated one of Warner's greatest assets in the forthcoming general election. Facing an experienced politician like Democratic nominee Andrew Miller, the Republican contender, Dalton said, "must be a man that others outside our party can support…We need the help of others outside the regular Republican Party."[74] Dalton's call to action mirrored Governor Godwin's remarks at the GOP convention earlier in the summer referencing the "great coalition of moderates and conservatives" the party needed in order to win.[75] Obenshain's widow made a surprise visit to the state central committee meeting and urged solidarity. "If we are to win this election we must…we have…to be united," Helen Obenshain told the GOP crowd. "Winning will not be easy. It will take hard work and determination. All must do their part. I intend to help in every way I can. Let's go forward united to victory."[76]

Renewing his assurance of continuity, Warner echoed Dalton's remarks in his own acceptance speech, citing that it was "imperative that we as a party, together with independents…Democrats…all concerned Virginians," reunite "that coalition that time and time again in the last 10 years has brought Republican victories."[77] While he pledged to serve in the tradition of those in Virginia's congressional delegation, the Republican Party's would-be savior went on to preview a defining quality of his character. "In times of great decision I draw upon a quotation that is familiar to each of you: 'To thine own self be true.'"[78] Though a committed Republican and self-described conservative, Warner had an independent streak that did not pigeonhole him. "My views are neither extreme right nor extreme left," he adds. "Critics say that may show an absence of strength of conviction on my part. But I hold my views as conscientiously as those on the fringe."[79]

Mark Warner the Dealmaker

For Republicans, 1978 started out as a typical election year but was abruptly mired by misfortune. Stepping in to pick up the pieces after Obenshain's death was not a job suited for just anyone. John Warner, the reluctant pick by many, proved to be the Grand Old Party's redeemer. "Everybody knows that people get bored when political campaigns get too long," Warner quipped in his nomination acceptance speech. Suddenly turning serious, he added, "We're not going to bore them."[80] In the wake of a tragedy, Virginians saw a man at work who could charm votes one at a time, energize a crowd, appeal to a broad audience and unite his party. "That chapter in my political life is the most valued because it was old-fashioned politics," said Warner thinking back. "We just grappled for a year and we never used a lot of negative advertising."[81]

On the trail, Warner channeled the excitement he felt while leading America's bicentennial celebration just a few years prior. "I traveled to every state in the Union. I traveled to twenty-two foreign nations and negotiated what they wanted to give to America."[82] He persuaded Great Britain to lend the United States an original copy of the Magna Carta. "There we were in this meeting and they were talking about loaning us tapestries," recalled Warner, adding, "I said, 'You possess the greatest document know to the Western world. Consider the loan of it.' There was absolute shock. Dead silence."[83] He got what he asked for, and the historic document sat in the U.S. Capitol for the next year under twenty-four-hour guard. A former bicentennial colleague recalls a classic Warner tale:

> *Once when we opened the Franklin and Jefferson exhibit in Paris, the French ambassador or whoever he was got up and made a long and eloquent speech about America and the 200 years of Franco-American friendship. It was greeted with great applause, and protocol demanded that Warner give an answering toast to France. Well, he got up, raised his glass and said, "To the world's oldest continuing democracy—the United States" and sat down. He toasted himself! The French were absolutely dumbfounded. They didn't know whether to be angry or amused. But in the end they let it go because they assume all Americans are a little crazy anyway.*[84]

On the road, Warner was at his best. He loved traveling to small towns in Middle America to give a "good-ole-red-white-and-blue speech," and so there is no surprise he loved campaigning.[85]

With just weeks to go in his first run for office, Warner was facing an experienced foe with a major problem. Andrew Miller had planned his

From Business Success to the Business of Governing

strategy based almost exclusively on facing Dick Obenshain. The party's anointed leader would quickly prove he could mend ideological fences and appeal to a broader audience, perhaps more than Obenshain ever could. Warner's advantage was his personality and his passion for people. "You've got to listen to these people as much as you can," Warner commented as he traveled around the state. "I learn a great deal, and I think people appreciate it if you take the time to listen."[86] Running on balancing the budget, cutting government waste and ending inflation, he remained true to his party's base, but it was the Warner persona that sold his candidacy.[87] "Meeting him, your first impression is of confidence—the quiet confidence that comes from a lifetime of hard work done well"—so read the campaign's literature.[88] Whereas his opponent was considered by many to be lackluster, Warner "plunged into the exhausting round of factory tours, luncheons, interviews and local festivals with the zest of a child loose in a candy shop."[89] Internally, Warner's "personal style, his outgoing and buoyant spirit, [were] important to his workers, helping them put behind their sorrow" after Obenshain's death.[90] He came about the boundless energy naturally, shocking many in the navy's formal setting. "When I was secretary of the Navy," said Warner, "I drove the admirals crazy. When I went to visit a ship I liked to go all over it and talk to sailors. Finally they gave up and said, 'If he wants to get all greasy let him do it.'"[91]

High-profile endorsements from household names helped raise Warner's stock in the final days of the contest. Governor Godwin and Winchester publisher Thomas Byrd, the son of iconic Democrat-turned-Independent senator Harry F. Byrd Jr., cut a dialogue-driven radio spot that essentially signaled a backdoor endorsement from the U.S. senator:

> *Godwin: Tom, one of the strongest reservations I have about Andrew Miller is just how much support he plans to give your father in the United States Senate. Frankly, I just foresee a great incompatibility between Miller and Senator Byrd.*
>
> *Thomas Byrd: I know what you mean, Governor Godwin. One reason I'm supporting John Warner so strongly is my personal feeling that he and my father will work well together to help Virginians instead of cancelling each other's vote.*[92]

Godwin's support was crucial but not guaranteed. After all, he not only nominated Obenshain at the GOP convention five months earlier but also

worked the floor hard to secure his candidate's victory. Warner was not one to hold a grudge, and bygones were bygones at this point in the race. So he asked if Godwin would tape a television ad. Soon thereafter, both gentlemen were in Colonial Williamsburg with a camera crew ready to film. Warner's campaign team came up with a script and made all the technical arrangements. On a tight schedule, the former navy secretary flew in just for this taping and, upon arriving, connected with Godwin. "I said, 'Let's mic up.' He said, 'No, what we're going to do is different. We're just going to walk in a circle slowly, and I'm going to be talking, and you're just going to nod your head.'"[93] As Godwin explained the new concept, Warner was thinking to himself how many hours went into planning the shoot and many thousands of dollars he was spending to just walk in circles around a garden. Not missing a step, he went with it, and the voiceover of the ad essentially was, "John Warner—listening to the conservative message of Virginia."[94]

The last joint appearance of the campaign took place in Old Town Alexandria less than a week before election day. "Every television set imaginable was there taking that debate in," said Warner, "because it was an interesting race, and no pundit dared predict who was going to win that race."[95] He believes that what Andrew Miller did and said next had an impact on the final result. "Being the sitting attorney general, he spoke last to address the crowd," said Warner. "And he stood up and he shook his finger at them. You should never do that as a politician. Always like a preacher…wave your hands gracefully. But I know he shook his finger and he pointed at them. He said, 'You should vote for me, because I'm a native Virginian. I'm a native Virginian.' And he sat down. And I got up and I said [to myself], okay old boy, how do you top this?'"[96]

Warner came up to the podium and looked around at the audience. Then he turned his attention to his ninety-year-old mother, Martha, who was seated in the front row. The two proceeded to have an impromptu colloquy. First, Warner asked her a question. "I said, 'Mother, did I have anything to do with where I was born?' And she said, 'No. Your father was chief of gynecology at this hospital, and of course, I was taken to his hospital, which is in the District of Columbia.' She said in a little voice that was hers, 'If I had known you wanted to be a senator, I would have crossed the river and had you under the trees.'"[97] Immediately the room became raucous with laughter. Warner had the crowd eating out of his hands. Not skipping a beat, he continued the show. "I said, 'Well you know folks, I really don't have much to say about where I was born, as my lovely mother said.'"[98] He paused, gazed across the ballroom and then, in a stern and forceful voice,

From Business Success to the Business of Governing

declared, "But I had everything to say about where I wanted to be educated. I went to my father's college, Washington and Lee University. I went to law school at Mr. Jefferson's University."[99] After each proclamation, the crowd audibly expressed its approval and admiration, so Warner continued, "My opponent left the state and went north, north to Princeton."[100] The crowd just erupted. As soon as the event came to a close, the cameras flocked to Martha Warner. She was the star of the show.

Inspiring scores of volunteers, raising cash hand-over-fist and traveling to every inch of the state, John Warner steered his campaign to a close victory over Andrew Miller on November 7, winning by just 4,721 votes.[101] "My nickname was landslide Johnny," jokes Warner, adding, "But if you stop to look at it…from the position of what it takes to run a Senate campaign in terms of staff and money and travel, there was, when I finally got the Republican state central committee nomination, less than nine weeks to go. And fortunately, a lot of the basic staff stayed, and I took off like a rocket."[102] Warner's 0.3 percent victory made it, at the time, the closest statewide contest in Virginia history.[103] The campaign's victor describes his one-time opponent as a true gentlemen in the tradition of Virginia who even raised money for his subsequent reelection effort. "We've always been good friends," said Warner. "We still see each other and joke. We say, 'We've got to sit down and have a drink and really go over that campaign to figure out what each of us did right.'"[104]

Before the freshman senator could get settled in on Capitol Hill, he would first receive a not-so-subtle reminder of the Virginia-centric expectation he had already come to adopt on his own. Warner happened to be in Richmond in early January for an office opening when he received a request for Elizabeth and him to join the governor and the First Lady for lunch. While a terrible snow and ice storm developed over the course of the day, the couple made their way to the Governor's Mansion and were warmly greeted in Virginia tradition from the porch by both occupants of the nineteenth-century landmark. Warner recalled:

> *The two ladies took each other by the arm and walked on into the mansion. The governor said, "Now pause here a minute, senator. I want you to look at this piece of roadway out here." I'm saying to myself, "What's all this about?" He said, "I want you to know that all roads in Virginia lead to Richmond. And when they get to Richmond, they come to this very, historic spot where the General Assembly serves the people. And then it ends right here at the mansion at these steps. Now, young man, don't you forget that as you make your decisions in Virginia."*[105]

Mark Warner the Dealmaker

Following the whirlwind events of 1978, the vigorous campaigner soon joined the ranks in the U.S. Senate as a crusader for America's interests at home and abroad but always put the state he loved so much first. For Warner, Virginia was also his playground. No business-related visit would be complete without taking in the local culture. "To travel with him around the state is quite an adventure," said Susan Magill, Warner's longtime confidante and chief of staff for eighteen years. "He knows the little markets, when the festivals are, when the crops come in, and loves to go into the antique stores."[106] Sometimes Warner would have to store items he purchased at the Roanoke farmers' market in Magill's brother's house. "The economy of Roanoke always prospered when John Warner moved through town," added Magill.[107] The savvy Southwest Virginia native went straight from William & Mary to Capitol Hill, initially working for respected Congressmen Caldwell Butler and William Wampler Sr. "Both of these Virginia leaders schooled me in how to operate effectively to get things done in Congress," said Magill, whom Governor John Dalton later tapped to direct the state's Liaison Office in D.C.[108] Magill eventually made her way to Warner's Senate office, first as a legislative assistant before quickly being promoted to chief of staff.

Even after a heated debate at the Homestead, Warner immediately got into his truck and went trout fishing in the mountains for a few hours before heading home. On the road, he would go into a restaurant's kitchen and ask the cook what he should order. When in town, he would seek out the gardener at Colonial Williamsburg and ask him about what he was doing in his own garden at home, even what was the best manure. And when in Virginia Beach for a meeting, he would go take a swim if he had a free hour.[109] What separates John Warner from many of his colleagues is his zest for living and the joy he creates out of everyday obligations in spite of a life under public scrutiny. "Even if he was a bit late due to spending too much time at an antique store, many have heard John Warner start his speeches by intoning the advice: 'Be brief; and ye shall be re-invited,'" says Governor George Allen, adding, "And then ignoring his written remarks, he would regale the audience with a repertoire of good stories."[110] Allen has no shortage of unique John Warner stories. "Some of his ways would jolt people," he says. "I recall flying with Sen. Warner in a small plane from a short runway in Front Royal in 1991. He told our driver, Henry Doggett, to wait to see if we took off successfully."[111] Warner's reason to Doggett: "If we crash, then you have to hold a press conference."[112] The Surry County native and Virginia political staple who often drove Warner around the state

stars in the following story about a memorable trip in the dead of night while heading home:

> *It's 1992, a cold February night, and Doggett is driving Warner north on Interstate 95 toward the 2,400-acre farm the senator owned near Middleburg. In the rural darkness, Warner tells Doggett to turn right, then right again down a back road. Then another right, Warner said.*
> *"And that's when I say, 'Senator, we're going in a circle,'" Doggett recalls. Warner lowers the passenger side window, sticks his head out and looks skyward, his thick, silvery hair whipping in the bitter wind.*
> *"He says, 'I'm navigating by the moon, my boy. I'm an old Navy man. I know what I'm doing,'" Doggett said between laughs. "Next thing I know I see a sign that says Fredericksburg, 5 miles. We weren't even close."*[113]

ROOKIE TO THE RESCUE

The younger Warner's political rise took a different path. Having worked on several campaigns, been a staffer on Capitol Hill during college and raised money for the Democratic National Committee after law school, Mark Warner knew the nuts and bolts of running a political campaign. But after his departure from politics in 1982, when he vowed to become a success in business, that experience lay nearly fallow for years. After his first two businesses failed, Warner struck gold, becoming an early investor in cellular technology. He took a risk on what appeared to everyone else to be a huge gamble. Patient, positive and persistent, Warner proved them wrong and made millions. By 1986, he was eager for a new opportunity and, more importantly, a return to politics. The 1989 race for governor gave him that chance.

Doug Wilder made a career out of firsts. He was the first African American since Reconstruction to be elected to the state Senate, the first to chair a Senate committee and the first to be elected to a statewide office in Virginia, having won a close race for lieutenant governor in 1985. If he succeeded four years later, Wilder would become America's first elected African American governor.[114] Wilder, who once described the office of lieutenant governor as "vacuous," believed that as a minority, he would have to have some entry point that shows "proficiency in some preceding degree."[115]

"That's what the office of lieutenant governor allowed me to do," said Wilder.[116] It did not come easy, however. Wilder credits his victory to a

workhorse mentality and his desire to campaign around the entire state. He and manager Paul Goldman embarked on a 3,500-mile tour in a borrowed station wagon.[117] "Had I not taken the non-stop 60-day trek around the state...I would never have had the real opportunity to know Virginia's people, and they know me."[118] The Democrats went on to sweep all three statewide offices, electing Gerald Baliles as governor and Mary Sue Terry as attorney general alongside Wilder.

Warner, who was living in Northern Virginia, met Wilder for the first time in 1989 after he announced his campaign for governor. Shortly thereafter, Toddy Puller, who managed two campaigns Warner had worked on, jumped on the opportunity to run for an open seat in the House of Delegates. Puller was Wilder's Northern Virginia coordinator and was later elected to the state Senate. "There was nobody there to take over," said Warner. "So I said, 'I will be your Northern Virginia coordinator, and I'll do it for free. The only caveat was that I was going to get married soon.'"[119] Warner was engaged to Lisa Collis, whom he had met at a keg party in 1984, when she was working at the World Bank. "He was having one of those keg-of-beer and pretzel parties where you're lucky to find a pretzel," said Collis.[120] University of Virginia graduate and the daughter of a navy pilot, Collis recalls meeting Warner, who at the time was making waves as a successful cellular broker. "I liked him because he was different," she says. "I remember he was into Peter, Paul & Mary and that really wasn't a cool thing to do but he didn't seem to care. He was very interesting, high-energy and sincere. He didn't try to impress me and I liked that."[121]

Thus, Warner took over as regional coordinator for four to five days a week before he and his bride headed off on their honeymoon to Egypt and Greece. What began as a traditional celebration for the newlyweds went south quickly when Warner's health took a turn for the worse. "My appendix burst on my honeymoon," he says, "and I spent nearly two months in the hospital after returning and almost having died."[122] Warner lost thirty pounds and had thirty-two transfusions during his stay. But a near-death experience was no match for Warner. His commitment to the Wilder campaign was a constant source of irritation to hospital staff, as Warner continued to run the Northern Virginia operation from his hospital bed. Two months later and out of the hospital, Warner was asked to come to Virginia Beach for the second gubernatorial debate.[123] He had no idea that he would witness a major turn of events for the Wilder campaign.

The Virginia Press Association was hosting Republican Marshall Coleman and Democrat Doug Wilder at the Cavalier Hotel on July 22.

From Business Success to the Business of Governing

The two sparred in the first contest just a week earlier at the Greenbrier resort in White Sulpher Springs, West Virginia, a long-standing tradition sponsored by the Virginia Bar Association. Rules approved for the first debate became the central issue of the second. Both campaigns before the Greenbrier debate agreed that no video footage taken during the debate would be used in commercials "because of fears that their remarks will be distorted or misrepresented by their rivals."[124] Whether this agreement applied to the second debate in Virginia Beach was the question. On the eve of the debate, Wilder and his media consultant Frank Greer were filming TV commercials in Southwest Virginia.[125] At the beach, Bob Goodman, Coleman's media consultant, was busy preparing the Cavalier for filming the next day's debate: "One camera was set to film Coleman with an American flag draped behind him. Lights were trained on the area. The second camera was focused on the more dimly lit spot where Wilder would stand."[126]

Wilder was adamant that the debate would not go on if it were going to be taped. Coleman's camp didn't blink. With the debate scheduled to begin at 1:00 p.m., Coleman made his way to the stage. Wilder did not appear, essentially canceling the event, which infuriated the over two hundred members of the media from all across Virginia. The campaigns held dueling press conferences with each side blaming the other. Being prepared, the Coleman camp distributed questions intended for Wilder's embarrassment during the debate, which only complicated Wilder's attempt to answer questions during his own press conference.[127] The day ended with the Wilder campaign in obvious turmoil. It was then, at a donor's home in Virginia Beach, that Wilder tapped Mark Warner to help pull the campaign out of its slump.[128]

What was supposed to be a couple days a week in the Richmond headquarters for Warner quickly turned into five days a week as he ran the race. That was not, however, a sign that the Wilder campaign was floundering. "The campaign was not in that bad of shape really," said Warner. "What I really did for about a month was go around and visit with all the political powerbrokers and establishment, so they knew the operation was running smoothly."[129] Modest of his involvement in the turnaround, Warner said the campaign really just "needed kind of a kick start. The systems were there. They just weren't fully operating."[130]

Veteran strategist Frank Greer points out that Warner's role was more than just a manager. "He came in at a moment of disarray and no one knowing who to trust, and pulled everything together," said Greer.

Warner featured Governor Doug Wilder (center) and Senator Chuck Robb (right) at campaign stops during his first run for office in 1996. *Michaele White.*

"He's the untold hero of this campaign."[131] Warner recalls hosting a high-level strategy meeting at his King George County farm along the Rappahannock River, for which people flew in from all over the state. It was a way to help the party brass understand the plan and assure them that the campaign was back on track. "Every campaign goes through an August downturn," said Warner. "The question is can you get through your August downturn and come out. We kind of got through it with Wilder, and the campaign took off."[132]

Election night on November 7, 1989, was momentous. Repeating the circumstances of four years prior, the Democrats swept the statewide ticket. Doug Wilder was elected governor by a slim margin, becoming the first elected African American to do so in American history. He was joined by Don Beyer and Mary Sue Terry as the new lieutenant governor and attorney general, respectively. Even though by 11:00 p.m. that night Wilder seemed to be ahead by only a few thousand votes and there was no indication Coleman was going to concede, Wilder led the way downstairs to the Richmond Marriott ballroom stage and pronounced, "I am here to claim to be the next governor of Virginia."[133] That his election was probably headed for a recount made no difference at the

moment. Margaret Edds describes the historic scene in *Claiming the Dream: The Victorious Campaign of Douglas Wilder of Virginia*:

> Tears were streaming down the faces of some, and the candidate's own cheeks glistened with sweat as he praised the Virginia electorate and "many who are not even alive at this time." To murmurs of "amen" and a chorus of applause, he vowed, "We've come this distance because people prior to our coming believed in what we could do."
>
> His election, he said, was no fluke. "No one can blame it on the weather. No one can say it was a single issue. No one can say that notwithstanding a record turnout I could not be elected." Wilder, who even at the euphoric moment seemed more composed than most of those around him, also repeated the moving lines he had uttered at certain rare occasions during the campaign. "As a boy when I would read George Mason and Thomas Jefferson that all men are created equal, and endowed with certain inalienable rights, I knew it meant me…I can't say any more than to tell you how humble I am, and how proud I am to be a Virginian."[134]

Larry Sabato recalls, "1989 was the real thing. For Virginia, even by a tiny margin, to become the first American state to elect a black governor was electric. Never has a state election drawn so many international news organizations. It was headline news around the world that a state so identified with the old Confederacy had broken this key barrier."[135] For Wilder, this victory was a "direct result of the civil rights movement," which he says "opened the door for the fuller participation of African Americans in American society."[136] For the commonwealth, the Wilder race showed Virginians leading the way to the fulfillment of the founders' promise in the Declaration of Independence.[137] For Mark Warner, the race was a test. It was a personal journey that revealed the tip of his potential as a strategist, as an executive and as a leader. Quickly after the election, he took the reins as the transition chief for the Wilder administration and later, in 1993, the chairmanship of the Democratic Party of Virginia. Despite overwhelming past Democratic wins, infighting still existed among the different camps, and Mark Warner was perhaps the only person who could unite his party during a time of Republican resurgence.

2
VIRGINIANS VALUE INDEPENDENCE

Paying His Dues

Following Mary Sue Terry's loss to George Allen in the 1993 race for governor, the state Democratic Party needed a boost. Enter Mark Warner, who, just seven years earlier, was relatively new to the Virginia scene but had a background in national politics. Former chairman Larry Framme remembers the day in 1986 when Warner stopped by to introduce himself and asked how he could get involved in politics again. "Here's a guy who walked in cold, he's worth a few million, and he said he was willing to do anything," said Framme. "He didn't even say the words 'central committee.'"[1] Framme quickly put Warner to work, beginning with working the polls on election day. Warner was well accustomed to paying his dues, having worked his way through college with jobs in campaigns and on Capitol Hill. By 1989, he had leaped from being a regional coordinator to managing Doug Wilder's gubernatorial campaign in a matter of months, not exactly a common occurrence in the world of politics.

Warner's work ethic, political track record and fundraising ability made him the obvious choice for chairman in 1993. He was determined to lead his party's return to its roots. "I wanted to bring some level of enthusiasm and organization back to the Democratic Party following Mary Sue Terry's loss to George Allen," said Warner, adding his main areas of focus.[2] "I wanted to go into the rural parts of the state. I really wanted to see if I

could get younger people involved."[3] He worked tirelessly to properly equip the organization for immediate and long-term gains. "Treating the party's 1993 statewide and House of Delegates losses like a downturn in earnings, the self-made multimillionaire implemented a new strategic plan, improved the party's technology and revamped its fund-raising apparatus, leaving the party with a $277,000 balance."[4]

Perhaps what solidified Warner's reputation as leader came when "he brought together potentially warring factions into a unified party that bucked the national trend [in 1994] and re-elected [Senator Chuck Robb], as well as six of its seven representatives."[5] Warner recalls that a combination of a bitter primary battle that Robb eventually won followed by Doug Wilder's short-lived Independent bid for U.S. Senate almost unraveled the party just a year into his chairmanship. "[Everybody] predicted the equivalent of political Armageddon," said Warner. "What we managed to do was stay united, and I'm real proud of that."[6]

When Mark Warner announced in June 1995 that he was stepping down to ponder a run for Virginia's other Senate seat as he campaigned for state legislative candidates, he had solid support from the party's grass roots and its leaders. "Mark Warner's business know-how, political savvy and relentless energy were critical in rebuilding our party," said Don Beyer. "He [left] a state party that is stronger, more unified, better organized and more financially sound than at any time in recent history."[7] Warner wasn't the only contender. Leslie Byrne had already announced her intent to run for the office. The trailblazer was Virginia's first woman elected to Congress; however, Tom Davis ousted her from the newly created Eleventh District seat after just one term. Byrne boasted her base of support came from labor organizations, women's groups and environmentalists, while insinuating that the "Democratic elite" backed Mark Warner.[8]

Trying to defeat Senator John Warner would be a difficult undertaking for any Democrat, let alone a more partisan one. For Mark Warner, this was a first attempt at public office, but he was not unfamiliar to what it takes to be successful. "I know what a campaign is all about," he said in June as he was stepping down. "I wouldn't be putting myself through this for the next 18 months if I didn't believe that I could win."[9] Impervious to Byrne's attacks, Warner was clear from the get-go that he was going to run his own kind of race and that the Democratic nominee would need "a greater passion for the job and new and different ideas about where our state and country ought to go." Drawing a contrast to Byrne's campaign style,

From Business Success to the Business of Governing

Warner added, "If I just come to the table with traditional positions: one, I don't think I would win, and two, that's not what I'm about."[10] With ease, he walked away from the 1996 Virginia Democratic Convention as the party's nominee after handily defeating Byrne.

Battle for the Heart and Soul of the Party

While Mark Warner's campaign was up and running, John Warner had a more pressing battle to fight. In December 1995, Jim Miller announced he was challenging the incumbent senator for the Republican nomination. Miller, who served as President Ronald Regan's budget director, was making his second attempt at the U.S. Senate, having lost the nomination to Oliver "Ollie" North, retired U.S. Marine Corps lieutenant colonel, at the 1994 Republican Convention. Standing in front of Alexandria's city hall with only ten supporters out to cheer him on, Miller said, "I am a true Reagan conservative who will fight Bill Clinton and stand up for the taxpayers and families of Virginia."[11] Setting out to forge a "coalition of conservative Republicans who are pro-life and favor a balanced budget and term limits," Miller reinforced he was a "Reagan Republican" setting to take out "Clinton Republican" John Warner.[12]

Mike Farris and Donald Huffman, former Republican Party of Virginia chairman, signed on as Miller's campaign co-chairs. Both were out for blood after Warner had committed one of the "deadly sins" as far as Republican activists were concerned. In 1993, Warner refused to endorse Farris, founder of the Home School Legal Defense Association, who was running for lieutenant governor against Democrat Don Beyer.[13] When reporters asked if he would endorse Farris, Warner said, "Come see me the day before the election."[14]

Farris had strong ties to several organizations blurring the line between religion and politics, including evangelical reverend Jerry Falwell's Moral Majority political action committee based out of Lynchburg, Virginia.[15] While running mates George Allen and Jim Gilmore were elected governor and attorney general, respectively, Farris lost to Beyer by nearly nine percentage points. Allen defeated Attorney General Mary Sue Terry by nearly seventeen points while Gilmore defeated Delegate William Dolan by over twelve points.[16]

As the odd man out, Farris had to contend with an ideological roadblock from the beginning of his run for the state's second-in-command post. It

was enough for John Warner to take a stand. "Farris tried to link the growing, very serious problem of breast cancer with abortion," Warner wrote in an op-ed following the race, addressing his decision to buck the GOP's lieutenant governor nominee.[17] Farris proclaimed, due to its pro-abortion bias, America's medical establishment had kept research linking breast cancer and abortions out of the hands of women.[18] "In South Boston," Warner wrote, "he called for hearings to determine whether Virginia should enact a law requiring doctors to tell women that some experts believe abortion dramatically increases the risk of breast cancer."[19] The son of a doctor took exception to injecting unproven science in the race, adding, "When Mike Farris came out with this during his campaign, I thought of my father. He was a medical doctor, having received his undergraduate education at Washington and Lee University, class of 1903. After medical school, he devoted his life to medicine, as a physician in gynecology, and performed some of the early research in the late 1930s and 1940s on female cancers. Ironically, cancer, his life's work, took his life in 1946, just weeks after I returned from World War II service with the Navy. My only brother was saved from the same fate by a miracle—major cancer surgery."[20]

The lack of enthusiasm for Farris in his own party was growing. A month before election day, a "Republicans for Beyer" group came forward, led by former first lady Virginia "Jinx" Holton and several prominent business leaders around the state. For the sake of the future of the Republican Party, Holton emphasized voting Republican at the top and bottom of the ticket but taking a pass on Farris. Charlottesville consumer electronics guru Bill Crutchfield, a major donor in George Allen's gubernatorial race, served as treasurer of the split-ticket effort trying to prevent a Christian Coalition takeover of the party.[21] While Warner did not go as far as supporting the Beyer candidacy, he wanted the voters to know why he was rocking the boat. "Some criticism has been leveled at me for failing to issue a weak, pro-forma endorsement in the name of unity," he wrote in the December op-ed. "I do not, and will not, do things pro forma. Political expediency may be acceptable to some, but not to me. My way is to either do it with heart and conviction or don't do it."[22]

Wasting no time, Farris was eager to exact revenge on Warner. "We've got a sickness in our party and that sickness is named John Warner," he said of the former navy secretary.[23] Standing with Jim Miller at the lackluster Alexandria announcement in the winter of 1995, Farris was confident his pick to take on Warner for the nomination would garner strong support from his base at the right time. "Republican activists are suffering an election hangover following the Nov. 7 election, in which Republicans failed to take

From Business Success to the Business of Governing

control of the legislature," Farris commented just weeks after the entire General Assembly was on the ballot.[24] He added that in the ensuing two months, "when the reality that there's not going to be anybody but Jim running sinks in, the groundswell will build."[25]

The Farris race was not the only bone of contention. In 1994, Warner refused to endorse Ollie North for U.S. Senate; he served, in fact, as campaign chairman of Republican Marshall Coleman's Independent bid.[26] Coleman, a fellow marine who spent thirteen months in Vietnam, served in the House of Delegates and was elected in 1977 as Virginia's first Republican attorney general. He ran twice unsuccessfully as the Republican Party's nominee for governor in 1981 against Chuck Robb and eight years later against Doug Wilder, losing by less than .5 percent.[27] With a Senate race featuring candidates arguably on the two extremes of the political spectrum—incumbent Chuck Robb on the left and Republican Ollie North on the right—there was a perceived opportunity for a middle-of-the-road candidate like Coleman to win, running on the slogan, "Don't choose the lesser of two evils."[28] Robb, the former lieutenant governor and governor of Virginia, faced blistering personal attacks and questions on his Senate record from North and Republican officials.

In the adversarial game of politics, Robb fired back with the same gusto, capitalizing quite effectively on North's own skeletons. It did not help that days before the election, First Lady Nancy Reagan said before a large crowd at a New York City event, "I know Ollie North has a great deal of trouble separating fact from fantasy," referring to the Iran-Contra affair. The "Great Communicator's" better half continued by saying, "And he lied to my husband and lied about my husband, kept things from him that he should not have kept from him."[29] In March, President Reagan had taken issue with North's claim that he authorized the Iran-Contra arms-for-hostages deal. In a letter to Senator Paul Laxalt, a Republican from Nevada, Reagan wrote, "I never instructed [North] or anyone in my administration to mislead Congress on Iran-Contra matters or anything else. And I certainly did not know anything about the Iran-Contra diversion. In fact, as you know, the minute we found out about it, we told the American people and called for investigations."[30]

John Warner looked at his stand in this race as a matter of principle. "I have a duty to my country, a duty to my state, a duty to my party," he said in response to questions at the time about his support for Coleman over North.[31] Warner added, "Every day senators talk to me about it. The North supporters are looking at this in isolation, but it is of great national

significance. I challenge you to get one U.S. senator to say they want Oliver North to come to the U.S. Senate."[32] The public agreed with Warner's stand. A Mason-Dixon poll taken in the heat of the Senate race confirmed his own convictions, with 88 percent rating Warner's performance as either good or excellent, making him Virginia's most popular politician. The respondents were 34 percent more likely to vote for him in 1996 for not supporting North, and 56 percent of them supported a Warner Independent bid for the Senate in the event he was forced out by the Christian Coalition.[33]

As for any hard feelings, time has healed old wounds. "Let me say something about Oliver North," said Warner. "We had our differences at that time. But since then we've steered our own careers and I think he's done a remarkable, professional job in journalism. I mean I read his material on a regular basis and admire him for the courage."[34]

Robb's campaign continued to flourish while North's was stagnant in the final weeks. On November 8, 1994, the verdict was in. With just 11 percent of the vote, Coleman did not capture the center of the electorate as he had hoped. The failed Independent bid left the two mainstream candidates in a close match, with North losing to Robb by just under three percentage points.[35] A spoiler or not, John Warner remained the John Warner of year's past, commenting at the time, "I'm perfectly willing to accept responsibility and accountability for my actions, which I believe were in the best interests of my country and my state."[36]

With the backdrop of Warner's independence from the Republican Party, activists were concerned with what could result if they selected a convention as the nominating method. A convention historically favors the rank-and-file favorite and, at times, the extreme candidate, in this case Jim Miller. Warner favored a primary contest, and Miller gladly claimed he would accept, boldly saying, "If he wants a primary and we have a primary, I'll meet him on that battlefield, and I will beat him."[37] If John Warner were to lose a convention, activists feared he would run as an Independent, to which concern Miller replied, "The bad news is that I'd be in a three-way race. It'd be Jim Miller vs. the Warner brothers—the producers of Looney Tunes."[38] While Miller was confided he could win regardless, wiser and cooler heads prevailed with the selection of a primary in June.[39]

There was a significant difference in the caliber of endorsements each candidate received. Miller seemed to attract bitter supporters who would rather put life in terms of Republican versus Democrat or Conservative versus Liberal. Longtime activist and Virginia's Republican National committeeman Morton Blackwell said at the time, "If we renominate

FROM BUSINESS SUCCESS TO THE BUSINESS OF GOVERNING

the incumbent, we ought to take up a collection and erect on Monument Avenue in Richmond a statue of Benedict Arnold."[40] Republican state chairman Pat McSweeney failed to gain the support from his state central committee in selecting a convention. Fearing Warner would attract nontraditional voters at the primary, he took to the courts, suing the state because of its open primary law. Denying his suit, U.S. District Court judge Richard Williams said, "Discontented 'mavericks' who find that the process doesn't 'fit the purity of the thought they desire' shouldn't be allowed to rewrite election rules."[41] Coming to Miller's aide was minister and televangelist Pat Robertson, founder of the Christian Broadcasting Network and the now defunct Christian Coalition. While it did not endorse candidates, the Christian Coalition, run by conservative activist Ralph Reed and headquartered in Chesapeake, Virginia, distributed over seventy-five thousand voter guides featuring Miller.[42]

John Warner's supporters, on the other hand, approached their endorsement as a matter of what was best for Virginia and the country. The man they came to know lived up to the moniker he earned during his time at Washington and Lee. "'Mad Dog' was just a nickname that was given to me because I was a bit of a rascal in those days and I don't deny it. Not necessarily a conformist."[43] Warner was a distinguished marine officer, served as secretary of the navy and was the ranking member on the Senate Armed Services Committee. He negotiated the "Incidents at Sea Agreement" with the Soviet navy in Moscow on behalf of the United States, calling it his "personal experience at dealing eyeball to eyeball with the Soviets."[44] He earned respect from national figures who, in turn, stood by their go-to defense expert, including 1996 presidential nominee Senator Bob Dole; President George H.W. Bush; and his vice president, Dan Quayle. They were later joined by Colin Powell, former chairman of the Joint Chiefs of Staff.[45]

Tom Davis was "the rock" during the campaign, says Susan Magill. The Republican was the only member of the Virginia congressional delegation to publically support Warner during the primary. "A brilliant political strategist, Tom helped raise money and guide the operation," she adds.[46] Davis first met John Warner in 1978. He attended the Republican convention but was pulling for the frontrunner. "I was an Obenshain delegate," he says, adding, "To this day, I don't think [John Warner] knew I was an Obenshain delegate. I stayed through all six ballots."[47] After the tragic plane crash that altered the race, Davis joined his party in standing behind the new nominee, working tirelessly for Warner through election

day. Over the years, the two politicos bonded on a shared philosophy. In 1994, when Davis defeated incumbent Leslie Byrne for the Eleventh Congressional District seat, Warner cut an ad for him while taking a pass on endorsing Ollie North. Davis had a solid record to stand on, having served on the Fairfax County Board of Supervisors for fifteen years, four of which as chair. Warner's endorsement offered Davis the inoculation he needed from North's political baggage, and it also showed the voters he had an independent spirit. While his colleagues either sat on the sidelines or were the impetus for Miller's candidacy, Davis signed on as Warner's campaign chairman and brought on veteran Capitol Hill staffer and Republican strategist John Hishta to run the race. "People forget that John Warner is and was and forever shall be a mainline conservative politician," said Hista, adding, "He had done a lot for the state over those years as a conservative politician. So to try to portray him as somebody he was not was going to be tough on the part of Jim Miller."[48]

In the course of the loud ramblings of the minority of Miller Republicans, Governor George Allen reminded activists at the time, "We need to remember who our real opponents are. I don't think it does any good, [Republicans] arguing with Republicans."[49] Despite the widespread news coverage of a brewing Republican revolution, when it came down to primary day, extremism lost to practicality. Common sense prevailed that day, with Republicans turning out in droves to vote for the man who had steadfastly served them in the Senate with distinction for eighteen years. Warner defeated Miller with nearly two-thirds of the vote, claiming victories in high-population urban areas of the state and even some rural counties that were predicted to go big for Miller.[50] "This was a Republican primary with few Independent voters; this was not a primary where a lot of folks crossed over. That was negligible," said Hishta. "Warner won everything. He won the most conservative and the most liberal of self-identified Republicans and everything in between."[51]

Brimming with pride about his party's loyalty, John Warner took to the stage at the Jefferson Hotel in Richmond in front of a crowd of over three hundred supporters. "We're ever so fortunate," he said, "...to live in a great state of people of common sense, of wisdom, and they are fair-minded and they responded today, and I accept very humbly their verdict."[52]

From Business Success to the Business of Governing

Same Name, Different Styles

The Old Dominion is home to scores of political traditions. The first debate for statewide campaigns, sponsored by the Virginia Bar Association, is held in the peak of summertime, usually at the Homestead resort in Warm Springs. Shad Planking, originally a get-together of friends celebrating the James River running of shad—the oily, bony fish smoked for the occasion on wood planks over a fire pit—is a gathering held every April in Sussex County.[53] Co-opted in 1949 by the service-based Wakefield Ruritan Club, Shad Planking has steadily evolved into a politically charged gathering of candidates, activists and media from all across Virginia.

Kicking off the unofficial start of the fall campaign season is the Labor Day parade in Buena Vista, a small city in Southwest Virginia's Rockbridge County. In 1996, the scene along the parade route illustrated the contrasting campaign styles of John and Mark Warner:

> *John Warner cruised down the center of Magnolia Avenue on Monday looking like the U.S. Senator from Central Casting.*

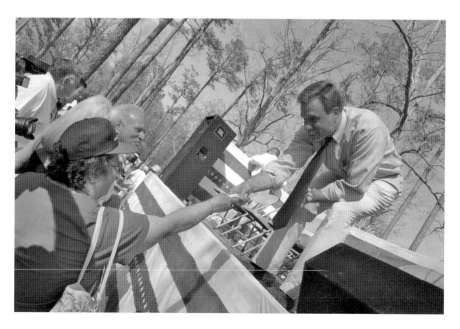

Even when he was not on the ballot, Warner spoke at Shad Planking, a Virginia tradition sponsored by the Wakefield Ruritan Club. *Michaele White.*

Mark Warner the Dealmaker

He sat ramrod straight on the back of a power-red convertible, his face shielded from the morning sun by a Stetson that was more country squire than cowboy.

The Republican waved and called out an occasional greeting to the people along the parade route.

Mostly, Warner maintained a dignified distance befitting a 69-year-old patriarch holding such high office.

A few blocks back, Mark Warner—no relation to John Warner—dashed back and forth across the street, pressing every square inch of flesh within reach.

"I'm the underdog; I've got to work harder," the 41-year-old Democrat huffed, pausing long enough to shake hands with a klatch of lawn-chaired women.

"My hand's sweating, that's right," he said to a young family. "I'm working hard. If I'm not willing to run for it, you shouldn't hire me."

By the end of the two-mile parade route, Mark Warner had soaked through his button-down shirt and khakis, leaving behind a wake of sweat beads. Mark Warner was in such a hurry that he climbed into a helicopter and disappeared over the mountains before his turn came to speak before a Labor Day gathering at Glen Maury Park.[54]

While Mark Warner began his campaign with a sprint, eyeing the finish line on November 6, John Warner was no slouch. After the primary battle, he had spent just about all his money and had to quickly go to a full-time fundraising mode, not to mention worry about the other nuts and bolts from research to building up a full campaign calendar.[55] Mark Warner had several key advantages not typically afforded a challenger. He won the money race, out-raising his opponent two to one. His nomination competition more or less fizzled out before the convention. At forty-one, Mark Warner was nearly three decades younger than his competition.

The sixty-nine-year-old John Warner, on the other hand, faced a different type of campaign than he had ever run. "His tough campaigns had been back before there was a 24/7 media, not as many outside groups getting involved and not the level of funding necessary to be on television," said Susan Magill. "It was a different way of operating."[56] Those challenges, although significant, did not pose a problem. "John Warner every day, even when the Senate was in session, had events in Northern Virginia when he could not travel around the state," she adds. "We took Sunday mornings off. That was it for months."[57]

From Business Success to the Business of Governing

Fresh off a bitter primary fight, one could reasonably assume the victor would face trouble with the Republican base. For John Warner, that was not true. Because he had defeated Jim Miller so handily, the loud but relatively small opposition for the most part was silenced.[58] Some of that hostility was quelled just two weeks before the primary at the state party's convention with a change in leadership. Pat McSweeney, outspoken Republican chairman and anti-Warner critic, stepped down in favor of Randy Forbes, a pro-Warner state delegate up to the challenge of moonlighting as his party's more reasonable standard-bearer. Forbes would later join Warner in Congress after he was elected in 2001.[59]

For Warner's campaign's manager, the senior U.S. senator was a surprisingly easygoing candidate. "He was one of the best I've ever worked with," said John Hishta. "He never looked back on anything once a decision was made. I think the most untold story about John Warner that year is the fact that he essentially said to a bunch of us—in my case a thirty-four-year-old guy that time and he was sixty-nine— 'Go run my campaign.' I think that was a big leap of faith on his part."[60] Warner also was not afraid of what he was up against. The nomination fight was just the first half of an exhausting and expensive campaign year. Famously confident, John Warner's initial reaction to a Mark Warner challenge was no surprise. "I guess the first thing I said was, 'Who's he?'"[61]

With his party's backing and virtually a lifetime of public service in credentials, John Warner forged ahead with a campaign based on results. The plan was to remind the voters of his experience, seniority in the Senate and what he had delivered for Virginia—most importantly, jobs. That was reason enough to keep him in Washington. A major player in defense, Warner had gained the respect of his colleagues and insiders. He had a strong environmental record and was the author of the highway bill that brought in money for the Woodrow Wilson Bridge, a key infrastructure project connecting Virginia, Maryland and Washington. Perhaps Warner's biggest asset was being an independent voice that really looked out for what was in the best interests of the state.[62]

It was that same independence that handicapped Mark Warner's message from the start. While trying to appeal to Independents and pick off moderate Republicans from his opponent, Mark Warner faced an uphill battle due, in large part, to John Warner's stance on Ollie North's candidacy just months prior. This was a significant issue in vote-rich and Democrat-trending Northern Virginia. Then Virginia Commonwealth University political science professor Bob Holsworth released a startling statistic that

"among people who [were] aware that John Warner opposed North, 75 percent said they planned to vote for the Republican."[63] Based on those results, it was clear that "those people made up their minds a long time ago," said Holsworth. The John Warner–Ollie North situation had "undermined Mark's campaign from the beginning."[64]

That issue aside, the younger Warner thought he could make the race about new versus old and who understood the new age, and that meant technology.[65] America in 1996 faced different issues from the America in 1978. Putting the race in familiar business terms for voters, Mark Warner said, "There are times when the management's done a good job, but the nature of the industry has changed. Sometimes a change in management is good."[66] From the beginning of his candidacy, he stuck to an economic message based on his own success. As a self-described "Third Wave" high-tech candidate, Warner told crowds, "I am very proud of my business experience. I am proud of the fact I built businesses from scratch. That's part of my experience I'm going to talk about—about creating jobs, particularly in the technology field."[67]

On the stump, Mark Warner focused on what he called "reclaiming the American dream." He was proud to have made campaign stops in every one of Virginia's cities and counties at least once and believed he was breaking through the barrier that Democrats at the time faced in Southwest Virginia. "Our message about making sure no part of Virginia got left behind, resonated extraordinarily well in rural Virginia and in the inner cities," said Warner.[68] Growing up in Middle America and paying his way through school, he was a living and breathing example of the campaign's message. Warner's raw talent and instinct helped him achieve business success that made him millions. Proud that he truly had lived the American dream, he told crowds from Norfolk to Roanoke, "I want every child growing up in Virginia to have the same opportunities that I had."[69] America in the '90s was in the midst of a technological revolution. "Just as the railroad and interstate highways transformed communities—hurting some and helping others—Warner said the information highway could bypass Virginia unless the state signs on with the computer revolution."[70] That was not going to happen just by accident. Warner was clear that "we have to have leaders that understand the ramifications of this change," adding, "My great fear is that 10 to 15 years from now we would look back at an America that is divided between the information haves and the information have-nots, that cuts across racial, social, economic, geographic lines."[71]

From Business Success to the Business of Governing

With the deck stacked against him, the rookie kept his cool throughout the race. As Hishta remembers, Mark Warner did not take the campaign's goings-on personally. "What was interesting about Mark, in my mind, was that he was always very cordial, very friendly on the campaign trail. We used to joke around all the time when I'd see him."[72] At Shad Planking that year, the two chatted for an inordinate amount of time, something Hishta recalls sets him apart from others. "If Warner was like most candidates," he says, "there's no way he would have done that."[73] Two years later, when he was packed and on his way to Arizona to run Dan Quayle's leadership PAC, Hishta missed a call from Mark Warner, but there was a voicemail. "This is the story I always tell about Mark that I think shows his character," he says. "The message said simply, 'I want to say congratulations. Do Virginia proud.' And I thought, that was really cool."[74]

3
POLITICAL FOES TURNED POLICY ALLIES

Following the '96 race, it was business as usual for the two Warners. John Warner was serving his fourth term in the U.S. Senate with both houses of Congress in Republican control. Mark Warner was continuing to close business deals at his Columbia Capital firm in Alexandria, which by then had already produced four public companies and more than three times as many private companies.[1] Spending a great deal of time on the road for years both as Democratic Party chairman and as a candidate gave Warner a great appreciation for everyone who had helped him along the way. After a tough loss, he did not retreat as many candidates would. Instead, he hosted a series of "thank you" parties around the state for over 1,400 supporters, donors, staff and volunteers.[2] This gesture was by no means a swan song. Capping the night at each of the gatherings was a less-than-subtle hint: Warner would thank everyone for all they had done for him and for all they might do for him in the future. At the Richmond event, featuring Governor Doug Wilder, Warner said, "You can call me the guy who made it close. Or you can call me the guy who got his head chopped off in a TV commercial," he said jokingly, referring to a doctored photo used against him during the campaign. "Or you can call me the guy who rode around in his wife's minivan to all [of Virginia's] jurisdictions. But one thing you can't call me, and that is history."[3]

It wasn't until several months later, in April, that the two Warners were together since the campaign ended. There would first be a reminder of the contest's major sticking point. Neither Warner knew that the other was

flying into the Wakefield Municipal airport before heading to the forty-ninth-annual Shad Planking gathering, nor did a large group from the Virginia Federation of Republican Women coming to greet John Warner. So when Mark Warner's plane landed first, the airport staff announced that "Warner" had arrived, not realizing the residual confusion over the shared last name. "All of the ladies came up to my plane," recalled the younger Warner, "and I got out. A second later someone shouted, 'It's Mark Warner, not John Warner,' leaving the crowd to appear a bit disappointed."[4] Not missing a beat, Mark Warner in good humor chatted up the Republican women and treated the warm welcome as his own rally.

Time went by, and in 1999, the two got together in John Warner's office in the Russell Senate Office Building around the corner from the U.S. Capitol. Mark Warner was awestruck with the collection of memorabilia from the senior U.S. senator's whole career in public service. "His office was classic Virginia," he remembers, impressed by all the mementos from the senator's family and his past.[5] Following a brief tour, the two Warners, one-time political rivals, sat down and talked. "Somehow, we fairly quickly got past the 1996 race," recalled Mark Warner, adding, "I told him how much I admired and respected him...and I really did. You know, the '96 race was never anti–John Warner."[6] From that point on, a friendship ensued that would evolve over the next couple of years when both Warners were to have a stake in the outcome of the 2002 election. This time, they would be on the same side.

When Mark Warner was elected governor in 2001, that he faced an uphill battle was an understatement. A combination of the economic aftershock of 9/11, a recession and a severe state budget shortfall—compliments of his predecessor—meant that his first year in office was sure to be a bumpy one, saddled with a cash-strapped Virginia and a Republican-dominated state legislature. Working with Republicans and Democrats, Warner pushed the idea of taking advantage of Virginia's coveted AAA bond rating, at a time when interest rates were at a record low, to finance long-overdue improvements to college campuses and state parks. But first, the voters would have to give approval for the bond packages in the November 2002 election, which would ultimately provide $900 million for college building projects and another $119 million for state parks.[7] It was a midterm election year, which meant that only the congressional seats were up for grabs. That also meant that voter turnout would be substantially lower.

On that same ballot would appear Senator John Warner, but unlike in his previous race, opponents Libertarian Jacob Hornberger and LaRouche

From Business Success to the Business of Governing

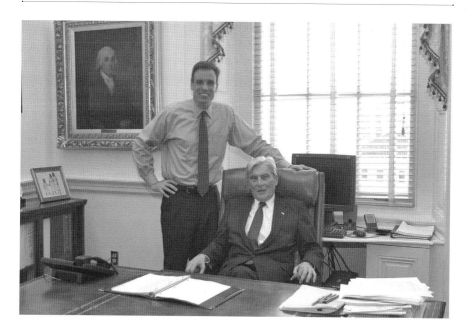

Political opponents turned allies Mark and John Warner formed a bond after the 1996 campaign. *Michaele White.*

Independent Nancy Spannaus posed no serious threat to his reelection. That left the door open for Mark Warner to enlist the help of his friend to drum up support all across the state for the referenda. From town halls to press conferences and filming television commercials, the John and Mark show hit the road.[8] Mark Warner praised his partner for going above the call of duty. "He didn't have to step out on these issues," the governor said. "He could have said, 'Well, I have my own re-election campaign to deal with.' But he has been tireless in his efforts to put Virginia first."[9] John Warner underscored the significance of his pairing with the governor on this issue. "I bet there is no other place in America where today you would have the senior senator from one party and the governor from the other standing together united in one cause," he said.[10] The elder Warner had a policy from day one that he would work with every governor. "He 'checked politics' at the door, so to speak, after every election," said Susan Magill of Warner, who served with eight chief executives over the course of his five terms in the U.S. Senate.[11] "And if [the voters] elected a Democratic governor, then that was their choice," added Warner. "And we helped people in Virginia. That's what we were put in office to do."[12]

Not every measure on the November 5 ballot was a sure bet. Along with the two bond packages appeared a regional sales tax referendum for

voters in Northern Virginia and Hampton Roads, the two areas of the state clamoring for major road construction and mass transit projects. With the General Assembly's continued reluctance to address Virginia's crumbling infrastructure needs, legislators opted to pass the buck to the voters. Senate Transportation Committee chairman Marty Williams, a Republican, pushed through Senate Bill 668, providing the framework for the voters to decide if they would solve the gridlock-laden road network. The bill passed overwhelmingly in both houses with as many Republicans as Democrats signing on as co-patrons. Support for the transportation funding plans was a major sticking point in Mark Warner's gubernatorial campaign, with his Republican opponent opposing the local sales tax options. While Mark Earley had signed the Americans for Tax Reform "Taxpayer Protection Pledge," he was given an opportunity by the organization's president to support the referenda while not breaking his strong anti-tax stance. "It's not a violation of the pledge to allow somebody to put something on the ballot," Grover Norquist told Earley, confirming that the pledge only applies to "direct action to raise taxes."[13] A year later, with the referenda on the ballot, Norquist changed his tune and issued a warning to the General Assembly. "Efforts by elected officials who have signed the pledge to place tax-increase referenda on ballots—without an offset provision of greater or equal value—violate the Taxpayer Protection Pledge," he said,[14] adding, "The last person who broke that pledge was [President George H.W. Bush] and he was invited to do something different for the rest of his life."[15] Even with a way out in 2001, Earley chose to stand firm.

The last time the legislature voted to put significant dollars toward transportation came in 1986 under Governor Gerald Baliles, a Democrat serving with a Democrat-controlled General Assembly. A special legislative session concluding in September that year produced $420 million annually, just $150 million shy of the original proposal. In 1986 terms, the cost of Baliles' plan meant that the average Virginian would pay about $125 more each year in taxes.[16] "At the time most officials viewed Baliles's funding package—a combination of gas and sales taxes and fees—as an installment that would be supplemented every five years or so," said Bob Chase, Northern Virginia Transportation Alliance president. "It was not seen as a one-time solution."[17]

Fifteen years later and absent action from the Republican lawmakers, Mark Warner was faced with a legislative roll of the dice. The state's coffers were dried up, and the referenda were "the way to move these projects off the drawing board and into reality," he says.[18] Warner's only realistic option

From Business Success to the Business of Governing

was to allow voters the opportunity to understand the problem and decide if it warranted a fix. "Virginians are of a mind to support bond issues for good purposes," said Larry Sabato, "assuming a convincing case is made by a well-funded campaign and no fierce counter-balancing opposition surfaces."[19] That is exactly what separated the parks and educational packages from the regional transportation plans.

From day one, proponents of the transportation solutions, whose outreach efforts were spearheaded by the Yes Campaign in Hampton Roads and Citizens for Better Transportation in Northern Virginia, understood they were entering a difficult battle to educate the public of the need for the measures while fighting back criticism from anti-tax groups with extensive grass-roots support. They were not alone. Congressmen Tom Davis and Frank Wolf, both Northern Virginia Republicans, joined Senator Warner and Governor Warner in support of the measures. Also on board were Republican and Democratic members of the General Assembly, as well as a slew of local elected officials from the counties and cities included in the two regions.[20]

Thus began a two-tiered sales campaign. Mark Warner hit the road first to make the case for the college and parks referenda. "Every generation, Virginians are asked to make these kind of long-term capital commitments," he said standing with business leaders, road builders, environmentalists, college presidents, students, elected officials and community activists. "Every generation in the past, when having been asked, has voted overwhelmingly, resoundingly yes."[21] It had been ten years since Virginians voted to authorize $613 million of general obligation bonds to finance projects for parks, mental hospitals and college campuses.[22] Warner's voter outreach plan was fueled by Foundation 2002, a committee led by Judy Wason that raised over $3 million for the cause. Joining the foundation's efforts was a group of William & Mary students who formed the "Students PAC," the precursor to Virginia21, a statewide advocacy organization focused on giving eighteen- to twenty-six-year-olds a voice in the political process in a nonpartisan way to make college affordable, ensure that young people have jobs and build a government that works.[23] Despite the two packages' net-zero tax burden, October polling showed strong but not overwhelming support for them, with 57 percent favoring the higher education bond and just 53 percent the state parks referendum.[24]

Turning his attention to the transportation measures, Warner was brimming with optimism. However, he was well aware of the public's underlying distrust of government that had reached an all-time high just a

year earlier. Wide publicity of road construction budget blunders stemming from the Gilmore administration had not been forgotten. "The biggest detriment to getting [the referenda] passed," Warner admitted at the time, "is not some of the groups that will oppose it but something like news of cost overruns on I-64, or another cost overrun on the Springfield Mixing Bowl. People will say, 'Why am I going to put up more money, if they can't use the money more efficiently?'"[25] The U.S. Department of Transportation's Office of the Inspector General had recently issued an audit report that showed a bleak outlook for Northern Virginia's transportation projects. The review's most striking finding was that 70 percent of the 152 projects planned from 1994 to 2000 were either delayed or no longer scheduled to begin construction.[26]

Despite the tough odds, John and Mark Warner made a final push, setting out on a four-stop tour that crisscrossed the Old Dominion just days before the election.[27] A poll of Northern Virginia voters in late October showed the transportation battle would come down to the wire. Asked if they would vote to raise their sales tax a half cent per dollar, from 4.5 to 5 percent, to jumpstart road projects sitting currently unfunded, the split was nearly fifty-fifty. With only 8 percent undecided, 49 percent of the sampled registered voters said they would support the measure, while 43 percent opposed it.[28] "Whenever an election is as tight as this one, every vote counts," Senator Warner told the crowds he campaigned with Governor Warner. "That should be an inducement for all of us to get out and cast our votes."[29] Solidifying his support, he added, "We are fortunate to have a governor who went through the school of hard knocks in the business world. I back [Governor Warner] 100 percent when he says he doesn't have [additional funds for transportation improvements in Northern Virginia.]"[30]

The two Warners began the day at a metro stop in Northern Virginia before heading to Richmond for a press conference at the state capitol. It just happened to be one of the worst weather days that fall, but it did not keep either from trying to outdo the other in making his case to the press and supporters who attended the events. "It quickly became a growing battle for who was the better campaigner," said Susan Magill, laughing.[31] John Warner did not miss the opportunity to point out his former opponent's accustomed way of touring the state. "I don't have a big car, driver, and airplane," Senator Warner said and quipped, "Susan and I just drive ourselves around."[32] The weather was getting worse just as they were about to leave Newport News. As a result, the pilot said they would not be flying to Charlottesville. While Mark Warner decided to head back to Richmond,

From Business Success to the Business of Governing

Magill opted to take the next Amtrak back to Northern Virginia in lieu of a bumpy plane ride. John Warner, not willing to leave his trusted advisor behind as he flew to Dulles, changed his plans last minute. "Mark, you don't need to send me back on this expensive plane," Warner told the governor. "Susan and I will just take the train."[33] Warner and Magill had no idea what they were getting into. Their anticipated peaceful ride back turned into a seven-hour nightmare, with a car stuck on the track near Richmond and an engine problem occurring shortly thereafter. Magill recalls there was virtually no one on the train, leaving John Warner sitting there figuring out what it was costing the taxpayers for the train to run to Northern Virginia. "He was up with the conductor asking all kinds of questions," said Magill. "I knew then he was going to call Amtrak to figure out if we can really afford to run this train."[34] Even Warner's arrival at the Alexandria station that evening was troublesome, and in fact, he almost did not make it home in one piece. As the train pulled up to unload the few weary passengers, Warner jumped off with one bag and quickly reboarded to retrieve his second. At the same time, the conductor, trying to make up for being so far behind schedule, did not see Warner and proceeded to pull off at full speed. "I didn't want to have one bag in my possession, lose another at the station and then have to go all the way to Washington just to take a cab home at one o'clock in the morning," said Warner, who leapt from the train with the balance of his luggage before the platform came to an abrupt end.[35]

With one of the longest days of their lives behind them, John and Mark Warner had done all they could to support the referenda. It was now up to the voters. Relatively confident about the education and parks initiatives, they were still guarded about the fate of the transportation proposals, which called for $7.7 billion in Hampton Roads and $5.03 billion in Northern Virginia for the planning, design and construction of road and mass transit projects. More significant in scope but less burdensome on the wallet than the 1986 transportation package, the 2002 increase in the local sales tax was projected to cost the average household about $100 annually.[36] For some, including two holdout delegates from Hampton Roads, that was still too much of a burden to all but end road gridlock. While their colleagues banded together in a near unanimous fashion favoring the referendum, two delegates—one Republican and one Democrat—condemned the solution in a last-minute television commercial, in effect saying, "Don't trust us, we are not going to spend your money wisely up in Richmond."[37]

By the early evening, it was clear there were some winners and losers. John Warner was easily returned to the Senate for his fifth term, where he

would regain his chairmanship of the Armed Services Committee. He was joined by all of Virginia's eleven congressional incumbents, none of whom were looking at a difficult reelection. Voter support for the various referenda, however, was mixed. Seventy-two percent voted in favor of borrowing $900 million for campus construction and renovation projects, generating an estimated fourteen thousand jobs and making room for an additional thirty-two thousand students in Virginia's higher education system.[38] Sixty-nine percent voted for the $119 million state park and nature preserve referendum, giving the state the opportunity to acquire new land, expand current properties, protect wetlands and improve campgrounds and trails.[39] Breaking from the two bond issues, the referenda "died the death of a thousand cuts," said Mark Warner.[40] The voters rejected both transportation initiatives, leaving support for the Hampton Roads sales tax plan at just 38 percent and that for Northern Virginia slightly more at 45.[41]

The reality was that the voters had little trust in their representatives' ability to manage transportation dollars and get the job done. Election after election, General Assembly candidates campaigned on seriously addressing transportation. Year after year, state legislators would come to Richmond and fall short of any solution. Meanwhile, day after day, driving in gridlock, the voters saw little improvement to areas that had been under construction for years. YES Campaign co-chair Josh Darden, a Norfolk business leader and philanthropist who passed away in 2014, at the time released the PAC's internal polling, which indicated that 70 percent believed that the newly generated sales tax dollars would be seized for some other government expenditure other than roads. "They thought it would go to Richmond and never come back," he explained. "We tried to talk about roads and bridges, and [opponents of the referendum] made it a campaign about taxes."[42]

Exit polling conducted in Hampton Roads by Christopher Newport University confirmed the pre–election day polling. It appeared that the initially popular notion of a regional self-help transportation plan presented too many doubts in the minds of the voters by the time election day rolled around. While the Yes Campaign raised over $2 million for extensive radio and TV ads, opponents of the tax plan used a grass-roots strategy that reached critical mass under the radar. "The reality is that voters, at least those in Hampton Roads, were sending their leaders a more complex message about the way the state [was] being governed," said Dr. Quentin Kidd, director of the Wason Center for Public Policy at Christopher Newport University.[43] Eighty-five percent of the exit poll respondents agreed that they did not trust the General Assembly to use the money raised for its intended purpose.[44]

From Business Success to the Business of Governing

Making matters worse, the state's Department of Transportation had a poor track record that all but guaranteed that the road projects would not be completed on time and within budget constraints. Moreover, the legislature a year earlier had failed to pass a budget in what was a very public fight with Governor Jim Gilmore, Mark Warner's predecessor, over Gilmore's insistence that the General Assembly advance his chief political promise despite its detrimental long-term fiscal impact to Virginia.[45]

Liberal with their condemnation of the proposals in Hampton Roads and Northern Virginia, the same opponents offered unrealistic solutions of their own. Days after the vote, Delegate John Welch, a Republican from Virginia Beach, suggested that highway dollars set aside for rural areas of the state should be hijacked for Hampton Roads and Northern Virginia. "We need to tell the rest of the state, 'This is the way it's going to be from now on,'" said Welch.[46] Then Ken Cuccinelli, a Fairfax Republican who was elected to the state Senate in a summer 2002 special election while chairing the Coalition Against the Tax Referendum, offered a similar suggestion, insisting the solution was to "change the state's formula for disbursing transportation money, giving priority to areas with the most traffic congestion."[47] Warner pointed out the obvious flaw in that logic at the time. "That's the thing that some of the opponents in Northern Virginia were saying, that 'Let's just take it from other parts of the state, take it from areas like Hampton Roads.' Seems to be pretty much a zero-sum game," he reminded reporters in the fallout.[48]

A comprehensive mass transit and roads plan is a multibillion-dollar venture demanding colossal debt or new revenue. Cuccinelli's proposition, which called for arbitrarily shifting existing dollars out of political expediency, was one of many plans offered by his legislative colleagues. These so-called solutions ignored the revenue side of the equation. As a result, even the General Assembly's most ardent penny-pinchers could not identity enough existing state dollars to solve the problem. In fact, some of the most outspoken Republican opponents were arguably equipped with the state budget know-how to address the problem, having several terms in the General Assembly under their belts. Instead of offering solutions, they offered criticism. Delegate Jack Reid and Bill Bolling, a Hanover state senator elected lieutenant governor in 2009, joined a cadre of Richmond-area delegates at a press conference in the wake of the failed referendums to do just that.[49]

No viable plan survived the General Assembly's gauntlet until eleven years later. It was in 2013 that Bill Bolling, finishing up his second term as lieutenant governor, was a prominent cheerleader for Governor Bob

McDonnell's bipartisan transportation funding package fueled by $6 billion in tax increases. Bolling's public conversion on the issue took center stage after Cuccinelli bested the McDonnell heir apparent for the GOP nomination for governor. Cuccinelli, who was ushered into statewide office as attorney general thanks to a 2009 GOP wave, outmaneuvered Bolling with Republican activists and solidified his nomination a year before the 2013 governor's race.[50]

Warner's fight in 2002 could not have come at a worse time for the Old Dominion. Virginia was badly bruised by the recession, and during his first year behind the governor's desk, he cut the state budget to the bone. "We've taken $4.5 billion out of the current budget cycle, and we have another billion to take," said Warner in response to the idea that the money the General Assembly needed for a transportation fix was staring right at them.[51] "One of the reasons why you saw such virtually unanimous support from legislators in both parties [for the transportation tax referenda] was that if there was other money around, they would have gone after it."[52] The General Assembly also rejected other revenue sources, including voting down a proposal that would have imposed a modest tipping fee on all out-of-state trash dumped in Virginia. Virginia was second only to Pennsylvania at the time in the trash import business. While the $76 million that the $5-a-ton fee would have generated annually was no silver bullet for the transportation and land use problem, it was a start in the ongoing revenue discussion.[53]

Notwithstanding the transportation referenda setback, Mark Warner was no quitter. A year into his term seemed to him like an eternity. It was a year of budget shortfalls, election losses, massive cuts to the government workforce and policy battles with the General Assembly. It was more than enough for just any governor to throw up his hands and surrender. But this was Mark Warner—a man who knew defeat, who faced adversity and who never quit. While others were likely to run away, he was just getting started.

4
SMALL-TOWN DREAMER

MIDWEST VALUES

The Rockville High School class of 1973 had its thirtieth reunion in late November 2003. While seventy-two faithful alums attended, one person was noticeably absent. Mark Warner, who had never missed a reunion, couldn't make it to the festivities, which were held over Thanksgiving weekend. But that was not going to stop him from participating. Warner asked friend and reunion coordinator Kathy McFadden Onthank to read aloud—as champagne, compliments of the then governor of Virginia, was passed around—an invitation for everyone to come to Richmond in the spring. Onthank added, at Warner's instruction, "It's coming out of [his] own pocket."[1]

"It's a once-in-a-lifetime thing," recalled classmate Leslie Wilson McMahon, who, along with nearly everyone who attended the reunion, was treated to a weekend at Virginia's nearly two-hundred-year-old Governor's Mansion in downtown Richmond.[2] This gesture was neither unexpected nor out of character for Warner, who cherishes the friendships he has made in his life. In fact, a year later, he hosted his Harvard Law classmates in a similar fashion. Of course, the itinerary called for a spirited pickup game of basketball, which Dave Croall recalled "did not result in any serious injuries."[3] A former Harvard intramural basketball player himself, Croall remembers the intensity on the court in his mid-twenties. "Harvard Law students are a fairly competitive bunch, as you might expect. Some frustrations were

worked out on the basketball court that probably did not need to be worked out there."[4] In light of the fact that two and a half decades had passed since then, and with his wife's strong encouragement, Croall decided to take a pass on the game. It was, however, very well attended. Following dinner and drinks at the Governor's Mansion, Warner gave personal tours of the capitol accessed only by the underground tunnel system. He allowed each of his guests a chance to sit in the governor's chair and be chief executive for a minute before getting back home just in time to tuck in his three young girls, who had been patiently waiting at the top of the stairs in their pajamas.[5]

Both memorable weekends showed that Warner, ever the gregarious, fair and classy guy, had not changed since his days at Rockville High, where Leslie McMahon says that "no matter what clique you were in," Warner greeted everyone by name.[6] Now a successful businessman and political rising star, Warner hasn't forgotten his roots and the friends he made so long ago.

His disposition was a product of a loving middle-class family. His father, Robert, a marine and World War II veteran, and mother, Marjorie, welcomed Mark Robert Warner into the world on December 15, 1954, in Indianapolis, Indiana. Together with his younger sister Lisa, they moved in 1966 to Washington, Illinois, near Peoria, where Warner remembers that as a young kid, "I walked through a cornfield to go to school."[7] The family would later, in 1969, move to the small town of Vernon, Connecticut, where Warner entered the eighth grade at Rockville High School.

Bob Warner, a safety evaluator for Aetna Life & Casualty for over thirty-eight years, ran a tight ship. "I always stressed that you've got to be honest, you've got to be trustworthy and you've got to be respectful of your elders," he says. "I didn't like long hair; I wasn't going to tolerate any drinking or drugs. I always let Mark know that these were my guidelines and if he felt man enough to take me on, c'mon."[8] With the rules on the table, young Mark Warner didn't rebel like many defiant teens in the '60s. "Turns out I probably didn't have to be that way," said the elder Warner. "He never really caused trouble, at least any that I know about."[9]

Mark Warner's penchant for service was rooted in his parents' involvement in the community, not in politics. "My parents were never political," he says. "They were always Republicans but not active in politics. They were, however, involved in the community. They were the PTA president, the Boy Scout troop leader or the Indian Guides chief. They were involved through their kids."[10] Bob and Marge Warner instilled in their children a culture of caring about and being active in their community. Growing up, "it seemed obvious to me that I should be involved," said Warner.[11]

From Business Success to the Business of Governing

The younger Warner gives his father, Bob, a seat in the governor's chair. *Michaele White*.

As a boy, Mark Warner was like any other kid. He played football and baseball. A tradition that continues today, he would arrange pickup basketball games in his driveway. He was a Boy Scout, read comic books, collected coins, loved to read and was intrigued by American history.[12] He also had an enterprising streak, delivering newspapers in his neighborhood, "and he made all of his own spending money right up to the time he graduated," said his father.[13]

Friends say that Warner was a natural leader. "He was always the organizer and the center of attention," said Bruce Carter, a Hollywood television director and Warner's best friend in high school. "He liked pulling people around him and creating a sense of community."[14] At Rockville High School, Warner was elected president of his class for three years in a row. "He didn't have to campaign," said Carter, who also served on the student council. "He just had such good relations with everyone—students, teachers, the school board—that everyone knew if you wanted something done, you'd go to Mark."[15] He put his abilities to work, convincing "the Vernon Town Council and local business leaders to help fix up an abandoned convalescent center and stock it with ping-pong tables. It became known as the Vernon Teen Center."[16]

Around the seventh grade, Warner was bit by the political bug. "My aunt was a precinct captain in the Indianapolis Democratic organization," he

says. "They were Catholic and huge Kennedy fans. My parents were huge Nixon fans. I remember the family arguments about it."[17] A year later, the Warners were in Vernon, and young Mark was the Richard Nixon surrogate in his social studies class debate, much to his father's delight. It was 1968, a presidential election year with Nixon facing Democrat Hubert Humphrey. "I really didn't know much about politics at that point in my life," he admits.[18] It was soon thereafter when father and son would no longer share the same political leanings. "He became a Democrat shortly after that," said Bob Warner, jestingly adding, "I don't know why he went astray."[19] So began a standing disagreement on politics between the two Warners. "Sometimes we'd debate each other," Bob Warner recalled. "He'd say, 'Dad, you're not listening to my side on this,' and I'd say, 'That's because you're not listening to mine.' Soon, we'd just stop talking because we knew neither of us could change the other's mind."[20]

It wasn't all about arguments in the Warner household. It was 1968, and there were reasons to celebrate. Congress passed the Civil Rights Act, Elvis Presley made a return to the stage and astronauts aboard Apollo 8 became the first to see the far side of the moon. Tragically, 1968 was also met with events that changed our country. The Vietnam War seemed endless with America being dealt setbacks. Dr. Martin Luther King Jr. and Robert F. Kennedy were assassinated, delivering a huge blow to the civil rights movement. And antiwar protests dominated the Democratic National Convention in Chicago, leaving the party divided.

In this tumultuous time, there was a notion that young people were going to change the world. "I wasn't old enough to be involved in the student protests, but it was romantic though to see it," said Warner. "I always thought I was old enough to get touched by the idealism of the '60s but not old enough to get jaded by it."[21] With all that was going on, Warner had made his choice of political party. "It seemed to me that the Democrats were doing more and had a help-people component," he says. "They were waging the war on poverty and had a lot of good intentions on social programs."[22] Warner felt that it was the Democratic Party that was bringing out the best in America. "It still is the party, when it is at its best, that plays on our hopes and aspirations."[23]

Back in Vernon, Warner was inspired to act locally. "In high school I started to get a little more involved in politics," he says. "It just seemed like politics was a way to make a difference, make a change."[24] He became the local Democratic committee's resident "young guy," leafleting for Joe Duffey's campaign for the U.S. Senate.[25] As president of his high school

From Business Success to the Business of Governing

class, Warner took his job seriously. Fundraising was no exception. But it wasn't just about planning social events and scraping together a few bucks. As a leader, he recognized there was an "added responsibility that you then had to say, 'all right, it can't just be about helping folks go organize skating parties or whatever it is,'" says Warner, "you've got to worry then about the safety of people in terms of drinking and driving and everything else that goes along with it."[26]

With his time in high school coming to a close, Warner was focused on what he would do after graduation. "I had decided at that point that I knew I was interested in politics," he says, "so I applied to three schools in Washington, D.C., as well as the University of Connecticut, just to make my parents happy." Warner knew he wanted to go to D.C. and was accepted to Georgetown, American and George Washington. He ultimately chose GW, because it was the center of the political universe, and most importantly, they offered him more financial aid.[27] August 1973 was a proud moment for Bob and Marge Warner. With their eldest child moving out and on a path to be the first in the family to graduate from college, they knew they had done all they could to prepare him for his next step. Mark Warner, eager, ambitious and determined, said his goodbyes. With that, he left his Meadowlark Road home in Vernon and headed south to take on the nation's capital.

Majoring in Washington, D.C.

Like any other college freshman, Mark Warner was on his own for the first time. Enrolled at George Washington, the largest university in the District, Warner quickly achieved academic success and demonstrated political skills rare for a college graduate, let alone a freshman. "Mark stood out because he was so successful landing jobs on Capitol Hill and still got good grades," said Keith Frederick, Warner's freshman roommate in Thurston Hall.[28] "Back then, he was pretty much the same guy he is now. He was very interested in politics, had lots of energy, and he loved basketball."[29]

True, Warner set out for D.C. to follow his passion. "He had an interest in politics and a desire to serve," said Frederick. "There was a lot of discussion at the time whether the Great Society had failed or succeeded. There was a backlash, given the Nixon era, against limousine liberals. Mark never was ultra-liberal. He exhibited pragmatic social consciousness. The discussion was, 'How do we do this right?'"[30] In a time when Watergate, *Roe v. Wade*

and the close of the Vietnam War dominated the news, Warner thrived on discussions of current events and sharing ideas with his classmates. "What he used to do in college was pull together study groups of other students in his classes," said Frederick. "Mark would be the instigator of those things and we'd talk through what was going on in class and Mark would do a lot of his learning that way."[31] Graduating as the class of 1977's salutatorian, Warner was no slacker. He has always been a quick study and was more interested in making learning a social event.

While his academic course load kept him busy, his heart was set on politics. Warner's father, Bob, recalls his first visit with his wife, Marge, to see their son in college. They had previously asked young Mark to get them into a tour of the White House. "His mother and I arrive in D.C.," said Bob, "and I asked, 'Did you get those tickets?' And he said, 'Yes, I got two tickets.' I said, 'Two?' Mark explained yes, he had one for me and one for his mother. 'So why didn't you get one for yourself?' I asked. And he replied, 'I'll see the White House when I'm president.'"[32]

Even at eighteen years old, Mark Warner seemed determined to seek public office one day. He needed his start somewhere. "I managed to try to lobby every person I knew in local politics to write letters to try to help me get me a job with Senator Abe Ribicoff's office," said Warner.[33] Ribicoff, former Democratic congressman and governor of Connecticut, was serving his second term in the U.S. Senate. Successful in his job-hunting attempt, Warner got right to work. "I thought I had died and gone to heaven," he says, thinking back on the opportunity to work on Capitol Hill as a student.[34]

"I'll always remember my first job on Capitol Hill," said Warner. "I would ride my bike every day—I had to be there at 7:15 to open the mail. Here I was, a freshman in college, I thought it was pretty cool."[35] Warner also remembers with little fondness his ugly green suit, the only suit he had at the time. With no other choice, he was forced to wear it, even when the Washington humidity was near swamp-like conditions. "You know, I had my polyester leisure suit on at that point, which was good if you're riding your bike up because you could kind of squeeze it out afterwards."[36]

For Mark Warner, one job was not enough. "About a week into school after getting this job in Ribicoff's office," he says, "I had a full load of college courses but still wanted to find a third job that would be more substantive."[37] Warner ended up getting an unpaid but more substantive position in Congresswoman Ella Grasso's office. Grasso served several years in the Connecticut state house before getting elected to Congress in 1970. Warner

From Business Success to the Business of Governing

recalls, "A lot of the time I would work part of the day in Ribicoff's office then go over and spend four hours in Grasso's office."[38]

Working on the Hill was not purely an extracurricular activity for Warner, who still needed to pay for what his scholarship did not cover. Despite a full college schedule, he "worked 30 hours a week and aced his classes while seldom missing a pick-up basketball game or a bar call."[39] He also saved by not having to worry too much about food, although he stuck to a typical college diet. "These was the days when there were a lot more receptions on the Hill," said Warner, "and you could graze your way through every night. A lot of the times I would keep plastic bags in my pockets, take the extra food, ride my bike back to the dorm around 8 and eat all kinds of slightly crushed shrimp, fried won tons and all other kinds of stuff."[40]

Warner took his work a step further at the start of his sophomore year, picking up his books at GW and immediately driving back to Connecticut "to serve as youth coordinator for Congresswoman Grasso's gubernatorial campaign."[41] Grasso became "the first woman elected a state governor in her own right," Warner says proudly.[42] He managed to not get caught skipping most of the semester, and his absence did not affect his grades. Under pressure once back on campus, Warner "borrowed notes and pulled straight A's."[43]

In just over a year's time, Warner had paid his dues as a gofer, legislative correspondent and coalition builder, all the while going to school. So after returning from the successful Grasso campaign, Warner once again sought work on Capitol Hill. This time, he struck gold. He was offered a position to become, in effect, one of Congressman Chris Dodd's junior legislative assistants, working a paid twenty-five-hour-a-week job during the day and taking classes early in the morning or late in the evening.[44] Dodd had just been elected to the House and would later serve in the U.S. Senate for three decades.

Warner recalls one of the most memorable Washington experiences that put everything into perspective. In 1975, Congress was considering the Metric Conversion Act, which would have America join the rest of the world and convert from inches to meters in ten years.[45] Warner's portfolio included the Committee on Science and Technology, and he brought up the idea that they should add the construction industry to the Metric Conversion Board. He went right to work, writing up talking points and helping lobby members. "I think it was one of Dodd's first amendments," said Warner. "He offered the amendment in committee and it got adopted. We continued to work the amendment through the House until it was passed into law."[46] Warner's chest was puffed with pride as they continued to be successful every step of

the way. "And when it passed, I was thinking, my gosh, here I am, a 19-year-old kid helping making law in the United States."[47] He quickly adds, "And the perspective is that the bill became law, and thirty-five years later the country has still not converted to metric."[48]

Following His Heart

In 1977, Mark Warner was graduating from George Washington, the result of a conscious decision he made four years earlier to head south and pursue his passion. This landed him right in the middle of D.C. politics. By the same token, Warner now had to make a similar decision; however, this time, his days on GW's campus were numbered. His passion was still politics, and as it did to many in the field, law school just seemed like a natural next step. Logically, Warner would want to stay in D.C., build his political résumé and be ahead of the game when he graduated. But sometimes, you just have to throw logic out the window and listen to what really matters to you at the time. For Warner, it was a girl. "I was dating a girl at that point who was going to Harvard, and she said, you know, you ought to apply to law school here. And I had really never thought about it. I had never thought you know, I could never get into a place like Harvard."[49] He applied and got in. Acknowledging it was a great opportunity, not to mention the fact that he was offered a scholarship, Warner could not pass it up.

Harvard presented Warner with an equally stimulating and educational experience. "I met an extraordinary amount of very, very bright people," he said. "I was intellectually challenged at a level I had never been before."[50] Warner's magnetic personality and warm demeanor seemed to break the ice in this intense Cambridge bubble. He was the link that made new friendships possible in spite of the competitive atmosphere.

Friend and classmate Helen Blohm remembers fondly that the class of 1980 was uncommonly cohesive, saying, "In part that was really Mark's influence. He would often be the one planning the party, getting the group together, or doing social things that made us seem more connected to each other."[51] Blohm, captain of the school's first women's intramural basketball team, approached Warner with some of her teammates to see if he would coach the team. Ever the immodest hoopster, Warner could not resist. "He took it in the right degree of seriousness—he taught us some skills, held

From Business Success to the Business of Governing

practices, and coached during the games. He would get really mad when guys played ridiculously tough with us."[52]

"He wasn't part of a faction," said friend and classmate Howard Gutman, who was later appointed ambassador to Belgium by President Barack Obama. "He overlapped everyone."[53] Warner co-founded what he calls the largest organization at the time at Harvard called the Sommerville Bar Review, a group that met every Thursday night at a different bar in Sommerville, Massachusetts, a small city two miles north of Boston. At its height, during Warner's third year, nearly two hundred classmates joined in.[54] While others may remember fondly making the *Harvard Law Review* or winning the Ames Moot Court competition, Warner's recalls his best memories are of "sneaking beer into the law library and toiletpapering the law school on Halloween."[55]

Nearing graduation in 1980, one thing was clear to Warner. "I determined I would not be a good lawyer," he says. "There is a different level of specificity. It robs you of some of your energy."[56] He had two summer internships at law firms, and as a result says, "I just found the culture and work of law firms to be uninteresting."[57] Warner is happy that he discovered this early on, which in no way left him with a sense of defeat. He proudly boasts, "I was the only member of the Harvard Law School class of 1980 that did not get a job offer at either place I clerked as a summer associate."[58]

While everybody else was getting job offers from law firms that would pay between $45,000 to $80,000 to start, Warner kept trying to get a job with the Democratic National Committee. "I finally went down to D.C. the week between finals and graduation," he recalls. "I basically wouldn't leave."[59] Warner proceeded to lobby anyone he could find to give him a chance. The pestering paid off. Impressed with his persistence, DNC treasurer Peter Kelly finally gave in and said that instead of going right back to Harvard, Warner should stay for a few days. Kelly immediately put him to work on a fundraiser for President Jimmy Carter. "I was sleeping on someone's couch," he says, "and they didn't offer me a salary for the first four or five days."[60] By the end of the week, he was hired and was to report back immediately after graduation.

Excited and relieved, Warner drove back to law school just in time to graduate. He was glowing and remembers telling all of his friends, "I got a job. I stayed pure. I didn't sell out. And I'm going to go change the world."[61] His prize was an $18,000-a-year salary at the DNC.

Warner had a couple days to say his goodbyes and pack his car. He had no place to live, few possessions and a small stereo. None of that mattered.

He was coming back to Washington, and after nineteen years of school, he was ready to be a bona fide adult. Little did he know that some drastic changes were made during the week he had gone back to Harvard. "The guy who hired me had been fired," said Warner. "The Carter campaign came in and took over the DNC."[62] Warner recalls his first day on the job like it was yesterday. "I came in where my office was a week prior. I had no desk. I had no chair. I had no phone. They put me out in the hallway at a folding table."[63]

The DNC's fundraising operation was now in the hands of Terry McAuliffe, a twenty-three-year-old political whiz kid with deep connections and boundless energy who would eventually chair the national party. Like Warner, McAuliffe's entrepreneurial spirit made him a natural fit for the make-it-or-break-it business. The prolific fundraiser, capitalist and noted best friend of the Clintons would later follow in Warner's footsteps with a historic win in 2013's gubernatorial race after having fired up the Democratic base and, at the same time, authentically appealed to moderate Republicans and the commonwealth's growing block of Independent voters. Furthermore, McAuliffe's ability to rake in cash and implement a modern ground game would be the envy of any presidential contender. His victory marked the first time in thirty-eight years in Virginia that a candidate for governor of the same party as the president came out on top.

The younger of the two still laughs today at Warner's reaction in 1980 to the surprising news about his DNC job. "After Mark asked what happened," said McAuliffe, "He was told to 'talk to the young guy down the hall. He's the boss now.'"[64] Warner couldn't believe that in a week's time the guy who hired him was gone, and now he had to deal with a new boss he had never met. "To make things even worse," said Warner of McAuliffe, "he was a couple years younger than me. I was always used to being the young guy."[65] Accepting his new circumstances with humility, Warner was ever eager to succeed. "I had to prove myself to Terry and the guys there that I could do my job."[66] While President Carter came up short in his reelection bid, the finance team worked tirelessly to keep the Democratic ticket competitive with the Reagan-Bush juggernaut. "He was a real star," said Warner of McAuliffe, "and to this day, nobody has been a better fundraiser than Terry McAuliffe."[67]

Washington is a place where you can move up quickly if you have the talent and make the right impression on the right people. Naturally, Warner excelled in the business. And he also offered a not-so-common genuineness that put potential donors at ease. That, with a good bit of confidence, went a long way in being a successful fundraiser. "One of the things I learned at the

From Business Success to the Business of Governing

DNC was feeling comfortable around people with wealth," said Warner. "It wasn't intimidating. While I never practiced law, the value of the Harvard Law degree was also a good credential."[68]

By 1982, Warner was thinking back on where he was in his life, what he had accomplished so far and what could be his next step. With an offer to be the finance director at the Democratic Congressional Campaign Committee, there was an important decision to make. Having left the small town of Vernon, Connecticut, nine years ago for a future in politics, he had to decide what that future might hold. At twenty-eight and traveling the country as a successful fundraiser, after having paid his dues along the way, Warner had some options. "The experience at the DNC gave me the impetus to, if I were to try politics in the future, go out and make a living first," said Warner.[69] Being somewhat at a crossroads, "I could say 'OK, I'm rising up on the staff side in politics. Or I could try to say I could go off on my own and I may or may not come back to politics, but I'm going to try to do something else and then maybe come back to politics rather than just staying on the staff side.'"[70] While Warner may have weighed the options, his personality would lead him to only one conclusion.

5
WHEELING AND DEALING

WILLING TO FAIL

Growing up, Mark Warner always had the entrepreneurial bug. He had a paper route. He performed various maintenance jobs at a hospital. He bagged groceries and washed dishes. He was even a shoe salesman. "One winter," Warner recalls, "I got the town to hire me to be the safety patrol monitor at the frozen pond."[1] In college, he convinced the school to give him a free room in exchange for being a dorm's jack-of-all-trades, reprising his role in maintenance. "I didn't have any money," said Warner, "so I was always trying to find a way to get by on my own."[2]

In 1982, Warner was ready to move on after a successful stint as a fundraiser for the DNC. "He lived in a dingy Washington townhouse with three roommates, paying $100 a month rent. He had a blue plastic couch propped up with cinder blocks. His bedroom floor was piled with laundry. His 1965 Buick constantly broke down."[3]

Warner's living situation did not exactly scream "eligible bachelor." "We couldn't even set him up on dates," said Howard Gutman, a good friend who was an attorney in D.C. at the time. "I remember this friend of my wife tried to fix him up with a very attractive dental student from the University of Pennsylvania. She took one look at his car and decided she didn't want anything to do with him."[4]

With politics on his horizon and no money in his pocket, Warner knew that something had to change if he did not want to fall victim to his own ambitions.

"I swore to myself having seen fundraising up close that if I was ever to get into politics that I wanted to have some financial resources," said Warner. "I didn't want my livelihood to be dependent on success in politics."[5] He recalls the story of Ronald Sarasin, a Republican congressman from Connecticut, who was left with $300,000 in campaign debts following his unsuccessful 1978 bid for governor. "His whole future was altered," said Warner, speaking of Sarasin. "His family was changed. His choices were changed. I knew if you had your own means, you could never be compromised."[6]

With student loans coming due, Warner had to make a move. With the money left in his savings, a mere $5,000, he joined up with some friends and tried to start up an energy savings company. They had a novel idea involving an additive that you could put in oil-burning furnaces to make them burn more efficiently. The idea was great, but the execution was not. "We really didn't know much about what we were doing, and it wasn't successful," said Warner.[7] His first attempt had failed in six weeks.

An undeterred Warner moved to Atlanta, Georgia, to try his hand at real estate. "We tried to get pension funds to invest in real estate before it became all the norm," said Warner, adding, "I was the junior guy, and the two senior partners didn't get along."[8] As a result, the business fell apart, and Warner's second attempt had failed in six months.

An old acquaintance then changed his world. While raising cash for the DNC in 1980, Warner had first met Tom McMillen, a six-foot-eleven standout University of Maryland basketball player who was playing for the NBA's Atlanta Hawks at the time. McMillen would later go on to be elected to Congress. Warner checked in with McMillen after his real estate venture went bust. "With McMillen's help, Warner figured out that the government was basically giving away big swaths of the radio spectrum for cellular licenses—which were about to become critical to the operation of the wireless-phone industry."[9]

"These were the days that cellular was a biological term," said McMillen.[10] While others may have seen risk, Warner saw the enormous potential in getting in on the ground level of a new industry. "It was like taking a dog to water, but the dog still had to be smart enough to drink."[11] He jumped at the opportunity, taking with him a Harvard Law education, boundless energy, collegiate good looks, Washington street smarts and a nothing-to-lose attitude. Warner's connections he made while at the DNC could not have hurt either. "He was a fund-raiser, which was a great attribute to have when you're trying to raise money for business," said McMillen. "I even told him that: 'You ought to use your fund-raising network to get started in this.' That was exactly what he did."[12]

From Business Success to the Business of Governing

Selling a Vision

Warner's foray into putting together applications for cellular licenses led him back home. He set his sights on David Chase, who, Warner says, "had built a multi-hundred million dollar financial enterprise by just sheer entrepreneurial skill."[13] At the age of twelve, Chase, with his family, was moved by the Nazis from his home in Sosnowiec, Poland, to a ghetto. While over sixty members of his family were later killed in the Auschwitz concentration camp, Chase escaped and was freed by General Patton's Third Army. He came to America in 1946 with nothing but the clothes on his back and settled in Hartford, Connecticut.[14]

Warner did not know Chase, but he knew someone who did. Back in 1974 when he was working on Congresswoman Ella Grasso's campaign for governor, Warner met Edward Stockton, whom Grasso subsequently appointed as Connecticut's commissioner of the Department of Economic Development. Through his work on business issues, Stockton knew Chase. However, was he willing to set up a meeting with the richest man in Hartford? Stockton thought Warner's idea was "wacky," but after incessant calls, he agreed to introduce the young entrepreneur to Chase.[15]

Warner went in to see Chase and made a presentation on this seemingly futuristic cellular technology, admittedly naïve on the subject.[16] He explained that the Federal Communications Commission (FCC) was basically giving away cellular licenses, much like they had done with television and radio decades back. Warner presented the vision that there "might be unimaginable profits for those who get in early."[17] The deal meant Chase would put up the investment, and for his work managing the transaction, Warner would get a small cut. With Warner twenty minutes into his pitch, Chase abruptly stopped him and said, "I think I ought to apply for the Hartford license and maybe a few others."[18] Warner left that meeting with a deal for $1 million that Chase would invest in a technology he could neither see nor touch.

"I went in and made a presentation to him about this new technology, cellular, [and I] didn't really know that much [about it]," said Warner, "but he either saw something in me or saw something in the idea and was willing to invest."[19] Indeed, Chase did see something in Warner. "He was very unusual for a young man," Chase says of his first impression of Warner. "Frankly, I would have been receptive to almost any proposal he made that day. I just liked the way he dreamed."[20]

This feeling was not so much shared by Warner's friends, who figured he was trying to work another get-rich-quick scheme. "The idea of wireless

communications just made perfect sense to me," he says.[21] "All of my classmates from law school thought I was crazy. To think that maybe people would actually walk around with telephones or have telephones in cars, but to me it made a great deal of sense from day one."[22] Remembering his childhood, Warner likened the concept to "the two-way wrist radios of the comic pages' Dick Tracy."[23] Regardless of what others thought would come of his latest venture, Warner had his start and was off and running, quickly partnering with the *Washington Post* and soon thereafter adding the *San Francisco Chronicle* and the *Providence Journal*.[24]

Smooth Operator

In 1981, the FCC announced it was going to issue 1,468 licenses for cellular markets all around the United States.[25] Much like when it issued television and radio licenses, an interested party had to complete and file an application. "The FCC couldn't figure out how to give away what was very, very valuable," said Warner. "First it decided to hold comparative hearings. Then it figured out you really couldn't compare the applications on a valid basis. So it chose to hold a lottery instead."[26]

When the comparative hearing process was first in place, an applicant really had to know what he was doing. The complexity of the process presented an opportunity for Warner and his partners to step in and be more or less general contractors. "We helped people put applications together, and then we made a market in the application and licenses," said Warner.[27] The applicants were supposed to demonstrate "they had enough money to startup a cellular system and that they intended to operate the franchise in the public interest."[28] Unfortunately, the FCC did not screen the applicants that well, which resulted in a number of people who lacked the ability to build the system receiving licenses. Warner would then try to sell the licenses to more competent operating companies.[29]

By the time the FCC switched to lotteries, the quality of the applications received was not its top concern, and anybody was eligible.[30] This did not change Warner's approach to the business, however. "I would go to the companies or go to the individuals and sell them to or find a partner with a more major company who would come in and take over the operations," recalled Warner.[31] As he made deal after deal, owning a little piece of equity in each or getting a small commission, Warner didn't go out and buy new cars

and boats. He was frugal. "I put it all back into another startup business," he says. "And it ended up being the right choice because the equity ended up being very valuable."[32]

Warner, a fierce competitor with incredible drive and a steely determination, thrived on the craziness of the business. Yes, he made a lot of money, sometimes really quick and with little effort, but it was the challenge the market constantly presented that kept him going.[33] A competition with himself produced success after success. "He was very smooth," said Jim Murray, who would later partner with Warner. "He had a tremendous ability to walk into a room cold and win the confidence of everyone."[34] With seriousness in purpose also came showmanship. Murray recalls a deal in Jackson, Mississippi, that had some eleventh-hour problems: "Warner and a rival negotiator went into a room, shut the door and worked things out in seconds. Then each became concerned that his clients would think he gave in too easily. So the two agents stayed behind closed doors for another 20 minutes and put on a show by shouting at each other."[35]

First Cellular Broker

"I was very lucky to get into a space that was wide open," recalled Warner. "There was no good old boy network."[36] At that time, you did not see as many young people trying to be young entrepreneurs. It was still a fairly unusual thing. With most traditional industries, though, there was a hierarchy. Conversely, in the wireless business, there was no hierarchy. "It was more about if you could hustle…if you could make the case for something nobody knew about," said Warner. "And nobody knew whether cell phones were going to work."[37] While everybody else was working for big companies, Warner found himself as one of the only guys putting cellular deals together all on his own.[38]

In the spring of 1986, Warner was determined to build on his recent success with the FCC's third round of cellular license lotteries, having flipped a deal in the Charlotte, North Carolina market for five times its cost in just a few weeks. While this process today would be controlled by large, powerful investment banks, in the exploding wireless industry of the late '80s, it was anybody's game. So in a bold attempt to carve out a niche for himself, Warner put it all on the line in what became a turning point for his career. In his book, *Wireless Nation: The Frenzied Launch of the Cellular Revolution*

Mark Warner the Dealmaker

in America, partner Jim Murray details Warner's make-or-break attempt following the fourth round of the FCC lottery:

> Like most of Round IV applicants, Warner's clients pooled their chances in one of the three big settlement groups. CellTelCo, which was, like CTC, a loose amalgam of strangers, had collectively won ten of the thirty Round IV markets.
>
> Shortly after the lottery, the Washington lawyers called together their clients, and nearly a hundred CellTelCo partners convened in a ballroom at the Westin Hotel in Washington. The purpose of the meeting was to discuss joint action and governance, but Warner had other plans; he brazenly convinced the lawyers to give him a spot on the agenda, and plotted the move that could springboard a new, lucrative career.
>
> Mark Warner was the picture of self-confidence as he strode to the front of the room, but underneath his suit jacket, he was sweating.
>
> As dozens of businesspeople rustled through their papers and shifted in their seats, he began to speak.
>
> "We've won ten markets," he began, in his booming baritone, "and what we have to do now is decide whether we're going to build the markets or sell the markets."
>
> "We need to be in this together," Warner continued, his adrenaline rising, "and you need to have a single agent…What you all need to do is sign me up as your broker." He then related the story of the Charlotte-market sale and his client's remarkable windfall, warning that if CellTelCo didn't agree to hire him as its broker, "some of you are going to get $6 a POP, and some of you are going to get a whole bunch of money, and the rest of you are going to get screwed."
>
> As Warner spoke, the mood of the gathering shifted from polite boredom to an excited buzz. "It was so loud," Warner recalls, "it was almost like a revival meeting at one point." Who is this guy? And why should the CellTelCo partners turn over their deal making to him? He looked young enough to be a student, yet this Charlotte deal gave him a veneer of credibility—few others in the room had a clue about the value of what the partnership owned. Still, the natural first impulse of those in the room was to hold tight to their pieces and control their own desires; Warner would need every ounce of his considerable charisma and charm to sway the group.
>
> Warner stood at the front, waiting for the ruckus to die down. He had prepared a short document for each of the partners, with a paragraph stating that the undersigned agreed to pay him 5 percent of the sale price

From Business Success to the Business of Governing

if he brokered a deal the partners later accepted. As their agent, he would only make money if they did. A few tense moments passed, as Warner stood uncertainly at the front of the room, wondering whether someone was about to call his bluff. After all, he was only one deal more experienced than anyone else there, and the audience was stacked with far more astute businesspeople than he. Sure he had a law degree to bolster his credentials—yet he'd never taken the bar exam and hadn't practiced law for a single day. As the silence hung young broker, Warner feared his plan was about to flop.

But then a voice came from the back of the room.

Gus Mijalis, a Louisiana native with a down-home style and blunt character, piped up, "God dammit, Mark, I think we should do it with you." He stood up, walked down the aisle to the front of the room and laid his signed agreement on the table in front of Warner.

It was [as] if a spell had been broken. One by one, and then in a stream, the rest of the partners brought their agreements to the front of the room. "The whole thing could have fallen apart for me," Warner remembers, "If somebody hadn't kind of pulled the trigger and said, 'Okay, we don't really know Warner and we don't really know each other, but we've got to do this.'"

When all of the partners signed up, Warner was free to sell: He had just made himself into the cellular industry's first—but certainly not its last—cellular broker.[39]

No one expected Warner to do well in business. Even the man himself questioned whether he would be successful. After a couple failures leaving him broke and sleeping on his friends' couches, his instincts kicked in.[40] "I got drawn into this enormous wave of entrepreneurship, and it was cool to get things done," said Warner. "Being in that world, you shouldn't be afraid of the future. You can't predict it, but I'm sure not afraid of it, and that has awesome potential."[41]

In the '80s, the young wheeler-dealer successfully graduated from filing cellular license applications on behalf of investors to brokering complicated deals involving many partners. Finding his stride after a handful of key business maneuvers, Warner became a leader in an industry that was in the vanguard. While many of his friends took the traditional route of having to climb their way up in corporate America, Warner chartered his own path, blazing into new territory. He seized his future by not being preoccupied with it. "My businesses have been about taking risks," Warner proudly says. "And if you are going to build a business or try to change public policy,

you've got to be willing to take risks, and part of the process of taking risks is being willing to fail."[42] His biggest deal would come a few years later, when a seasoned Mark Warner saw potential in an idea others thought was sure to go bust.

6
RISK AND REWARD

By the late '90s, Nextel Communications had five million wireless subscribers, was a major NASCAR sponsor and was a corporate giant generating over $3 billion in revenue. When sold to Sprint in 2004, it was worth $35 billion. But before it was Nextel, the telecom juggernaut started out as Fleet Call Inc., a company born out of Morgan O'Brien's ingenuity, Mark Warner's connections, Peter Reinheimer's backing and Brian McAuley's business sense. O'Brien was an expert in the wireless field, both on the technical and legal sides. Warner was brokering cellular deals all over the country. Reinheimer founded an investment banking and brokerage firm specializing in mobile communications. McAuley was an accountant and executive with Millicom Incorporated and corporate controller at Norton Simon, Inc.

In 1991, Reston, Virginia–based Fleet Call Inc. was riding high after the introduction of the world's first combination digital dispatch radio and cellphone. "I had an unshakable faith that with an idea this powerful we would win," said O'Brien.[1] This success prompted a decision to go public, offering "up to 11 million shares at eighteen to twenty dollars in an IPO scheduled for January 1992."[2] High expectations met reality quickly in the winter of 1991, when the "U.S. economy was in the midst of a cold spell—particularly for wireless stocks—and when the Fleet Call offering was served up, investors proved reluctant to wager on something so speculative."[3] The initial public offering failed, and typically when that happens, it is fatal—not this time.

Mark Warner the Dealmaker

The day after the offering crashed and burned, "Peter called me up and asked what I was doing," said O'Brien, Fleet Call co-founder. Joking but still distressed, "I said, 'Well, I'm thinking about killing myself…what are you thinking?'"[4] Reinheimer responded, "What I'm thinking is of the investors who had indicated they were interested…when most of them left, I'm remembering the handful of investors that didn't."[5] While the investors who jumped ship numbered in the majority, there were still a lot of good names left. Reinheimer then hatched a plan to save the company. O'Brien recalls him saying, "Because this is the holiday season and everyone's not going to be paying attention to you anymore over the holidays, why don't we quietly reshape the deal by lowering the stock price and reducing the number of shares…basically we'll give them a much better deal. Let's quietly go around and see how many shares we could sell in an expedited new offering that we'd do in January."[6] That is exactly what they did, and in January, Fleet Call went public, selling $7.5 million in shares at $15 each.[7]

Its rocky public launch is similar to its rocky beginning. The story of Fleet Call, a company that almost failed, began with an idea from lawyer-turned-entrepreneur Morgan O'Brien that was propelled forward by Mark Warner's connections and reputation in the financial and telecom industries.

Learning the Industry

It was 1970, and Morgan O'Brien was headed back home to the Washington, D.C. area after having graduated from Northwestern University Law School and completing a clerkship with a federal appellate court judge. He was interested in working for the FCC, and despite there being no jobs available, O'Brien was persistent. After much prodding, they finally found something for him, although the job was described as the worst because it was in the Mobile Services Division of the Common Carrier Bureau. Remember this was 1970, and it would be twelve years before anyone would hear of the word "cellular." Being told it was the least glamorous part of the FCC, O'Brien quickly responded, "It's not going to be my last job. It's just my first job, so I'll take it."[8]

Within the first couple months, one of the engineers handed him Docket 18262, suggesting that he take it home and read it. "I came back and said, 'Wait a second, am I reading this right? Does this mean that there's going to be roughly a thousand times more spectrum available for mobile services

than there is today?"⁹ Docket 18262 "set aside spectrum for both cellular and Specialized Mobile Radio, or SMR—the technology used by all manner of dispatch services, from taxicabs to courier services. It essentially increased the amount of spectrum designated for mobile services by a factor of more than 1,000."¹⁰ When the engineer told him he was right, O'Brien knew right then he was going to stick to that area.¹¹ Through twists and turns he ended up as assistant bureau chief for Spectrum Management of the FCC's Private Radio Bureau, part of the agency that regulated SMR. "I really liked it, and I always had the concept that it's important to be an expert," said O'Brien.¹² He proceeded to do everything he could to absorb all aspects of the technology, both as a regulatory lawyer and also to understand the underlying business.¹³

Wanting to be a part of the wireless revolution instead of watching it happen on the regulatory side, O'Brien left the FCC. After having immersed himself in everything mobile, he put his law degree to work, joining a small firm in D.C. It was during this time that he first met Mark Warner, who, as a broker, was looking at the cellular business in a different way than O'Brien, who prepared applications for clients. For the most part, everyone's attention was on cellular. O'Brien was arguably the only lawyer who worked on cellular radio and was an expert in SMR, whereas probably ninety-nine out of one hundred people working in the cellular field had never heard of it. When he met with clients, O'Brien would not just talk about their FCC business, he would ask them every possible question about the technology they were using, how they developed their marketing strategies and how they structured their businesses. His focus on the specifics was razor sharp, and his interest in the industry was insatiable. He was laying the foundation for what would drive his own business plan in the future.¹⁴

A Quick Study

By 1987 and still in Washington, O'Brien was the partner-in-charge of the telecommunications practice at Jones, Day, Reavis & Pogue, which at that point was the second-largest law firm in the world. "The only reason I was partner there—because I never would have had the patience to work my way up in a big firm," jokes O'Brien, "was that Jones Day acquired my old law firm, primarily because they wanted the New York office."¹⁵ Knowing his life would be ruled by the hours he billed, O'Brien wanted to

act on the tremendous urge he had to be an entrepreneur. After consulting his immediate supervisors at the D.C. firm, O'Brien headed to Cleveland, Ohio, to see Dick Pogue and make his proposal to start a company within Jones Day. Pogue said, "Normally, we say no to this, but we will say yes to you because we figure that if we say no, you will leave...and we like you. The odds are the business won't succeed, and we would like you to be here when it doesn't."[16] So with that conversation they cut a deal, and O'Brien—along with Chris Rogers, a young lawyer he had hired several years before at his old firm—started working on how he would put together a business focused on SMR technology.

In those days, you could not raise the kind of funds in D.C. that you would need for a business to take off. So Rogers suggested that O'Brien and he speak with Mark Warner, who was plugged into the New York side of things. Soon thereafter, the three sat down for lunch, and O'Brien launched into his spiel: "When the FCC created cellular and decided to make it a duopoly, they did so because they did not have enough spectrum to create more than two. But in the same proceeding that created cellular, the FCC took another big chunk of spectrum and made it available for SMR."[17]

"My idea," O'Brien told Warner, "is to go into the best markets in the United States and try to acquire as many of the SMR businesses that are out there to accumulate their licenses."[18] O'Brien further explained, "As I understand it as a lawyer representing many of these guys, looking at the market price of those properties, there may be a ten-to-one or much greater difference in value...a ridiculous disequilibrium."[19] O'Brien added, "If you pay someone a good price for their property, you would be buying their customers and their ongoing business, but you would also be buying the underlying spectrum. That spectrum is identical to what cellular uses; however, if you do the math, there was an anomaly of value."[20]

If you took out almost any of the other smart people doing cellular in those days, they would have been incapable of understanding a story about a different kind of spectrum with different rules. "Their brains would simply not have opened up enough," said O'Brien. "But there is a thing about Mark...he can listen. He does not even go to the trouble of try to getting into any fundamental level of understanding of the details. He just gets the gist."[21] Indeed, Warner got the gist of O'Brien's vision and understood that, if he were right, then they could buy these properties and acquire these licenses, knowing that while they may not be valuable now, some day that discrepancy could get corrected. "It was no more sophisticated than that," said O'Brien.[22] The gamble was that if everything worked out as planned,

then the investment made on the front end would pay off exponentially on the back end.

Assuming O'Brien, after making this pitch to anyone else, found someone interested in the idea, how many weeks would they have studied it? How cautious would they have been? Well, that's just not Warner's style. "Mark's total length of studying this proposal was between appetizers and entrees at not a very long lunch," remembered O'Brien.[23] Warner told him, "Morgan, I have no idea of what you are talking about; but I have always liked you, and I just have a sense that you would be a good person to be in business with. So I'll split the seed money with you."[24] Warner committed his share of the $125,000 on the spot but instantly went into his standard frugal mode, urging and prodding O'Brien to find ways to save and not waste a lot of money.[25]

Vision Becomes Reality

Mark Warner's role in making Fleet Call's transition to Nextel extended well past his commitment to kick in seed money. He was instrumental in leveraging his connections in the financial industry, and he provided a steady beam of focus and energy when at times the future looked dim. As they walked out of their lunch, O'Brien and Warner could not ignore the eight-hundred-pound gorilla: Fleet Call needed help in financing its efforts, or it was going nowhere fast. O'Brien admittedly had no experience in that side of the business, but Warner did. "We visited all of these big New York investment bank houses and sold our vision," said Warner. "Nearly everyone turned us down, saying it didn't make much sense or it wouldn't work. We were down to our last meeting after nine months of trying this."[26] That is when Peter Reinheimer entered the picture. A veteran financier, Reinhemier started his own boutique investment-banking firm in 1988. Warner called up Reinheimer and set up a meeting in New York. "Probably of all the people out there," said O'Brien, "the one who was best suited for a project like ours was Peter."[27]

The two headed up soon thereafter, and O'Brien made the pitch. Reluctant and cautious, Reinheimer told the guys, "I do not understand any of this, and to me, cellular has sucked all of the oxygen out of this space...I do not think you can do this. But, let's see."[28] Reinheimer added, "Also, I can tell you I won't raise money for a company run by a lawyer."[29] Looking

at O'Brien, he said, "Are you planning on running this?"[30] O'Brien, not willing to let that issue screw up the deal, conceded that he would not have to be the CEO but would be a decision maker. Thus began a series of trips for months, at Reinheimer's urging, taking O'Brien, Warner and sometimes Chris Rogers all over the county with individuals who held SMR licenses. Because O'Brien was an expert in the field, he pretty much knew everybody, making it relatively easy for the guys to get it. For the most part, he had either represented the licensees, or he knew who had represented them. "We tried to get a feel for whether they would sell to us, and if so, what kind of terms would they be looking for," said O'Brien but quickly adds, "We didn't make much progress, and I got discouraged."[31]

Warner had been around enough of these types of deals to not let them get the better of him. "There were a couple of times when I was discouraged, and he basically kept me focused on moving forward," said O'Brien.[32] Getting wind of the ups and downs of their efforts, Reinheimer let O'Brien and Warner know he was sending a guy from New York who might be able to help them out. His name was Brian McAuley, a "seasoned operations manager and accountant."[33] "That was crucial," said O'Brien, "because, as it turned out, Brian and I were essentially the two who ran the company in the early days."[34] McAuley met O'Brien, Warner and Rogers in Washington in a small office Warner rented, where the guys gave him the pitch. No sooner did they finish than McAuley said, "I looked at this opportunity once before when I worked at another company, and we did not see anything to it…but you are approaching it in a slightly different way."[35] McAuley asked for some time to kick around a few ideas and wanted them to come up to New York the next week so they could talk about ideas.[36]

McAuley hastily got to work and presented O'Brien and Warner the next week with what became the basic Fleet Call business plan. The proposal called for the acquisition of properties with sufficient positive cash flow that they could carry two-thirds of the purchase price with debt. The entrepreneurial plan included buying similar businesses and putting them together. That practice would nowadays be called a SRM roll up. "We thought that if we could put a bunch of companies together who owned these licenses, and we could convert them from push-to-talk radio to cellphone radio, we could take exactly the same licenses and they would be worth fifty or one hundred times more," said Warner.[37]

"With an ability to breathe in chaotic numbers and breathe out an organized spreadsheet," said O'Brien, "Brian built a simple yet durable framework around our vision, and from that day forward, we were off

From Business Success to the Business of Governing

and running."[38] Fleet Call started to buy what it deemed were the best, most profitable businesses in what it decided were the best six markets in the United States. That meant snagging as many SMR licenses as it could get its hands on in Chicago, Dallas, Houston, Los Angeles, New York and San Francisco. Reinheimer raised in two different transactions somewhere around $10 to 12 million, supplemented by another $20 million in borrowed cash. "We then went on an acquisition spree to buy roughly $30 million worth of properties," said O'Brien. "There really had never been anybody out there as a buyer for these properties."[39]

Fleet Call had finally graduated from concept to reality. O'Brien, Warner, Reinheimer and McAuley had beat the odds. They put the company on a path to be a leader in the digital revolution, thinking outside the box and at times being unconventional when others were traditional. "I've never met anyone who shrugs off problems the way Morgan O'Brien does," said Tim Donahue, former president and CEO of Nextel. "He never lets adversity get in his way, and there were hundreds and probably thousands of naysayers about the plan to build Nextel out of these local SMR players, and he did it. He had an incredible vision and he executed against that vision."[40] O'Brien credits his partners with their willingness to stare failure in the eye and not blink. With Warner in particular, "the intense period of Mark being involved was when it was not a real business at all," said O'Brien. "It was just an idea that I had. His contribution was helping me bring it to life."[41]

7
TRAILBLAZING VENTURE CAPITALISTS

The Partners

Before Nextel became a telecom powerhouse, a partnership formed among five men who each had achieved success in his own right during a period Jim Murray calls the "Wild West atmosphere" of cellular spectrum deal making. Murray teamed up with Bob Blow, Dave Mixer and Mark Warner to form Columbia Cellular Corporation essentially as a cellular industry investment bank. Mark Kington joined in a year later. "We wanted to form a partnership to do [mergers and acquisitions] on a more professional and structured basis, but we didn't know where it would go," recalled Murray. "We knew that we each had the right resources and skill sets to be successful, but we knew we had a better chance of doing it together than individually."[1]

All of the partners had previously worked together or across the table from one another in past deals. In the early '80s, Mixer and Murray were active on the buyers' side. Mixer was president of Providence Journal Cellular and later went out on his own as Mixer and Company. Murray had a diverse background not only as a broker but also in venture capital and real estate development. Blow was a telecom entrepreneur who got his start in radio. He paired up with Warner following the 1986 CellTelCo auction, and together they operated as Capital Cellular, brokering transactions between FCC lottery winners and corporations preparing to build regional cellular networks. It was then during negotiations that Mixer got to know Warner and Blow well. In fact, Mixer was the largest buyer in the market next to

Mark Warner the Dealmaker

Craig McCaw, a private investor who in just a decade amassed a fortune as a result of cable, cellular and intellectual property ventures. Kington was a banking expert at First Union National specializing in cellular before joining Malarkey-Taylor Associates, where he met his future partners at events around D.C. By the late '80s, Murray and Warner had partnered with Wayne Schelle and Gary Thomas for a short-lived venture in Schelle, Warner, Murray & Thomas. Their departure prompted Columbia Cellular's founding.

Kington and Mixer remember specifically when they decided to abandon their corporate jobs for a chance in this risky, new venture. Kington recalls:

> *I was this buttoned-down banker, and I remember going to Las Vegas for a cellular convention. At dinner, I was having my soup, and the rest of the table started talking about deals they were working on. One deal in particular came up, and someone said, "Did we ever collect that $50,000…I don't think we ever called that guy about the $50,000." I remember thinking, "If I just hang out and collect the crumbs that drop off the table, I would make more money than I was at the time." That was the "crumbs off the table" mentality.*[2]

Mixer's realization was also plain as day. "I flew out with the owner of Providence Journal in a private jet to sell a bunch of markets to McCaw Communications. Warner was there. In a matter of an hour, a big chunk of the things I had been buying were all sold. Warner had made more in that hour than I had made in a year or year and a half."[3]

Murray details in his book *Wireless Nation* this partnership's success and evolution over the course of the first decade of the spectrum rush, where Columbia Cellular brokered more than $4 billion in transactions on behalf of major cellular carriers and multiple lottery winners. "We spent five years matching buyers and sellers, helping to consolidate the industry and disentangling the scrambled ownership created by the FCC's lottery process."[4]

Columbia Cellular replicated the process all over the country with a relatively simple business model. They would find someone who won a cellular license in a lottery and recruit them to be a client. Next, they would go out and find a cellular operating company, such as US Cellular, and try to convince it to buy the license from the individual. After the deal was final, the firm would collect a 5 percent commission for its matchmaking work. Murray recalls that "at first these licenses were selling for $1 to $1.5 million each, and 5 percent was a nice fee. If you could do two or three of those a

year, you could make a decent living."[5] However, the value of the licenses rapidly grew to the point that they were each selling for $10 to $20 million, and Columbia Cellular was still collecting its 5 percent fee. "Some of these transactions were completed in forty-eight hours or less from the time we signed up the client and had it sold," said Murray. "So you could make $1 million for three hours of work."[6]

This kind of turnaround appealed greatly to Mark Warner. "He and Bob Blow were superstars at the business," said Murray. "Nobody's ever been better. The rest of the firm was sometimes in awe of how well Mark could convince people into selling and buying. Nobody was better at closing the deal than Mark."[7] Blow, who died of a sudden heart attack in 2002, was equal to the task. "Bob was probably our best partner. He was an incredible wheeler-dealer. He never went to law school but really was a natural attorney who understood deal structure."[8] For Warner, sometimes the payoff could not come fast enough. "Mark's problem with instant gratification is that it takes too long," said Murray.[9] In the early days of the business, Warner and Blow really built the firm when Columbia Cellular's primary source of revenue was these transactions that were negotiated in brief, highly intensive periods of time.

Kington credits Warner's energy and his sense of urgency for the deal-making success that comes so naturally. "I would tell you in hindsight that was his greatest contribution to the firm. I think we were all very ambitious, and so I'm not sure we would have been exactly sitting around contemplating our navels without him, but I do think he really injects into any group a real sense of vibrancy. And that's very valuable."[10]

Unique Business Model

As time passed, Columbia Cellular's mergers-and-acquisition business evolved into Columbia Capital Corporation, a venture capital firm specializing in telecom investing.[11] "Switching from an investment bank to a venture capital firm happened by accident," added Murray. "As the revenue grew in the early '90s from hundreds of thousands of dollars per deal to millions per deal, we had capital that we could put to work, and we had people coming to us with deals."[12] The firm could never be lumped into just one category. It was unique. "We were not classic venture capitalists by any means," said Warner. "We were simply guys with a little bit of money

in our pockets doing deals in the wireless space. We then started to add infrastructure around this and we became a quasi-venture capital firm."[13]

While traditional venture capital firms invest in early-stage, high-potential startup companies and raise funds in advance to invest, Columbia Capital took a different approach. "There was no template," said Kington. "We were the experts in an industry that we had been in for just a couple of years."[14] The partners decided they would take all the risk. "Anytime we would start a new company, we would simply put in the money ourselves," said Warner. "We'd bootstrap it."[15] Whether presented with an idea or coming up with one on their own, the five partners would get together and decide whether or not to take on a proposal. If they moved forward, that meant they would invest several hundred thousand dollars or more in the deal. "And when we did that," said Murray, "it literally meant all five us sitting down and each writing a check for one-fifth of the total amount."[16]

There was nothing organized or deliberate about how they chose investments. However, after putting in place a blackball process, whereby any one of the five could stop a deal, they were developing a fairly rigid screening process. "You had five pretty smart people with pretty broad experience looking at a deal," said Murray. "To get a majority vote out of all five probably meant that we were choosing well. And as history later showed, we had."[17]

Early Success

While supplementing their traditional mergers-and-acquisitions practice in December 1989, Columbia Capital made its first direct investment in an in-house venture called Sterling Cellular. Several more ensued over the next four years, including wireless network interface equipment developer Telular Corporation, a cellular operator called CCT/Boatphone and Skywire, a developer of "end-to-end solutions for wireless data applications."[18] By the mid- to late '90s, Columbia Capital had invested well over $100 million in twenty different companies.[19]

The firm's involvement was diverse. In some cases, the partners took on a startup company, identified a management team, housed the business in their office suite, and then eventually birthed it out to the world. "On the other hand, in many of our other investments, we would basically take over a company," said Kington, adding, "This was not done in a bad way,

From Business Success to the Business of Governing

and we didn't fully realize it at the time either. We didn't just go in and say we're going to fire everybody. Rather, we would go into a deal and want to have control over the company's future to position it for success."[20] One of the firm's largest deals, a software company based in Canada, is a perfect example of this approach.

In the late '80s, Mark Warner met a freelance dealmaker named Oliver Bush, who in 1991 came to him with an idea. Bush was familiar with Saville Systems, which designed cellular billing software, in Edmonton. Warner subsequently introduced Bush to his Columbia Capital partners, who set in motion what would become one of the firm's most successful investments. The effort did not come without its challenges.

The partners tapped Jim Murray as the lead on the project, and he would soon rack up considerable frequent-flier miles. "After an initial review, we realized we just bought this bucket, and it had three or four holes it," said Kington. "So every time we poured money in, it just leaked out as a result of the contracts that Bruce Saville negotiated while trying to save his company."[21] Of course, Saville did what he had to do to keep his company alive, but it created long-term problems. Murray, wearing his lawyer hat, read the contracts and recommended renegotiating them. Successfully doing so meant landing two major deals. The first was with Sprint in the United States to create a joint venture to Bell Canada's long-distance billing, and the second was for AT&T's third-world telephone billing. Shepherding these deals took Murray on probably fifty to one hundred trips to Kansas City, Missouri, for Sprint and Bedminster, New Jersey, negotiating with AT&T. In the end, the team plugged the holes in Saville and created a vehicle that would hold value for which a third-party investor would pay.

A few years and $1.5 billion in investment later, Saville grew from thirty-two employees in Edmonton with about $700,000 (U.S. dollars) per annum in revenue to about three thousand employees headquartered in Galway, Ireland. In November 1995, Saville went public on the NASDAQ and later merged with another public company. "The high point," added Murray, "was when the enterprise value of the public company was worth more than $2 billion."[22]

Because venture investing takes enormous patience and not everyone in the firm was disposed to that virtue, reality set in as to who was best suited for the different aspects of the industry. "We at Columbia evolved into a candid recognition of each other's strengths and weaknesses," said Murray.[23] Warner was clearly the big-picture guy of the group. While some partners were managing deals, he evolved as the rainmaker. "I used to joke, 'Mark doesn't know what a lease hold improvement is,'" says Kington. "And the

truth is he's not formally trained. His great skill as a businessman is he's a judge of character. He's an incredibly good judge of people. With the nature of early state investment, you know the deal is going to twist and turn. So you want the person who can get in there and twist and turn the deal so that it actually fits the circumstances as they evolve. Mark was smart enough to realize that. And I think he added value to a lot of deals by making good judgments about people."[24]

Central to the firm's success was also a clear understanding of ethical business practices. "There were many occasions in the early days of the cellular industry when we could have taken a shortcut and made a lot more money," said Kington adding, "Every time Mark would say, 'Nope, we're going to do it the right way.' He is very much driven by what was right—not what was expedient."[25]

If Warner's mantra was standard practice when money was at stake in backrooms with his business partners—his friends—then that is certainly what was happening in every other part of his life. "As someone who views Mark as a friend, a neighbor, a business partner, and as a U.S. senator from Virginia, that's the most important thing," said Kington. "And, unfortunately, I can't say that about everybody who's in politics."[26] For Mixer, it was all about avoiding the gray areas. "There was a bright line, and we always knew how to make sure we were on the right side of the bright line. In the industry we were in and the things we were doing, there are a lot of gray areas. We always did make sure that we stayed on the right side of the bright line."[27]

The Foundation of Trust

It is standard practice for a firm to operate under a partnership agreement, but just as they did not take a traditional approach to venture capital, Columbia Capital's partners did not feel compelled to solidify their relationship in a legal document. "The thing that is so remarkable about Columbia Capital," said Murray "is that we never had any written agreement. Nothing."[28] Although there were one or two half-hearted attempts to say, "Shouldn't we have a partnership agreement?" nothing came of it. Here you had five guys who, in the first year or two, had several million dollars or more in revenue, and they would split it up. By the late '90s, they were dividing up tens of millions and even hundreds of millions of dollars. And they did it all with nothing in writing.[29]

From Business Success to the Business of Governing

The partners did manage to work out a process to review the books and divvy up the profits. "On every deal," Warner says, "80 percent would go to the partnership and 20 percent of the deal would go to the "worker bee," the leader of the deal."[30] Using this model, there was a clear incentive to work hard on the deals. Deciding on who the worker bee was and how they would split up the pie was not so clear. There were no written criteria. There were no boardroom meetings. There were, however, annual retreats, where each partner's ability to convince, cajole and badger the others directly impacted their share of the firm's revenue.[31]

"So every February," said Murray, "We would have a retreat at Warner's farm on the Rappahannock River. We'd leave on a Thursday or Friday afternoon, go to Sutton Place Gourmet and get a trunk load of beer and wine and good food. Then we would head down to Warner's farm."[32] Invited for part of the time was Neil Bryne, Columbia Capital's CFO, who gave the partners the high-level numbers and explained how much cash was in the bank. Then he went over each deal and reported on the amount of money the firm made—or lost, in some cases. After Bryne completed his review and left, the games began. "In a very friendly way," said Murray, "We would debate how hard somebody had worked on each deal. We would set aside 10 to 20 percent of the profits to be divided up among the people who did the work on each deal."[33] This process involved quite a bit of productive contention. One partner would say he did 80 percent of the work. Then someone else would say, "No, no…I did at least 40 percent, so you couldn't have done 80 percent." Then one of guys who didn't work on the deal would say, "You know I was around the office…I really think it was more like 70 percent." So in that case, the five guys would settle on a 70-30 split on the worker bee portion of the profits.[34] "Sometimes a partner would get a little more this time and a little less the next time," said Warner. "There was a general understanding that it would all work out in the end."[35]

And so Blow, Kington, Mixer, Murray and Warner would debate with one another for everything that happened in the preceding year. Usually by 10:00 or 11:00 p.m. on first night, they would have most issues resolved. "Most of the time, even with a relatively large deal, we could cut it up within minutes," said Kington. "Everybody understood what their share was, and the partners had pride about their own truthfulness within the group. No one was going to put forth a number which we all knew wasn't right, because you'd rather have your pride within the group than the money."[36]

While the guys took care of business, one of the farm's caretakers would occasionally cook a turkey. After their big dinner, wine continued to flow

as the partners stayed up telling jokes in front of the fire. Murray recalls he was "always relegated to sleeping in the pool house because it was infested with mice, and no one else would clean the mouse droppings out of the convertible sofa."[37] With good rationale, Murray added, "But I loved it, because I wouldn't have to listen to those guys all night. I could go to bed whenever I wanted."[38]

While others may talk about trust in business, Columbia Capital's partners lived it. Their partnership was an experience of the highest level of trust imaginable. With the partners dealing in very large sums of money, the worker-bee split literally meant somebody giving up half a million or a million dollars to a partner because it was fair. "Everybody would invite each other in to work on a deal, and so nobody would invite you in if you were a hawk," said Kington. "It was actually amazingly efficient."[39] That does not mean the gentlemen did not disagree. "Mark had been a valuable tie breaker in many of those discussions," said Murray. "In my career, I have probably trusted way too many people way too often, but I would rather err toward trust. That is one of the reasons why Mark and I did so well together in business. I think Mark, too, would rather err toward trust."[40] It's hard to imagine anything potentially more contentious than arguing with a close friend over splitting up millions of dollars. And yet the partners found it to be fun. "It was probably one of the most enjoyable weekends in all of our lives in those years," said Murray.[41]

Handing Over the Reins

As Columbia Capital was nearing the end of a decade in business, the founding partners wanted to avoid what Warner calls "the classic venture capital model" in which "the first generation partners want to keep hold of the reins too long and get too greedy, and the younger guys splinter off and start their own fund."[42] It was 1996, and Warner was running for the U.S. Senate. Bob Blow was having health issues. Kington, Mixer and Murray were naturally entrepreneurial and therefore had interests of their own to pursue. Moreover, all of the partners were looking to transition from the firm they were to a firm that gave more ownership and control to a younger generation willing to work longer hours to manage a larger venture portfolio.[43]

Columbia Capital was not a traditional venture capital fund. It was unique because the partners were the sole investors, and the firm was run

From Business Success to the Business of Governing

like a portfolio company. Only the partners controlled the money. "We were constantly looking at what we should do with the firm," said Mixer. "It wasn't like there were a lot of models out there."[44] As a result, the partners from time to time consulted with Wall Street experts to see if they should grow and become either a buyout firm or a hedge fund. Instead, they decided to stay the course until it became clear a change was necessary.

That didn't take long. Kington quickly realized how much the firm had exploded since the early days. As an investor in a deal in the $35 million range, he used his personal checkbook—the same checkbook he used to pay monthly bills—to kick in his share. By design, that's the manner in which Columbia Capital partners invested. The numbers were getting out of control. It hadn't always been that way. "When we started, none of us had any money," added Mixer. "We said we'd pay ourselves a salary of $50,000 a year…if we could make it. It was a lot of eat what you kill in those days."[45] Well, those days were gone. "I'd open up my checkbook and see $35 for Orkin Pest Control, $500 for Christ Church, and then $800,000 for Columbia Spectrum Management," said Kington. "And we said, 'This is crazy. We can't continue to write these checks, so what are our options?'"[46] It was partly that realization that prompted the partners to look at a new direction.

A hand over was in line. In the early '90s, Columbia Capital added three new managing directors: Jim Fleming, Phil Herget and Harry Hopper. "We knew that unless we created a situation where Phil and Jim and Harry felt justly rewarded, the company would self-destruct," said Mixer.[47] Turning over the company was not about economics or how much money the founding partners were going to make or not make. All of the issues were about the people involved. "We needed to have these guys feel that they're in control, and create a culture where they know that their turn will come," said Mixer. "We were not going to blow up the firm by greeding out."[48]

Columbia Capital had a solid reputation and great success as an early investor in several key telecom ventures, including Nextel and XM Satellite Radio.[49] In order to make the transition as smooth as possible, the partners hired Ernst & Young to look at the books for everything that had been done since the late '80s when they had opened up shop. "We knew we had done fairly well," said Murray.[50] But the proof of that success had not yet been documented. What the five senior partners wanted was a report they could show to potential investors in a new fund what their successful track record was in order to maintain continuity.

Having run the numbers, Ernst & Young came back with a final report showing that Columbia Capital had an annualized rate of return of 194

percent over the life of the firm.[51] The auditors essentially said, "By the way, it doesn't matter if you look at the first five years or the second five years…it doesn't matter if you throw out the top deal or the bottom deal…it's always 194 percent per year."[52] To put those figures in context, a venture capital firm operating over that same period of time would have been ranked in the top quartile in the United States if their rate of return had been 25 percent per annum compounded.[53] Arguably Columbia Capital had the highest returning fund in the venture industry at the time.[54] "We had done something right," said Murray. "Even though when we had set out to do it, we did not know we were in the venture industry and had no intention of forming a venture fund. Ten years later we had become a venture capital fund almost unintentionally."[55]

Columbia Capital's success story goes back to day one. It began with the founding partners' shared belief in ethics, trust and the value of hard work. It continued with creative ideas and smart investments. And most importantly, the firm's reputation became its legacy. While some in business are not satisfied unless they bleed every last dollar out of a deal, Warner and his partners at Columbia Capital took a different approach. Their business model meant leaving a little bit on the table, knowing that there was always going to be another deal and that their reputation for fairness and balance was more important than making an extra buck. That philosophy has permeated Warner's life in business and politics. "If everything is about one piece of legislation or one deal or one company," said Warner, "then maybe you can be inflexible and extract that last pound of flesh. But if you believe, in business or politics, that you are going to be a long-term player, then your greatest asset is going to be your reputation."[56]

8
SOCIAL ENTREPRENEUR

Mark Warner had lived the American dream. He grew up in a middle-class home. He was the product of public schools and was the first in his family to graduate college, relying on student loans and several part-time jobs. "My parents taught me the values of hard work, responsibility and perseverance," said Warner. "My church taught me compassion and tolerance."[1] Leaving his $18,000-a-year salary at the DNC, Warner fit everything he owned into the back seat of his beat up 1965 Buick.

With a few bucks in his pocket, an entrepreneurial wink in his eye and no fear of the future, Warner set out to make it in business. His first try failed, taking with it what was left of his savings. Confident he could overcome, Warner tried again but failed a second time. He was broke. Close to striking out, Warner didn't give up. "There's nothing wrong with failing if you've got the will to try again," said Warner.[2] Through a twist of fate, he got another chance. This time was different, but only Warner could see the potential when others would balk. He thrived in the "Wild West" of the cellular industry, brokering deals all over the country and amassing a fortune along the way.

Rewind to 1973 when Warner was a senior in high school. He was serving his third year as class president at Rockville High School and had chosen Washington, D.C., as his next destination. College took a back seat to his passion: politics. He found his home at George Washington University. While most freshmen were adjusting to being on their own for the first time, Warner was working on Capitol Hill.

Fast-forward to the mid-'90s. Warner had just turned forty-two years old. He had beaten expectations but fell short in his first attempt at public office. That's when it came to him. "There were a whole lot of articles being written at the time about who was more powerful: Bill Gates or Bill Clinton," said Warner. "It raised the question: Is politics really necessary to make the changes I'd been talking about? I decided to put my money where my mouth was."[3] Together with his wife, Lisa, he had already formed the Collis-Warner Foundation, which supports private and state initiatives that make a difference in the lives of at-risk and low-income children.

A careful planner and visionary, Warner focused on what had driven him all those years. Just as he had been able to live the American dream, Warner wanted to "make that dream real and possible for every Virginian."[4] To succeed, however, Warner would have to put his business acumen, fundraising ability and strong relationships all over the state to work. Where government had not succeeded or would be overreaching, the private sector had an opportunity to be a part of the solution. And so through a series of initiatives, Warner set out to find ways to improve access to healthcare, technology, jobs and education.

Serving Virginia's Most Needy

In 1992, there was a lot of momentum for healthcare reform; in fact, it was a key issue for Bill Clinton as he challenged President George H.W. Bush for the White House. Clinton's healthcare overhaul concept faced an uphill battle, both in Congress and among the various healthcare industry interests.[5] In anticipation of reform, the Virginia Joint Commission on Health Care proposed and passed Senate Joint Resolution 117 during the 1992 General Assembly session. The resolution essentially asked the governor to use the stature of his office to bring prominent citizens together to create the Virginia Health Care Foundation (VHCF) with the mission of increasing access to primary healthcare for uninsured and medically underserved Virginians.[6]

At the close of the session, the resolution made its way to Debbie Oswalt's desk. Oswalt was deputy secretary of Health and Human Resources under Governor Doug Wilder at the time. "Typically," according to Oswalt, "all of the resolutions related to our secretariat came to me after the session, and I had to figure out what to do with them. Most were study resolutions.

From Business Success to the Business of Governing

However, this was a little bit different. I had never seen a resolution that said: Go create a foundation."[7]

As she was trying to figure out how to implement the resolution, who should knock on her door but Mark Warner, who had come by for an entirely different reason. At the time, Warner had been serving on the board of the Medical Care for Children Partnership (MCCP) in Fairfax, which was doing a terrific job delivering healthcare to uninsured children. MCCP had just won a Ford Foundation award for innovation and had asked Warner to give $1 million to replicate the program throughout the state.[8]

Oswalt said that "because Warner always does his homework, he came calling to ask, 'Is this a good idea?'"[9] Oswalt said that it was not a good idea for a simple reason: there is only one Fairfax County in Virginia. MCCP had been so successful in large part due to the uniqueness of Fairfax, including its wealth and the abundance of physicians.[10] "As we talked more," said Oswalt, "I learned exactly what he was interested in—innovative ways of delivering healthcare."[11] Oswalt mentioned the resolution creating the Virginia Health Care Foundation and the intent to have it fund and evaluate innovative service delivery models so Virginia would be prepared when healthcare reform came down from the federal government.[12]

Oswalt sparked Warner's interest on the spot. Fast-forward a few months to June 1992. Governor Wilder and the Joint Commission on Health Care convened the three-day Leadership Summit on Health Care. Providers, industry groups, business interests and other stakeholders were all invited to identify representatives to attend on their behalf. Wilder made it clear to the one hundred participants that "we need to start identifying the basic health services that should be available to all of our citizens. That will enable us to explore the costs of such coverage, the cost shifts that may result and the best methods of providing various services."[13]

One outcome of the summit was the announcement that a foundation would be established and that Mark Warner would be its founding chairman. "Mark Warner likes to work fast," said Oswalt. "He doesn't waste any time."[14] Warner immediately got to work putting together the rest of the founding board, including different leaders in healthcare around the state. A six-month staffing agreement was made with Warner and Secretary of Health and Human Resources Howard Cullum, giving Warner time to raise some startup money and find an executive director.[15]

Ultimately, Oswalt filled that slot. She had a two-year-old son at the time and had planned to leave the Wilder administration in its final months to become a full-time mother. Warner promised her a four-day workweek

Mark Warner the Dealmaker

Virginia Health Care Foundation chairmen Warner and Lieutenant Governor John Hager. *Debbie Oswalt.*

and a flex schedule to which Oswalt laughingly says, "I have yet to see that twenty-three years later. My son is twenty-four years old, and the Virginia Health Care Foundation has become my second child."[16]

By September, the board was holding its first meeting and had figured out its guiding principles, solidified its mission and issued its first request for proposals. Even though Mark Warner is known for being frugal, he insisted the foundation set up shop in Old City Hall, even if it meant paying a little more for office space. Oswalt recalls Warner's advice: "If we are going to be a public-private partnership, then we need to be where the public part happens, and that's on Capitol Square."[17] Warner was right—being in the middle of the action helped the foundation establish its brand as a public-private partnership.

The foundation is guided by five principles: stimulate and support innovation, demonstrate impact, encourage grantees to be self-sustaining, maximize leverage of state funds and engage in partnerships because they are critical to success. "The key to the Virginia Health Care Foundation,"

said Oswalt, "is sustainability—both in terms of the way we evaluate grants and the standard to which we hold ourselves for the programs we operate."[18] This standard came out of Mark Warner's venture capital background. The goal was for the foundation to practice venture philanthropy instead of acting as a purely charitable institution. "We wanted to act as investors and scrutinize every proposal that came to us with the mindset of an investor," said Oswalt. "We wanted to make sure that we got a good return on investment so we could leverage our limited resources and be good stewards of taxpayer and donor funds."[19] Oswalt is fond of saying, "We fund ducks in a row, not a gleam in the eye."[20]

By combining public and private dollars, the foundation provides "seed money for projects delivering primary health care to uninsured and medically underserved Virginians throughout the state."[21] Innovation and readiness are crucial. "When a local community comes up with a good idea to alleviate the problem of health-care access," said Warner, "the Foundation can provide the spark plug to get the engine going."[22] Coming from an IT background, technology became Warner's mantra. "He always wanted to know how we were incorporating technology," said Oswalt "…to the point that I was ready to kill him. It became etched in my brain. It trained me to ask that question before I brought any idea to him. And now, years later, we ask all of our grant seekers the same question."[23]

The grant process is simple, relatively speaking. Grant seekers apply for funding from the foundation. If they satisfy the necessary requirements and are approved, they receive the funds over a three-year period. In each of the second and third years, the grants are reduced by 25 percent. This is done to wean the grantee off the reliance on the foundation's support. "By the end of the third year," said Oswalt, "they are better positioned to be on their own and sustain themselves."[24] That was all Mark Warner's idea. The grantee has to come up with at least 25 percent of the total project cost. This often requires the applicant to raise money from its community. The grantee also has to show what its long-range plan is for sustainability after the foundation's money is gone.[25]

Learning quickly after a few early grantees were ill prepared and faltered, the foundation has developed a reputation for being a very tough, scrutinizing funder. "People generally don't come to us unless they are prepared," said Oswalt. "But our process adds a lot of value for grant seekers. For those with intriguing initiatives whose business and operating plans are incomplete, we provide a list of items to be addressed to make the initiative a good candidate for VHCF funding. Then, we

defer consideration of the proposal to give applicants time to get their ducks in a row."[26]

For those that are funded, the foundation holds an intensive grantee orientation process, devoted in large part to sustainability, before a check is written. A grantee will survive on its own if it follows three basic rules of sustainability. First, it has to measure its impact in order to show the community the value it provides. Part of that means setting objectives and identifying what data it needs to collect right from the start. Second, it has to use that data to inform the community of its impact and value. A communications plan is required that includes three activities during the year that call attention to its grant-related work. Third, it needs to generate revenue and/or fundraise within the community as the foundation's money and support ends.[27]

The foundation's success rate is strong because of its thorough scrutiny of proposed projects and its laser-like focus on sustainability. This focus does not end with the completion of a grant. All "graduated" grantees complete an annual survey for three years after their grants have ended. The purpose is to collect data that reflects the nature and level of the grantee's operation in order to compare to when they graduated from the foundation. Emphasis on sustainability has paid off. "Eighty-nine percent of the projects funded by the foundation operate at the same or higher level three years after graduating from foundation funding," said Oswalt. "All of that results from our venture philanthropy approach to grant making."[28]

As a public-private partnership, the Virginia Health Care Foundation has an unmatched record. In fact, no other state health care foundation even comes close to Virginia's results and leveraging capabilities. Public funds have increased over the years, beginning with $2.2 million a year from the General Assembly. Today, the foundation receives about $4 million a year.[29] "We are expected to supplement the public funds with money from the private sector," said Oswalt.[30] "The foundation as an average of more than $11 in cash, health services and other in-kind contributions for every dollar spent since VHCF's inception."[31]

That leverage capability has afforded the foundation far-reaching influence. Take Patient Assistance Programs, for example, which are operated by pharmaceutical companies to provide free medications to uninsured people suffering from chronic diseases who cannot afford to buy their medicines. In the late '90s, there were over two hundred of these programs, all with their own hoops to jump through. An application for

each medication took on average thirty minutes to complete manually. "We thought it was burdensome for someone to have to fill out a separate application for each medication," said Oswalt.[32] As a result, the foundation sought a way to expedite the application process. It created a software called "The Pharmacy Connection" (TPC) to reduce redundancy and cut the application time to an average of five minutes. Approximately 160 organizations use it today, including free clinics, community health centers, hospitals, physician offices and community service boards for mental health patients. It is also being used in nine other states. To date, TPC has generated more than $2.2 billion in free medicines for more than 276,000 uninsured Virginians. "This was all developed as a result of our philosophy of innovation, technology and leveraging," said Oswalt.[33]

By taking a comprehensive approach to increasing access to healthcare, the foundation has branched out to behavioral and dental health services. It has funded programs that encourage free clinics and health centers to incorporate the delivery of behavioral health services and with primary medical care. It has also spearheaded an effort to address the shortage of psychiatric nurse practitioners by instituting a scholarship program to underwrite the cost for health safety net nurse practitioners to obtain a post-master's certificate in psych-mental health.[34]

As half of Virginians go without dental insurance today, the foundation has instituted a menu of lifesaving initiatives, including establishing discount programs, introducing dentures, providing training and technical assistance and publishing how-to guidebooks. It is the state's largest funder of dental safety net clinics and has invested nearly $10.7 million since 1998. Since 2000, it has partnered with the Virginia Dental Association Foundation to get the Mission of Mercy program off the ground. What started out as a weekend dental fair for uninsured adults in Southwest Virginia has blossomed to events in every corner of the commonwealth.[35]

The standards and guiding principles established during its inception have been critical to the foundation's success and impact. Never accepting the status quo, Mark Warner focused on growing and improving. He was relentless in leveraging resources, measuring impact, demanding accountability and insisting on innovation. That was all built into the DNA of the Virginia Health Care Foundation from day one.[36]

Easing Difficult Decisions

When caring for his mother, who had been diagnosed with Alzheimer's disease years earlier, Mark Warner was frustrated. "Helping my father find [assistance] for my mother was a nightmare," he recalls.[37] "As my family looked around for useful information, for available services, even for a simple list of local support groups for my dad and her, we were baffled that there was so little useful information gathered in one place for caregivers."[38] He was determined to do something about it, so other families struggling with the same issue wouldn't be left in the dark. Curious if others experienced the same problems, Warner started talking with friends whose parents were in different states of decline. They, too, were frustrated that they could not find options easily and determine the best course of action.[39] Out of that frustration, Warner wondered "whether we could create a tool to help solve [this problem]."[40]

In the fall of 1998, Warner received a survey asking if there was anything in particular that he would like covered at an upcoming VHCF board retreat. As Executive Director Debbie Oswalt recalls, "Mark didn't just fill out the survey; he called me and asked to have something on the agenda about the elderly and how we need some way to help people navigate through the maze of services for the aging, because it's impossible." Oswalt adds, "Mark is the kind of guy who sees a vacuum as an opportunity to do something meaningful."[41]

Oswalt arranged for a presentation on the challenges facing the aging population and their families by Dr. Dick Lindsay, who led the Division of Geriatric Medicine at the University of Virginia Health Sciences Center at the time. He focused on the gaps that would exist as the aging population grows—namely, helping people get access to the right services. At the conclusion of Dr. Lindsay's presentation, Mark Warner advocated that the foundation develop a mechanism to help people identify health and aging services. Another board member added that there should be a patient education component. And then Warner pointed out the importance of using technology. A back-and-forth ensued with additional suggestions. Oswalt says that by the time they were all finished, "It was the retreat idea from Hell."[42]

Initially, Oswalt left the retreat thinking that this concept had to exist somewhere, that she could do some research on what was being offered elsewhere and then move on to some of the other initiatives that were suggested at that same board retreat. However, nothing like it did exist.

From Business Success to the Business of Governing

"We hired someone to do the homework and interview professionals in the aging field to see if this idea would be useful," said Oswalt.[43] Having received positive feedback, Oswalt put together a plan for SeniorNavigator and offered it to Warner. While the proposal called for a primarily web-based operation, Warner was not satisfied, recalls Oswalt. "He said it was not enough. It was just the Internet piece, and we needed to have a human piece." Warner's gears were turning, fast. "He said that we needed SeniorNavigator centers all around the state, where people in all communities could access the help and information available through SeniorNavigator. And he insisted that we involve the health systems and hospitals."[44] Despite frustrations about a hugely complex idea, Oswalt concedes that Mark Warner was right from the start about all of those things. He wanted to make it "high-tech and high-touch."[45]

SeniorNavigator began as a nonprofit subsidiary of the Virginia Health Care Foundation, which devoted five years to developing and nurturing the site with the help of hospitals, healthcare systems, area agencies on aging and advocacy groups. Oswalt and the board helped raise $1 million to jump-start the project, with special help from the AOL Time Warner Foundation and the Collis-Warner Foundation. In addition, over one thousand individuals participated in focus groups to help create the site.[46]

Today, SeniorNavigator is a public-private partnership of over 850 corporate, nonprofit and government organizations. Nagivation centers have been set up in every city and county across Virginia, located within trusted community organizations such as libraries, senior centers, hospitals and churches. Through grass-roots efforts, trainings, conferences and fairs, it has reached almost a quarter of a million individuals. The National Governors Association and the Southern Governors' Association have recognized SeniorNavigator as a best practice and a model for other states. It has also received national awards for being an outstanding technology solution and having a positive impact on the quality of life for older adults. The organization's success prompted its board of directors to develop VirginiaNavigator as an umbrella for future growth opportunities. Subsequently, disAbilityNavigator launched in 2008 as a portal dedicated to serving individuals with disabilities and their families.[47] Now, VeteransNavigator is under development.

From Mark Warner's vision to the Virginia Health Care Foundation's incubation, SeniorNavigator is accomplishing its mission. "It has helped Virginians find vital resources over seven million times," said Executive Director Adrienne Johnson, "and is the only public-private partnership nonprofit of its kind in the country, utilizing technology and community partnerships to help meet the complex needs of older adults, caregivers,

adults with disabilities and their families."[48] With its holistic approach, SeniorNavigator has ensured that anybody—no matter where he or she is economically, educationally or geographically—can tap into the valuable information it contains and use it in the way he or she needs.

Leveling the Playing Field

In 1997, high-tech companies could not fill private-sector jobs fast enough. With CEOs of area companies complaining about a shortage of tech workers, Mark Warner was determined to "increase the pool of potential applicants for the jobs from outside the normal realms of computer science and engineering."[49] Meanwhile, Warner was in the midst of ongoing discussions with college presidents and staff about how they and their students "could tap into the industry for jobs and financial support."[50] His role as a trustee of the Virginia Foundation for Independent Colleges (VFIC) presented a unique opportunity.

The foundation is composed of fifteen small private colleges and universities: Bridgewater College, Emory & Henry College, Hampden-Sydney College, Hollins University, Lynchburg College, Mary Baldwin College, Marymount University, Randolph College, Randolph-Macon College, Roanoke College, Shenandoah University, Sweet Briar College, University of Richmond, Virginia Wesleyan College and Washington and Lee University.

Founded in 1952, the foundation was born out of necessity to raise money from the private sector and bring awareness to the growing community of liberal arts education. Its trustees have traditionally been considered the who's who of the business community and among the strongest power brokers around the state. These colleges and universities, unlike their public counterparts, do not receive taxpayer funds.

In true Warner fashion, always being just ahead of the curve, Mark Warner was able to take his role as chairman of the foundation's board of trustees in the '90s and help transform the organization that was in need of a jump-start. Working hand in hand with then-incoming foundation president Linda Dalch, Warner helped reinvent its operation. "He sees practical ways to make things happen," said Dalch. "First he helps to see it and believe that you need to put it in a form of action. He is then there to be supportive, open doors but then stay out of your way."[51] This approach helped Dalch exceed all prior fundraising records for the foundation.

From Business Success to the Business of Governing

There was still, however, the pending question of how to connect the VFIC's liberal arts students to new opportunities in order to "help them credential skills that we thought they already had, but had no way of exhibiting," said Dalch. "A lot of students didn't have degrees in information systems, information technology and computer science. For most of the private schools, that wasn't offered at the time. These students were extremely proficient and capable in working a job or in an industry that had those major components. We realized that was a job block and wanted to find a way to prove the students had those skills, even though they may be a history or English major."[52]

"This liberal arts disconnect would continue to grow as the world became more digitally directed," recalled Dalch.[53] On the job front, "many high-tech jobs aren't necessarily reserved for programming whizzes and circuitry savants," said Elizabeth Griffin, the foundation's director of development initiatives at the time.[54] For management positions, employers are looking for people with "critical judgment, solid reasoning skills and basic technical know-how," Griffin added. "Basically, that's the liberal arts profile."[55]

Was there a solution that would take a three-pronged approach to filling Virginia's well-paid information technology jobs, giving students credit for skills they possessed yet were unquantifiable and helping liberal arts colleges expand their reach? Enter Mark Warner again. Treading in unchartered waters, he knew this was a perfect opportunity for Virginia to set a standard that others could follow.[56]

Warner and Dalch led an effort seeking collaboration among corporate human resources offices, the Virginia colleges' career development specialists and professors in technical fields from the schools involved. They decided, Warner says, that what they needed was "not a normal point-and-click computer exam, but something that could show critical thinking skills."[57]

The four-hour Information Technology Certification Exam, more commonly known as the TekXam, picked up support from AT&T early on in the form of funding and design advice.[58] The test was designed to measure an individual's "knowledge of hardware and software and understanding of legal and ethical issues."[59] Rather than focusing on programming expertise, TekXam focused more on a student's "general aptitude for computer use."[60] The test was "not about turning kids into technicians," said Warner. TekXam was about "giving kids with broad intellectual grounding the tools they need to prove they can operate in the Information Age."[61]

Three years after initial discussions began, the test became a reality in 2000. Joining AT&T in support were dozens of companies, including Bank

of America, EDS, Gateway, IBM and Philip Morris.[62] "We obviously had developed a product whose time had come," said Dalch, "because people were hammering down our door to get to it."[63]

While this did not come easy, a lot of hard work and cooperation paid off. Thanks to Warner's direction and Dalch's management of the process, the foundation produced in rapid time a one-of-a-kind assessment tool. Dalch particularly commends Warner's leadership on the TekXam, because he "helped us find a way to facilitate the process quickly, so we were ahead of the curve. Most of us tend to live in the world in which we are in and not be able to envision the world around the corner," added Dalch. "Mark Warner, on the other hand, does both."[64]

Building the New American Workforce

Standing with Marie McDemmond, president of Norfolk State University, days before Christmas in 1998, Mark Warner launched a public-private partnership unlike any other in Virginia. As part of his continuing search for ways to help fill the nearly twenty thousand unoccupied information technology (IT) jobs in Northern Virginia, not to mention thousands more in the Hampton Roads and the Richmond areas, Warner announced the creation of the Virginia High-Tech Partnership.[65]

The partnership had three goals: expose students from the five historically black colleges and universities (HBCUs) to tech firms through summer internships, help students find permanent jobs and build strong relationships between tech firms and the participating schools. Virginia's five HBCUs include: Hampton University, Norfolk State University, Virginia State University in Petersburg, Virginia Union University in Richmond and St. Paul's College in Lawrenceville.

Warner, who was a member of Virginia Union University's board of trustees at the time, said he hoped to expand the program to other state universities in the future. He started with the historically black schools because he said only 4 to 8 percent of "information workers" in the state were African American. "It makes good business sense and good moral sense for the high-tech industry to reflect the makeup of Virginia," said Warner.[66]

The partnership stemmed from a steady stream of conversations with executives from high-tech companies in Northern Virginia. For quite some time, Warner had been approached with concerns that they could not find

good people in their own backyard. Warner recalls many of his friends saying, "We've got to go recruit from India, China or wherever else. We don't have enough Americans."[67] Thinking of a different approach, Warner asked them if they had ever recruited at a historically black college. None of them had. A significant number of the high-tech CEOs were not from Virginia, and even some of the African American executives were not too familiar with the HBCUs.[68]

Acting quickly on the idea, Warner reached out to the school presidents, high-tech leaders and friends with the Northern Virginia Technology Council. In November 1997, he arranged a stakeholder meeting hosted by Dr. Ed Bersoff, CEO and founder of BTG, Inc., an IT firm he founded in 1982. At this meeting of college presidents, top-level CEOs and other business leaders, Warner presented an idea: "We'll do the job fair. We'll make it easy for you. We'll assemble these kids."[69] Warner recalls that at first, some of the college presidents and staff were suspicious. But it quickly became clear to them this was really a well-intentioned effort to link together a pool of highly motivated and talented real world–bound college students with Virginia businesses in the hi-tech sector.[70]

The concept was a win-win for everybody. Companies would send their human resource representatives and other recruiters to a one-day job fair at the Richmond Convention Center. Colleges would help identify students interested in an IT job after graduation, and if they could not get to Richmond on their own, Warner would arrange transportation.

In its first year, the partnership "matched 25 students with 17 high-tech companies concentrated in Northern Virginia. Eleven of those students secured jobs as a result of their internships."[71] Reinforcing the program's value, the original seventeen participating companies returned the next year eager to expand and diversify their workforce. A mutually beneficial arrangement, the partnership has helped change the way companies recruit. "This isn't asking a company to do a good-guy deed," said Warner. "It's dollars and sense."[72]

Despite the dot-com bubble burst, the number of student internship-seekers continued to grow, as did the number of companies wanting to add to their talent pools. The job fair attracted representatives from AOL, IBM, LMI, NASA, Northrop Grumman, Oracle, SAIC and Xerox, just to name a few. Also involved were the Northern Virginia Technology Council and the Center for Innovative Technology.[73] Regarding diversity, "we feel like it's a competitive advantage in the sense of having a lot of different types of perspectives, people with different backgrounds and experiences considering

all the options," said Apex Systems CEO Brian Callaghan, a participating member of the partnership.[74]

Over the years, the number of opportunities for students has climbed steadily to several hundred, with one year producing 125 internships alone.[75] That 500 percent increase since the inaugural year solidifies a real partnership that has helped expand the labor pool and keep Virginia competitive with other states in attracting high-tech companies. "Work force development is one of our major issues," said Bob Stolle, who served as Virginia's secretary of Commerce and Trade at the end of the Allen administration. "If that talent pool is right here in Virginia and is ripe for the picking, I think all involved should make efforts for the good of the state."[76]

Bringing Technology to Communities

"In the late 1990s," recalled Mark Warner, "I worried that parts of Virginia were falling behind. The technology boom was transforming Northern Virginia, but it was not reaching the rest of our state. While Northern Virginia was gaining tech jobs, [Southwest and Southside] Virginia relied on textiles, tobacco and furniture-making—not industries in which you would want to hold a lot of stocks."[77]

Born out of the digital divide debate, Tech Riders came into existence. Inspired by the civil rights Freedom Riders of the 1960s who registered people to vote, Tech Riders was designed "to bring a whole new kind of freedom—the freedom to be empowered by computers and the Internet, to join in the great transformational change of the day."[78]

Warner partnered with friends Steve Case, founder of AOL, and his wife, Jean. "But we faced an interesting challenge," he says. "You could put computers in a library, or build a fancy computer lab and offer lessons—but many people wouldn't come. They didn't want to try something new in a strange place. They didn't want to be embarrassed."[79] With traditional locations out of the picture, Warner thought Tech Riders needed to focus on where people would be most comfortable. "So our question became: How can you get people to approach technology without fear or resistance," said Warner.[80] The answer lay in places where they already felt a sense of community, where education was a core principle. So Warner decided to partner with churches, synagogues and mosques to serve as de facto classrooms.

From Business Success to the Business of Governing

The next step meant finding staff and equipment. "We hired college students to go around the state," said Warner.[81] AOL, headquartered in McLean, Virginia, chipped in and provided hundreds of computers and the necessary accounts to access the Internet. First, Warner contacted friends with the historically black colleges and universities and the liberal arts schools around Virginia to help identify students who were strongly computer literate and had the patience of Job.[82]

Tech Riders then put together a training course and PowerPoint presentation focusing on the basic principles of Microsoft Word and Excel, as well as for using the Internet. The students committed to a ten-week program, whereby they would work in small teams and set up shop in a different house of worship each week for several nights.[83] This was a real community effort. "Sometimes," Warner remembers, "you would get these teams of people that would stay with a church family for a week. And at the end, they would leave behind a couple computers in each church."[84]

Making surprise visits around the state, Warner spent time on the road. Using some of his own money and raising more from others, he wanted to see firsthand that the program was making a difference. Training courses took place all over the state but focused in several key areas, including Danville, Hampton Roads, Harrisonburg, Lawrenceville, Lynchburg, Northern Virginia, Roanoke and Southwest Virginia as far west as Abingdon.[85] It was heartening, Warner says, to help people see that "embracing this new technology did not mean leaving behind what was important to them. And within two years, 16,000 Virginians of all ages—many of them parents and grandparents—had benefited from Tech Riders training."[86]

Applying Business Principles to Social Problems

"After 30 years in the software business, I was ready for a new mission," said Mario Morino. "It had to help children of low-income families because too many today don't have the same opportunities to succeed that I had growing up in the 1950s."[87] An established entrepreneur, venture capitalist and technology expert, Morino co-founded and helped build the Legent Corporation, a software and services firm that became a market leader and one of the industry's ten largest firms by the early 1990s. He also formed the Morino Institute to "figure out how the Internet and Internet-driven economy could bring about positive change."[88]

"For eight years, I talked with hundreds of people from all walks of life, digging in to understand the nonprofit world and how social services are funded and delivered in our nation," said Morino. "What I found was both inspirational and disturbing. Smart, dedicated nonprofit leaders are developing workable solutions to the toughest problems in our communities. But while the current efforts of foundations, volunteers and donors work fine for small nonprofits; these same sources come up short for organizations seeking to scale their impact. These nonprofits need more capital and more support than traditional sources can provide."[89]

"I saw that the dysfunctional element for the nonprofit sector was its funding," said Morino. "When the donor drives the organization, and there are strings attached to that money, it makes it an imbalanced situation between the funder and the funded. Being able to stay on mission is difficult because of the funding system."[90] Further compounding the problem is "an acute shortage of executive-level talent to help these organizations grow."[91]

Morino wondered if he could demonstrate a different way of funding organizations with a breakthrough need, whether you could, in fact, cause a significant inflection point in the nonprofit sector.[92] There were several hurdles, however. "Getting money to build an organization was almost unheard of in the '90s," said Morino.[93] So he began to reach out to several of his friends: Raul Fernandez, Bill Shore, Bob Templin and Mark Warner, to name a few. Templin has been president of the Center for Innovative Technology in Virginia, a senior fellow at the Morino Institute and president of Northern Virginia Community College, one of the nation's largest community colleges. Raul Fernandez—founder of Proxicom, a company he took public and sold for roughly $450 million—is chairman of ObjectVideo and a part owner of the NHL's Washington Capitals, the NBA's Washington Wizards and the WNBA's Washington Mystics. Bill Shore, a former Capitol Hill staffer, founded Share Our Strength in response to the Ethiopian famine and is now the driving force behind NoKidHungry, which is on track to end hunger for children in the United States.

"We began to look at creating a social venture fund employing not a grant model but an investment concept," said Morino.[94] "We wanted to find a way to fund nonprofits with exemplary leaders, who had a vision for change that we could invest in and help them achieve that vision. Our investments would yield social not financial return."[95] Morino, Fernandez and Warner thought early on that they would partner with a fourth and each put $4 to 5 million in for a $20 million fund. Warner was at the core of the thinking of how they were going to put this idea in place. "We took a different approach,"

said Morino, "much like a high-end quality venture company that Mark understood very well. Instead of taking grant applications, we were going to study the region and figure out who we wanted to approach."[96]

Their concept quickly became a reality. Venture Philanthropy Partners (VPP) was born out of a convergence of forces. First, out of the '90s was emerging a new kind donor. This was a relatively wealthy individual, younger and someone who wanted to be more hands on and engaged than what was historically true of donors. Second, the concept of social entrepreneurship was emerging as a force, creating new opportunities. Third, people like Raul Fernandez, Mario Marino and Mark Warner brought to bear a strong foundation from the business world and wanted to see how it could be applied to the nonprofit sector. In looking at the issue from a systemic point of view, maybe they could they take an organization to scale. Fourth, certain nonprofit organizations were reaching critical mass but needed growth capital, which is available in the commercial space but did not exist easily in the nonprofit world. "It was the union of these four points that said we needed to do it," said Morino.[97]

Co-founders Fernandez, Morino and Warner started reaching out to families and foundations for the first fund, ultimately securing $34 million in commitments despite the dot-com burst and recession. The Morino Institute provided additional capital to incubate and grow the organization. The search then began for nonprofits serving the National Capital Region with a clear outcome: having a material impact of an enduring nature in the life of a child. "There are lot of programs that do really quality work," said Morino.[98] "The question of whether they are meaningful and sustainable is a whole different ballgame. If there isn't exemplary leadership in place, then our model doesn't hold."[99] For Morino, VPP's model requires an organization to have a strong leader who is poised to advance the nonprofit's mission based on that individual's vision. VPP has to, of course, buy into that vision. "If we have those ingredients," said Morino, "then we will put anywhere from $1 million to $5 million into the organization, all grant money, but done as an investment with clear benchmarks and clear performance expectations. And we provide significant executive assistance—senior executives in our team to work with that executive and their board. That is a model that Mark is very familiar with from Columbia Capital."[100]

"The idea of being able to take this outcomes-oriented business approach to turbo charge the growth of select nonprofits has turned out to be a very powerful model," said Nigel Morris, co-founder of Capital One Financial Services and VPP investor.[101] "We joined Venture Philanthropy Partners at

its inception," said Gabriela Smith, who, along with her husband, co-founded the Amanter Fund, a philanthropic endeavor focusing on children, families and education. "Our decision to join was based on the model's originality and potential, as well as our trust and respect for Mario Morino, Mark Warner, and other investors."[102] Morris adds, "Executive directors spend their whole time worrying about where the next meal is going come from. We are proud to be able to say, 'We'll give you this amount of money, and it's going to last for this amount of time…now, go focus on growing your organization and serving your clients, rather than having to chase the next dollar.'"[103]

What VPP does is not for all nonprofits. It is aimed at a particular type of nonprofit: an organization that has had a breakthrough. It is either a smaller organization that has an opportunity to really scale its impact through growth, or it is a larger organization that has the chance to not only grow but change its impact on those they serve.[104] "VPP was created to bring about change," said Raul Fernandez. "It does not shy away from working with organizations that are tackling our communities' toughest problems, and our portfolio of nonprofit investments proves this."[105]

Morino says that from the start, the founders wanted the success of VPP to have a ripple effect through the nonprofit sector, so others would see the benefit.[106] "We're trying to do something bigger," said Morino. "We're using funding for children as a way to do this, but our real goal is to impact philanthropy."[107]

"VPP's demonstrated successes in helping [compel] community leaders build stronger, more effective nonprofit institutions offer real-life lessons to policy makers in two key areas," said Warner. "First is innovation. VPP's support and assistance to good nonprofit leaders is not only helping them be more effective in tackling difficult social problems, but also giving them the opportunity to think differently about how to move their organizations to the next level of impact for children in our region."[108] The second, Warner adds, is "the importance of breaking down silos. By being uniquely positioned at the intersection of the business, philanthropic and nonprofit worlds, VPP can assist in brokering cross-sector partnerships that make a lasting difference."[109]

Warner believes that VPP's work in education is the area that has had strongest impact overall. "Not only is VPP heavily invested in breakthrough K-12 organizations with the potential to become national models, it is also investing millions in organizations that support these young people outside of school. These include programs for early childhood development, afterschool, mentoring and those that help qualified students navigate the college admissions process."[110]

From Business Success to the Business of Governing

Warner invested early on in education programs for children using a new venture philanthropy model. *Michaele White.*

Over a decade and a half after it was founded and two investment funds later, VPP is pioneering social change. When it was created in 2000, it was in the vanguard. Co-founders Raul Fernandez, Mario Marino and Mark Warner were willing to give an experimental model a shot. Now tested, VPP's impact is significant. Today, the Friendship Public Charter School serves nearly 4,000 children as the largest charter system in the region. With VPP's support, the number of students taking AP exams exploded from 52 to over 750. Year Up Capital Region puts urban young adults on a path toward living-wage careers and opportunity, with 80 percent of graduates going on to post-secondary studies or securing full-time employment making at least fifteen dollars an hour. Mary's Center, a community health clinic serving low-income neighborhoods, has immunized 88 percent of its two-year-old patients, outpacing the national average by almost 10 percent.[111] VPP's success stories are the result of a bold vision backed up by hands-on leadership, an infusion of proven business practices and, above all, a commitment to making a difference in the lives of children.

9
REWRITING THE POLITICAL PLAYBOOK

Labor Day in 2001 felt all too familiar for Mark Warner. It was just five years before that he was battling Virginia's most respected politician for the U.S. Senate. Stepping out of the spotlight after a close loss, Warner was determined to follow through on his promise to work on the problems facing Virginia as it moved into a new century. Win or lose, those problems would still exist, and if he was not able to help as a U.S. senator, he was committed to making it happen as just a private citizen. "We are entering an information-age economy," he declared while kicking off efforts to infuse capital in the distressed Southside and Southwest regions of the state. "It will affect the way we work, how we live, how we educate our children. I want to make sure that no part of Virginia is left behind as we enter this new age."[1]

Mark Warner had the vision. He had the time. He had the energy. He had the resources to make a difference. Through a series of socially charged ventures, he was excited to return to what made him so successful in the first place. "It was like being an entrepreneur and starting a business again."[2] The Virginia Health Care Foundation, SeniorNavigator, Tech Riders and the Virginia High-Tech Partnership are proof that government does not have to be the answer to all of the world's problems. A shared vision fueled by private ingenuity can be the vehicle to bring about change. "These efforts were all about identifying a need, putting a management team together, and trying to solve a problem," said Warner.[3] Even with the success he and business leaders had achieved in a short period of time,

their mission was not over. Virginia was still at a crossroads, and its people were clamoring for leadership.

By 2001, state government was showing signs of an impending economic spiral and not just anyone could help right the ship. The status quo had become the problem, and the enemy was given a face in that of the General Assembly and Governor Jim Gilmore. A bipartisan coalition within the Republican-dominated Senate chanced legislative gridlock over a fundamental disagreement with the Republican governor, whose chief political promise was sending the state down a fiscally irresponsible path.[4]

At the same time, a weakened Virginia Democratic Party was in search of hope for not only its own sake but also that of the entire state. Despite the challenges facing the next governor, nothing could keep forty-six-year-old Mark Warner away from politics for too long. The proven businessman, party uniter and consensus builder picked a critical time to jump back in. Five years removed from being an out-of-work candidate, Warner was back on the job market. This time he was running for governor, and on September 3, 2001, he was literally running for votes in Buena Vista at the annual Labor Day parade, just as he did in 1996. His enthusiasm had not waned.

On parade routes, Warner rarely stops for more than just a quick handshake while sprinting from one side of the street to the other. *John Rohrbach.*

From Business Success to the Business of Governing

Warner crisscrossed the main drag here in a frenetic half-sprint, sweating through his blue oxford shirt, shaking hands and flashing his toothy smile as campaign workers doled out stickers and candy. His Republican rival, Mark L. Earley, looked comparatively dry and relaxed as he greeted the crowds, despite an early lead for Warner in money and popular support.[5]

Riding in a car and waving to a crowd has never been Warner's style. When he says he wants to earn votes, he means it. And Warner prefers to do it one person at a time. His parade sprint is as unique as it is effective. For a few seconds, locked in a firm handshake, you have the attention of man who, by the look in his eyes, has genuine seriousness of purpose. And all too often, if he has seen you before, he will recognize you in a flash. In return for that brief, friendly encounter, there is an exchange. Warner, who thrives on personal interaction, is noticeably reenergized, and you feel reassured that he is the right man for the job. But beware: you may get sprinkled by a little bit of the sweat off his blue oxford cloth shirt.

GOP at Its Peak

It was Independence Day, and Mark Warner was on the road again, this time making the nearly four-hour trip to Virginia Beach. He had plenty of time to make a dent in his call list, with Republican Party executive director Ed Matricardi at the top of the heap. Any candidate would be ill advised to ring up the opposition party's chief strategist, who in Matricardi's case, was tasked with ripping apart Warner in the media every chance he got. That was no concern to the Democratic nominee, who was heading to a staunchly Republican event, the Filipino-American Friendship Day Picnic, when he called up Matricardi to wish him a happy birthday. Disappointed he got Matricardi's voicemail, Warner just left a lighthearted message for both of their amusement. "I remember the message like it was yesterday," said Matricardi. "He said 'Happy birthday, Ed. I hope you take the day off today because any day you're not criticizing me is a good day for America.'"[6]

A former party chairman, Warner understood Matricardi's role as his party's cheerleader. Now a powerful D.C. lobbyist and grass-roots tactician managing nationwide efforts like Bill and Melinda Gates's "ED in '08—Strong American Schools" campaign and T. Boone Pickens' crusade for energy independence, Matricardi is first and foremost a master political operative. The architect

behind the Republican Party's takeover of all five statewide offices and both houses of the Virginia General Assembly knew exactly which buttons to push to drive Warner crazy. Quick on his feet and perpetually on message, Matricardi could capitalize on the smallest of faults and deflect attacks of great enormity, all along rousing his GOP base. "Ed was relentless every day," Warner recalls. "Whatever we were doing, he had a jab back. Ed made me mad at times, but I still respected him."[7]

Opportunities were aplenty for Warner to push the limits of traditional politicians. He was not going to be a "you're with me or against me" kind of guy. He was not going to shy away from making the case for his candidacy in unfriendly audiences. In fact, if there were someone wearing his opponent's sticker, Warner would offer the same enthusiastic greeting that he would to one of his own supporters. Animosity toward others was not something he learned growing up, and that was not the kind of politician he would be.

For Mark Warner to be successful at the ballot box, he had to be himself, often ignoring the advice of consultants and traditional Democratic advisors. "You've got know why you want the job," he says. "You've always got political advisers that are pushing you toward the more conventional approach. If anything, my campaign was characterized by me fighting my advisers. People are so tired of politicians who are viewed as entirely poll-driven and consultant-driven."[8]

Winning in Virginia meant understanding Virginia, a state that had every Republican advantage you could imagine. A Republican occupied the Governor's Mansion for the first time in over a decade with George Allen's election in 1993. The party swept all three statewide offices in 1997, ushering in Jim Gilmore as governor, John Hager as lieutenant governor and Mark Earley as attorney general. After operating under a power-sharing agreement with the Democrats, Republicans gained an outright majority in the state Senate in 1998 thanks to a special election victory. A year later and for the first time in the state's history, Republicans took control of the House of Delegates. The GOP's electoral dominance continued in 2000 when George W. Bush was elected president, and George Allen unseated Chuck Robb in the U.S. Senate contest. Republicans also controlled seven of the state's eleven congressional seats, including then Independent Virgil Goode's Fifth District one. They added an eighth in 2001 following the death of Congressman Norm Sisisky, when Randy Forbes, a former delegate, state senator and chairman of the state Republican Party, was elected in a special election.[9]

From Business Success to the Business of Governing

Warner was facing Chesapeake native Mark Earley, who had, prior to his election as attorney general, served in the Virginia Senate since 1987. A Republican, Earley had a politically conflicting family background. His father was active in the AFL-CIO, and his mother was a Democratic voter registrar. Regardless, conservative Republicans welcomed Earley, whose beliefs stem "from his devout faith, which led him to a theology degree from [the College of William & Mary], followed by a year in a Philadelphia divinity school. From there it was two years in the Philippines as a Baptist missionary, where witnessing the dictatorship of Ferdinand Marcos led him to consider a political career."[10] With help from television evangelist Pat Robertson, "Earley became the first Virginia attorney general with strong open ties to both the evangelical Christian movement and abortion rights opponents."[11]

Earley was poised to follow in the footsteps of Governors George Allen and Jim Gilmore. It seemed like the political environment would almost guarantee it. "We had been on this incredible run," said Matricardi. "We controlled all three statewide offices, both houses of the General Assembly, eight of the eleven congressional districts and both U.S. Senate seats. President Bush named Governor Gilmore chairman of the Republican National Committee. We were totally in ascendency, at the top of the mountain top, and then the roof caved in."[12]

The Republican Party in Virginia had become a super-majority, and it started to breakdown into factions. When it was in the minority, the party easily united against a common enemy: Democrats. "But once we got to the top," said Matricardi, "we became so big that we started to factionalize into pieces."[13] Unfortunately for Mark Earley, that all happened in the middle of his campaign.

While Mark Warner cruised to the Democratic nomination without opposition, Earley had a more difficult path, facing Lieutenant Governor John Hager in a convention. Hager was a prominent businessman from Richmond and perhaps the party's best chance to beat Warner in the fall. The drawn-out nomination fight underscored a division within the ranks, causing fractures that still exist today. The immediate impact, however, left many mainstream Republican financiers and heavy-hitters either sitting on the sidelines in protest or eventually crossing over to support Warner. Also related to the bitter nomination fight was a philosophical divide among Republicans that permeated all levels of their influence in the state. Jim Gilmore campaigned and won on a three-word bumper sticker slogan in 1997. By 2001, the financial bind the "No Car Tax!" pledge had put Virginia

in set the stage for a no holds barred match among Gilmore, the House, the Senate, and Republican activists. It would set the stage for a change in which party would control the Governor's Mansion.

Post-Partisan Alternative

Standing before a packed house at the Southwest Virginia Higher Education Center in Abingdon, Mark Warner kicked off his campaign for governor, vowing to leave no part of the state behind. It would be the first stop over eleven days where he visited fifty-four communities around the state.[14] "I believe very strongly that one of the opportunities that comes about in this 21st Century economy is that a young person in a rural community shouldn't have to move away and leave their home to find a good quality job," Warner told the Southwest Virginia crowd.[15]

As governor, Warner would be unconventional. He was not going to be the typical Democrat. "I think generally a Democrat's historical perspective of trying to look out for some of the more disadvantaged of society is something I adhere to," said Warner, "but I'm a Democrat that feels that it's better to teach someone to fish than to give him the fish."[16] His priorities for building a better Virginia were a product of his business background. Innovative solutions, greater accountability and improved management, highly skilled workforce and a better quality of life were his mantra.[17]

"Everything about our lives, whether we want it to or not, is going to change," Warner told supporters at every stop he made.[18] From education to healthcare to job opportunities, Warner made the case that prosperity will be for the taking, as long as we make the right choices. "What we really need and what we've got to have is a governor who understands those issues," he said. "We've got to move beyond the partisan issues. I'd like to bring a set of new ideas to Virginia and make Virginia a world leader in the economy."[19]

Warner's business success set him apart from any other candidate for governor in modern history. It gave him instant credibility. "What I am is an entrepreneur," he said. "An entrepreneur is somebody who can sometimes seize upon a good idea, bring people together, hopefully, then empower a management team to then go out and work on that idea, and then take it into action. The thing I'm proudest of is that record [of saying], 'Here's a problem, here's hopefully a fairly creative solution,' and then, as opposed to talking about it, actually doing it. That spirit and that attitude, I'd like to try

From Business Success to the Business of Governing

to bring to state government."[20] Warner was determined to shy away from the divisive social issues that generally plague politics and instead focus on offering solutions to the problems people really cared about.

Every Vote Counted

The 1996 race against John Warner was a tough loss. Despite the years of traveling around the state his party's chairman, Mark Warner came up short. Failure has never kept him down. It gave him the resolve to work harder. "There's nothing wrong with failing if you've got the will to try again," he is fond of saying.[21] The most important lesson Warner learned from the U.S. Senate race was preparation. "He was never going to be unprepared for something again," said veteran Democratic insider Mike Henry, a staple of Virginia politics who coordinated the party's statewide efforts in 2001. "Mark wanted to make sure he completely understood the geography and then plan a strategy around leaving no stone unturned."[22] With careful planning, the clock would no longer be the enemy. Warner set out to spend enough time preparing for the race by making the rounds, developing relationships, building coalitions and getting input. His strategy was simple. Every county mattered. Every precinct mattered. Every vote was up for grabs.

Warner was not going run a campaign tailored to just Democratic votes. Mathematically that would be a losing strategy from day one. More importantly, Warner wanted to do well in all regions of the state. That meant he could not just focus on Democrats. He had to appeal to Republicans and Independents. He had to appeal to liberals, moderates and conservatives alike. He had to spend as much time speaking with voters in rural Virginia as he did in urban communities. "He took a holistic view to Virginia that nobody was going to be left out," said Henry.[23] "He was determined to go everywhere. He was going to be aggressive. He wanted to meet as many people as he possibly could, shake their hands and make the case for his candidacy."[24]

Warner made the decision to throw out all of the old models and come up with a new plan, a Virginia plan, which meant that all of the state's localities were on the table. The new strategy called for expanding outreach well-beyond Democrats. "It meant in the campaign we had to not lose any one of our traditional Democratic [families], yet if we only relied on Democrats in Virginia, we end up somewhere between 44 and 46 percent of the vote.

We had to reach across dramatic lines."²⁵ He worked just as hard for votes in urban cities, Northern Virginia suburbs and rural counties. He actively sought votes from everywhere. "His model was very much, 'I want to win all of Virginia. I want to fight for every vote,'" says Henry. "A lot of people talk that way. But with Mark Warner, he was serious."²⁶

Southwest and Southside Virginia were used to being ignored, regardless if it was campaign season or the legislature was in town. In 2001, that all changed. "Mark Warner was a breath of fresh air for rural Virginia," said Ben Davenport, a Republican businessman from Chatham in the heart of Southside. "He unabashedly went into Northern Virginia and said, 'If I'm governor, I'm governor of the whole commonwealth of Virginia. I'm not going to neglect the part that needs us most.' He said that, and he meant it."²⁷ Dubbed the "Solon of Southern Virginia," Davenport runs two companies, First Piedmont Corp. and Davenport Energy, and is a past chairman of the Virginia Chamber of Commerce.²⁸ For years, Warner put his own time, resources and business know-how into helping rural leaders like Davenport reenergize their sluggish economies. "By the time the gubernatorial race came around," said former Democratic Party chairman Larry Framme, "Mark was not a candidate parachuting around. He had already established a record of being out there trying to help Virginia. He understood the necessity in campaigning to make people understand he really cared about them. Mark was able to do that because he really does care."²⁹

MODEL PUT TO THE TEST

Seven weeks out from election day, Mark Warner enjoyed a lead that he had kept up all summer. The only problem was that a quarter of the voters were still undecided. Based on the two previous gubernatorial races, Mark Earley could potentially benefit from a 15 to 20 percent bump in the closing weeks of the campaign.³⁰ Warner's three-point lead meant nothing, and everything was riding on his untested strategy.

Strict adherence to the campaign's fiscal message, strong fundraising numbers, Independent and Republican defections and Warner's relentless campaign style paid off. He broke the Republican stronghold over state government, defeating Mark Earley with 52.2 percent of the vote, taking with him Tim Kaine, former mayor of Richmond, who defeated Republican

From Business Success to the Business of Governing

Jay Katzen for lieutenant governor. Southwest Virginia native Jerry Kilgore, who served as Allen's secretary of Public Safety, was the only Republican to win statewide, defeating Delegate Don McEachin for attorney general by over twenty points.[31] McEachin was later elected to the state Senate in 2007. Even though the Democrats claimed the top-two spots on the ticket, down-ballot races had a different result. Republicans in the House of Delegates grew their hold on the leadership to a nearly two-thirds majority, electing sixty-four seats in addition to two right-leaning Independents.[32]

"Not only were we successful, but we won in every part of Virginia," said Warner.[33] The most significant factor in his victory was the extraordinary performance in Southwest and Southside. In 2001, rural Virginia claimed nearly one out of every three voters. By comparison, only a quarter of the United States population was considered rural.[34] Mark Warner's laser focus on the unique economic hardships facing the distressed Southwest and Southside regions helped him capture over half of Virginia's rural vote, the first time a Democratic candidate for governor had done so since Gerald Baliles in 1985.[35] "Many of the localities that Warner carried in Southwest Virginia—Salem and the counties of Alleghany, Bath, Craig, Franklin, Henry, Pulaski, Rockbridge, Smyth and Tazewell—hadn't voted for a Democrat for governor since 1985," said Larry Sabato.[36] Add to that the fact that "Warner won by 118,000 votes in a state that Republican George Allen carried by 150,000 votes a year earlier in the race for U.S. Senate."[37]

"We had a message that reached out to all Virginians," said Warner. "We won where Democrats traditionally don't."[38] The victory showed that Warner's willingness to transcend party lines with the right message was effective. He captured nearly a quarter of the 2000 Bush voters. Eleven percent of Republicans and 56 percent of Independents cast their ballot for the Democrat. "Not only did a third of Warner's vote come from voters who had a favorable opinion of Gilmore," said Sabato, "but in a head-to-head election matchup of Mark Warner and Jim Gilmore, Warner prevailed over the incumbent by 47 percent to 45 percent."[39]

Sabato also analyzed Warner's performance in the congressional districts that had flipped in the Republicans' favor in 2000. Warner performed very well, winning six of the eleven districts. He claimed landslide victories in "the African-American Third and the liberal Northern Virginia Eighth," said Sabato. "Healthy Warner majorities were also recorded in the Tidewater Fourth (Earley's home district), the Southside Fifth, the Southwest Ninth, and the Northern Virginia 'swing' Eleventh district. The Fifth and Ninth have usually backed Republicans, so Warner's triumph in them was considerable."[40]

Mark Warner the Dealmaker

Warner with his wife, Lisa Collis, and their three young daughters on Inauguration Day in 2002. *Michaele White.*

Important as his cross-party performance was, a victory would not be possible unless Warner held on to his Democratic base. "We carried over 90 percent of the African-American vote," said Warner, "the highest percentage for a Democratic candidate since Doug Wilder's historic win in 1989."[41] Warner launched a comprehensive outreach effort to members of the Asian and Hispanic communities, the fastest-growing culture groups in Virginia. He put the Spanish that he had learned as an exchange student in Argentina to good use. It was the first time when "a gubernatorial candidate for either party actually campaigned in Spanish on Spanish radio and Spanish TV," Warner says proudly.[42] The organized labor community stepped up in the fundraising and outreach areas, providing a significant base of voter contact volunteers. Warner, a pro-choice Democrat, was not willing to have the campaign hijacked by social issues as it had been in the past. Mark Earley had "built his base, and built his whole political life on his opposition to abortion."[43] Instead of making the campaign about abortion and other socially divisive issues, Warner appealed to women by focusing on children's health and education.[44]

Before the 2001 election, Virginia Democrats had little to be excited about. In fact, they were on their way out of the game almost entirely—

that is, until Mark Warner came along. "He solidified the brand of what it meant to be a Virginia Democrat," said Mike Henry. "He turned it all around for us."[45] In a matter of months, Warner had breathed life back into a quickly fading Democratic Party and gave hope to a commonwealth in search of direction. The results were a party rebranded and a state reassured. Mark Warner was a man on a mission fueled by a vision for Virginia few had the skill to make reality. Daring was the endeavor. Innovative was the plan. Historic was the victory. Easy to come by, however, the outcome was not. To understand why and how he won, one must first understand the environment in which he ran.

10
GRIDLOCK SETS THE STAGE

For some candidates, the end of a campaign signals the time to put politics aside and get down to the business of governing. This was not the case for Jim Gilmore. The Republican staked his entire gubernatorial campaign on three simple words: No Car Tax.[1] Gilmore, a former commonwealth's attorney for Henrico County, was elected attorney general in 1993 as George Allen claimed the top of the ticket. He faced Don Beyer, a successful Northern Virginia car dealer elected lieutenant governor initially under Doug Wilder and then reelected in 1993. Unfortunately for Beyer and the Democratic ticket, Wilder decided to stay neutral in the statewide races. The Republicans, on the other hand, were unified and riding on a wave of prosperity. "The economy was strong, a condition that always helps the incumbent party," said Larry Sabato, "and [Governor Allen] had high popularity ratings during the entire election year."[2]

The Gilmore-Hager-Earley ticket snagged all three statewide offices, a first for the Republican Party. "Jim Gilmore won virtually everything—almost every group and every region—in building a massive statewide plurality of 230,000 votes," said Sabato.[3] While he crushed Beyer by over thirteen points, Hager and Earley each finished with comfortable five-plus-point victories.[4]

Five months into office, Gilmore threw himself a party. His signature campaign initiative had passed the General Assembly, and the bill was ready for his signature. "Today is a great day for the hard-working people of the commonwealth of Virginia," Gilmore said on May 20, 1998, before a crowd of over four hundred staff, activists and supporters on capitol

grounds. "I am making good on that promise. No car tax! We are making that happen."[5] Almost exactly a year before, Gilmore announced his plan to offer what he called a "dividend, paid by Virginia's growing economy, to the working families of our commonwealth whose toil and taxes, ingenuity and investment, have made our prosperity possible."[6] The ceremonial bill signing, sponsored by Gilmore's No Car Tax political action committee, had the fanfare and euphoria of a campaign victory speech. "On cue, a small plane circled Capitol Square as Gilmore spoke to the faithful, most of whom had retreated with soft drinks or snow cones under trees on the north side of the capitol. Heads poked out from beneath the cool shade to look at the plane's banner, which read, 'Way to Go Guv!!'"[7]

It Started with a Promise

During the campaign, Gilmore announced he would eliminate the tax that individuals pay on their personal property, such as cars, trucks and motorcycles. This "car tax" is a local tax assessed by counties and cities on an annual or semiannual basis. Local governments would continue to collect the tax, but it would be phased-out over a five-year period. While individuals would reap the benefit of the tax cut, the state would hold the local governments harmless, reimbursing them for the lost revenue.[8] Gilmore proposed that the tax break go into effect during his first year in office. For vehicles valued up to $20,000, taxpayers would get back 12.5 percent of the tax in 1998, 27.5 percent in 1999, 47.5 percent in 2000 and 70 percent in 2001. A full repeal would be in place by 2002.[9] High-priced vehicles would qualify for the tax cut too. For vehicles valued more than $20,000, owners would be responsible for paying the tax on the amount in excess of $20,000. At the other end of the spectrum, vehicles assessed at or below $1,000 would be exempt entirely.[10]

When proposed, the plan was supposed to be a bargain. In a robust economy, the tax cut was not going to be a problem. "This is a period of unequaled prosperity, and the people should benefit from that," Gilmore said as the General Assembly convened for the 1998 session.[11] He was projecting $2.8 billion in new revenue for the state's coffers over the four years of his administration.[12] While running for governor, Gilmore gave the fully phased-in relief package a price tag of $620 million.[13] According to his campaign's 1997 position paper, "This tax relief will not require any cuts

from existing programs." It continued, "As the economy grows, tax revenues received by government increase. Virginia's tax revenues and expenditures have increased each year over the last five years by an average 7.2 percent. So long as the economy continues to grow, this tax-relief plan will continue to be implemented. Should the economic growth slow down, the tax relief will simply be phased in more slowly."[14]

Cautious members of the General Assembly's money committees were banking on Gilmore's "out clause" in case the economy showed signs of weakness. As a result they wrote into the bill three specific "circuit breaker" triggers. The next year's phase out would not continue if "general fund revenue is less than the official general fund forecast by one-half a percent; the projected growth in general fund revenue is less than 5 percent over the preceding fiscal year; and the December general fund revenue forecast shows that projected revenue will be less than the budgeted spending for the coming year."[15]

Ignoring Warnings

In December 1997, as Governor Allen announced his outgoing budget, he included $260 million that Gilmore requested to pay for the first year of the car tax cut. Although suspicious of the low amount, "We gave Gilmore what he asked for," said an Allen administration official, adding, "You ought to be careful what you ask for because you could get exactly that."[16] Their suspicions were right. Less than a month later, Gilmore acknowledged the actual amount for the first year had ballooned to $493 million.[17]

The near-double miscalculation affected the total package price, which had blown up to $2.8 billion, "making it the priciest tax cut in state history."[18] The estimate was recalculated by the Senate Finance Committee in November.[19] Well before election day in the summer, Gilmore was warned by the Virginia Municipal League (VML), a trusted statewide association representing all of the state's city, county and town governments, that his figures were way off. Predicting an annual cost when fully phased in at $1.37 billion, VML said that "Gilmore failed to factor in 9 percent average annual growth in personal property tax revenues over the past decade caused by growing population and increasing vehicle prices."[20] This error put the annual cost at more than double what the Gilmore campaign had originally announced. Gilmore and staff brushed off VML's concerns, labeling the

group as part of "the big tax lobby in Richmond" and responding that its estimate was "nothing more than an orchestrated attack on Jim Gilmore at taxpayer expense."[21]

At the same time, respected University of Virginia law professor and constitutional scholar A.E. Dick Howard expressed his own concerns. Howard, chief author of the revised 1971 Virginia Constitution, offered the opinion that Gilmore's car tax repeal "could not be implemented without amending the state Constitution—a process that could take three years."[22] As a result, Republican legislators requested that Attorney General Richard Cullen, whom the General Assembly appointed to fill Gilmore's vacancy so he could run full-time for governor, rule on the matter. By September, the verdict had come in. Cullen, in response to Delegate Vince Callahan's request on behalf of his colleagues on the House Appropriations Committee, "said lawmakers could avoid amending the Constitution by simply changing state law so that cars are legally defined as 'household goods'—which the constitution exempts from taxation—instead of as 'personal property.'"[23]

Regardless of the significant underestimation in the numbers, Jim Gilmore was determined to see his promise through. "I have been looking forward to this day," Gilmore told the press as he announced his legislative plan for the car tax bill. "It's good policy; it's the right thing to do for the people of Virginia."[24] His chief of staff and the architect of Gilmore's political strategy echoed support for the concept regardless of the flawed figures. "It sets a steady source of giving back to the people what they've earned," said Boyd Marcus, adding, "It's a responsible plan."[25] Days before his inauguration, Gilmore reiterated that the bill would not affect core government services. "My objective here is to eliminate the car tax, but do it in the soundest way to make sure that we continue the essential services and achieve the important goals of the commonwealth," he said.[26]

Economy Goes South

Over the next two years, the tax cut progressed as planned. "General fund revenues, adjusted for inflation, grew very rapidly in fiscal years 1998, 1999, and 2000," said John Knapp, veteran economist at the University of Virginia's Weldon Cooper Center for Public Service.[27] "These gains were looked upon as an ongoing fiscal dividend from Northern Virginia's high-tech sector and the new economy. Overlooked was the fact that revenues

From Business Success to the Business of Governing

were also stimulated by the booming stock market. Realized capital gains in the stock market added to Virginia individual income tax revenue. Beginning in tax year 1996 there was a dramatic increase in the capital gains portion of adjusted gross income."[28] Internal Revenue Service data showed that "the share of taxable income from net realized capital gains was 6.8 percent in 1998, more than double the 3 percent share in 1995.[29]

According to Knapp, consumer confidence was high. "Rising house and stock market values also caused a wealth effect that encouraged consumer spending. The increased economic activity was a stimulant for the individual income tax, the general sales tax, and the motor vehicle sales tax."[30]

If past market behavior was any indication, with any up, there had to be a down. By 2000, Virginia had hit the ceiling, and the second half of the year's revenue collections, which were lower than in 1999, confirmed the bad news.[31] Addressing the House and Senate money committees at the annual joint meeting in December, Gilmore presented his changes to the two-year budget the General Assembly had passed in 2000. A customary measure, the General Assembly adopted an amended budget in the second year of the biennium that reflected "changes in revenue and new demands for state funding."[32]

When the legislature adopted the budget in 2000, it left out two crucial expenditures, which it planned on adding via amendments in 2001. Funding pay raises for teachers, state employees and constitutional officers were slated for the second year of the budget, as were operational funds for nonprofit museums, parks and cultural attractions.[33] Given that the economy was strong when the budget was passed in April 2000, amending the spending plan a year later to include these items was not going to be a problem.

It was a shock when just eight months later, the governor and the General Assembly were dealt a harsh reality. Facing a hole in the budget, Gilmore would be unable to continue the next phase of the car tax cut. The news was something the governor simply would not accept. For him, moving forward was going to happen one way or another, regardless of the consequences. Standing before members of the Senate Finance, House Appropriations and House Finance Committees, Gilmore offered a solution that would help him keep his signature campaign promise, but by doing so, he would have to break others.[34]

The Not So Silver Bullet

"This budget consists of sleight of hand, gimmicks and fuzzy math," Senator Janet Howell said following Gilmore's address and presentation of his budget.[35] In order to show that the state's previous fiscal year's revenues had reached the 5 percent growth mark, which would trigger the next phase of the car tax cut to 70 percent, Gilmore proposed going into debt and counting the borrowed dollars as new revenue.[36] By selling "Virginia's stake in the national tobacco settlement to investors, generating a one-time revenue windfall of $1.2 billion," Gilmore would be able to take $460 million and place it in a trust fund to finance new construction and renovation projects for the state's colleges and universities.[37] In doing so, the budget would reflect enough new revenue to avoid tripping the car tax legislation's revenue growth "circuit breaker" provision.[38]

"Those who oppose this tax cut persist in stating that the money from our bonds will pay for the car-tax cut," responded Gilmore to his critics. "It isn't true. The money for the car-tax cut is already in the budget," he added.[39] Even if there were enough dollars in the budget to provide for the 70 percent cut, Gilmore's proposed budget broke his campaign promise that the car tax relief would "not require any cuts from existing programs."[40] On top of the tobacco settlement transaction, Gilmore proposed $206 million in cuts to state agencies. His budget also left out "an estimated $56 million to pay for the next phase of cuts in the food tax—action that critics contend would benefit many more Virginians than would the car tax cuts."[41] While Gilmore recommended a pay raise for state employees, teachers were not included. Instead, he "said that localities should increase salaries by using some $100 million they have saved from smaller contributions to the state retirement fund."[42]

Gilmore warned members of the General Assembly's money committees to resist the "powerful opposition from the special interests" that he said would "try to preserve the status quo at the expense of the taxpayers."[43] The status quo was in fact endangered with Gilmore's plans to "erase $55 million in cash for school construction and replace it with bonded indebtedness," along with scrapping $10 million in mental health services.[44] "What the governor calls special interests," responded Senator Howell, "are the parents of mentally retarded children, parents who want quality education for their kids and commuters stuck in traffic in Northern Virginia."[45] Delegate Jim Dillard was unwilling to turn his back on Virginia's most vulnerable citizens. The Republican took

seriously his responsibility as a member of the House Appropriations Committee to protect the state's core services. "Many of us can't go back to constituents and say we cut mental health to fund your car tax," he said.[46]

Drawing a Line

Gathered for the annual State of the Commonwealth address in the House chamber on January 10, 2001, members of the General Assembly eagerly awaited to hear Jim Gilmore's roadmap for his last year in office. Plans for higher academic achievement, more affordable college tuition and new jobs were hastily overshadowed by an unmistakable threat. "Because the money is already in the budget," said Gilmore that evening, "any bill that would halt the car tax cut I believe would amount to a tax increase. Any bill that would cut the car tax less than 70 percent would also amount to a tax increase, in my judgment."[47]

Gilmore alleged that not finishing out the tax cut would be a "breach of faith."[48] The threat did not sit well with members of the legislature. "He stuck his fist in the face of a bunch of people who have to run for elective office," said Delegate Dick Cranwell, who was House minority leader at the time. "That was a mistake."[49]

"Yes, we have promised the car tax, and we want to see that promise carried through," Senator Mary Margaret Whipple made clear while delivering the Democrats' official response to the governor's address. "But we promised to cut the tax in a way that would not jeopardize the future solvency of the commonwealth."[50] Sharing the response with Whipple was Creigh Deeds, a delegate turned Senator from Warm Springs, who criticized the direction the state was headed. "In a year under their [Republican] leadership, we've gone from the best of times to a situation where the commonwealth must borrow money, raid the tobacco settlement funds and slash services just to balance the budget. That's not a record that inspires confidence."[51]

Even the GOP's candidate for governor saw the potential for disaster. "We used to have a saying," Mark Earley recalled, referring to his time in the state Senate. "We'd say, 'You need to keep your powder dry.' In other words, the legislative process draws out over a period of time. Over a period of time, there's a lot of negotiation that goes on. People have bills they are interested in getting forward; you have bills you want to have go forward. And the last

thing you want to do is draw a very bright line in the sand on day one and leave no opportunity for negotiations."[52]

Gilmore's speech underscored a fundamental disagreement on the role of campaign promises at all costs in running government. "You can argue about the details and say, 'Well, you know, we never made this promise or that promise,'" said Gilmore. "But the fact of the matter is that the public has an expectation and I think it's legitimate."[53] Expectation or not, Jim Gilmore had showed his hand, especially with members of his own party. The usually congenial evening was soured, and the governor's speech was the prelude to an almost yearlong clash over principle and the fiscal stability of the Old Dominion.

Revenues, Patience on the Decline

The next morning, the Senate Finance Committee met for the first time of the 2001 session, taking up Gilmore's linchpin legislation to backfill the general fund. This was not the first time the governor had tried to use the tobacco settlement money for another purpose. In 1998, after "Philip Morris Inc. and other tobacco companies agreed to make annual cash payments in return for protection from lawsuits trying to recover smoking-related health care costs," Virginia was slated to receive payments over twenty years worth $3 billion.[54] Legislators stopped Gilmore's first attempt in 2000 to use the settlement funds in order to jumpstart road construction projects.[55]

By securitizing the funds in the case of the car tax relief measure, Gilmore projected a one-time payment of $1.2 billion, considerably less than the protracted value.[56] His assumption that the entire $460 million would count toward the state's revenue for the fiscal year was inaccurate. "Even in the rosy scenario of a guaranteed return of 6 percent after reinvestment for inflation, the correct figure [would be] $27.6 million, not $460 million."[57] A swift fifteen-to-one vote stopped the attempt dead in its tracks.[58]

With the bill dead in the Senate and its companion still alive in the House, Gilmore had to figure out a strategy to get the money in his budget. But first he would receive some more bad news from his secretary of finance, Ron Tillett, less than a week later. The creative policy tactician and financial whiz was initially appointed by Governor Allen for the top post after having served first as his and Governor Wilder's state treasurer. Tillett could be bested by few in his knowledge of Virginia's budget and historical economic

trends. With little surprise to the General Assembly's budget writers, Tillett announced that the state's continued economic decline left revenue growth during the final six months of 2000 at just 0.2 percent and that December's tax collections were down 11.1 percent from 1999. "It marked the worst month for state tax collections in almost five years."[59]

Predicting a silver lining in the ominous report, Tillett expected tax collections to pick up during the first half of 2001 by 6.8 percent, which would be on track on with the "administration's forecast of annual growth of 3.8 percent."[60] He reminded legislators to make prudent spending decisions in light of the state's fiscal condition. "There will be no additional revenues," Tillett said. "My advice is you should be cautious about new spending items."[61] Some legislators did not like hearing they should be confined to the governor's spending priorities. "You're telling us to trust the budget and keep the car tax (cut) and if there's nothing else in there, that's just the way it will be?" questioned former Democratic Speaker of the House Tom Moss.[62]

The General Assembly was not without options, however. About $360 million would be freed up if they chose to freeze the car tax relief.[63] "The arithmetic makes it impossible, but the arithmetic has always made it impossible," said Senator John Chichester, lamenting the strain the car tax relief had placed on the budget.[64] The Republican chaired the Senate Finance Committee and was not alone in his apprehension. "At some point you've either got to put politics first or the state first," added Senator Ken Stolle. "I don't know how, in good conscience, we can place the funding of the car tax above everything else at this stage."[65] Concerning their duty to come up with a sound budget, Chichester emphasized the potential long-term consequences of the legislature's actions. "When you have growth in the double digits, you can make a mistake and recover. Now, making a mistake would be catastrophic."[66]

EXECUTIVE POLITICS

With the fate of his legacy in the hands of the Senate, Jim Gilmore turned up the heat. It began with an e-mail from his political consultant Ray Allen to over five hundred Republican activists around the state saying, "The Virginia legislature is preparing to break the promise they made to the people of Virginia to fully phase out the car tax."[67] Attempts to apply pressure quickly escalated. Gilmore's "No-Car-Tax Project" housed in his New Majority PAC

hired Conquest Communications & Data to get constituents on the phone and connect them to their senator in order to pressure them into progressing the car tax cut.[68] It resulted in a criminal investigation.

Colonel Gerald Massengill, the Gilmore-appointed state police superintendent, ordered an investigation into whether "operators for the telephone bank that solicited the calls and transferred them to lawmakers' offices in Richmond listened in without first seeking the permission of those who made or took the calls."[69] "The victims have either been the constituents or the senators or the senators' aides," said Massengill.[70] He had to determine if the phone bank's employees had listened in on the calls; if so, they could be charged with a felony, punishable up to five years in prison and a $2,500 fine.[71]

Several senators reported suspicious voicemails and background noises on the calls.[72] "I was talking with a constituent the other day, and it was click-click. And I said, 'Is someone listening,'" said Senator Madison Marye, a Democrat from Montgomery County.[73] Senator Janet Howell reported that a voicemail left on her phone had a male voice saying to another person, "Was that all right? Did I do OK?"[74] The phone calls, which cost Gilmore $29,000, were part of a broader advocacy campaign with a tab of about $100,000.[75] After investigating the allegations, law enforcement officials did not file charges on the suspected eavesdropping.[76]

Following up the blitz, Gilmore made a last-ditch effort in the media. At stops along a fly-around tour of the state days before the House and Senate voted on the final budget, he claimed the Senate was essentially raising taxes by $264 million by not continuing the car tax phase out.[77] The senators did not blink. "To say that this is a tax increase is like saying someone who failed to get a bonus at the end of the year got a salary cut," said Senator John Chichester.[78]

Other members of the Senate Republican leadership reached out to Gilmore and asked him to put an end to politicizing the budget process. "He directly declined that invitation," said Senator Tommy Norment.[79] "Using Republican PAC money raised by Republicans for Republicans… to attack Republicans who disagree with you—it's putting some stress in the family," he added.[80] Stolle joined Norment in meeting with Gilmore to help calm the waters. "It doesn't do any good to try and escalate the rhetoric so high that you're inducing an atmosphere where compromise is not possible," said Stolle. "I think the worst thing that could happen for Virginia, for Gov. Gilmore, for the Republican Party, is for the General Assembly and the governor to leave the session without a budget."[81]

From Business Success to the Business of Governing

Give and Take Begins

A rift in the Republican Party had been brewing for years centered on ideology and exactly how big the "big tent" party was supposed to be. Sparked by the car tax debate, it was being played out under a magnifying glass, highlighting the difference in philosophy between the governor and the leadership of the Senate. With John Chichester at the helm, the Senate would continue the reliable approach of budgetary restraint and legislative discipline that had become a Virginia tradition.

"Chichester is very much of the old school in Virginia that represents fiscal responsibility," Larry Sabato said of the Northern Neck legislator. "Gilmore is part of the Republican new wave that believes in tax cuts first, and everything else follows. It's really just a fundamental divide and a principal difference between the two," added Sabato.[82] "Old school believes that government does many honorable things and plays a very constructive role in society. New school Republicanism believes that government, if not an inherent evil, must be limited to the greatest extent possible, and one way you limit it is by draining the coffers of money that can be spent."[83]

"We will stop the car tax to keep our children and grandchildren from paying 20 years (of interest) for a benefit we receive now," said Chichester.[84] "That is the only fiscally conservative course."[85] Besides, he believed he was keeping his word. "We promised that if revenues did not meet certain parameters, the car tax would be phased out on a slower schedule. That was the promise we made."[86] While the House Appropriations Committee more or less rubber-stamped the governor's funding mechanism to keep the car tax cut in forward motion, the Senate Finance Committee halted the relief at 55 percent.[87]

The Senate applied about $300 million in savings from continuing the car tax relief to funding long-overdue investments, including a 6.0 percent raise for teachers. The governor's plan did not contain teacher salary increases. The House concurred with the Senate but only included a 3.5 percent raise.[88] Both budgets took aim at questionable practices on behalf of the governor's office. They required that the governor receive approval from the auditor of public accounts before he shifted money between budget years. The House put limits on administration severance packages as a result of a $50,000 payout to an agency head who resigned. In response to the administration delaying $50 million in tax refunds to bolster the health of the state's coffers, the Senate mandated that the Department of Taxation process all refunds within seven days.[89]

Less than two weeks later, with little progress on a budget compromise, Gilmore offered a plan to free-up cash but stopped short of endorsing its

implications. "I'm not taking ownership of this," he said. "This is a way. It's an illustrative example. You can probably do it a hundred ways."[90] Senate Republicans were open to a leaner state government but not at the expense of skirting their responsibilities. "It's always appealing to say, 'Let's reduce the size of government,'" said Senator Walter Stosch, a Republican from Henrico. "We all subscribe to that. We want a government that's efficient, and we want a government that provides necessary services, but at minimum cost. However, we've got to look to see whether those cuts go beyond what our constituents would agree to."[91] For the Senate, any plan that cut existing programs to pay for the car tax cut was a non-starter.

After review by the Senate Finance Committee staff, Gilmore's "illustrative examples" would amount to just shy of $250 million in cuts to education, healthcare and public safety.[92] Student financial aid would be unfunded by $43.5 million. Medicaid and substance-abuse treatment for 21,400 elderly and disabled Virginians would be cut along with a 12 percent reduction in mental health services for children. Public safety would be hit hard, beginning with a delay in the scheduled hiring of state troopers. In addition, 225 proposed layoffs in the Department of Corrections, juvenile correctional centers and state prisons meant that these facilities faced a dramatic shortage in guard positions and probation officers.[93]

Two months after members of the General Assembly came to town, they could not reach an agreement on cuts to fund the car tax. As a result, the legislature adjourned without amending the biennial budget. Gilmore called a special session for late March in the hope that the legislature would be able to make headway after a brief cooling period.[94] In the meantime, he announced $421 million in immediate cuts as a result of the state's revenue shortfall. Without an amended budget, the state was operating under the two-year plan passed in 2000, which did not include funding in the second year, beginning on July 1, for state employee raises, museums, parks and cultural attractions.[95] Without General Assembly action, no new money could be appropriated; but in order to balance the budget, the governor could make cuts to line items not to exceed 15 percent. For Gilmore, that meant cutting to fund a 70 percent reduction in the car tax.[96]

"I'm pleased to announce that the budget has been balanced," Gilmore said as a result of the cuts. "The crisis is over."[97] From his perspective, he won. Slashing $421 million out of the budget meant Gilmore was able to keep his political promise. The victory came at a price, however. In order to accomplish the car tax phase out, he had to deliberately disregard his pledge to keep existing core services off the chopping block.[98] By doing

From Business Success to the Business of Governing

so, Gilmore made the Senate his scapegoat, and for all of the government services and people affected by the cuts, he laid the blame squarely on the body's Republican leaders. As a result, jobs were at stake, pay raises were out of the question and a hiring freeze was imposed. The cuts totaled $146 million and spread across fifty-two agencies.[99]

"If there is a [hiring] freeze of two or three months, a layoff or a line-item budget reduction," said John Jones, executive director of the 7,500-member Virginia Sheriffs' Association, "it means that [law enforcement] will have to do without."[100] Gilmore had deprived the sheriffs of their primary tool to recruit and retain deputies, almost ensuring negative repercussions throughout public safety budgets and cuts to core community services. "This means the public will have to do without," added Jones, underscoring the direct impact Gilmore's cuts would have on the delivery of law enforcement services in every locality.[101] An agitated Tommy Norment could not believe the lengths to which the governor had gone to make good on the tax pledge. "Cutting vital services to fund a car-tax reduction is both fiscally irresponsible and a threat to the future economy of the Commonwealth," the senator said upon receiving the news of the governor's plan.[102]

Also slashed was $214.5 million intended for capital projects for the state's thirty-seven colleges and universities.[103] Some campuses were in need of more help than others. "Every time it rains, every time more than five toilets are flushed, we have to run around putting plastic over the equipment," said President Tim Sullivan of William & Mary's loss of $20 million in construction funding, which included $15 million already appropriated to renovate the university's science building.[104] Sullivan was also concerned that a slashed budget would derail the school's concerted efforts to bring faculty salaries more in line with its peer institutions. "Faculty at William and Mary would receive an increase of only 1.4 percent—well below the state's council recommendation of 4.4 percent," he added of the impact the budget uncertainty would have on morale. "Indeed, some other universities would receive no increase at all—zero."[105]

Vetoes, the Constitution and the Courts

The General Assembly was back in Richmond the first week of April for the reconvened session, typically a one-day affair held six weeks after the regular session has adjourned in order to address the governor's vetoes and

amendments. While a couple vetoes are expected, this time Gilmore rejected seven bills, including four harmless measures carried by his opponents in the car tax battle on the Senate side of the capitol.[106] These included John Chichester's bill to allow the Joint Rules Committee to make appointments to the State Council of Higher Education, Ken Stolle's attempt to make the Virginia State Crime Commission a criminal justice agency and William Wampler's measure that would help improve water quality and availability in Southwest Virginia.[107]

While the General Assembly was unable to override those bills, it made history with a couple others. Senators Russ Potts and Walter Stosch survived the chopping block, with both houses voting to override the governor on their bills "sharply limiting state oversight of charitable gambling and changing which state agency oversees the Board for Accountancy."[108] The last administration when the legislature prevailed over a governor's veto was in 1993 during Doug Wilder's last session.[109] For the next four years under George Allen, a Republican governor with a Democratic legislature, the General Assembly did not override one of his vetoes. Unlike his predecessor, Gilmore, who had the advantage of single-party rule, was rebuked on a number of occasions, especially in 2001. "He didn't do too well," said Delegate Harry Parrish of Gilmore. "I'm afraid that some of his vetoes were more on a personal basis than they were on a legislative basis. I don't think that sat well with a legislative body, be it the Senate or the House."[110] Gilmore's response to the fellow Republican's criticism was reserved. "I can only assume they disagreed with the policy I expressed in the vetoes," he said. "I had a sound reason, I think, on each of those vetoes…So that's a matter they'll have to take up with voters at the appropriate time."[111]

On the agenda that day was a whole host of amendments that Gilmore had made to nearly one hundred pieces of legislation. One in particular was an expected point of disagreement in the Senate. Tensions were high in the chamber, and outside the doors in the capitol's rotunda there was an air of uncertainty. "We're all just waiting for someone to blink," Robley Jones said, as it seemed there was no end to the power struggle.[112] Jones, lobbyist for the Virginia Education Association, gathered with dozens of representatives from local government, public safety, mental health and the arts community. Gilmore attached the funding for raises for teachers, deputies, state employees and college professors to a Democratic senator's bill that "would allow local school systems to hire retired teachers who already receive benefits from the state pension system."[113] This was the same salary increase that Gilmore had put on the backburner in order to first continue the car tax phase out.

From Business Success to the Business of Governing

The question became whether the governor could offer an amendment to the bill in question that provided the necessary $125 million in cash derived from reducing the payments the state was supposed to make to Virginia's retirement system on behalf of its employees.[114] According to Virginia's Constitution, he could not because the amendment violated the original bill by also creating new revenue and applying it pay raises.[115] The official ruling would have to come from Lieutenant Governor Hager, the presiding officer of the Senate, a Republican running for his party's nomination for governor. Hager quickly brushed politics aside. "I don't shy away from my responsibility and taking stands and I'm willing to do what's right," Hager said in anticipation of the governor's amendment. "It's pretty important to uphold the integrity of the body and the process. You can't just cave in to a political situation."[116]

Facing alienation from the governor and anger from certain members of the Republican Party, Hager was bound by the rules and prepared for the consequences. "This is not about car-tax relief. Nor is it about the House versus the Senate. Nor is this about politics," he made clear at the press conference where he announced his ruling.[117] The constitution was clear, and Hager was bound by the law, delivering another blow to Gilmore's attempt to circumvent the budget process. "Certainly, the politically expedient thing for me to have done would be to rule this constitutional, get it out of the way and be done with it," Hager added. "But I cannot come to the podium this afternoon…and do something that I consider to be unconstitutional. To me, it's about integrity. It's about the integrity of the process, it's about the integrity of the General Assembly."[118]

A constitutional ruling was not the only legal issue Jim Gilmore faced. A group of legislators and business leaders filed a lawsuit in April citing Gilmore's budget amendments that helped keep on track the car tax phase out to 70 percent were submitted with "inaccurate revenue projections."[119] Senator Dick Saslaw, a Democrat, joined Republican Warren Barry, a fellow senator and member of the Fairfax delegation, in filing the suit with attorney Herbert Kelly; George Johnson, former president of George Mason University; Warner Dalhouse, former CEO of Dominion Bankshares Corporation and First Union National Bank of Virginia; and Earle Williams, former CEO of BDM International.[120] Williams, who unsuccessfully challenged George Allen for the Republican nomination for governor in 1993, had feuded with Gilmore over the car tax. The Virginia Business Council, an association of the state's top business executives, issued a report predicting "that the no-car-tax plan would blow a hole in the state

budget."¹²¹ Williams was "furious over efforts by Gilmore to muscle the council into keeping the report under wraps, even though it already had been leaked to *The Times-Dispatch*."¹²²

Attorney General Mark Earley argued for the Commonweatlh on behalf of the named defendants, including Comptroller William Landsidle, Department of Motor Vehicles Commissioner Richard Holcomb and State Treasurer Mary Morris.¹²³ The suit challenged Gilmore's proposal to fund the car tax relief at 70 percent with the sale of the tobacco settlement funds and claimed he "withheld grim revenue forecasts from his outside economic advisers, who might have argued for a delay in the car-tax program were they aware of the troubling projections."¹²⁴ Earley's motion in May contended that the plaintiffs' objections were based on a difference in policy and were "not well-grounded in law."¹²⁵

By August the verdict was in. Theodore J. Markow, a Richmond circuit judge, ruled in favor of the commonwealth, throwing out the suit.¹²⁶ Speaking only to the legal authority Gilmore had in crafting a budget, Markow could not address the unseemly use of accounting gimmicks to satisfy a political promise.¹²⁷ The state was still without a new budget. Core government responsibilities were unnecessarily cut. Virginians would have to do without essential services. Gilmore might have won this round, but at what cost?

Deadlocked

"It took the Republicans 100 years to gain control but only 18 months to show why it took them so long," lamented Delegate Tom Moss as the General Assembly was still toiling over a budget in the late spring of 2001.¹²⁸ House and Senate budget negotiators continued to meet and floated different proposals, but they fell on deaf ears.

A key ingredient to compromise was missing. "Are you in charge when the governor is out wandering around the world?" Senator Madison Marye asked Lieutenant Governor John Hager of Gilmore's absence.¹²⁹ In the heat of the budget debate, he left for Europe on a two-week trade mission. "I think you should take charge here," Marye said lightheartedly with an undertone of seriousness.¹³⁰ Jim Gilmore's duties as chair of the Republican National Committee kept him away from the state, but that did not keep him from taking the time to criticize his fellow Republicans in the Senate on national television for holding their ground. "The broad base of our

party believes when you make a promise, you keep a promise," Gilmore said during a CNN interview defending his stance on Virginia's car tax battle while also handling his RNC duties. "My leadership is recognized as one who keeps his word, his promises, and does good things for working men and women through tax cuts."[131]

The offhand comments had worn the patience of negotiators who had labored for months on how to keep Virginia's books in the black. "I can understand the governor's delusional analysis of this problem because while the General Assembly was laboring to resolve that impasse," responded Senator Norment, "he's been off in the Caribbean, or in Europe, or in Florida, or in Washington, and was providing no leadership to bring this to an end."[132] Norment added that it was "really disingenuous for the governor to blame some sort of unholy alliance with the Democrats" and pointed out, "The way I do the math, there were 18 Republicans in a majority of 22 who voted consistently" with the Republican-led Senate.[133]

"There's more than enough funds for the commonwealth to meet all of its obligations and compensate for any differences in revenues," Gilmore said of the June 30, 2001 revenue forecast, which was $52.4 million off the administration's target and put the general fund balance at 36 percent lower than it was in 2000.[134] Even with the continued bad news, the governor kept on singing his familiar tune. Tax revenues were unpredictable at best, evidenced by Virginia experiencing "the sharpest decline in corporate income taxes in more than 40 years."[135] Add to that the fact that the state tax department's failure to mail out $66 million in income tax refunds by June 30 meant that the $52.4 million shortfall in reality well exceeded the $100 million mark.[136]

With the state's fiscal picture even cloudier than before, Gilmore was adamant that he could keep his promise to fully cut the car tax in 2002, even if it meant once again ignoring the revenue "circuit breaker" that had been tripped as a result of the fiscal year's poor showing.[137] Addressing the money committees a couple weeks later, Gilmore announced that the state was "in sound fiscal shape."[138] The Senate Finance Committee, whose revenue predictions had been inconsistent with the administration's figures yet accurate up to this point, painted a different picture with a $775 million budget shortfall looming.[139]

As November quickly approached, failure was fresh on the minds of the voters, who over the last four years had put Republicans in total control of state government. The general consensus was that Governor Jim Gilmore had failed, the House of Delegates had failed and the Senate had failed.

As a result, the Republican Party had failed. On principle and by putting Virginia first, the Senate courageously stood up to the governor in opposition to mortgaging the future to pay for car tax relief. In the end, no budget compromise was reached, creating the opportunity for Jim Gilmore to slash core services to pay for a pledge continued in bad faith. Amid the failures and in spite of good government, politics ruled the day. "I think that when you run for office and tell people that you are going to try to do something and it's a significant reason they elect you," said Gilmore, "then you really ought to try to keep your word."[140] He stood his ground, and it came at a price. "He never understood the difference between campaigning and governing," said Delegate Ken Plum, who also doubled as state Democratic Party chairman during the Gilmore administration.[141] Criticism of the governor was so rampant that it even came from unlikely sources: his friends. "The first three years were fabulous. Then came year four," said former House majority leader and Amherst native Morgan Griffith, who left the General Assembly to run successfully for Congress in 2010. "He was a rising star, and in the span of three months, he left a negative impression he is unable to stave off."[142] Dissatisfied with their chief executive's gimmicks, the voters put the status quo on the chopping block. Jim Gilmore's head—not to mention his legacy and his heir apparent's chances on election day—would roll.

11
A VIRGINIA STRATEGY

Being governor of Virginia has many perks. When you walk into a room, everyone stands. When you attend an event, you never have to wait in line. When you travel around the state, it is usually with an entourage in a state police–issued black Suburban. And when you are introduced to a crowd, you are called "His Excellency." Overly generous praise and deference follow the governor wherever he goes. Hunting in a duck blind is no exception. As Mark Warner joined friends for an early morning hunt before Christmas at the tail end of his first year in office, ESPN's *Under Wild Skies* hunting and adventure show tagged along. In the usually banter-filled atmosphere where no one is safe from teasing, everyone is guilty of embellishing and being deferential when claiming birds is unheard of, the governor's presence changed the rules ever so slightly. "I realized what a great thing it is to go hunting as a governor," said Warner. "You're all in the blind and stand up and shoot. After the firing stops, everybody says, 'Good shot, governor' at whatever falls."[1]

It was not the first time Warner had hunted, and it would not be his last. Yet he has never claimed to be a hunter. As a kid he had a BB gun and went bird hunting with friends while living in Atlanta after law school. He loves the outdoors and typically reserves his Saturday mornings for long bike rides and pickup basketball games.[2] But with some hunting experience under his belt, it was with legitimate confidence that Warner participated in a shooting-related event while on the campaign trail. Traveling with Sherry Crumley, who led Warner's sportsmen coalition, he stopped at a crossroads

near Emporia, a small city in the heart of Southside Virginia. Any other day of the week, they would have just seen a country store, a gas station and an empty parking lot. On that particular Saturday, there was a large crowd gathered for a turkey shoot.

Modern-day shoots use bull's-eye targets instead of real turkeys, but this game of skill is just as difficult as it was decades ago, when "turkeys hid behind a big log in a pen," and you "had to call the turkey to get him to stick his head up."[3] Nowadays, the winner is the shooter who gets his shotgun pellet closest to the center.

As Warner got out of the truck, one of the event's organizers asked if he wanted to shoot. The candidate for governor said he did not bring a gun, and the man quickly offered his own. Without hesitation, Warner said, "Yeah, why not? I'll shoot."[4] At an event with the media present, any candidate would succumb to performance anxiety. A poor showing would have been embarrassing, so the pressure was on. Warner, not fazed by the sight and sounds of a few hundred spectators, calmly and assuredly walked up to take his place in the competition. With good form and a steady squeeze of the trigger, Warner peppered the target and finished in second place.[5] As they left the event, Crumley leaned over to him and whispered, "God does answer prayers."[6]

It was another successful trip for a man who staked his campaign on connecting with rural Virginia. Winning 51 percent of an area of the state often ignored by Democrats and historically underserved by the powers that be in Richmond, Warner changed the face of campaigning in Virginia not only for Democrats but also for any future candidate running statewide.[7] If the Northern Virginia businessman wanted to be accepted and trusted by the conservative, rural voters in Southwest and Southside, Warner would have to break with tradition and run his own kind of campaign. It began with a strategy that had helped him succeed all along: he had to be himself.

The Disruptor

When Mark Warner was running for the U.S. Senate in 1996, he sat in on a lecture given by Steve Jarding on behalf of the Democratic Senatorial Campaign Committee (DSCC) on why Democrats had to be more effective with and inclusive in how they related to voters. The main point was the Democrats were leaving too many voters on the table. They were simply

writing voters off. "The Democrats in Virginia and arguably throughout the South and around the country were beginning campaigns through the art of subtraction rather than the art of addition," said Jarding.[8] For Virginia, that meant candidates were willing to write off or not even try to compete in Southwest and Southside from the beginning of the campaign.

After the DSCC presentation, Warner, who wholeheartedly believed in Jarding's message, pulled the strategist aside and asked if he was interested in being a part of his campaign for the Senate. Already committed through the election cycle, Jarding declined the offer and later transitioned to advising Senator Bob Kerrey as the Nebraska Democrat contemplated a 2000 presidential run.[9] A few years later, Kerrey was on his way out of politics, announcing he was taking a pass on the race. The day after the article appeared in the *Washington Post*, Jarding got a call. It was from Mark Warner. As one man's political career was dimming, another's was rising. Warner mentioned Jarding's DSCC presentation and asked if he would meet. He was interested in running for governor but had not yet made up his mind and wanted to pick Jarding's brain on running an unconventional campaign that did not just go after the core Democratic constituency. He was not going to play it safe.[10]

A native of South Dakota, Jarding had a reputation of being a straight shooter with a penchant for authenticity and a passion for politics. He and Warner agreed from the start that if he were to run, Warner could do well in all parts of the state. How that was going to happen, well that's where Jarding came in. "The first time we met, I said that if you are going to run a media-based campaign, I'm not your guy," recalled Jarding, who later signed on as Warner's campaign manager.[11] A good media firm is a given in a statewide race, but Jarding articulated the real key to Warner's victory. "I'm very much into grass roots and voter contact," he told Warner point-blank, adding, "You never discount a voter. You begin with the premise that you can get all voters. You just have to learn how to message to them."[12] With that foundation, they were starting on the same page.

Warner's business, political and philanthropic pursuits helped give him an understanding of the state's economic, educational, racial and cultural diversity. He knew that if he ran for governor, he wanted to find a way to speak to every Virginian. Warner's ability to connect with people on their level and his passion for Virginia was an asset. "Every voter, every region, every demographic has a different message that may resonate," said Jarding, "but only a good politician has the ability to articulate that message well."[13] Going against the traditional grain, Warner agreed that was the type of campaign he wanted to run. From that conversation, the two

started brainstorming how Warner, as a Democrat, could breakthrough to traditionally unobtainable voters.

Republican statewide candidates for years had been taking for granted the votes of Independents, social issue–adverse Republicans and rural Virginians living primarily in Southwest and Southside. For a Democrat to break the Republican seal, he would have to understand the issues that drove their votes and, most of all, respect the culture in which they exist. "I believe that culture is an important part of a campaign and an important part of a message because culture is where we live, not literally but mentally," said Jarding.[14] Culture is what makes people comfortable, from sports and hunting to music. "So we started talking about how we break into the culture," he said, "as a way to try to show voters, particularly in rural Virginia, where Democrats were getting beat pretty handily, that in Mark Warner was, in fact, a Democrat who not only respected their culture but embraced it."[15]

Behind the Politics

After election day, Warner was credited for winning a race built on a brilliant campaign strategy geared toward rural voters. By 2001, nearly one-third of Virginia's population was rural, a notably larger percentage than America's at just 25 percent.[16] Warner ended up with just shy of 100,000 votes over Mark Earley from the same folks "who just 12 months before had rejected Democrat Chuck Robb against Republican George Allen for the Senate by roughly the same margin."[17] You could make the case that, had he written off or even downplayed Southwest and Southside Virginia as Democrats had normally done, Warner would not have been elected.[18] His successful outreach to hunters, NASCAR enthusiasts and bluegrass music fans created the potential for a model southern Democrats could bring into play. In reality, there was no model. "What started as isolated incidents turned into a kind of rural strategy," said Warner.[19]

It began with the simple premise that Warner's positions on the issues would be acceptable to rural Virginia if he just went there and told them directly. "We made forty-five separate trips to Southwest and Southside Virginia," said Jarding. "Most Democrats are lucky enough to go there 3 or 4 times over an entire campaign."[20] Warner's plan was simple. He was going to run a nontraditional campaign. He was going to ignore pressures from national Democratic interests. He was going to focus all of his efforts

From Business Success to the Business of Governing

Even after the election, Warner was often on the road in Southwest Virginia promoting tourism and the region's cultural heritage. *Michaele White.*

on understanding the voters, meeting them on their terms and talking with them, and by doing so, he was going to convert a lot of them.[21] "It was a consequence of going down and saying, 'I embrace your culture, I respect it, but I also know your problems…and as governor, I will fight to give you jobs, I will fight to give you some of the state pie that you often lose to the more urban areas,'" says Jarding.[22]

If Warner wanted his message to resonate with rural voters, he had to break down a political barrier that had kept Democrats out of the game. He needed to open a door that for years had been shut. That is where the cultural aspects of the strategy came into play. From day one, Warner's underlying message was about creating jobs and growing the economy, but sometimes he needed to break the ice with issues often taboo for Democrats, such as hunting rights and the Second Amendment. Throughout the campaign, he did not pretend to be someone else. He was honest with voters and himself. And more importantly, he was on the same side of the issues. "When I talked about the fact that a kid in Martinsville should get the same chance as a kid in Fairfax," said Warner, "it wasn't like I was some politician giving lip service."[23]

"The key is that Mark understood—and it's a lesson so many Democrats ought to be taking from him—that you don't have to be from the culture to be accepted by the culture," said Roanoke native Dave "Mudcat" Saunders, whom Warner asked for help with establishing inroads in Southwest and Southside Virginia. "He was genuine with us, it's that simple."[24] Warner's approach shows that a rural strategy is not a one-size-fits-all solution. "All too often in campaigns, candidates seem like they are from a different world, plopping into a rural community," said Warner. "For me, I'm a high-tech, Northern Virginia yuppie. But I had been coming there for years."[25] From Democratic Party chairman to U.S. Senate candidate to businessman, Warner knew the people and understood the problems they faced. "He had been traveling in and around Southwest and Southside Virginia for as long as I had known him," said Larry Framme. "It was not anyone else's strategy. It was Mark Warner's strategy. It was years long, and it was extremely effective."[26]

Nostalgic Inspiration

With the campaign in full swing by Independence Day, Warner was on the road six days a week, often making the several-hour drive to Southwest Virginia, along the way stopping at every small-town main street, mom-and-

From Business Success to the Business of Governing

pop store and burger-and-shake diner that reminded him of where he grew up. While consultants pleaded with him to focus on going where the most votes were or where he could bank the largest campaign donations, Warner stuck to what he knew mattered most. He wanted to make his candidacy about creating opportunities in areas of the state on the verge of being left behind. From his spring kickoff in Abingdon, a town closer to three other states than his Alexandria residence, Warner was committed to giving hope to an area that had become a second home to him. Matt Bai, a veteran journalist who tagged along with Warner during a summertime campaign swing, recounted in *Newsweek* magazine the reception the Virginia Democrat received at one of the world's oldest and largest traditions:

> *The entrance to the Fiddler's Convention in Galax was at the top of this steep embankment, and when Mark Warner hopped out of his SUV and started to make his way down the slope, dressed in a polo shirt and pressed jeans like he'd just left the country club, I think I actually cringed for him. Thousands of families from Southwest and Southside Virginia and neighboring Appalachian states were camped out in the mud, sending their kids for fried dough and cotton candy while they listened to bluegrass all around them. This was not a place for politics, and Warner's opponent, the state's attorney general (Mark Earley), seemed to get that; he shook some hands here and there—uneasily, it seemed to me—and gave interviews to local reporters. But here came Warner, the Harvard-educated millionaire Democrat, striding confidently into the throng, shouting to be heard over the banjos.*
>
> *To my surprise, the families did more than tolerate him—they actually seemed to like him. Hands shot out from all directions, and Warner shook as many as he could, asking where they had come from and how long they were staying. He smiled broadly when he saw the Bluegrass Brothers huddled together, playing for scores of fans. It took me a minute to recognize why: they were playing the one they put out about Warner and how he would keep your children home, the one that stuck to your brain like pine tar, until one day you found yourself singing bluegrass out loud at a table full of co-workers. Warner clapped along for a few beats, but he didn't pretend to be a fiddle buff. The point was that he knew the music mattered to them, and to those voters, that seemed to say a lot about the man.*
>
> *I remember that before we left I stopped and talked for a while with a guy who worked for coal companies in the seams near West Virginia. His face was hard and gray from a life spent in the mines. He was active in*

local politics, and he told me he thought Warner actually was going to win. By the time I left Galax, I thought so, too.²⁷

As unconventional as the campaign strategy was, there was still a feeling of old-time politics reminiscent of Warner's childhood. "Growing up in Indiana, the first campaign I was conscious of was in 1962," He remembers. "My family was Republican. There was a song for Birch Bayh who was running for U.S. Senate as a Democrat, and to this day, I remember it."²⁸ More than fifty years have passed, but the song, set to the tune of "Hey, Look Me Over" from the Broadway musical *Wildcat*, is still fresh on Warner's mind:

> *Hey, look him over*
> *He's my kind of guy*
> *His first name is Birch*
> *His last name is Bayh*
> *Candidate for senator*
> *Of our Hoosier state*
> *For Indiana he will do more than anyone has done before*
> *So, hey look him over*
> *He's your kind of guy*
> *Send him to Washington*
> *On Bayh you can rely*
> *In November remember him at the polls his name you can't pass by*
> *Indi-AAAAAAA-na's own...*
> **BIRCH BAYH!**²⁹

Warner's appreciation for tradition rubbed off on his team. In the shower one morning, Mudcat came up with lyrics to a song, simply named "Warner," that would spread like wildfire in a matter of weeks. "I had to hear the song three times before I realized they were singing about me," said Warner. "But it was a good enough song that a band with a following in the Roanoke Valley began to play it in bars, and it started getting requested. Then it got played on the radio as a real song, so we decided to use it in our TV commercial."³⁰

The song was symbolic of his approach to rural Virginia. Although not born and raised there, Warner knew the people, spearheaded regional venture funds aimed at jumpstarting the local economy, and served on the boards of the Blue Ridge Music Center and Grundy's Appalachian Law School. "He's not part of our culture," Mudcat explains, "but he's

From Business Success to the Business of Governing

sympathetic to our culture, and that's very powerful. He's got a great way of communicating to people out here that he cares about them."[31]

Mudcat set the lyrics to a tune called "Dooley," which the Dillards made popular on *The Andy Griffith Show*. "In order to establish any legitimacy where we were heading," said Mudcat, "we had to have a real hillbilly band. There could be no imitations, and very important, they had to be perky and rollicking musicians."[32] For Mudcat, there was only one choice. "With roots and mannerisms sprouted from deep in the coalfields of Russell County, the Bluegrass Brothers were made for this gig," he says. "Victor, Robert and Steve Dowdy are as hillbilly as they are incredibly talented. Victor, next to Dr. Ralph Stanley, has the weariest voice in the mountains and can innately sing songs that capture the sad problems of the region. Robert, who at the time was a regional legend, is now recognized as one of the best banjo pickers in America, and Steve, Victor's son, is a bluegrass version of Eric Clapton on the guitar."[33]

First made popular on radio and TV, "Warner" was played everywhere, including "in between innings at minor-league baseball games across the state, in between races at most of the short tracks in Virginia, at early-fall football tailgating parties at Virginia Tech and the University of Virginia, at every bluegrass festival, at every fair, and, of course, at every main Warner event," said Mudcat.[34] Its lyrics were simple, but the message was powerful:

Mark Warner is a good ol' boy from up in NoVA-ville,
He understands our people, the folks up in the hills;
He first came to the mountains many years ago,
His interest in our future then began to grow.

Chorus

War-ner, for public education,
War-ner, what a reputation,
War-ner, vote in this election,
To keep our children home.

Mark Warner is ready to lead our Commonwealth,
He'll work for mountain people and economic health;
Get ready to shout it from the coal mines to the stills,
Here comes Mark Warner, the hero of the hills.

Mark Warner the Dealmaker

Chorus

Mark Warner, he needs us as much as we need him,
No more tricks in politics that leave our future dim;
So you folks in the mountains at the end of your rope,
Get on out and shout it out, Mark is our hope.[35]

It didn't take long for Warner to realize the song was, for better or worse, resonating with people. Stopping by a country store one morning, he was approached by a few shoppers.

> One guy said to me, "Mr. Warner, Mr. Warner, would you do me a favor?" I said, yeah. He said, "Would you please not play that TV ad at 7:00 in the morning?" And I thought he was all offended at my ad, and I said, "Well, what's wrong with that ad?" He said, "I get that darned song in my head in the morning, and I can't get it out all day long." Later that day, I was in one of the airports in the executive terminal, and I walked in, and the lady behind the desk started singing, "Warner for public education," and I knew we had finally arrived, they were singing it at both ends.[36]

Credibility by Association

In one of his early talks with Warner, Jarding recalled bringing up NASCAR's prominence in Virginia. "It seemed like every other car driving up and down Interstate 95 had a sticker in the window with a number on it," recalled Jarding. "It was the number of their favorite NASCAR driver."[37] Not necessarily thinking anything would come of the idea, Jarding wanted to at least check into it as a way Warner could connect to racing fans in a way unlike others had tried before. The racing business in Virginia in 2001 attracted an average of 100,000 fans per event and generated about $168.5 million during a race weekend.[38] It was not until Mudcat got involved down the road that the thought became a reality, even a spectacle, often blown out of proportion by the media.

"I had not been a huge NASCAR fan before, but NASCAR is kind of intoxicating," said Warner, who grew up in Indianapolis fascinated by the Indy car phenomenon. "I give Mudcat total credit for the idea," he says

of the campaign's NASCAR sponsorship in the Crasftsman Truck Series.[39] "We sponsored one truck in one race, and the perception was suddenly that we were involved with NASCAR racing all over the South."[40] Warner's involvement in the sport did extend, however, beyond that race. "We had billboards at racetracks all across Virginia," said Warner. "[It was something] that had not been done before and actually *Sports Illustrated* indicated it was a sign of the coming Armageddon if politicians were starting to advertise at NASCAR races."[41]

Mudcat's talents were not limited to writing song lyrics, and his connections were crucial to validating Mark Warner's candidacy in rural Virginia. He even helped get Sperryville resident Ben Jones, famously known for playing Cooter in the original *The Dukes of Hazzard* TV show from the 1980s, to headline an event.[42] If Warner were to be successful in connecting with the NASCAR community, he would need to hitch a ride with a respected player in the business. In Eddie Wood, he found just that. "I didn't know a lot about politics," said the Wood Brothers Racing team co-owner. "But I've known Mudcat for a number of years and I've sent him out on a number of missions to raise money for us. I didn't have to know a lot about Mark Warner. I know enough about Mudcat."[43]

Warner's gamble of mixing campaigning and racing came in the spring of 2001. It was a mad rush to get ready for the Advance Auto Parts 250 being held in April as part of the Craftsman Truck Series at the Martinsville Speedway. Mudcat needed a driver, a truck and a motor. He only had a few weeks to get ready. Thanks to Eddie's nineteen-year-old son—Jon, a third-generation racer—just getting into the business, Warner could benefit from his association with the Wood Brothers, the Sprint Cup's longest continually active team. Ten days before the race, he sealed the deal for Jon to drive Billy Ballew's No. 15 Ford F-150 truck. "Billy quickly got us a motor from famed Georgia engine builder Ernie Elliott, brother of former NASCAR great Bill Elliot," said Mudcat. "We decked the truck out in the old-time Wood Brothers paint scheme of white body and red roof. The red and blue 'Warner 2001' decals looked fabulous and were easily read on the white body. On the quarter panels, we placed our 'Sportsmen for Warner' logo, complete with gun and rod."[44]

The risk paid off. "The Warner-sponsored truck didn't finish all that well in Martinsville, but that didn't matter to the voters of rural Virginia," said Mudcat. "Of much more importance was the fact that Virginia race fans instantly embraced the partnership of Warner and the Wood Brothers."[45] If the "Warner" song had not by then created a favorable impression of

Mark Warner the Dealmaker

Warner with his No. 15 Ford F-150 truck at the Martinsville Speedway in 2001. *Kelly Thomasson Mercer.*

From Business Success to the Business of Governing

Warner in the minds of race fans, then Jon Wood's radio commercial sealed the deal. "Jon's testimony connected NASCAR fans with Mark's message of hope for rural Virginia," said Mudcat:[46]

> [Music: "Warner" down-home instrumental]
> *Jon Wood: Hi. I'm Jon Wood of Stuart, Virginia's Wood Brothers and driver of Roush Racing's No. 50 truck in NASCAR's Craftsman Truck Series. Like lots of young folks, I don't know squat about politics, and I could care less if somebody is a Democrat or a Republican. The important thing is what they stand for, and whether they're genuine. And that's why I'm voting for Mark Warner for governor. I know Mark personally, and let me tell you, he's been there for folks all over Virginia. When Tultex closed down last year in Martinsville, Mark Warner was there. When Lane Furniture announced the closing of its factory in Rocky Mount, Mark Warner was there, trying to help. And Mark's sponsorship and support helped me move into the Craftsman Truck Series, where I'm hoping to make Virginia proud. This is NASCAR driver Jon Wood. Vote for my friend Mark Warner for governor this November 6th. He'll be there for all of us.*
> [Music fades up, lyric, "Warner, for public education…Warner, what a reputation…Warner, vote in this election…to keep our children home."][47]

Nothing to Lose

In 1993, the National Rifle Association (NRA) endorsed George Allen for governor, and four years later, it supported his attorney general, Jim Gilmore, for state's top post, with both of their Democratic opponents backing additional gun control measures.[48] Regardless of the NRA's support for Mark Earley in 1997 for attorney general, all bets were off in 2001, when the association broke the pattern of perennially endorsing the Republican gubernatorial candidate. For Mark Warner, it was a huge coup.

Claiming to have more than 115,000 members statewide in 2001, the NRA estimated that about 100,000 Virginians would cast their ballot on election day based on Second Amendment issues alone.[49] Republicans covet the NRA endorsement as well as the phone calls, e-mails and get-out-the-vote postcards that accompany it. For Mark Earley, who was down in the

polls late in the campaign, he needed the last-minute boost to turn out his base. The formal endorsement did not come, however. Instead, the NRA mailed a lukewarm letter twelve days out to members indicating Earley's record of service was "on balance, pro-gun."[50]

It turned out that the attorney general's A-minus record on guns was not as pure as the NRA leadership and its supporters would have wanted. Four years earlier, when he was running for the state's top prosecutor job, it was the more extreme Gun Owners of America and Northern Virginia Citizens Defense League organizations that attacked Earley for supporting Governor Wilder's signature one-gun-a-month bill, as well as legislation requiring all concealed handgun permit applicants to submit their fingerprints for an FBI database check. Furthermore, Earley's support for sportsmen's issues was called into question after it became public that his law firm represented the Norfolk-based animal-rights group People for the Ethical Treatment of Animals.[51] Earley was also late to join the bandwagon in support of a 2000 constitutional amendment guaranteeing Virginians the right to hunt and fish.[52]

Facing some criticism from members of his party, Mark Warner reached out to sportsmen and gun owners. "Yes, I believe in responsible gun laws," Warner said in his post-campaign remarks to the Democratic Leadership Council. "The question of guns, frankly, goes beyond just the issue, and goes to the heart, particularly in many rural constituencies, about the fact that Democrats just don't understand sometimes the cultural differences in rural America." Where past Democratic statewide candidates had conceded guns and sportsmen's issues to the Republican, Warner approached the issues head-on. "So, I visited gun stores. I had blaze orange Sportsmen for Warner campaign signs all over Western Virginia. And while I didn't retreat on any of the issues on guns, we built a base so that when the Republican opponent launched their kind of normal cultural attacks late in the campaign, we managed to withstand that."[53]

At the NRA's request early on in the campaign, Jarding and Mudcat met with representatives to discuss Warner's positions on gun-related issues. "We came in there and basically said that we did not expect the NRA's endorsement necessarily but did not want them to work against us," said Jarding.[54] He explained that Warner's positions on guns and sportsmen's issues would be more than acceptable to the NRA's membership. "Guns are a part of Virginia's culture," said Jarding. "We were clear that Warner's position on guns was, 'We have enough laws on the books. Let's enforce them. End of conversation.'"[55] While they were not courting the NRA's endorsement, sitting down and having a conversation about the issues was

unheard of for a Democrat for statewide office. "We were basically saying that the NRA had tended to endorse Republicans," said Jarding, "but that Warner's record on guns frankly was better than Earley's, who had supported some issues that the NRA had opposed."[56]

Warner's approach stunned many hardcore Democrats but helped persuade large numbers of Independents and moderate Republicans who would have likely cast their vote for Earley. "Warner and his 'Sportsmen' subgroup undertook to secure a detente with the NRA," said Larry Sabato. "Almost a third of NRA-sympathizers in the Virginia electorate voted for Warner."[57] His approach began a discussion in the Democratic Party about how to accept diversity on issues that resonate with so many voters. "What Mark has understood is we have to, both in the perception of our party and in the reality, be more accommodating not just to the center, but to some who are right of center," said former party chairman Larry Framme. "You're not disqualified from being a Democrat just because you have a strong belief in the Second Amendment."[58]

Hook and Bullet Girl

As important as Mark Warner's charisma, Steve Jarding's planning and Mudcat's connections were to the rural strategy, it was the guidance and credibility of a key leader in the sportsmen community who helped bring everything together. "Whatever you knew about Democrats and guns, we were going to break that stereotype," said Jarding. With Sherry Crumley on board, they did. "She became a huge symbol for the campaign…she is pro gun, a hunter and a conservationist."[59]

Crumley, whose father chaired Tennessee's Game and Fish Commission, now the Tennessee Wildlife Resources Agency, grew up in Bristol but did not hunt until after she was married and living near Roanoke. "I heard that turkey gobble, and I have never been the same," she recalls of a spring morning in 1986. "People can say that, but it is absolutely what changed my life."[60] She had just moved from Knoxville, Tennessee, with her husband, Jim. "When you go out into the woods in the dark and you hear the sounds that let you know the world is waking up," she said, "you just learn that there is so much more in the world than you're aware of."[61]

It was not until after she started hunting that Crumley got to see what was underneath it all. "The challenges with game laws, the anti-hunting

movement, gun rights, and environmental concerns...it made me become the 'soapbox queen,' as my husband calls me," she says, "and he did not mean on TV."[62] Although interested in government, Crumley had not been actively involved in politics before the Warner race; however, growing up in East Tennessee, she was exposed to a fabled practice of the past. "I remember the seedy side of politics where you would trade moonshine for votes," she says with a laugh.[63]

While Crumley considers herself a Republican, she tends to be a single-issue voter. "With me it is all about conservation, gun rights, and hunter's rights because you cannot have one without the other."[64] Her passion turned into activism. As a past chair of the Wildlife Foundation of Virginia, an organization that seeks out ways to increase access to public lands for hunting and fishing, Crumley has been a leader in the "Outdoor-Women movement."[65] She was the third woman to serve on the board of the National Wild Turkey Federation and has been active on the board of Hunters for the Hungry, a nonprofit organization that distributes low-fat, high-protein venison meat to food banks around the state.[66] She would later go on to be unanimously elected chairman of the Department of Game and Inland Fisheries Board—the first female to hold the post in the organization's history and quite possibly the first time that both a father and daughter had served as heads of their state's conservation agency boards.[67]

In the Crumley family, prominence in the sportsmen community is not just limited to Sherry. A marketing-education teacher and school administrator by trade, Jim Crumley put his entrepreneurial drive behind his favorite pastime only to become "the father of modern camouflage." A passionate bow hunter, Jim would sit up in trees wearing military green camouflage, and he realized that he was the only green thing up there. "Most folks who got into archery enjoyed making their own arrows or bows and/or just constantly tinkering with them to make them better," said Jim. "I liked doing that but for some reason kept wondering how I could be less detectable in the woods, so I started making my own clothes. At first I only wanted clothes that were gray and brown because all we had were military patterns that were green and tan."[68]

Hunters had very limited options at the time, including a brown-and-tan "World War II," dark- and light-green "Woodland Green," green-and-black "Vietnam Tiger Strip" and military snow-white patterns.[69] "I finally decided that it would be easier for me to look like something that belongs in the woods instead of trying to completely disappear," recalled Jim, which gave

From Business Success to the Business of Governing

him the idea to design a pattern modeled after a tree trunk covered in bark.[70] After several design attempts and experimenting with tie-dying, Jim found the solution, using "odorless Magic Markers to add squiggly lines to his tie-dyed camouflage work suit."[71]

The new Trebark® pattern, the first of its kind patented in America since 1942, quickly went from being manufactured locally and advertised in *Bowhunter* magazine to being sold nationwide and around the world.[72] In just a few years, Jim Crumley's ingenuity and marketing skills had paved the way for a flourishing outdoor apparel industry that exists today. Ever the entrepreneur, Crumley even considered for a fleeting moment the promotional slogan "No wonder it took so long to capture him" after military dictator Manuel Noriega, dressed in Trebark® camo, surrendered in Panama to American troops in 1989.[73]

Early one February morning in 2001, Sherry Crumley got a phone call from an old friend. It was Mudcat. "Sweetie, I've got a good deal for you," he said.[74] "It's to head the sportsmen's effort for Mark Warner."[75] Hesitating, Crumley first said, "I just finished a six month non-paying job, and I don't need another one."[76] Knowing she would not be able to flat out say, "No," Sherry agreed to at least meet Warner in Richmond. Keeping to her word, she showed up but was not willing to commit to anything, even after enduring two hours of Mudcat and Warner twisting her arm. Crumley reiterated her apprehension with taking on another unpaid job. She had just recuperated from an intense six-month statewide effort to amend Virginia's constitution, an ordeal that began with one simple question.

"Shall the Constitution of Virginia be amended by adding a provision concerning the right of the people to hunt, fish and harvest game?"[77] Thanks to the efforts of Crumley and the Virginia Heritage Foundation, 61.3 percent of the voters supported the 2000 ballot issue, ensuring Virginia's hunting and fishing traditions for generations to come. Winning by a margin of nearly 500,000 votes in a state where George Bush beat Al Gore in the presidential contest by less than half that number, the amendment's passage signaled the measure transcended party politics.[78]

With the support of Governor Jim Gilmore and both U.S. Senate candidates—Republican George Allen and Democrat incumbent Chuck Robb—Crumley began with the advantage of making the issue a bipartisan one.[79] She also began with one huge disadvantage: no money. A statewide campaign to educate voters and help turn them out to the polls was expected to be costly. With less than six months before election day, Crumley, working as a volunteer out of her Botetourt County home, got right to business.

She set out on a fundraising mission, eventually bringing in $150,000 in small amounts from individuals and large donations from the NRA and the National Wild Turkey Federation. "We lit a fire in Virginia's sportsmen," said Crumley, proudly adding, "On a shoestring budget, we sent out direct mail, polled likely voters and deployed signs all over the state. We held voter registration drives at gun shows and outdoor events. We built a statewide grass-roots organization. And we very effectively had 'Vote Yes' blaze-orange bumper stickers displayed on cars around Virginia."[80]

Raising money for a constitutional ballot question was not easy during a heated presidential election year, but Crumley was persuasive. When Rob Keck, CEO of the National Wild Turkey Federation, said that the organization would contribute $5,000, she replied with a counter offer. "I told Rob that we needed $25,000 and promised that the federation's investment in Virginia would come back to it one hundred fold," said Crumley.[81] She was right. Over the last decade, the state's chapter at the national convention has moved up to a slot in the top three chapters nationwide, with members crediting their standing to the gamble made in 2000.[82]

The November victory did not come without a fight. In the middle of a legal battle to block the amendment, Crumley received several threats from individuals opposed to hunting.[83] The Humane Society and the Fund for Animals sued over a perceived vagueness in language, only to have the suit rejected in a Richmond court.[84] More colorful criticism came from the Norfolk-based People for the Ethical Treatment of Animals (PETA). Calling hunters "diehards, clinging to their guns like babies to blankets, [who] are seen not as studs, but as duds," PETA representative Carla Benett said in a letter to the *Fairfax Journal*, "The Virginia right-to-hunt amendment is a joke—an attempt to contain a moral tidal wave with a cork."[85] Benett also claimed that society had "come to recognize hunters today as men attempting to compensate for feelings of insecurity about their masculinity. [They] are personifications of Maurice Linden's statement…that men become over-attached to guns, which become the external embodiment of the vigor and masculine aggressiveness they lack in themselves."[86]

Supporters of the amendment had a strong argument. With over one million licenses to hunt and fish sold in 2000, Virginia was realizing a boost of $1.34 billion in revenue.[87] At the time, it was estimated that Virginia was home to nearly one million deer, and without hunting, "the deer population would double in only three short years," according to the Department of Game and Inland Fisheries.[88] The department also released survey results indicating strong public support for the amendment, with 75 percent in

From Business Success to the Business of Governing

favor of legal hunting and 93 percent supportive of legal fishing. There is also a nutritional component. "Hunting and fishing provide good, nutritious food," said Crumley.[89] In addition to what is consumed at home, millions of pounds of venison have been donated to Hunters for the Hungry since 1991 in its mission to help combat hunger.

When Crumley met with Mark Warner in February 2001, she told him that if he were ever in Botetourt County and needed a place to stay, she and Jim would love to have him over. It was not long after that conversation when Mudcat called her up. Warner coincidentally was going to be near their Buchanan home at the beginning of turkey hunting season. He asked to stay at her house and wanted Sherry to take him hunting.[90] If he wanted to get her support, Warner knew that he had to "speak her language" and meet Crumley on her terms. The clock struck ten as Warner, Jarding and Mudcat were driving down Route 625 in the dark just a few miles from the Crumley's cottage. While Jim was plotting out the best spot for the turkey hunt, Sherry was putting the finishing touches on the homemade sausage biscuits she made for the morning's hunt. That's when the crew from Northern Virginia pulled up. Greeted by Jim, Warner asked for a beer, headed to the kitchen and said curiously, "Do I smell sausage?"[91] Sherry offered to cook him dinner, but Warner, overcome by the smell of the southern delicacy, was insistent that he have his breakfast then. For a couple hours, the group decompressed after the long drive and headed to bed, only to get up four hours later, something Warner was not used to, especially if that meant heading out into the woods.[92]

"I'll never forget when I looked over and saw Mark," said Sherry, describing a peaceful yet clearly exhausted Warner, who had fallen asleep sitting against a tree. "He was just plain worn out. It was probably the first time he sat down in months."[93] With no turkeys to be heard, Sherry and Warner traipsed through the woods, stopping occasionally to chat. The bonding experience was more than enough for Sherry to know she liked him. As he was leaving, Warner pulled her aside and said, "Sherry, I really do need your help."[94] Crumley said she was getting ready to go on a trip but would let him know by the end of the week. As soon as she walked in the house, Jim was waiting for her and said, "Baby, you need to do whatever you can to help get him elected. He's what we need. I'll sacrifice, do whatever I need to do, so that you can help him."[95] At that moment, Sherry thought back to her work on the constitutional amendment, when she put over sixty thousand miles on her car and worked seven days a week. "I was tired, but I knew that Mark Warner

was what Virginia needed," she says. "I was sold on him from the time I met him."[96]

A jubilant Mark Warner was confident everything was falling into place when he got a call the next day from Crumley, who said she would do it but that she could not start until after turkey season ended in mid-May. The dedicated huntress was not going to sacrifice the most important season for anything.[97]

Like the constitutional amendment operation, Sherry had a paid staffer to help her coordinate the sportsmen outreach effort. However, not surprising, the Democratic campaign, in short supply of sportsmen staffers, sent B.J. Neadhardt, a non-hunter from Chicago, to coordinate efforts with the team back in Alexandria. "I was getting so much grief from my Republican friends over supporting Mark," said Crumley, "and B.J. asked me one day, 'Sherry, why are you doing this?'"[98] A Game and Inland Fisheries Board member at the time, an outspoken Earley supporter, had warned the head of Hunters for the Hungry that if Crumley was not removed from the nonprofit's board, he would take not only his but also his friends' funding away from the charity. The bullying did not stop there. The same individual sent a scathing letter to Sherry and copied the media. He criticized the Crumleys for supporting Warner. Upon hearing this, Warner called Crumley up and said, "Sherry, I'm a big boy. I can take all of the shots they want to fire at me, but you've done absolutely nothing to deserve this letter. When I'm elected governor, I would find it impossible to work with someone who shows as little character as this man."[99] Without a doubt in her mind, Sherry had an answer to her young campaign staffer's question. "I said, 'B.J., I hope that one day you are as passionate about an issue as I am about conservation, gun rights and hunter's rights. Then you won't have to ask that question. You'll know.'"[100]

For her, the main focus of the sportsmen effort was going to be reminding people about the amendment campaign. Warner came out early in support of it while Mark Earley did not endorse it until days before the 2000 election. "It made it very easy for me to ask for sportsmen to support Mark because of that fact," she says.[101] So began another intense six-month stint for Crumley, fighting in the trenches for something she believed in. From direct mail to word of mouth, the committee signed up 1,250 volunteers who helped put up ten thousand four-by-eight signs and distribute an equal number of Trebark® baseball caps emblazoned with the "Sportsmen for Warner" logo. The faithful volunteers also manned booths at every outdoor event, gun show, fair and race across the state.[102] "In Southwest Virginia, we even teamed up with Brian and Jason Reger at Buck Mountain Outfitters in Roanoke and sponsored our own outdoor show," said Mudcat. "Together,

From Business Success to the Business of Governing

we brought in hunting supply vendors, all types of sporting demonstrations, the Bluegrass Brothers, three live monster white-tail bucks from Ohio, and plenty of good food. We drew 7,000 sportsmen over the two-day event."[103]

By the time November 6 rolled around, Crumley had in place an organization unequaled by any effort attempted in modern Virginia politics. "We had sportsmen representatives in every town and in every county," she says. "On election day, we had sportsmen for Mark Warner at almost every polling place in Virginia. We had a real effort."[104]

Turning Point

After Labor Day, Mark Warner was feeling comfortable his campaign was firing on all cylinders. His fundraising numbers were strong, he had a demanding travel schedule, and he was up in the polls. Then September 11 came, forever changing the lives of Americans and altering the campaign's course. All political activity stopped. The TV and radio airways were silent. Voter outreach efforts were halted. Everybody was hunkered down, not knowing exactly what do to. There was no precedent.

Standing on the roof of Warner's campaign headquarters just a few miles from the Pentagon, "staffers watched smoke rise from the crippled building; inside, the booms of fighter jets scrambling overhead knocked items from office shelves."[105] If there were ever a time to put politics aside, it was then. Within a few weeks, the campaigns steadily crawled out of obscurity, and with their message to voters, they went in opposite directions.

While Earley's camp focused the discussion on taxes and abortion, Warner took a different route. Instead of trying to appeal to voters with anger, fear and partisanship, he appealed to their sense of hope and optimism. In a call for unity, Warner looked right into the camera and said, "We've all been touched by this tragedy. But America's spirit shines through as we stand united in support of President Bush and our military."[106] The sincere approach worked. Earley's backfired, and the Republican's stranglehold on divisive social issues was exacerbated by two of his biggest supporters.

Appearing on the Christian Broadcasting Network's (CBN) nationally televised live program *The 700 Club*, evangelist Jerry Falwell said, "God continues to lift the curtain and allow the enemies of America to give us probably what we deserve."[107] Host Pat Robertson added, "Jerry, that's

my feeling. I think we've just seen the antechamber to terror. We haven't even begun to see what they can do to the major population."[108] A faithful supporter, CBN founder Robertson contributed $35,000 to Earley's attorney general campaign and an additional $60,000 to his gubernatorial bid, putting him in the Republican's "Top 10" individual donor list.[109]

Falwell explained that the American Civil Liberties Union (ACLU) has "got to take a lot of blame for this," speaking to the terrorist attacks on American soil.[110] He finished his lecture by pointing to the federal courts and other factors that were "throwing God out of the public square."[111] Going into greater detail, Falwell said, "The abortionists have got to bear some burden for this because God will not be mocked. And when we destroy 40 million little innocent babies, we make God mad. I really believe that the pagans, and the abortionists, and the feminists, and the gays and the lesbians who are actively trying to make that an alternative lifestyle, the ACLU, People for the American Way—all of them who have tried to secularize America—I point the finger in their face and say, 'You helped this happen.'"[112]

Relying on the remnants of Robertson's Christian Coalition to help turn out voters, Earley was in a difficult position, and the onus was on him to denounce the comments by both evangelicals. A spokesman for the campaign later called the comments "inappropriate."[113] An unapologetic Falwell said that he was "making a theological statement, not a legal statement."[114] His clarification did little to defuse the volatile sentiments. "I put all the blame legally and morally on the actions of the terrorist," he said but added that America's "secular and anti-Christian environment left us open to our Lord's [decision] not to protect. When a nation deserts God and expels God from the culture…the result is not good."[115]

The two reverends were no strangers to controversy. In 1989, as Falwell was shutting down his Moral Majority political action committee, Robertson was just starting up the Christian Coalition on the heels of his poor showing as a presidential candidate during the 1988 Republican primary.[116] Both leaders were accused of crossing the line with their advocacy for Mark Earley when he ran for attorney general in 1997.

Americans United for Separation of Church and State called for the Internal Revenue Service to investigate whether Falwell and other pastors were violating their churches' tax-exempt status in using the power of the pulpit to support political candidates, including Earley.[117] Around the same time, the Christian Coalition released its voter guide to about 500,000 churchgoers across Virginia. Arguing the representation of at least one candidate's positions was inaccurate, Bob McDonnell,

then Virginia Beach delegate, and Dave Hummel, chairman of the Republican Party's Second Congressional District Committee, mailed a preemptive letter discouraging recipients from distributing the guide. Their 600-person distribution list was no match for the coalition's vast following, even though both men had connections with Robertson. While McDonnell was a graduate of Regent University's law school, which Robertson started in 1986, Hummel was the director of Virginia's chapter of the Christian Coalition.[118]

Criticism also followed Robertson and the coalition in several nonpolitical yet particularly hypocritical instances. Employees sued the coalition for "Jim Crow–style racial discrimination" policies forcing them "to enter the organization's Washington headquarters by the back door and eat in a segregated area."[119] A settlement was reached in December 2001. Several months later, Robertson succumbed to his followers' outrage after the *New York Times* uncovered he had "invested $520,000 in a thoroughbred colt he named Mr. Pat," despite the Bible's condemnation of gambling.[120] In 1998, the Virginia Office of Consumer Affairs investigated Operation Blessing, Robertson's tax-exempt, nonprofit humanitarian organization. The yearlong probe, requested by Earley, determined that Robertson "willfully induced contributions from the public through the use of misleading statements and other implications."[121] The investigation stemmed from Robertson's fundraising appeals on *The 700 Club* back in 1994, as Operation Blessing was supposed to be airlifting refugees wishing to flea the Rwandan civil war for safety in Zaire, now known as the Democratic Republic of the Congo.[122] As Robertson was making pleas for money, the planes were in fact transporting equipment, not people, for his private diamond mining company called African Development Co. Robertson later reimbursed Operation Blessing for the use of the planes, and the Attorney General's Office did not prosecute the charity but rather called for it to enact bookkeeping safeguards.[123]

Earley could not hide the fact that his evangelical supporters on the highest order had a very public record of questionable Christian statements and duplicitous actions. Opportunistic tirades from Falwell and Robertson aside, the voters in the 2001 election for the most part shifted their focus to safety and security concerns in the wake of 9/11. "Military strength and law and order became the issue of the day," said Steve Jarding. "Fiscal responsibility, education and creating jobs all fell off the table."[124] For many, a line was drawn in the sand on whom they could count to lead Virginia during this critical time. No more powerful were the voices of the men and

women of the armed services. Gathered at the War Memorial in Richmond, Virginia, veterans led by Paul Galanti endorsed Warner in a show of force. "I've had it up to here with the run-of-the-mill politician," said Galanti, a former navy pilot and Vietnam prisoner of war. "We need a whole lot more like Mark Warner—proven, successful people who get out in front and do something."[125] A Republican, Galanti had originally supported Mark Earley and was instrumental in Senator John McCain's 2000 presidential campaign operation in Virginia.[126]

Equally important to Warner's credibility was support from the public safety community. From the get-go, he involved law enforcement experts in his campaign. Nevertheless, running against the former attorney general, Warner was starting at a disadvantage. He first contacted Garth Wheeler, the longest-serving president of the Fraternal Order of Police (FOP), the state's top association of law enforcement officers. The board changed its bylaws so that Wheeler, responsible for making the FOP a legislative advocacy and grass-roots powerhouse in the organization's heyday, could serve a third and later a fourth term.[127]

Warner asked Wheeler and Don Cahill, both loyal Republicans, to meet him in a Richmond hotel to talk about some of his positions, whether his platform would be supported by both the supervisor-level law enforcement as well as the officers who walked a beat. Regardless of party differences, the gentlemen agreed because at the end of the day, Warner had a 50 percent chance winning. For the sake of giving law enforcement a voice in the next administration, they wanted to have a working relationship with whoever was going to be the next governor. Cahill, the FOP's former national legislative committee chairman, wanted Warner to mull over reasonable line of duty benefits and to protect payments made to state's retirement fund. This was not the first time Wheeler and Warner had talked. They first met back in 1996 at a candidate forum.[128]

"Senator John Warner already had a reputation and was highly respected by everyone, including the law enforcement community," said Wheeler.[129] In the end, the FOP endorsed John Warner, but it was not a slam-dunk because Mark Warner brought to the table energy, ideas and charisma. "I thought he held his own against Senator Warner, who was dynamic and charismatic in his own right," Wheeler says.[130] The younger Warner's genuine sincerity had stayed with him over the years, which stuck out in Wheeler's mind during their 2001 encounter. "What I took away from our meeting was that he thanked us for taking the time to come meet with him because he was an applicant for the position of governor, because he thought he was

interviewing. It was a humble, classy approach. I knew after that meeting that he was the right man for the job."[131]

Warner took the same approach with law enforcement professionals every chance he could, talking not only to sheriffs and police chiefs but also deputies and officers. The work paid off. If losing out on the NRA endorsement was not bad enough, Earley was dealt some more bad news. The state's "Top Cop" was denied the endorsement from Virginia's only influential law enforcement association.

Representing the rank-and-file officers in every corner of Virginia, the FOP did not make an endorsement in the race because "neither candidate achieved the support of two-thirds of the local lodges, which [was] the new requirement to earn an FOP endorsement."[132] Warner managed to once again neutralize one of Earley's anticipated strong assets. He would follow up the victory by announcing endorsements from dozens of sheriffs and police chiefs of all political stripes.[133]

Transcending Party Politics

"It's time for a change," Governor Linwood Holton told a crowd of Republican and Independent supporters gathered in Richmond weeks before election day. Raising money for a bipartisan political action committee, "Virginians for Warner," Holton rekindled his famed slogan from the 1969 race that made him the Old Dominion's first Republican governor since Reconstruction.[134] "When higher education has been neglected as it has been for the past eight years, it's time for a change," he said. "When the average teacher salary...falls into the [nation's] bottom half, it's time for a change," added Holton. "When the management of the fiscal affairs of the state falls into such a [poor] state...it's time for a change," he concluded.[135]

That same day, while members of the Senate Republican leadership hosted a fundraiser for Mark Earley, their colleague joined Holton in support of Mark Warner. Warren E. Barry from Fairfax, a lifelong Republican and thirty-two-year veteran of the Virginia Senate, stepped out for the first time to break party ranks before a crowd of like-minded business and opinion leaders.[136] "I've expressed to Mark Earley my disappointment that he had written off Northern Virginia," Barry said of the Republican nominee's opposition to a transportation referendum proposal.[137] Barry and Holton were the latest in a long list of disgruntled Republicans fed up with the lack

of forward motion in government and an emphasis on divisive social issue-ridden agenda.

Almost four months earlier and following Mark Earley's nomination at the Republican state convention, a committee that would ultimately raise close to a $1 million was formed.[138] Virginians for Warner, a standalone political operation led by Judy Wason, whose roots in the Republican Party are as solid as they come, took cross-party support to an unprecedented level. "This committee is based on the belief that it's time to put Virginia first—ahead of party, ahead of region, ahead of ideology," Warner proudly told the packed room at the Jefferson Hotel in Richmond in late June.[139] He thanked the predominately Republican crowd for taking a chance on his candidacy. It turned out that Warner underestimated his bipartisan appeal. The committee had busienss leaders knocking down the door to get involved thanks in large part to the person who put it all together.

Judy Wason's foray into politics came at a time when the Democrats controlled everything from the courthouse to the Governor's Mansion. "I got tired of not having a choice on election day," she says. "I believed that there needed to be a strong two-party system."[140] She served as Virginia's national committeewoman to the Republican National Committee. She was instrumental in the gubernatorial campaigns for John Dalton and Mills Godwin's return to the Governor's Mansion as a Republican. In 1978, Wason managed Dick Obenshain's U.S. Senate campaign and, after his untimely death, led John Warner's team to victory. After key roles in several of the state's presidential campaign organizations, she was appointed by President Reagan as a special assistant in the Intergovernmental Affairs Division of the White House.

By the end of the summer, a poll conducted by the *Washington Post* showed a staggering 30 percent of voters who had supported Jim Gilmore in 1997 planned to jump ship and vote for Mark Warner.[141] The environment was ripe for the picking and for good reason. "We didn't get a budget and a lot of people have gone without raises because we put political promises above the welfare of Virginia," Wason said of the General Assembly's failure to reach an agreement with Gilmore over the car tax phase out.[142] "Only in politics could something like this happen," Warner said of the stalemate. "In business, your CEO gets into a fight with your board of directors and they don't come up with a budget, you're out of business."[143] Even so, Earley held firm his support of continuing Gilmore's tax cut the next year.[144]

Tired of the administration's antics, Delegate Panny Rhodes joined many of her Republican colleagues in the fight against four more years of Gilmoresque leadership. It would come at a price. A Duke University

FROM BUSINESS SUCCESS TO THE BUSINESS OF GOVERNING

mathematics major, Rhodes went from being a high school teacher to an engineer in the Nuclear Division of the Martin Company before her 1991 election to the House of Delegates. She had decided by 1999 that she would make one final run for her Richmond-area seat. Then the governor stepped in. Gilmore, joined by Mark Earley, Congressman Tom Bliley and Republican Party officials from Henrico County and Richmond, held a press conference throwing his support behind a primary challenger to Rhodes. His choice was Ruble Hord, an insurance agent and faithful Gilmore donor.[145] Rhodes did not pass the Republican purity test as Gilmore would have hoped. In the General Assembly, she was an independent thinker, which to rigid conservatives like Gilmore, meant she was a troublemaker.

Gilmore underestimated Rhodes's tenacity, hoping she would choose not to run in a messy intra-party battle. "I told my family that I had spent eight years telling people that they should vote the way they believe, that they should vote their conscience and they should work together," said Rhodes. "The first time that was challenged, how could I turn around and walk away? I could not do it."[146]

The Richmond delegate was not without her share of Republican allies, namely Senator John Warner. "The strength of any party has got to rest with its diversity, [and] with a certain measure of independence given to the stronger, public-minded office-holder," said Warner, whose empathy for Rhodes stemmed from his own primary battle just three years earlier.[147] The connection shared by the two races was Boyd Marcus, Gilmore's chief of staff, whom John Warner called the political "prince of darkness."[148] The erstwhile successful Republican operative had previously served as Bliley's chief of staff and, more personal to Warner, had been Jim Miller's chief strategist in the 1996 primary.

Despite the coordinated smear effort against Rhodes, the governor was dealt a huge blow on June 8. While Hord spent nearly half a million dollars to win the primary, Rhodes crushed him in every precinct with 56 percent of the vote.[149] "Even the powers of a popular governor are quite limited," said Larry Sabato of Gilmore's decision to get in the middle of a nomination fight involving an incumbent. "People don't like being told how to vote."[150] The *Richmond Times-Dispatch* featured a political cartoon with an elephant lying on its belly in the middle of the road covered in tire tracks with the simple headline, "Rhodes Kill."[151] That said it all.

Raking in high-profile endorsements and a record amount of campaign cash, the Virginians for Warner committee was widely effective. "The messenger became the message," said Ed Matricardi, who saw firsthand the

impact it had on Mark Earley's campaign. "Republican support for Mark Warner was a validator. When we tried to paint him as a liberal, former Democratic Party chairman, it just did not stick."[152] That strategy failed as a result of the number of Republicans willing to stand up and say Warner was the right man for the job. They were fed up with politics as usual and saw in Warner a way to change a failed political culture in Virginia. Beginning with the Virginians for Warner summer kickoff, a snowball of Republican and Independent support ensued. "If you didn't know him and heard him speak, you'd swear he [was] a moderate Republican," said Judy Maupin, a former Republican National Committee member who sided with Warner.[153] "I'm tired of the sound bites, I'm tired of the litmus tests and all the partisanship that's been going on," said Richmond grocery and banking entrepreneur Jim Ukrop of a primary reason for supporting Warner.[154] "He was a candidate that we had been looking for…for a long, long time."[155] As in any heated political campaign, crossover support was met with hostility from many of the party faithful. "A lot of my friends are very unhappy that I am here today," added Earle Williams, a pioneer in the business community and a past Republican candidate for governor. "I have been and I remain a partisan, but I believe that education, health care, transportation and economic opportunities are issues that transcend partisanship."[156] Still frustrated over the inability of the governor and the legislature to work together, Williams said it was time for a change. "I think what we've seen has been an embarrassment to the Commonwealth of Virginia," he added of the governor's initiatives that were sure to weaken the state's fiscal condition.[157]

In light of the political upheaval in the GOP and the stark policy disagreements among the governor, the House and the Senate, trust was at an all-time low. Election day was a fork in the road for recession-bound Virginia, and it was up to the voters which path they would choose. Warner's business skills, financial know-how and visionary approach came at a time when Virginia needed a serious problem solver. "The campaign became the perfect opportunity to contrast the change that we were seeking from a highly partisan administration to a more bipartisan and effective administration," said Larry Framme.[158] Many of the state's leaders were willing to put aside their own differences for the sake of getting Virginia back on the right track, but first, confidence needed to be restored in the governor's office. Leading by example, Warner showed all along the requisite independence to work with a Republican-controlled legislature while remaining true to his roots. He was still committed to the core Democratic principles that inspired him as a young boy, but he refused to let the same old divisive social issues

control the campaign. Instead, Warner focused on economic prosperity and hope, selling his vision one vote and one town at a time. Received with open arms in areas of the state long forgotten by many of its leaders, he established credibility in fiscal matters, breaking the Democratic barrier that had existed for so long and, in the process, solidifying his appeal with voters in the middle and on the right. "He makes himself a Democrat by saying he's a Democrat. But what he is is a moderate, and he could very easily be a moderate Republican," Wason was fond of saying to potential recruits to Warner's business coalition. "Most moderate Republicans feel that the very core principal is fiscal conservatism—and he is a fiscal conservative. That is the crux of it."[159]

12
STAND ON PRINCIPLE

When Mark Warner left office in 2006 with an 80 percent approval rating, *TIME* magazine called him one of "America's Five Best Governors."[1] Virginia was ranked the best-managed state in the nation, the best state for business and the best state for educational opportunity. Warner was the poster child for how a governor got it right during rocky economic times that reverberated across the country. The fiscal-conservative Democrat did it while working with a two-to-one Republican legislature. It was a stark contrast to his predecessor—Governor Jim Gilmore—who epitomized the expression "good politics makes good policy," having shoved a budget-breaking car tax cut down the throats of legislators, forcing a budget stalemate.

Warner was the opposite. For him, good policy makes good politics. He came into office with business credentials and a plan to steer the ship right, winning the support of a battle-hardened Senate Republican leadership still wearing the scars of the last administration's political fight. It was not an easy path for Warner. He failed along the way, just as he did in business, but he was the right man for the times. He was the catalyst for change—a chief executive who could deliver straight talk and successfully forge relationships across the aisle.

Just days on the job, Warner got the news that he inherited a budget shortfall estimated at $3.8 billion.[2] It eventually ballooned to $6 billion. Virginia was in the midst of its worst fiscal crisis in forty years.[3] Working with Republicans and Democrats, Warner tackled a long-term structural

Mark Warner the Dealmaker

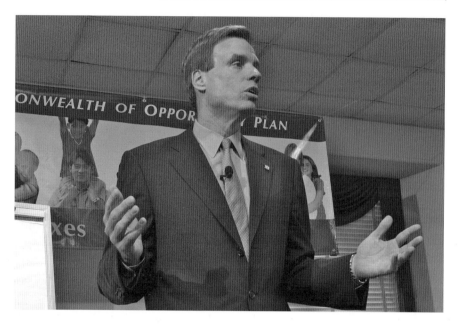

The "Power Point Governor" pitched his budget and tax reform plan to community leaders as part of a forty-six-stop tour. *Michaele White.*

imbalance in the budget only after implementing a series of government reform measures and having made deep, difficult cuts. With Virginia cut to the bone, he appealed to people, educating them on the need for budget and tax reform that would put the state on a sound fiscal footing.

Warner led a bipartisan, bicameral coalition in the General Assembly to approve a two-year, $1.4 billion package that not only paid the bills in the drawer but also invested in core services from K-12 education to pubic safety. It was true tax reform, with 65 percent of Virginians paying less, funded primarily by increasing the sales tax by a half-cent on the dollar and raising the tax on tobacco goods. The plan also created a fairer tax code by lowering the income tax for all Virginians, reducing the tax on groceries and eliminating corporate tax loopholes and exemptions. A much-needed but pricey transportation component did not make it in the end.[4] The results were a budget surplus, Virginia's coveted AAA bond rating was saved and the public's trust in government was restored. Here's how Warner did it.

From Business Success to the Business of Governing

Proven Business Practices

Warner signed Executive Order 5 after a few days on the job, creating the Commission on Efficiency and Effectiveness, and named Governor Doug Wilder as its chairman. The so-called Wilder Commission wrapped up its work by the end of the year. The result was a list of more than sixty recommendations, none of which were exactly headline-worthy ideas. Warner preferred that his team focus more on good government initiatives and less on empty rhetoric. Wilder brought his fiscal-conservative clout and political savvy to the effort, but it was the commission's vice-chair who was the workhorse. Nigel Morris, a Warner confidant, was president and COO of Capital One Financial Corporation. It was his business and strategy background that helped focus the group's mission. He didn't come alone. "I pulled together a team of experts from Capital One on a pro bono basis, most of whom were ex-strategy consultants, and reviewed with administration staff to see where the major opportunities might be," said Morris. "There are a lot of very good people in state government who want to do the right thing. If you can bring to bear some of the tools and techniques that have been trusted in the business world, they can really make a difference."[5]

Warner required performance agreements for all of his cabinet secretaries and agency heads—all political appointees—thus making them responsible for achieving measurable goals as any executive would have to in the private sector. He also wanted to implement structurally sound budgeting practices to change a culture that had led Virginia astray. As a result, the General Assembly codified his recommendation, requiring governors to submit a six-year financial plan with each biennial budget.[6]

Agency consolidation recommendations resulted in a leaner government, but Warner was adamant that the level of responsiveness not be sacrificed:

> *Wherever possible, we chose to maintain direct services to people as our first priority. For example, we decided to cut clerical staff for parole officers so that we could maintain parole officers themselves—even though that decision required parole officers to spend more time on administrative duties. We decided to cut pollution prevention activities so that we could maintain actual water quality monitoring and testing. We decided to cut health education programs so that we could continue actually providing health care and medical services to our citizens.*[7]

Warner and his cabinet. *Michaele White.*

Government decentralization practices for decades had made a colossal operation even less manageable. It was big government at its worst. The commission sought to get a handle on the state's assets it had on the books. "We launched a first-ever review of the Commonwealth's real estate holdings," said Warner, "marking the first time that the state had made a comprehensive effort to locate, organize and analyze the land and real estate assets owned and rented by the state through an enterprise-wide effort."[8] Then Warner looked at the use of technology, prompting the development of eVA, Virginia's online procurement system, which has introduced leveraged purchasing power to agencies and higher education institutions when ordering anything from pencils to printers.

Tackling information technology (IT) consolidation proved to be a much more difficult enterprise. In fact, it is still being implemented after years of growing pains. In 2002, Warner hired George Newstrom as secretary of technology to lead an ambitious effort to improve the planning, purchasing and overseeing of the state's IT practices. "When we walked in the door, no one knew how much Virginia was spending on technology," recalled Newstrom, who joined the administration as an executive with over three decades of experience in IT services domestically and around the world.[9] The reality that government grows up in stovepipes, with each

component building its own fully functional organization, was evidenced in the Newstrom's top-to-bottom review, which showed that at least ninety agencies had duplicative IT divisions.[10] It was a culture Warner tried to change—change that has not come as smoothly as was expected. "I don't think I fully realized how radical what we were doing was," he says. "It made business sense, and Newstrom was a great change agent on the business case, but I think we underestimated the bureaucratic resistance to it."[11]

IT reform wasn't the only challenge to conventional business thinking. It was obvious when Warner entered office that Virginia was living from election to election. That's just the nature of politics, and with a new governor coming in every four years, there is little time for strategic thinking that transcends elections. Dubby Wynne, former CEO of Landmark Communications, wanted to change that lack of continuity. He pushed for the creation of the Council on Virginia's Future as a way to engage business leaders with the executive branch and legislators in a more formalized manner. The concept had Warner's backing and won sweeping General Assembly approval. Three changes in the governor's office since have proved the reform successful. "Each time, the investment we made in building a consensus around the goals has paid off," said council executive director Jane Kusiak. "The new governor has embraced the initiative whole-heartedly."[12]

The Wilder Commission didn't corner the market on good ideas. Warner launched an initiative to involve the state workforce in his quest to improve government operations. Hundreds of employees from all across Virginia submitted proposals, and Warner sifted through many of them. "For example, after an employee suggested we review the use of toll-free telephone lines across the enterprise of state government, we identified and eliminated 63 unnecessary or little-used toll-free telephone lines, saving $103,589 annually," he says. "At the conclusion of the 'Ask Why' campaign, we singled out nine state employees for special recognition for suggestions that, when implemented, netted a combined $1 million in immediate annual savings and long-term savings projected at $4.2 million."[13]

CUT TO THE BONE

Virginia's financial outlook was bleak. A subdued Warner delivered the news to members of the House and Senate money committees during his scheduled address in the summer of 2002. "Virginia still faces its most daunting budget

challenge in at least the past two decades," he said, announcing the new projection putting the state $1.5 billion in the red.[14] That was on top of the $3.8 billion shortfall the General Assembly dealt with just a few months earlier. He had a plan, and it was going to be painful because there would be significant layoffs. "We cut more Virginia state government than any governor in Virginia history, eliminated 5,000 positions in state government, closed down eight agencies, and eliminated 70 boards and commissions," said Warner of the tough decisions in earlier days of his administration.[15] He didn't leave those decisions to staff either. The cuts were the result of a process he was involved in from the beginning. Secretary of Finance John Bennett structured a plan to go agency by agency, with each having first submitted three versions of cuts based on 7 percent, 11 percent and 15 percent. "Then we would sit down with Governor Warner, and he would go through each option, line by line," said Bennett. "He would make the choices. Some were more difficult than others."[16]

By October, Warner took to the airwaves to speak directly to the people in a televised address. He was candid, first explaining the problem and pointing out that it wasn't created overnight, and it wouldn't be solved overnight. This announcement included an average of 11 percent cuts across 140 agencies plus 1,837 state employee layoffs. The $858 million slashed over the biennium affected core services. There was no way around it.[17] "We had to close all of our DMV offices one day a week—and some of the smaller ones we closed completely," said Warner. "When people had to stand in line for hours to get their licenses renewed, that really hit home. They knew we were serious."[18] Critics called it a political maneuver. The DMV commissioner asked Warner at the time if he wanted to decide which offices should close, to which he replied, "No, you should made the determination, from a business standpoint, as to which ones make sense."[19] Politics was the last thing on Warner's mind because he knew this would not be the last time he would be forced to make cuts. More tough decisions were going to have to be made.

The Case for Reform

Warner invited members of his political kitchen cabinet over to the Governor's Mansion for dinner to discuss where his head was on tax reform. "I remember telling them, 'Guys, the string has run out. We're going to lose our bond rating. We're going to have to make huge cuts in higher education.

From Business Success to the Business of Governing

We can't do this anymore. We have to go for it.' Then Alan Diamonstein blurted, 'You've just committed political suicide.'"[20] Diamonstein, the ultimate party insider—the don of Democratic politics—was one of the most effective legislators during his three-decade stint in the House of Delegates. Warner valued his counsel but had already decided to eschew politics. He had nothing to lose. It was a low point for the governor. Outside the Richmond bubble, he was fine, but inside the Richmond bubble was a different story. Some members of the press corps attacked him for spending too much political capital on the failed transportation referenda in 2002. It was during that first year in office that Warner learned the hard way about trusting career politicians. The press criticized him for aggressively lobbying to make failure to wear a seatbelt a primary offense in 2003. Warner also took heat for backing the Wilder Commission's recommendation giving the people the right to elect governors to run for reelection. His support for the measure wasn't self-serving—it would not have gone into effect until he was out of office.[21] The losses didn't matter to him.

Warner told his dinner guests, "I'm not going to be the guy that gives up our AAA bond rating. And I won't have our colleges ruined on my watch. I may lose…we may lose, but if we go down, I'll be fighting the whole way for what I think is important." The spirited discussion wasn't going his way, and if there had been a vote at the table, Warner would have lost hands down. "But I said 'No—we're doing it.'"[22] The debate was over. He was all in.

It was the spring of 2003, and the budget shortfall had reached a total of $6 billion since Warner took office. He couldn't sit still. Everywhere he turned, he had ideas about how to make things work but only for the short-term. But that wasn't the legacy he wanted to leave. Instead, he wanted to put the state in a posture that, for a reasonably long time, it could meet its spending commitments. He was using the phrase "structural imbalance" to refer to Virginia's predicament that, even if the economy came back, the budget would still be out of kilter. "We started with a longer term economic outlook and a longer term expenditure outlook," said Bennett. "What we concluded was the lines don't uncross. Our obligations were greater than our ability to fund them under any reasonable economic scenario."[23] It was then—after exhausted attempts to reform state government, after making deep cuts in services and after exhausted analysis of Virginia's financial standing—that Warner looked at additional revenue. "If you're going to go out and ask people for more revenues, you have to have rock-solid credentials," said Warner. "You've got to show the taxpayer that you're going to squeeze every dollar and efficiency before you ask for more."[24]

Governing magazine named Senator John Chichester and Warner as its "Public Officials of the Year" in 2004. *Michaele White.*

From Business Success to the Business of Governing

The Senate leadership at this point had reached the same conclusion. "We tightened and cut the budget to the point that, by the spring of '03, we'd swept every corner," said then Senate Finance Committee chairman John Chichester. "We'd cut $6 billion out of the budget along the way and really, at that point, there was no place to turn. Revenue was just not improving, yet obligations continued not only to exist but to increase."[25] The Senate had ongoing discussions about the impending inability to maintain core governmental services. Virginia was upside down in its transportation funding. Mental health services were underfunded. The Standards of Quality required a financial commitment for K-12 education that the state couldn't match. Salaries for deputy sheriffs were a disgrace. The mental retardation waiver list was out of control, with some people waiting a decade for services. "I saw the biggest threat to Virginia's stature as a national leader was its inability to perform core services," said Chichester. "I was chairman of the Senate Finance Committee, and I was not going to sit idly by and do nothing about it."[26]

Chichester was driving to Richmond almost every day in the summer of 2003. He would peer over detailed reports of deposits into the state's coffers and compare the numbers over time. The news was startling. "It occurred to me in July, thinking to myself, 'I'm not sure if we're a AAA bond rated state anymore.'"[27] He was right. Just weeks earlier, he was in New York City with Warner and House Appropriations chair Vince Callahan for their annual meeting with the major credit rating agencies—Moody's Investors Service, Standard & Poor's and Fitch. Moody's wanted to know what the gentlemen had planned to put the state's long-term expenditures and revenues back into line. Virginia has held on to its AAA rating since 1938. It has a dual significance. The rate allows the commonwealth to borrow money at the lowest possible cost, resulting in millions of dollars in savings. It also means Virginia has a "Good Housekeeping Seal of Approval" as a well-managed state. For some House Republicans in search of justification to support the reform package, that's what they needed.[28]

Warner returned to New York with the money committee chairmen in the fall. This time he laid out a plan. "And we looked them in the eye," added Warner, "and said, 'We're going to try to get this done. Don't just downgrade us now. If we can't get it though the legislature, we understand the consequences. You've got to give us the chance to make the case to the people of Virginia.'"[29] Moody's gave them the breathing room to give it a shot, but Virginia wasn't off the hook. In September, Moody's signaled its

seriousness by placing Virginia on the "credit watch" list with the potential for a downgrade. The fate of the reform bill was now in the hands of the legislative process.

Gang of Five

Republicans gained control of the Virginia Senate for the first time in 1998. They had operated under a power-sharing agreement with the Democrats for the four years prior. By 2000, the GOP had a twenty-three-to-seventeen majority. At that point, John Chichester was elected president pro tempore, a position reserved for the most senior member of the party in power. William Wampler, the second-most senior member of the caucus, joined Chichester and Majority Leader Walter Stosch on the budget conference committee. In the past, the majority leader also ruled the Senate floor. Under the new leadership structure, the floor leader role belonged to Tommy Norment. Ken Stolle rounded out the Republican team as majority whip. Whether they got along or didn't, the so-called Gang of Five was thrown into a significant spotlight and quickly formed a bond as members of a body steeped in tradition and ruled by the "Virginia Way."

Mark Warner was not alone in recognizing that the state's structural imbalance didn't arrive overnight. "You could not have been in a position of authority on the money committees and not realized that one of two things was going to happen: either we were going to meet our core services, or the state was going to fall behind," said Stolle. "You could see this was coming going back to 2000. It was a slow build until 2003. Then, it ignited when we entered the 2004 General Assembly session. It was a powder keg ready to blow."[30]

The Senate's initial proposal increased revenues by $2.5 billion, with over half dedicated to funding transportation, a component of the budget compromise that ultimately didn't survive. Warner's came in right at a billion dollars.[31] Some critics argued that the two plans were a coordinated effort to force a deal. That was not the case at all. "Each of us knew the other was doing something to enhance the state's revenue," said Chichester, "because the choices were obvious; each of us knew what taxes were under consideration; but neither of us knew exactly what changes the other was going to propose, or by how much."[32] Over the next four months, Warner put his faith primarily in five Republican allies

From Business Success to the Business of Governing

to not only deliver the Senate, which they controlled, but also help secure votes in the House, which they didn't.

John Chichester was Senate Finance Committee chairman—the most powerful position in Virginia government. As such, he knew the budget cold. "He was a master at the legislative process...a diplomat extraordinaire...someone who could tell you 'No' in the most graceful way and make you like it," said Stosch.[33] The Northern Neck native benefited from four years of experience on the money committee before rising to a leadership position. He learned from the best—Senator Hunter Andrews—the Hampton Democrat who ruled the Finance Committee for a decade and Virginia's government for a much longer period of time. For Chichester, coming onto Senate Finance was like walking into the General Assembly for the first time. "I went from a guy on the back bench to co-chairman...and literally the fiscal matters pertaining to seven million people in this wonderful state rested in my lap," said Chichester. "I threw myself into learning all I could. It changed my entire outlook...my whole legislative life."[34] He never cared much for politics. He was more interested in getting it right. "John had a depth of knowledge that could not be met by anybody else and would not be met by anybody else," said Stolle.[35]

William Wampler chaired the Commerce and Labor Committee but also developed a unique knowledge of healthcare and transportation issues. The youngest member of the leadership came from the hills of Southwest Virginia. His father, William Wamper Sr., served in Congress for eighteen years. "William was reflective on issues, always willing to mix it up a bit, but he was also a good calculus among the five of us once we harmonized and came to respect the talents of one another," said Norment.[36] Wampler also served as chairman of the Committee on Committees, wielding control over plum committee assignments.

Walter Stosch had an unusual and perhaps difficult role because he was majority leader. "I always took the position that the majority's view would always prevail," he says. "The important thing is for the minority to be heard. So within our caucus, I was constantly trying to make sure that those that I knew would have an opposing view to what we were doing or wanted to do had an opportunity to be heard."[37] As a consequence, Stosch was the mediator, often the peacemaker. The role suited him well. "Walter is a sequential thinker and builder," said Stolle, "but his role, to a very large degree, was keeping peace in the valley within the caucus while trying to project the Republican values."[38] The trained accountant was the Senate's consummate bean counter, with everything laid out on a chart. "You would

see a set of complex numbers," said Chichester, "and Walter would be able to transpose them into a more common sense view, making it easier for everyone else to understand."[39]

The final two members were a team within the team. Tommy Norment and Ken Stolle were a package deal. Norment's intellect drives his personality, and as floor leader, he kept his eye on the political consequences probably more than anyone else in the leadership. "Not only was he responsible for controlling the Senate floor, but he was a natural leader who people trusted and would follow into fights," said Stolle, whose role was to pick the fights.[40] As majority whip, Stolle was responsible for advancing the leadership's agenda and to ensure it was implemented, one way or another. As such, he was the enforcer, a familiar role for the former Virginia Beach police officer turned lawyer. He was also the vote counter.

While Norment chaired the Rules Committee, Stolle's domain was Courts of Justice. He also chaired the Senate Finance Public Safety Subcommittee and headed up the Crime Commission. Stolle's close ties with George Allen—co-chairing his gubernatorial campaign in 1993—catapulted him politically as a newcomer in the General Assembly. Allen made the Virginia Beach Republican his point man on truth-in-sentencing legislation that abolished parole in 1994. Stolle's legislative portfolio ran the gamut, from reforming the twenty-one-day rule to toughening laws against cyber crimes, DUIs, gangs, sex offenders and repeat violent felons. He also pushed for increased mental health funding, immigration reform and counterterrorism preparedness measures. Stolle had a greater influence on public safety in Virginia than anybody else during his eighteen-year stint in the Senate.

Being an effective senator is often times dependent on one's ability to persuade. For Norment and Stolle, it came naturally. They were legislative warriors willing to get out front in a confrontational and adversarial way they were accustomed to doing as lawyers. Once the Senate leadership congealed on a course of action, the two would get in the trenches. "They had an ability to look at what is, ask the question what should be, and then try to bridge that gap," said Stosch.[41] The brilliant tacticians realized they had to make alliances with Republicans in the House to make it all work. They also thrived on close relationships with centrist Democrats in the Senate, particularly Dick Saslaw and Janet Howell. "Some of my caucus thought I was too close to them, just as many in the Republican caucus thought they were too close to me," said Saslaw.[42]

The Republican duo learned a valuable lesson early on in its first term from an unlikely mentor. "Tommy and I were very aggressive debaters," said

From Business Success to the Business of Governing

Stolle. "I think that impressed Hunter Andrews."[43] A giant in the political world, Andrews was not only Senate Finance Committee chairman but also the Democratic majority leader. "The fear was that, if you crossed Hunter Andrews, you may not get another thing for your district as long as you served in the Senate," jokes Stolle.[44] Andrews approached Norment and Stolle during their second session while the Senate was at ease one afternoon:

> *He came over to our seats in the far left side of the Senate chamber and took us to the dais right in front of the clerk's desk. He said, "I want you to look over here to the left and tell me what you see." I said, "I see all Democrats." He said, "Now look over to the right and what do you see?" I said, "I see all Republicans." He asked, "What is the difference between the two?" I half jokingly said, "About twenty-five years per senator." He immediately said, "That's right. In a few years you guys are going to be running this place. You need to know how to do it, so I want you to pay attention to me. I'm going to explain to you what I do and why I do it, and you guys need to understand this." Over the next couple years, Hunter would walk over to Tommy and me during the session and give us advice. He'd say, "You've got to do this…this is why I did this…you need to control the floor." He was always coaching us. The traditions and the role of the Senate was so important to Hunter, that he wanted to pass those on to somebody, and so he picked us.*[45]

In 2001, Chichester, Wampler, Stosch, Norment and Stolle were embroiled in a nasty battle with Governor Gilmore and the House over advancing the car tax. The decision to hold firm was made as the five gathered in a conference room on the tenth floor of the General Assembly building. Stolle pointed out the political implications of blocking the amended budget from going into effect:

> *I said that we could either stand on principle and block it, or we could give in to politics. It would have been a lot easier for us to say, "All right, we're going to cave in on this and then come back to nickel and dime it along the way." But we would have had to have given up on our principles. What I find most despicable about politics is when people are willing to wholesale sacrifice their principles for a political victory. For the five of us, it was just dead wrong to do that.*[46]

Warner couldn't have asked for better allies in the fight that was about to heat up.

WHEELER-DEALER RETURNS

A day after he announced his proposal, Warner went on the road to sell it. Armed with a laptop, projector and slides, the "PowerPoint Governor" was in familiar territory, convincing community leaders why they needed to get on board. Unlike his cellular broker days, there was no razzle-dazzle. It was all straight talk. His first pitch of a forty-six-stop whirlwind tour of the commonwealth was at a fire station in Roanoke. Traveling the state, listening more than talking, was where Warner hit his stride. And with a scribble of a pen, he inked the winning slogan.

It began with a series of brainstorming sessions on the third floor of the capitol. There was a suggestion that it would be helpful to show the benefit of the plan to the average Virginian. John Bennett met with Tax Department officials, who were able to demonstrate that two-thirds of tax filers would pay less. At the appropriate time in his presentation, Warner would walk over to the easel and write in big, bold print, "65% Pay Less."

The slogan froze everyone in their tracks, because the opponents were ready to label it a tax increase, plain and simple. "Our big worry was that people would say the plan was dead on arrival," said John Bennett. "But now

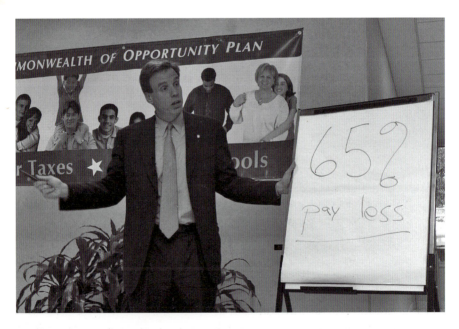

Warner's budget and tax reform plan created a fairer tax code, with 65 percent of Virginians paying less. *Michaele White.*

From Business Success to the Business of Governing

they could make the determination in their mind, 'If most people were going to benefit, maybe I can't just be knee jerk against this.'"[47] The public's trust hinged on the figure, and Bennett made sure it was not a political apparition.

Roy Pearson, an economist who advised six Virginia governors, confirmed that the methodology was sound. "I concluded that the estimate that 65 percent of Virginians would pay less is sound, and in fact an underestimate."[48] Naturally, Warner wanted a technology component. For him, it had to be personal. "We even had a[n] on-line tax calculator that allowed people to go onto the Web and figure out what the likely impact of the changes would be on them and on their family," he says.[49] Warner used every opportunity available to him to refocus the debate in terms that would resonate with the public. "We were going to have an honest discussion about what people in Virginia were willing to pay for state government and what they would get back," he says. "So we laid out a plan that said 'We're not going to start new government programs, we're just going to meet our obligations, meet our commitments in education, public safety, health care, and people stepped up."[50] Now he needed a public relations strategy to help sell it all over Virginia.

Strange Bedfellows

The same infrastructure that successfully backed the parks and higher education referenda in 2002 was back in business. The Foundation for Virginia, a convergence of powerful interest groups, spearheaded an education and advocacy campaign to help the public understand why taxes needed to be raised and what was in the bill that would come back to their communities. Warner asked Judy Wason to take charge, essentially reprising her role in herding business leaders—the Virginians for Warner crowd—in what was an unprecedented show of bipartisan support for the reform measure. "Even if I'd had a Democratic majority, we couldn't have done this on a strictly partisan basis," said Warner. "It's so easy to demagogue this issue: if it had been Democrats versus Republicans, I think most people would have viewed this as just a matter of political posturing. The campaign needed to aspire to something greater than normal partisan bickering."[51]

Doug Smith was executive director at the time of the Virginia Interfaith Center, the state's oldest faith-based advocacy group. "We saw our role in the effort as providing cover where needed but were also intentionally and

aggressively working to advocate with members of the House that we knew we had to peel off from their party and encouraging them to step up and do the right thing." Smith didn't expect that he would need to help shore up some Democrats, too. He helped counsel a couple of junior members of the House to vote their conscience. "From a social policy level, we advocated that the state should invest in the next generation through education and in the vulnerable communities that are around us, who we want to move from need to sustainability," said Smith. "Safety net programs are important. They should be safety nets, not trampolines. It's in the best interest of the commonwealth to make that transition to sustainability possible."[52] The faith community's efforts helped Democrats and Republicans understand they had the moral and social responsibility to leave the politicians behind as they crossed the aisle in favor of the bill.

Warner didn't just want to re-create the coalition from the earlier bond campaign. He wanted to blow it up. He brazenly assembled a team of unlikely allies, including those who had worked against him in the past. "We had main-street business—not just big business. We had labor. We had higher ed. We had law enforcement in record numbers. We had the environmental community that had opposed the transportation bond effort. We had people who were tired of high property taxes because the state had been shifting away from its obligations to support local government. We had all the health care advocates."[53] The list went on and on. Teachers were also critical to the operation. "That's when I learned the difference between an active coalition and a coalition on paper," said Princess Moss, a Louisa County music teacher who served as president of the Virginia Education Association (VEA).[54] The VEA invested significant resources in the cause as part of its Brighter School Campaign and was also effective in assuring Republicans that teachers would stand with them come election time. "We told legislators, 'If you vote with us on the bill, then we will not leave you behind,'" adds Robley Jones, lobbyist for the fifty-thousand-member organization of educators.[55]

The foundation was a full-fledged campaign operation. It educated the public with advocacy calls, direct mail and carefully placed radio and TV spots. Members of the inner circle's "Coalition of Coalitions" strategized regularly, coordinating grass-roots and grass-tops outreach and divvied up lobbying and fundraising targets. The Virginia Hospital & Healthcare Association, which represents over one hundred hospitals across the state, released polling and focus group data showing that the public was more receptive to the need for reform if it was presented as a package instead of a disjointed free for all.[56] Coalition members committed to working as a team.

From Business Success to the Business of Governing

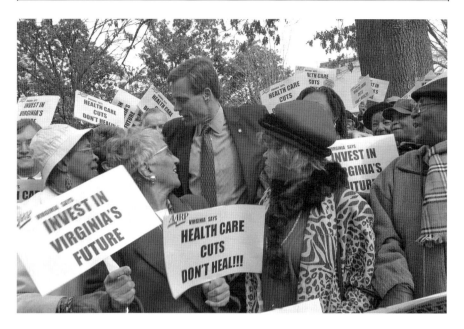

Hundreds turned out for a rally on Capitol Square in support of saving core services under Warner's budget and tax reform plan. *Michaele White.*

As legislators were feeling the heat from the foundation's activities, reform opponents tried to break the momentum. "Not only did the coalition form, but it really hung in together," said Warner. "There was a very tangible effort to peel off this or that group in the coalition, whether it was law enforcement or higher ed, by promising to take care of them. But, interestingly enough, everyone held together."[57]

Organizing on the part of the foundation's partners hurried along budget resolution. House members agreed to take the plan straight to the people with a series of town hall meetings around the state. "The House was absolutely convinced that they could go home and persuade the people that this reform bill was a terrible idea…that it was a huge tax increase, and it was going to cripple the community," said Stolle. "I encouraged the plan because I knew that they didn't know how to read the public."[58] Stolle was right. The town halls backfired. As time went on, the foundation's organizing developed into a true grass-roots movement to the point that people were turning out on their own. "They had begun to articulate the core messages in their own words," said Smith. "For them, it wasn't necessarily about the long-term budget figures, it was about families and people—their neighbors."[59] AARP advocacy director Madge Bush attended several of the community gatherings and helped pack

the room with members of the powerful senior citizen lobby. Support for what Warner and the Senate had proposed was overwhelming. "I remember a delegate asking out loud, 'Whose idea was it to have a public hearing, anyway?' It was a tipping point positively for the effort."[60]

The Four Horsemen

Public safety funding took center stage in the reform package as many deputy sheriffs qualified for food stamps and funding to local police departments was stagnant. That prompted the "Four Horsemen" of public safety—the heads of the state's law enforcement associations: Kevin Carroll, Dana Schrad, Wayne Huggins and John Jones—to team up. Kevin Carroll was new to the political scene in 2004 but has been the Fraternal Order of Police's de facto lobbyist for over a decade since. In 2014, the lawman with nearly three decades of service was elected president of the 7,500-member organization representing all levels of law enforcement and including police officers, deputy sheriffs and state troopers.

Dana Schrad is the face of the Virginia Association of Chiefs of Police. She has worn many hats over the years, from journalist to attorney with the Virginia State Crime Commission. She was impressed by Warner's general attitude of inclusiveness. "We never felt like we were the second seat at the table," she says. "He is also one of best listeners that we ever had as governor. When we laid out the need for the state to live up to its commitment to '599 funding' for police departments, he heard us loud and clear."[61]

Wayne Huggins leads the Virginia State Police Association. A former Virginia state trooper, he got his start in law enforcement with the Uniformed Division of the U.S Secret Service, served as sheriff of Fairfax County in the '80s and was later appointed state police superintendent under Governors Allen and Gilmore. Warner went to bat for Huggins supporting Line of Duty Act healthcare coverage for troopers who were disabled on the job over the course of a twenty-eight-year period and were unintentionally left out of reform legislation. Huggins met the final member of the law enforcement quartet when he ran for sheriff in 1979.

John Jones has been executive director of the Virginia Sheriffs' Association longer than any current sheriff and all but one member of the legislature. "About 90 percent of the time, John and I have been able to work together, but we do represent different constituencies," said Huggins. "We have always

From Business Success to the Business of Governing

been close enough where we could put our differences aside and remain friends."[62] That friendship has been crucial over the years, and together with Schrad and Carroll, law enforcement has a voice louder than most other special interests around the halls of the General Assembly Building.

Jones is a unique case, though. He represents the commonwealth's 123 elected sheriffs and a membership of 8,500 deputies in every corner of the state. His is an operation backed by political muscle unlike anything else in Virginia. He rarely loses a fight, and by virtue of his nearly four decades of experience, John Jones is the most influential lobbyist in Virginia. When he's not on Capitol Square, the Mecklenburg native usually unplugs on Virginia's Eastern Shore. His passion for the outdoors has endeared him to influential politicos over the years. In fact, he is as serious and competitive about hunting as he is about winning legislative battles. While on a caribou-hunting trip in northern Quebec with sheriffs, Jones walked fifty yards past Senator Ken Stolle just so he could claim the longest shot at 485 yards. Years later, on a different hunt, Stolle let an elk walk past that distance just so he could beat the record. He has never let Jones forget it.

Mark Warner approached Jones eighteen months before the 2001 gubernatorial race even began. "He initiated the get together," said Jones. "I thought to myself, 'Here's a guy who really was concerned about policy. He wanted to talk about deputy pay and health insurance.' Thinking back, that was the first time a statewide candidate came to me to really try to understand the issues facing sheriffs and deputies."[63] Warner took note of the association's heft in 2001, in the midst of the car tax battle, when it produced hundreds of deputies with little notice to meet with legislators, testify before committees and pack the House and Senate galleries.

Months before the 2004 session, Warner arranged a meeting with Jones; his association president, Harold Plaster, who was sheriff of Pittsylvania County at the time; and others on the VSA's board. "I told him that he needed to convince our leadership," said Jones. "I also reminded him that Sheriff Plaster was a Republican." At the gathering in the capitol, Warner sat at the head of the table, and Plaster was directly across from him. Jones sat to Warner's right, and Bob McCabe, Norfolk sheriff, sat to his left. Warner was direct. "You have to be with me, and I'll help you, but you have to be with me," he told Jones and the sheriffs. "I know that you can do an end run and get your stuff passed, but you have to get all of my stuff passed. If you try to do an end run, then I'll veto the bill."[64]

Jones knew that Warner wasn't kidding when he said, in essence, that he was going to reward his friends and not be so kind to his enemies. Plaster

immediately replied, "Governor, we want to be your friends."⁶⁵ Warner continued with his demands, which Jones hasn't forgotten:

> He said, "Here's what I need...I've got some already, but I need eight more Republican House members. I can get the bill passed in the Senate, but I can't get it passed in the House without eight more votes." So I drew a large eight on my pad. All of a sudden, he added, "I tell you what," as he reached over with his own pen and said, "No, I need nine,' while drawing a big, bold nine on top of my eight. I said, "Governor, we'll work on that, but I'm going close my notebook before you put a one in front of it." We had a little laugh for a moment, but it was a serious talk. We knew he expected the sheriffs to deliver those votes.⁶⁶

The pressure was as intense as ever, and Jones worked on his nine votes for Warner right up to the final hour. He added one more to the tally in the morning and then arranged to have seven hundred deputies in uniform line the halls of the capitol and be seated in the House gallery before the noon session. No legislator could bypass them. Jones walked through the door with Delegate Riley Ingram, a Hopewell Republican who wasn't committed either way at the moment. Ingram had been bombarded by interests on both sides of the argument for weeks. Supporting a significant cigarette tax increase was troubling for him, given Philip Morris had a plant near his district.⁶⁷ As Jones walked with Ingram down the hall to the House chamber, he said, "We need to get some of these deputies off food stamps." Ingram told Jones that he just couldn't vote for it. Jones was running out of time, so he had to play hardball. "I told him that there are over seven hundred deputies here today, and we'll pack the House gallery. Then I said, 'I want you do introduce the deputies in the morning hour. We'll rely on you to introduce them, and I want you to vote for the bill.' Delegate Ingram looked at me and said, 'All right, I'll vote for it.' We got Warner's ninth vote."⁶⁸

Fiscal Conservatives Lead the Charge

The business community helped shape the reform debate by providing a roadmap for how to get it done right. It also gave legislators weary of losing their pro-business chops some needed cover. The advice didn't come without

From Business Success to the Business of Governing

some bruises, however. The Virginia Foundation for Research and Economic Education, or Virginia FREE, took the first punch in 2003.

The nonpartisan organization, described as "an A-to-Z of corporate respectability," evaluates legislators' support for business issues and releases a scorecard each year.[69] For the first time, Democrats in the House scored higher than the Republicans. The reason was that Virginia FREE's evaluations committee, with its board of directors concurring, determined that the General Assembly ignored its clarion call to action. Virginia FREE demanded a plan to fix the state's structural budget imbalance and give core government services, including education, transportation and healthcare, the priority they deserve.[70] "Virginia FREE took the opening salvos, and it was brutal," said founding president K. Clayton Roberts. "We delivered a powerful message from business, and House GOP leaders decided to shoot the messenger. It was a painful time as politicians and business leaders were waking up to the demands of a twenty-first century Virginia. A lot of them woke up grumpy."[71]

The second punch came in January 2004. The legislature had been in town for only a couple weeks when the Virginia Chamber of Commerce, the state's preeminent assembly of businesses, large and small, was about to jump into the tax reform debate. Two men in particular were in the spotlight: Hugh Keogh and Bob Archer. Keogh, who had spent four decades boosting business in Virginia, was the chamber's longtime president and CEO. Archer was just elected chairman of the organization's board of directors. The Salem resident is president and CEO of Blue Ridge Beverage Company Inc., one of the state's largest full-service beverage distributors.

The chamber's fifty-member board was in the middle of meetings when Archer, who had not been chairman for even a day, trudged across Capitol Square with Keogh and Steve Haner, vice-president for policy at the time, to address the media in the basement of the capitol. There, a dozen members of the press corps clustered around the three gentlemen. Archer announced that the chamber's leadership had determined Virginia faced a fiscal dilemma it could not solve without new revenues. The news stunned many in the media and politics. "Business saw the wisdom of a general sales tax increase and was willing to take that on," said Keogh. "Here, you had a mainstream, disciplined, fiscally conservative organization endorsing a tax increase. It was a big deal, and it sent a clear message."[72]

The chamber gave Warner, Senator Chichester and Speaker Bill Howell the opportunity to separately address its members in advance of its decision. "You had to build the business case to people around the state and the

business case was pretty compelling," said Warner. "If you could read a balance sheet, you could see the problem we were in."[73] An intense and lengthy debate among board members followed the presentations with little dissent, but the consensus was not reached in haste either. The board had its own concerns about Virginia's future regardless of who was governor. "It was not something that happened overnight," said Archer. "We had been debating the issue of tax reform for three years."[74] The chamber's concern began during the budget impasse in 2001. "By the tail end of the Gilmore administration," added Keogh, "Eight out of ten Virginians could spell impasse."[75]

The chamber was not going to sit idly by and risk a repeat of 2001. Like Virginia FREE, it sent a clear message to the General Assembly. The board backed a sales tax increase for General Fund commitments, endorsed a gas tax increase dedicated to transportation and urged compromise on increasing the tax on tobacco goods. It had more or less agreed with a combination of Warner's plan and some of what would be included in the Senate proposal. The government affairs team, in anticipation of the affirmative vote, prepared a mock-up of a position paper by which the chamber would express its support for reform. It was an independently conceived document—not a rubber stamp of Warner's plan by any means. "The board acted because, in the course of the ongoing discussions, it reached a consensus on its own that Virginia needed to be more assertive in increasing revenues for core services, or it would risk withering on the vine," said Keogh.[76]

Archer considers the chamber's bold stance a red-letter day for the business community. "It was a time when the chamber finally took its place politically for standing up for a very controversial issue and making a difference," he says. "Looking back, who would have guessed that a Republican-leaning and fiscally conservative board would vote unanimously in support of tax reform."[77]

OUTSIDE FORCES HAVE MIXED IMPACT

In the heat of the debate, Governors Allen and Gilmore criticized Warner for breaking a campaign promise. They were joined by an unlikely "frenemy"—Governor Doug Wilder, the conservative Democrat whom Warner helped cross the finish line as the victor in 1989. The former chief executives pushed for a referendum instead of direct General Assembly action. They also said Warner didn't keep his word on taxes.[78] In 2001, Mark

From Business Success to the Business of Governing

Earley signed Grover Norquist's anti-tax pledge and ran an ad claiming Warner, who refused to sign the pledge, would raise taxes, referring to the transportation plan he proposed on a regional basis.[79]

The time for political games was over. Delegate Vince Callahan—the longest-serving Republican in the General Assembly—was well versed in Virginia's financial predicament. He recognized that Warner had a duty to the people, not to politics. "Campaign promises are made to be broken, and there's not a Republican in the House who hasn't broken one campaign promise or another," said Callahan. "Circumstances change. The governor was pragmatic and wanted to get the job done. He deserves credit for that."[80] The Northern Virginia delegate spent thirty-six years on the Appropriations Committee—nearly a decade as chairman—before retiring in 2007. He carried the ill-fated car tax legislation in 1998, a decision he later regretted. "The figures Gilmore used were so utterly erroneous and far-fetched that they were mind-boggling," said Callahan.[81] He developed a close relationship with Warner forged out of a shared desire to see Virginia regain its footing. When Callahan would come over to the Governor's Mansion for late-night chats, his usual Scotch on the rocks would be waiting for him.

Just as the 2004 debate was beginning to heat up, Warner's once political foe joined the fray on his own accord. Senator John Warner made the trip to Richmond to endorse the reform package with one simple statement. The senior Republican, surrounded by press in the capitol, exclaimed, "Politics be damned! Let's consider what's best for the men and women of this great state and their families and children."[82] He was growing concerned that Virginia was going to lose out in the Department of Defense's next round of base closures just a year away unless the state pulled its weight. The Senate Armed Services Committee member added, "As one who wants Virginia to maintain as many of its military installations as possible, I am becoming more and more concerned about our communities' ability in the current budget climate to maintain the hospitals, schools, services and infrastructure that have made Virginia the best possible location for military service members."[83]

Months after the General Assembly approved the reform measure, Americans for Tax Reform released a Wild West–themed poster entitled "Virginia's Least Wanted." It included Warner's 2001 quote opposing taxes and featured mug shots of the Republicans—fifteen senators and nineteen delegates—who voted their conscience in the spring of 2004. Unfortunately for Norquist, the poster became a running joke—a badge of honor in fact. Many legislators secured autographs from their colleagues and proudly displayed the memento in their offices.

Mutiny

Reaching critical mass in the House Republican Caucus began out of frustration from two of its most senior members. Delegates Jim Dillard and Harvey Morgan orchestrated a meeting with over a dozen of their colleagues open to discussing solutions to the budget stalemate. Both served on the budget-writing Appropriations Committee and were chairmen in their own specialties. For Dillard, it was the Education Committee, and for Morgan, it was the Agriculture, Chesapeake and Natural Resources Committee.

A former public school teacher in Fairfax County, Dillard was elected to the House in 1971 at a time when you could count the number of Republicans among its membership with two hands. Speaker John Warren Cooke, a principled Democrat with bipartisan flair, gave him a seat at the table with plum committee assignments in the early '70s as more senior Republicans were still waiting their turn. Cooke encouraged Dillard to pursue his passion for education and the outdoors. The two would sail around Put-In Creek near Cooke's home in Mathews County. In the summer, the now retired Dillard is known to spend more time on the water than land when he's not working on his '48 Lincoln.[84]

With almost three decades of elected service under his belt, Dillard made a promise to his wife that he would not run again in 2003, but there was some unfinished business on his mind. "Joyce knew that I was pretty unhappy about the fact that I was not going to be part of tax reform solution," he recalls. "And so one day at the dinner table, she said, 'Well, if you really think you ought to run again…go ahead.'"[85] He did, and two months into the 2004 session, tired of all of the political posturing clouding the House chamber, Dillard partnered with his good friend Harvey Morgan, a fellow Republican who claimed the Middle Peninsula seat that Speaker Cooke once occupied. He later retired in 2012. The two veteran legislators instantly bonded years before over sailing and a love for the Chesapeake Bay.

The duo's heart-to-heart conversations with other members generated interest. However, they underestimated the resistance to an uprising by the powers that be. As a result, the early March attempt to build a coalition of caucus members was scuttled. Perhaps setting the meeting on the sixth floor of the General Assembly building—just steps away from leadership offices—was not the best decision. "In hindsight, we should have gathered in a beer tavern instead," jokes Dillard.[86] It was only a minor setback. In the wake of the meeting's collapse and out of an independent desire to reach a resolution, two other delegates picked up the ball and carried it from there.

From Business Success to the Business of Governing

Momentum Builds

Delegates Preston Bryant and Chris Jones had offices next door to each other on the seventh floor. Bryant, a part-owner of a civil engineering firm, served on the Lynchburg City Council before running for the House in the late '90s. He was the House patron of the state's public-private partnership statue and shepherded landmark land and water conservation measures through the General Assembly during his decade-long tenure. The Republican was later appointed Secretary of Natural Resources under the Kaine administration. Like Bryant, Jones understands local government. He served two terms as mayor of Suffolk and was elected to the House of Delegates in 1997. The Medical College of Virginia–educated pharmacist remains a true citizen-legislator today. In 2014, Jones was tapped as chairman of the Appropriations Committee.

Back in 2004, the two were accustomed to burning the midnight oil. "We shared a tradition that, after dinner or a reception, we would go back to our apartments, put on jeans and then head back to the office to write letters, send e-mails and get caught up," said Bryant. "It was during those hours that we started thinking out loud with each other. One would plop down in the other's office, feet up on the desk, and we'd start sketching out ideas."[87] The work continued for each back home in Lynchburg and Suffolk when the General Assembly was not in town. They e-mailed spreadsheets back and forth with numbers that eventually became the framework for the final House proposal.

Around this time Warner reached out to Jones. After a mostly Republican pickup basketball game, the two headed up to the governor's office to chat. Over a few Coronas, they started talking about what could be done to bring resolution to the budget. "I was just relentless after that in pursuit of House Republican allies," said Warner. "Every night I could, I was taking legislators out to dinner, having them over to the mansion for drinks, making calls on the weekends, basically whatever I could do to connect with them. Even if the delegates didn't agree with me, they respected my persistence."[88] Some members even admitted they had been in the governor's office more with Warner than the last three governors combined.

Bryant and Jones started working their caucus members on an individual basis. "We went through the list together of our colleagues to see who we thought, off the top of our heads based intuitively or on statements they had made, we could get to buy into such a plan," said Bryant.[89] They divided up the list and didn't ask for commitments. Instead, they focused on gauging who was open to exploring the concept further.

The pair also started talking with the Senate. "Going into this, I knew that if you take on the Speaker and the leadership and you win, life is going to be miserable. If you take on the Speaker and lose, life is going to be especially miserable," said Bryant. "Losing was not an option. We all went into this with our eyes wide open. We also viewed that it was completely fruitless to go down this path if what we were assembling was not going to pass in the Senate."[90]

Norment and Stolle were dispatched to work with the House. It was a familiar role for the two friends. "The governor was critically instrumental in securing those 17 House Republicans, but by the same token, those 17 were relying upon the assurances that we in the Senate were going to deliver the votes ourselves," said Norment. "They wanted the personal reassurance of Ken and me."[91] Other Senate leaders were also involved, but Chichester had to be more careful. He had become more or less a villain and did not want to put any delegates in harm's way. "I remember several members saying over the phone, 'I cannot come talk to you, because someone might find out. We had been instructed that if you go see John Chichester, then you have to report back what was said.'"[92] The collective work of the Senate Republican leadership gave Warner the intel he needed to close the deal. "We could bring him intelligence on who was listening and who understood the problems," said Chichester, "and he would take those members to his office and sit down with them and work through their concerns and ideas—and keep at it until he had the number of bodies he needed. This was crucial."[93]

In early April, Bryant informed Speaker Howell that he had fifteen to twenty members of the caucus ready to vote for a House budget. Howell doubted the number but didn't stand in the way. "The Speaker agreed to allow us to have an up or down vote," said Bryant. "I had great sympathy for the position that he was in. He had just become Speaker. He found himself in this storm not of his own making. He was trying to establish good relationships with the Senate. He was trying to hold his caucus together. Throughout it all, we had a difference in opinion, but it was professional and collegial the way we worked with each other."[94]

Opponents were no match for the collective persistence of a broad coalition wishing to reach a deal. On April 13, after much debate, seventeen Republicans voted with Democrats to pass a $700 million House spending plan.[95] The fight wasn't over yet. The legislature still had to agree on a compromise between the two houses.

From Business Success to the Business of Governing

Resolution

Warner concedes that Norment and Stolle didn't get the full credit they deserve. "They calmed me down," he recalls all too well. "There were a number of times when I would tell them, 'All right, we've just got to a make a deal with the House.' They would come in…they were always so cocky…they stroll in the governor's office and say, 'Governor, just calm down. It's not time yet.'"[96] Warner remained in contact with the two senators throughout the day when the General Assembly was in session. "There were times I would call Ken…it was just that I was so nervous. It was almost like a relief valve. He would just talk to me and keep me calm."[97] Stolle says Warner called more like fifteen times a day. That didn't include scheduled meetings or late-night strategy sessions.

Norment embraced Warner's management style over his predecessor's. "I appreciated his willingness to meet one on one without having staff draped off him."[98] Stolle, too, was amazed at how Warner kept his dealings personal. "We would have meetings with no one else in the room. He never had a bunch of staff in there. Sometimes Tommy and I would suggest that we were trespassing into the political areas, not policy areas, and that he ought to get his political people in there. His response would always be, 'Hell, if I can't trust you two guys to give me good political advice to make good policy, then I can't trust anybody.'"[99]

Warner's high-energy and demanding management style meant that he had his hand in everything that was going on, and he didn't like to let other people make decisions for him. So it was difficult in the waning hours leading up to the April 27 House vote to leave the fate of the compromise bill in the hands of the legislature. "He was absolutely convinced that we had asked for too much money," recalled Stolle, "that we should settle this thing at $1 billion and not hold out for $1.4 billion."[100] The number of Republicans since the historic April 13 vote had fluctuated. Warner was concerned. "I went to Preston and Chris and said, 'I don't think we've got it.' They said, "No, let's go for it.' Like any smart legislator, you always keep another vote or two in your pocket."[101]

Warner was also nervous about holding on to Democrats in the House. He couldn't afford to lose them. Three dozen members of the caucus had gathered in his conference room on the third floor of the capitol earlier in the day. It was standing room only. Some of the members started carping. Warner was almost at his wit's end. "I said, 'We've come this far. This is not a perfect bill—I agree. But this is our chance to do something that is

good and right.' I'll always remember Kenny Melvin and Jackie Stump, who actually complained about it, saying, 'This is our governor. We trust him. He's worked his heart out. We've got to do this.'"[102]

Norment and Stolle made their way up to the governor's office as the House was preparing to vote. At this point, Warner had his conference room cleared out. He would pace back and forth, and then he would sit down. And then he would get up again. He couldn't sit still. The pressure was intense. Stolle remembers:

> Mark literally started yelling at me. He said, "You guys are going to cost us this whole thing…we're not going to win the vote…your overindulgence on the budget compromise is going to cost us the whole thing." He was literally yelling at me in the office as he was lying down on the couch. Then he stopped as his assistant, Cathy Ghidotti, walked in and said, "Governor, the House just passed the bill." There was dead silence in the room. Warner looked at me, and I looked at him. And I said, "F—— you…and congratulations," because I knew that was going to be his hallmark achievement as governor…maintaining the AAA bond rating and setting Virginia on a solid course for the future. It was a proud moment to share with him.[103]

The final vote was fifty-two to forty-five. Warner, the Senate and brave members of the House were victorious. The celebration began immediately and continued until the next day. It hadn't been twenty-four hours since the vote when Warner dialed Stolle's number out of habit and said, "I just want to wean you off these calls. I didn't want you to go cold turkey."[104]

13
THE TURNAROUND KID

Problem and Opportunity

In the three years prior to Warner's election, many children from low-income working families weren't able to participate in the newly created federal Child Health Insurance Program (CHIP) because Governor Jim Gilmore was philosophically offended by it.[1] CHIP, named the Family Access to Medical Insurance Security (FAMIS) program in Virginia, provides comprehensive health insurance to the children of low-income working families who cannot afford private insurance but exceed the income threshold to qualify for Medicaid.

Gilmore frequently railed against the program, calling it welfare.[2] When a bipartisan General Assembly ultimately forced him to implement it, Gilmore did so in a way designed to make participation nearly impossible for low-income families. Regulations and eligibility criteria were very difficult to meet, applicants were burdened with a lengthy and incomprehensible application, and there was a disjointed interface between CHIP and the Medicaid for children program. The result? While other states' participation rates were near 20 percent, Virginia had signed up only 7.4 percent of eligible children in the first five months of the program.[3]

This poor performance continued throughout the Gilmore administration and ultimately resulted in Virginia turning away nearly $56 million in federal funds for CHIP.[4] Adding salt to the wound, these were dollars that paid 66 percent of the cost of the program, enabling Virginia to provide

comprehensive health insurance for children at only one-third of its actual cost—a far better deal than the regular Medicaid program, which only pays 51 percent of the cost.[5]

This frustrated Warner from both a human and economic perspective. "The failure to go out and aggressively sign up these kids wasn't just bad health policy, it was poor fiscal policy," said Warner.[6] "We pay the price one way or another if these children don't have health insurance. Children in need of medical care either show up in the emergency room where the costs will be passed on to everyone else, or we could enroll them in this program at a bargain. This is not about just being a good guy. It makes sense."[7]

With some quick to view the program as another government handout, Warner discourages opponents from punishing young children for economic circumstances beyond their control. "Providing insurance for these children is a hand-up, not a hand-out," he says.[8] "Many working families live precariously on the edge, just barely earning enough to make ends meet. A serious illness or medical emergency often can devastate them financially."[9]

Warner recalls meeting a mother who had to make the impossible choice between the health of her daughter and paying the bills. "I will never forget her," he says. "She was a school bus driver and her job didn't provide health insurance for her child. When that child became sick, she scraped the money together to take her to the doctor, but she couldn't afford all the medicine prescribed, so she gave the child just half the dosage. The inadequate dosage was not enough to cure her and, in fact, it made her even sicker. Imagine the mother's pain to learn that her efforts had only made the situation worse."[10]

Warner's frustration built as Virginia's poor performance implementing CHIP continued, and Virginia ranked among the worst of all states in enrolling children from low-income working families.[11] This ultimately led the founding chairman of the Virginia Health Care Foundation to make a bold promise on the campaign trail in 2001. Warner pledged that if he became governor, he would sign up all eligible uninsured children by the time his term was over.[12]

Flipping a failed program in a short period of time was going to take an approach foreign to government bureaucracy. It would mean breaking the public assistance stigma and creating a private-sector model. It would call for state agencies working together with nonprofit organizations. It would require a streamlined and technology-based solution. And above all else, it would demand accountability at all levels, including the governor himself. While Warner's promise was a gamble, the challenge he issued united a diverse community behind a noble cause.

From Business Success to the Business of Governing

The Stars Align

Warner's election in 2001 immediately signaled a change in the state's approach to healthcare for children. Warner's first order of business was appointing Senator Jane Woods, a Republican from Fairfax County, as his secretary of health and human resources. Although she was reluctant to join a Democratic administration, she was no match for Warner's persistence. "He used his standard line of, 'Don't you know you can't say no to the governor of Virginia?'" says Woods.[13]

Effective at meeting people on their turf, Woods had the support of healthcare advocates and private organizations that for years had endured the Gilmore administration's hostility. With credibility on both sides of the aisle, she had the necessary political clout among her former colleagues in the General Assembly to guide the governor's agenda through the halls of the capitol.

The priority of maximizing enrollment in FAMIS was reflected in many of Warner's appointments and reverberated throughout the state hierarchy. He appointed Pat Finnerty to be the new director of the Department of Medical Assistance Services (DMAS), the state's Medicaid office. Finnerty

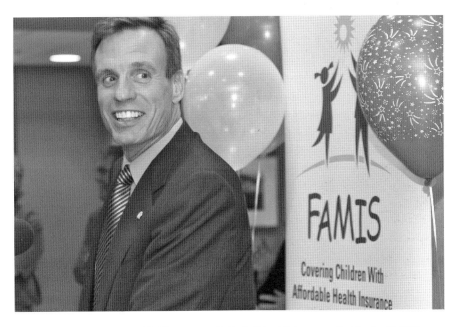

Warner finished his term with 98 percent of all eligible children enrolled in the FAMIS healthcare program. *Michaele White.*

had been serving as executive director of the Joint Commission on Health Care and was knowledgeable about and a proponent of FAMIS. Finnerty's handpicked deputy director, Cindi Jones, had just spearheaded an audit of DMAS and the performance of its child health insurance programs while staff to the Joint Legislative Audit and Review Commission. She knew where all the problems were and how to fix them.[14]

To complete his "dream team," Warner appointed Linda Nablo to administer the FAMIS program. Linda was an advocate who had spent the previous three years training individuals to enroll eligible children and who knew the rules backward and forward. What resulted from this deliberate hiring process was 100 percent buy in from all levels of the administration and a mantra of action focused on revamping the program.[15]

"When Mark Warner became governor, it was like all the stars had suddenly aligned," said Debbie Oswalt, executive director of the Virginia Health Care Foundation. "If you were to do a case study about how quickly improvements can happen when everybody in a huge bureaucracy works together from the top down, this is a perfect example."[16]

Keeping a Promise

For the state and its partners to be successful in turning around its enrollment numbers, several changes had to be made from the outset. "We took the application form from thirteen pages to one," said Warner.[17] "Cutting out the bureaucratic mess was key. It always drove me crazy that for a lot of people who needed services, instead of getting a job, they had to spend half their time dealing with bureaucracy and getting bounced around from office to office."[18]

Along with a shorter form, Virginia implemented a joint FAMIS and Medicaid application that when previously separate had been a major stumbling block for families. "It is so simple that I was able to use my mas o menos español (more or less Spanish) to enroll a family at the Arlandria clinic," said Warner, who visited the health center near his home in Old Town Alexandria.[19]

Correcting inefficiencies and applying pure common sense measures paid off, and within a year of taking office, Warner announced that the state had signed-up more than fifty thousand children in FAMIS.[20]

The outreach campaign extended well beyond Warner's visits around the state. "We empowered our hard-working and under-appreciated

From Business Success to the Business of Governing

Medicaid and DSS workers to do their jobs," he says. "We gave them the tools they needed to launch better marketing programs to reach more working families."[21] As a result, several new avenues were explored. Public schools gave parents the opportunity to request information about insurance coverage for their children through a simple check-off box on the student emergency card sent home at the beginning of the school year.[22] Call centers were opened with real, live people answering the phones and providing enrollment assistance. A "no wrong door" policy was instituted so that families could submit applications online, at their local Department of Social Services office or by mail to a FAMIS Central Processing Unit.[23]

Warner was so focused on making the program a success that he demanded a weekly report on DMAS's progress. "Mark always says that which doesn't get measured, doesn't get done," said Oswalt, who knows as well as anyone the high standard that is expected by Warner.[24]

It didn't take long for Pat Finnerty and the staff at DMAS to realize just how closely Warner was watching. Early in the administration, after his weekly report showed a dip in the number of enrolled children, Warner called Finnerty and asked why the numbers had decreased. In all of his years working for the state, Finnerty had never received a call like that. "It was enforcement and accountability at its best," said Oswalt. "That is the kind of leader Mark Warner is."[25]

Warner's hands-on involvement extended to the nonprofit organizations working in concert with DMAS. With the Virginia Health Care Foundation taking the lead, Oswalt applied for a grant from the Robert Wood Johnson Foundation (RWJF) called "Covering Kids and Families." Notified that Virginia had been selected as a finalist for the $1 million grant, Warner was adamant he come to the site visit to personally tell the RWJF representatives how important the grant was to him.

"They were blown away that the governor would come and say anything," said Oswalt, "but his passion, enthusiasm, and commitment…it was so very clear."[26] Just a few months later, the RWJF awarded Virginia a four-year grant to assist in its outreach activities, and Warner later headlined a press conference for the RWJF at the National Press Club, kicking off a national enrollment initiative.

As his days in the governor's office were coming to a close, Mark Warner had many reasons to be proud, but one in particular was the result of nearly a decade of advocacy, both as a private citizen and as governor of Virginia. In four short years, Virginia had taken a leap many had not thought

possible. The state's health insurance program for children of low-income, working families had seen an across-the-board transformation.

By the end of his term, Warner had delivered on his campaign promise. As a result of accountability measures, innovative thinking and pure hard work, Warner finished his term with 98 percent of all eligible children enrolled in the FAMIS programs. For parents of those 138,000 additional children, there would no longer be a choice between the health of their children and paying the bills.[27]

14
RESTORING CREDIBILITY

Rail Essential to Reform

Six months before the end of his term, Warner capped a three-year reform effort by signing a key piece of legislation he had pushed to look at transportation from a more comprehensive point of view. Understanding that the state could not pave its way out of its traffic woes, Warner worked with his secretary of transportation, Whitt Clement, to create from existing funds a way to improve and expand Virginia's almost exclusively private-owned rail system. Through the use of public-private partnerships, the state could commit grant dollars to CSX or Norfolk Southern with a matching financial commitment and performance standards for the private railroad companies. With the creation of the Rail Advisory Board and later the Rail Enhancement Fund, the first dedicated revenue stream of its kind in Virginia history, $23 million a year would go to improving and expanding the state's rail infrastructure.

"Where most public officials are hesitant to deal with the private sector, Mark Warner went head-on in engaging companies like CSX, Fluor and Transurban," said Pierce Homer, Clement's deputy secretary of transportation, who got to know Warner when he served on the Commonwealth Transportation Board in the '90s. When Clement left the administration in 2005 to return to his law practice, Homer assumed the top cabinet post and stayed through Governor Tim Kaine's term. "The Rail Enhancement Fund has quantifiable, defined benefits," he adds. "With a

seventy-thirty state-to-private match, there is risk-sharing involved. For the benefit of expanding passenger and freight rail and to strengthen Virginia's intermodal networks, Mark Warner was willing to take a risk."[1]

Requiring that projects serve a public interest connected a variety of the administration's priorities, from environmental protection to job creation and alleviating road capacity. "Public interest can mean improving service for passenger rail, the number of heavy trucks taken off the highway, a reduction in air emissions or how the track is improving economic development opportunities," said Clement, a fourteen-year veteran of the General Assembly representing Danville and Pittsylvania County.[2] Warner tapped Clement because he "would bridge the gap between rural, suburban and urban Virginia in transportation."[3] Of particular interest to the former delegate was restoring prosperity to the once-booming Southside region he called home.

Clement and Homer shared Warner's vision for the Rail Enhancement Fund as an effective tool to attract and retain employers and grow the port of Virginia. As a result, the fund has played a role in securing Virginia's inclusion in major multistate rail infrastructure public-private partnerships, including the Crescent Corridor running along Interstate 81, as well as the Heartland Corridor and National Gateway projects connecting the port of Virginia to the Midwest. The fund is connecting passenger rail from Lynchburg and Norfolk to D.C. and the entire Northeast corridor. As governor, Warner helped guide the Dulles Metrorail Project through the environmental process, supported expanding capacity for the Virginia Railway Express (VRE) commuter line that runs between Fredericksburg and Washington, initiated the Norfolk Light Rail system (the Tide) and supported the TransDominion Express (TDX), a proposed passenger rail project across southern Virginia.[4]

"The Rail Enhancement Fund underscores that Mark Warner recognized the revolution of technology to initiate the changes at DMV," said Pierce Homer. "That forward-thinking approach freed up capital, thereby making public-private partnerships for rail extension projects possible."[5] The fund's impact has been lasting in great part due to Warner's initiating a complete operational overhaul of the state's transportation department in 2002. While subsequent administrations have abandoned some of those good government practices out of political expediency, Warner's all-out war on inefficiency is a model of success. Through a combination of honest planning, accountability, workforce restructuring and a renewed business-oriented mission, Warner and his team revived an agency that for years lacked leadership and had been bruised by politics.

Turning Point

It was not always in bad shape. "VDOT for years had been regarded as one of the best transportation agencies in the country," said Warner. "When I was on the Commonwealth Transportation Board in the early '90s, it was nationally known."[6] Then a few policy decisions under Virginia's governors thereafter had profound consequences.

With the hope of getting a bigger bang for the state's buck, Governor George Allen offered an early retirement buyout program that would accomplish two things: cut the size of government and contract with the private sector to hopefully bring more efficiency to what VDOT employees had done on the state's dime.[7] In the short-term, VDOT was booming. A strong economy kept construction and maintenance dollars flowing into the agency. The bloated budget left VDOT's funds open to being raided if the dollars were not quickly allocated to specific construction projects. "The concern was, if the cash sat there for long periods of time, the General Assembly would take it, so rules were relaxed to get work moving," said Barbara Reese, VDOT chief financial officer during the Warner administration.[8] "Once you start that train, and it picks up steam, it's not like you can just stop it on a dime," adding, "And maybe there wasn't the political will to stop it."[9]

The need to quickly get projects out the door created a situation where the recently retired engineers were hired back as higher-paid private consultants, in many cases working on the same projects they managed as state employees.[10] While Allen and hundreds of VDOT engineers fared well in the deal, the agency was put on a long-term path for decline. However inadvertent, the buyout decimated the collective knowledge of senior staff and spurred a practice of starting projects without necessarily identifying the funding to complete them.[11]

Over the next several years, conditions failed to improve. "VDOT was actually just about as low as an agency could have gotten," said VDOT chief of technology Gary Allen.[12] "It was under fire constantly for not being able to deliver projects on time or on budget. A lot of that stemmed from the fact that there was a general lack of focus. There was also very low morale in the agency."[13] It was plainly clear to Warner once he took office. "You can't be so anti-government and then expect your government employees to produce for you," he says. "You need to give some level of emotional support. VDOT personnel just felt beat up by the time we got in. They were beat up, intimidated, manipulated and politicized."[14]

Phantom List

"VDOT is so often a political football. It's a darn shame," said Governor Jim Gilmore in August 2001 as he stood in the middle of Northern Virginia's Mixing Bowl project connecting I-95, I-395 and I-495.[15] While he proclaimed the project was "one of the great works of the modern world," VDOT's maintenance account was "overdrawn by $5 million, and the main account for road construction contained barely more than a week's worth of cash."[16] Virginia's transportation agency was operating without long-term sustainability in mind and was plagued by poor management practices.

Gilmore's first year in office saw construction projects post cost overruns of $46.8 million after "contractors persuaded VDOT to modify their work orders by more than $200,000 a total of 69 times."[17] An accounting error overpaying 209 VDOT employees a total of $193,608, which the state did not recover, was written off after the VDOT commissioner "argued that it would be unfair to ask for the money back."[18] The famous Mixing Bowl project south of Washington, D.C., officially named the Springfield Interchange carrying nearly half a million vehicles daily, was projected in 1992 to cost $220 million. The costs first doubled and then tripled before Gilmore left office.[19]

Fearing the runaway train of expenditures would soon catch up with the cash-strapped department, VDOT executives pleaded with the governor to put the brakes on the highway construction spending spree. Advancing his "Innovative Progress" agenda, Gilmore instead forged ahead with an eye on increasing the agency's building capacity, funded by using future federal transportation dollars for his present needs and all the while incurring more debt. As he had tried unsuccessfully with the car tax cut, Gilmore pushed for using national tobacco settlement funds to help pay for his transportation package.[20] As ambitious and creative as the plan was, it lacked the fiscal integrity Virginia had been accustomed to for years. "It was thrown together to give Gilmore his means of addressing transportation," said Deborah Brown, director of debt and innovative financing for VDOT during the late '90s. "A real fix would have meant slowing down some construction work and not adding more things to the already overloaded plate."[21]

Reversing course meant stopping the nonsense at the planning stage. "Shortly after taking office, it became painfully clear that the Six-Year Program had become little more than a wish list of projects that bore little

resemblance to the Commonwealth's ability to fund the projects listed," said Whitt Clement. "For instance, the program included $250 million worth of contracts that VDOT didn't have the cash to pay for."[22] The responsibility of updating the Six-Year Improvement Program (SYIP) rests in the hands of the Commonwealth Transportation Board (CTB), a seventeen-member policy-making panel appointed by the governor and charged primarily with divvying up funding for highway construction projects.

The CTB, under Gilmore, had carried out his wishes in approving a series of projects that looked great on paper but in reality would never see the light of day due to lack of funding. The 2001 SYIP was updated six months late, leaving a $10.1 billion commitment on the books in December while Virginia was diving head-first into a recession.[23] "Furthermore, the program reduced maintenance funding in order to boost the construction program; held down cost estimates; and relied on overly optimistic revenue estimates," added Clement. "It included projects that had no foreseeable funding sources.[24]

Five days into his administration, Warner addressed the CTB and made it clear from that day on that he would accept nothing short of the truth.[25] Wasting no time, he ordered the state's auditor of public accounts to comb through the Department of Transportation and complete a full review of the books. An initial investigation showed that project costs grew on average by 217 percent from the approval stage to the start of construction. Once building was underway, projects experienced additional cost overruns of at least 25 percent. Additionally, poor financial planning left more than $250 million in CTB-approved road construction and maintenance contracts in limbo out of fear that VDOT's bank accounts would be overdrawn.[26]

While the state auditor reported back with sixty-two management and budgeting recommendations, Warner had to first make some drastic cuts before he moved on to operational reform. Going back to the CTB, wholly composed of members appointed by his predecessor, Warner presented the state of Virginia's transportation system and asked it to consider the facts in adopting a realistic six-year plan. "The governor felt it was important to avoid any partisan shots and therefore wanted to have the same board that approved the SYIP six months earlier vote on a substitute plan," said Clement. "No complaints came because the money was not there in the first place. It was a phantom list."[27]

With the facts undeniable, the CTB removed 166 projects and gutted the original plan's call for $10.1 billion in spending by almost a third, leaving a six-year $7.3 billion program that no longer read like "a political wish list."[28]

For Warner, there was no time to declare victory. Reclaiming control over an erratic process was just the first step in bringing private-sector accountability to the bureaucratic transportation department. With a sound financial plan in place, it was now time to see what VDOT professionals could do with it. All they needed was the right leader.

Enter the Fixer

"I got this phone call from a search firm," said Philip Shucet.[29] At the time, he was an executive vice-president at Michael Baker Corporation, a public and private engineering and construction firm with offices worldwide. "I was flattered but I told the guy I couldn't do it."[30] Shucet had a two-year-old child, and he had just bought a new home in Virginia Beach and could not afford the huge pay cut if he were offered an agency head position in Richmond with the new administration.

A month before he took office, Governor-elect Warner announced a nationwide search for a new VDOT commissioner. At the time, the state's full-service road, bridge and tunnel maintenance and construction agency had over ten thousand employees and an annual budget in excess of $3 billion.[31] It had a solid national reputation, but in the '90s was crippled by mismanagement, severe cost overruns and political games that weakened the agency's credibility. With an eye on streamlining operations and improving the agency's efficiency, Warner had no choice but to propose a complete overhaul. He had only one shot to get it right, so rewarding an ally with the job was not an option. This was not the time for patronage. He needed an outsider, someone with a solid business background and no political loyalties who could lead the agency back to prominence. That's where Philip Shucet came in.

The Mountain State native started his career at the West Virginia Department of Transportation in the agency's environmental section after graduating from Virginia Tech. After a stint in the Midwest working under his West Virginia boss who left to take the Arizona commissioner's job, Shucet moved back east to the private sector. Putting his environmental expertise to work, he joined Michael Baker in its Richmond office and, in just two years, jump-started the financially troubled Baker Environmental division.[32]

Surprised by the call from Korn/Ferry International in 2002, Shucet asked how his name came up. "I had zero involvement in Virginia politics,"

From Business Success to the Business of Governing

he remembers thinking at the time, wondering why he would be considered for a political-appointee job. "I knew who Warner was but had never met him."[33] After a lot of "no...I can't do it...I'm not interested...," Shucet reluctantly agreed to meet with Warner's secretary of transportation, Whitt Clement, whom he did not know either. Still uncertain about the opportunity, Shucet called his father on the way home from the interview. "My dad said, 'What do you think would give your life the most meaning, doing the job you're doing now or being commissioner of the department?'" Shucet recalled. "That settled it for me. How often in your life do you get an opportunity that offers so much challenge and so much opportunity to do good things?"[34] The next step was meeting with Warner. "I went up to the governor's office with some notes in my pocket...actually a piece of paper with handwritten notes. I'm sure the governor thought I was crazy. He was probably thinking to himself, '*This* guy wants to be commissioner...coming here with some handwritten notes.' But I honestly had not thought much about doing it."[35]

Shucet recalls Warner's sincerity in making VDOT the great agency it once was. "I remember him telling me in the interview, 'I've already reconciled myself to the fact that I'm not going to be the kind of governor that cuts ribbons...so I'm not looking for somebody to get a bunch of construction projects out the door. I want somebody to fix the VDOT and the business of transportation in Virginia.' I felt like I had a meeting with a CEO of a large company who understood business and was looking for a businessperson to run VDOT. That really hooked me."[36]

Walking out of the interview Shucet was sold. "After saying 'no' for so long, I knew then that I wanted the job," he says.[37] It was clear to him that what mattered most to both Warner and Clement was trust and honesty. Their commissioner would need to make ethics and teamwork guiding principles for the agency as it climbed its way back to the top.[38] Not mincing his words, Warner offered Shucet some advice if he were to be hired. "He said, 'lead by example, tell the truth, and give me the facts. If you give me the facts, then we can deal with it. If you make a mistake, dust yourself off and move on, but don't make the same mistake again.'"[39] When it comes to his expectations, Warner pulls no punches. "I told my wife that if Warner and Clement mean 50 percent of what they say, as far as looking for a professional to run VDOT," said Shucet, "then this will be a once in a lifetime chance."[40]

Time went by, and Shucet went back to his job at Michael Baker until one day in April when he was driving to the Eastern Shore to meet a client.

"I got a call from someone in the governor's office who asked if I could be in Richmond that day."[41] Getting ready to cross the Chesapeake Bay Bridge-Tunnel, he said, "Of course" but that he needed to first make some calls. So Shucet turned around and drove to Richmond. "I arrived at the capitol and walked up to the third floor and said, 'This is Philip Shucet, and I'm supposed to see somebody in the governor's office.'"[42] He first met with staff and then all of a sudden, Mark Warner entered the room and said, "Philip, I'd like you to be the VDOT commissioner, and we'd like to make an announcement tomorrow."[43] Before Shucet accepted he had to make one important call to his boss, the CEO of Michael Baker, so he could resign.

Shucet's first day could not come fast enough. With only $28.5 million in maintenance dollars remaining, the department was going to run out of money after just nine days of pothole repairs and repaving.[44] The pressure was intense. Warner made it clear what Shucet's job would be. "I want roads built on time and on budget," he said on day one, impressing on Shucet to get the beleaguered transportation department back in shape. "I want Phil to produce measurable results."[45] Then there was the issue of honesty. Shucet was keenly aware of Warner's expectation for him to "restore confidence in the planning and programming side of VDOT," said John Milliken, Warner's transition director and secretary of transportation under Governor Doug Wilder. "When VDOT says, 'Here's the project we're proposing, here's what we think it's going to cost'—that those become believable things."[46] Shucet was barely settled into his Richmond office when he realized the severity of the problem that had plagued the agency for years.

Getting Back on Track

"It was apparent to me that VDOT had turned in on itself so much so that, from a leadership point of view, it had almost lost sight of the fact that we were there to work for the taxpayers and that every day we would chunk through $14 million," said Shucet. "So a day wasted was a big deal."[47] By the end of his first week, Shucet knew things were bad. "I attended the Northern Virginia Six-Year Plan meeting on my first day on the job. By the end of the second day, I knew that we were not going to be doing any of those projects. We eventually had to cut almost $3 billion worth of projects in the first pass through the plan."[48]

From Business Success to the Business of Governing

Amending the list of construction projects would prove useless unless Shucet first tackled the organizational structure and day-to-day operations at VDOT, an agency that he described early on as "steeped in tradition—a cautious, protective, very defensive culture."[49]

"I looked at the organizational chart and could not really figure out who really was in charge of engineering," he says. "There were seven or eight different divisions that performed engineering functions. They reported to three different assistant commissioners and the three assistant commissioners reported to two different deputy commissioners. So whose neck do I grab when I have a problem with engineering? This example replicated itself in other areas."[50] Shucet simplified the flow of responsibility and restored accountability across the board. "To streamline the agency's top management, [he] retained a single deputy, hired a chief financial officer, and eliminated all assistant commissioner positions," said Clement.[51] "Some of the personnel actions were drastic," admits Shucet. "[They involved] people who had very good careers, well-respected," he says.[52] When it came to staff being indecisive and bureaucratic, Shucet was tolerant only to a point. At the risk of being a strict and demanding boss, he chose to put the department first.

After hitting the road to visit the nine regional offices, Shucet came to the conclusion that the old culture of relying on the central office to make all the decisions needed to change. "I found this approach dangerous in an agency of 10,000 employees, where 9,000 of them were in the districts and not clearly responsible for making decisions," he says.[53] Removing unnecessary layers of bureaucracy, Shucet had the district directors reporting directly to him. The new way of running VDOT meant that the central office was a policy-making body, but the executing body was out in the field. "The point of the restructuring was to get people in the agency to see that the best decisions are the decisions that are made as close to the issue as possible," said Shucet. "For a lot of things, that meant moving as much decision making as possible to the districts."[54] A corresponding challenge was getting the agency's construction team to see contractors as partners and not enemies. "To truly see that a project that is getting constructed when both VDOT and the contractor are well served means we succeeded," he says adding, "A good job is one that goes well for both sides."[55]

Changes at the new VDOT were not limited to just authority. Shucet had to show there were real consequences for unethical behavior, too. After discovering that twenty-five employees were viewing pornography on their work computers, he fired them on the spot. An additional sixty-one were

suspended without pay for two weeks for spending more than two hours a day on average accessing Web sites unrelated to work.[56] His efforts to rein in behavior tolerated and ignored by previous administrations were not without bumps in the road, however. Warner recalls Shucet's first major meeting with him after three days on the job. "Philip brought in two veteran VDOT staffers who gave me the financials on a particular major project," he says. "I looked at it and I said, 'This doesn't add up. Where do these figures come from?' The response was, 'Governor, what number do you want?' It was clear that the numbers had been cooked. You could see Shucet's face just turn white. It was obvious that he had no idea that's what they would say."[57] It was probably the first time in years that a governor had asked to look at the numbers. Suffice it to say, Warner never saw those guys again. "I said tell me what the numbers really are, not what I want you think I want to hear," added Warner. "You can't operate a government based on what is going to look good."[58]

Shucet's skilled handling of VDOT's workforce should not be understated. By the time he was through reorganizing the department, it was leaner, more efficient and more effective with over one thousand fewer employees.[59] "In a year-and-a-half period, Philip established a strong leadership team, used some existing executives, brought in some from the outside, and promoted some employees," said Jack Rollison, a seventeen-year veteran of the House of Delegates whom Warner appointed to advise on urban transportation policy.[60] Before he left office to work for VDOT, Rollison, a Republican delegate from Prince William County, was chairman of the House Transportation Committee. Mindful of Warner's expectations, Shucet ran his department like a business, always keeping a close eye on the bottom line. "We're a business that's spending $14 million of taxpayers' money every day, and we have a duty to steward those dollars effectively," said Shucet.[61] "He fired state employees, not an easy thing to do in government," added Rollison. "In the history of Virginia, all of the combined firings of state employees don't equal the number of employees he has fired. He made sure that employees stuck to doing their jobs. Yet he didn't punish those who made mistakes, who took risks, or who were innovators. But he was serious about bringing results in on time."[62]

The New VDOT

The annual debate in the General Assembly over new revenues for road construction had no bearing on Shucet's plans for the agency.

From Business Success to the Business of Governing

> *One of the biggest challenges is that for years we've had an argument over what to do with the money that we don't have to address transportation. Well, that dog just doesn't hunt. Let's get real. Instead of talking about what we don't have, let's talk about what we're going to do with what we do have. It means taking a stand and saying "Let's be clear about what we can do, go out, do it and then show the people we are doing it." In the end, their lives, in terms of using the transportation system, will be easier.*[63]

The reality of an unwilling legislature and a distrustful public gave Shucet just one option. "For me the lack of money was not the issue," he says. "The greater problem was something much more significant. Nobody could tell me the number of projects that were on time. There were no basic business measuring tools in place."[64]

At the time of Governor Gilmore's transition out of office in 2002, a shocking 20 percent of construction projects were completed on time, and only 51 percent were completed within budget.[65] For Shucet, improving those numbers became VDOT's new mission. Three years later, he had delivered on his promise. The agency that completed just one-fifth of its projects on schedule had turned the numbers upside down by the end of 2005, completing a staggering 82 percent on time. Keeping a close watch on VDOT's fiscal performance had paid off, too. In the same time frame, the department was able to improve its track record of spending tax dollars wisely to completing 88 percent of construction project on budget.[66] The steep climb back to credibility all started with an executive staff meeting on Shucet's first day in the office.

"When Philip was hired, the very simple thing he did was focus on one thing that everyone could rally behind and that you could measure," said Gary Allen. "He asked a question about monitoring projects. There was this long, deathly silence. Then I simply said that I always thought that the department needed something like a dashboard that would tell you in visual terms how we were doing with respect to projects and budgets. Philip looked at me and said, 'Do you think you can put together something like that?' I said, well, we can try."[67] A week later, Allen and his team came back with a design based on a concept they had sketched on a napkin. Launched in early 2003 and now in version 3.0, Project Dashboard resembles a vehicle's instrument panel with real-time information about construction and maintenance projects across Virginia. "It just made sense that if we were spending $3 billion of taxpayers' money a year, they had a right to see how it was being used and to ask questions of the person responsible for the

project," said Shucet. "Yes, it made some of our folks nervous, but we have to be accountable for what we do. No excuses. No hiding."[68]

With the help of technology used to create a state-of-the-art accountability system, Shucet was able to take his mantra and tie it to the real life performance of VDOT. "On time and on budget became our core business," said Allen. "That is the only thing Philip talked about. He met every month with all of the districts. He measured time in days, and every one hundred days he would send out brief updates to all VDOT employees. There was not a single person who did not understand what on time and on budget meant to them because they could all fit in with it."[69] Well known for using the expression "that which gets measured gets done," a confident Warner trusted his commissioner and was certain the agency was in good hands.[70] "He was not a micro manager," said Shucet. "It was a situation where he basically said, 'I want you to run the business of transportation, and you are going be accountable for what you do.'"[71]

With Shucet's laser-focused attention to VDOT's mission, public faith was restored for the first time in years in the agency's ability to deliver on its promises. "We became transparent in a way that everybody could understand," said Allen. "Now if the public wants to see the details of a project, all they have to do is click on the Dashboard. It will bring up every project in the state. Then you could search for a particular project, find it and see who the project manager is, what the budget is, how much has been spent and whether it is red, green or yellow. That is pretty simple yet highly effective."[72] The Dashboard's usefulness is not limited just to satisfying the public's watchful eye. "It tells me in a moment what would have required going through reams of individual project reports to pull together before," said Connie Sorrell, VDOT's chief of system operations who coordinated the project's effort from the beginning. "Before Dashboard, we were data rich, but information poor."[73] Using technology to hold the agency's feet to the fire still left a major problem that had plagued it: unreliable projections on the front end resulting in unnecessary cost overruns.

"The next order of business was the adoption of a uniform cost-estimating system," said Whitt Clement. "Costs that historically had been as much as 200 percent of initial estimates fell to 30 percent in the first year after the refinement and adoption on a statewide basis of a standard methodology."[74] "Shucet wanted a tamper-proof database so the numbers could not be fudged," said Pierce Homer.[75] "Many early project cost estimates included too much guesswork and were far off the mark, usually on the low side," added former VDOT assistant public affairs director Donna Purcell

From Business Success to the Business of Governing

Mayes. "Many estimates were based on employees' judgment, expertise, and experience rather than a sound, consistent, methodological approach. The estimates often were created at differing points in a project cycle or in differing ways. Inflation was rarely factored in. Certain environmental treatments and unusual construction cost items were not always considered early in the projects' development, which resulted in costly work orders when those items came up after construction began."[76] As a complement to the Dashboard's accountability measures, Shucet put his team to work on developing a cost-estimation program that would never again allow anyone to alter the figures to satisfy a desired outcome. As far as he was concerned, those days were gone forever.

Focus, Discipline and Attitude

With bull's-eyes on their backs, VDOT employees are easy targets to criticize. Every citizen has a stake in transportation and uses the system one way or another every day. Any slip up automatically lands on the shoulders of someone at VDOT. It is no surprise, then, that by the time Mark Warner took office, VDOT was teetering on a morale crash. "For an agency full of highly competent, highly technical people, VDOT had been buffeted by the winds of politics for a long time," said Gary Allen.[77] When Philip Shucet walked in the door, everything changed.

A simple philosophy of focus, discipline and attitude guided the new commissioner, who could care less about politics but was more interested in bringing the outcome-based business principles that had driven his successful career in the private sector. "It is easy to get people focused," said Shucet, "but it takes discipline to maintain your focus. It is hard work, and it is not fun. But with that discipline and the resulting accomplishments, you earn your attitude."[78] Shucet's philosophy made the biggest difference in helping turn the demoralized agency right side up. "The dramatic shift in attitude and productivity was a byproduct of making decisions at the right place and realizing that the people executing your work are your friends, not your enemies," he adds. "Attitude is about saying, 'We are all winners because we are in it together.'"[79]

An instant connection with Shucet left Mark Warner confident that the agency was in the right hands. "He's the kind of transportation professional VDOT needed," said Warner. "He took an agency that had lost most of

MARK WARNER THE DEALMAKER

Warner helped restore credibility to Virginia's Department of Transportation with the use of proven business practices and an "on time and on budget" mantra. *Michaele White.*

the public's trust, lost the trust of most legislators, had a six-year plan that was a wish list, and on time and on budget that was pathetic—and his team turned it around."[80] While the path to VDOT's success was no easy feat, it would not have been possible without three simple words Shucet asked his co-workers to live by in the performance of their jobs: simplicity, clarity and truth. "When you peel back the [bull], almost everything is truly simple," he says. "There are simple root causes of every problem. If you can champion simplicity, issues become clear. When they become clear, you can deal with them truthfully. Then you know what to do."[81]

The Warner administration's "fix it" approach was purposeful and consequential. Taking away from legislators the excuse that VDOT needed overhaul was intended to force a debate on the big picture. Whitt Clement says:

> *I feel that what we were doing was setting the table for an honest discussion about what kind of transportation network or program Virginia policymakers wanted for the state. We set about eliminating all excuses about mismanagement, fiscal irresponsibility and too much bureaucracy at VDOT. We tried to eliminate all of those excuses so that people could then see the state of affairs for transportation.*[82]

From Business Success to the Business of Governing

When Warner left office in January 2006, the fog that had engulfed VDOT for so many years was lifted. The debate of whether or not to build a transportation network for the future hinged on whether the General Assembly had the political will to put up the cash. That eventually happened seven years later. In 2013, after many setbacks, a large bipartisan coalition answered the call and passed the most significant investment in transportation since 1987.

15
HONORING A COMMITMENT

Uncovering Problems

Home to nearly 800,000 veterans, one-third of whom are sixty-five years or older, Virginia has established itself a leader in the nation in the treatment of its military heroes and respect for their sacrifice.[1] That was not so much the case when Mark Warner walked into the governor's office for the first time as the state's new chief executive. For an agency that prides itself on customer service, care and dedication, the Department of Veterans Services today is an advocate not only for the men and women who have served in the U.S. military but also for the families that are the partners in their sacrifice. From assisting in processing benefits claims, coordinating mental health treatment and improving educational opportunities to providing assisted living services, ensuring proper burials and advocating for veterans in the legislative process, Virginia has a multifaceted yet coordinated and deliberate operation for the sake of its veterans. That is a far cry from what existed in 2002.

For over sixty years, services for veterans were spread across different agencies, devoid of any sort of accountability measures and seemingly invisible to the public. A slip up in oversight was bound to happen sooner or later. Unfortunately for Mark Warner, it was sooner. And so began a costly operational and public relations nightmare. Fortunately for veterans in Roanoke's care center, there was no better time for an ongoing management problem stemming from the Gilmore administration to land on Warner's doorstep. Years in the making, it all came to a head just a month after he

took office. While dealing with a $1.2 billion budget shortfall and trying to learn the ropes, Warner started to receive troubling information about the operation of Virginia's only state-owned veterans care home.

The Virginia Veterans Care Center opened its doors in 1992 as a semi-independent state agency operated by a supervisory board of trustees under the direction of the secretary of administration. Among other responsibilities, the board was charged with hiring an executive director and contracting with a long-term care provider for the 240-bed facility.[2] Located next door to the federal Veterans Affairs Medical Center in Salem, the Southwest Virginia care center was designed to be a model of privatization in state government. Struggling to fill beds and plagued by operational issues from the beginning, the center's problems took a serious turn for the worse in February 2002. Board members contacted the Attorney General after they discovered financial irregularities and also that the center's executive director was simultaneously working as the head of the Georgia Association for Primary Health Care in Atlanta. That is when the state auditor and law enforcement stepped in. The longtime administrator later resigned in the course of the investigation.[3]

That was just the beginning of the bad news. In April, the care center's contractor, Diversified Health Services of Virginia, announced that it and BEP Services Inc., its parent company, were going out of business and would make May 31 the long-term care provider's last day of service in the veterans' home.[4] Following Diversified's bankruptcy, the board uncovered another setback. The center's private contractor and former executive director had let the facility's general liability and medical malpractice insurance coverage lapse at the end of 2001.[5] Around the same time, the state's auditor reported back with a full review of the care center's books, detailing a host of irregularities. According to the report, the executive director misused nearly $30,000 in welfare funds for purchases ranging from personal items to fruit baskets for board members to oranges that he later gifted to employees for Christmas.[6] The director also circumvented the state's appropriation process by opening a savings account in a local bank, where he handled just under $500,000 in veterans' subsidy payments.[7]

While the problems uncovered in 2002 showed a pattern of serious mismanagement, it was not the first time the care center had made headlines. In 1995, a member of the board of trustees resigned after being banned from the facility as a result of complaints substantiated by Social Services that he "had verbally abused residents and staff members."[8] The complaints did not stop there. Family members of residents pleaded with the board to

From Business Success to the Business of Governing

address their growing concerns of "understaffing on weekends, failure to give medications on time, not enough attention to grooming of patients and even lost clothing."[9]

Saddled with an organization that for years had operated with deficient oversight, Mark Warner had to put a stop to the nonsense. "It was not the way we ought to have been doing business," he lamented as the details unfolded. "Ratcheting down on financial mismanagement anywhere in state government has just got to be the way we operate."[10] While the fiscal and operational challenges were great, the real tragedy of the situation was the disregard for the fate of the residents or casualties of administrative negligence. The lack of respect by a few individuals for the veterans who trusted the state with their care nearly put a couple hundred of Virginia's war heroes out on the street. Grave as the problem was, shocking it was not. Problems at the Veterans Care Center added the facility to a long list of agencies, policies and practices carried over from the Gilmore administration that the Warner was determined to undo or scrap all together.

New Leadership

Dealing with the immediate problem first was Warner's biggest concern. Attempts to maintain the care center's privatization status by re-leasing the building and bidding out the long-term care contract failed. In fact, countering the state's request for a proposal, contractors said they could not operate a profitable business given the circumstances and that the state would have to pony up dollars to keep the center afloat.[11] Warner had no choice but to take over the problem-riddled facility and, under the state's control, make it run properly again.

There was little time. A month before the outgoing contractor cleared out of the building, Warner helped secure a one-year deal for the Maryland-based nursing home operator Ruxton Health Care to provide continuity in care for the residents.[12] A plan was set that, by June 2003, the new administrator would take control, and all the employees would be required to reapply for their positions.[13]

To complete the transformation, Warner would need to tackle the root of the center's problem: its board of trustees. He was not the first to try to rein in control. Gilmore and individual members of the General Assembly had previously failed in their attempts to increase the state's oversight of the

care center.[14] However, with approval from the General Assembly during the 2003 session, Warner abolished the supervisory board and put in place a direct line of accountability to the governor's office. It did not take long for the restructuring to work. Hiring solid management and staff, ensuring proper healthcare standards, obtaining proper insurance coverage and instituting sound financial practices had paid off, and over the next year, the care center went from a six-figure deficit in operations to a positive operating income of about $450,000.[15]

In the heat of the care center mess, Warner heard from several veterans, including Paul Galanti. The retired navy commander was a prisoner of war for nearly seven years in North Vietnam's infamous Hoa Lo Prison, commonly known as the "Hanoi Hilton." If Warner was going to overhaul veterans' services in Virginia, the former naval fighter pilot and lifelong Republican was going to be in the middle of it. In June 2002, Warner issued Executive Order 15, creating the Governor's Advisory Commission for Veterans Affairs. He tapped Harold Gehman Jr., a retired admiral and resident of Virginia Beach, to lead the distinguished twelve-member panel. The former NATO Atlantic supreme allied commander and commander in chief of the U.S. Joint Forces Command had the requisite experience to lead a comprehensive review the effectiveness of the state's veterans' programs. He was co-chairman of the Department of Defense's review of the 2000 USS *Cole* bombing and chaired the Space Shuttle *Columbia* Accident Investigation Board following the tragic explosion in 2003.

Working with the full power of the governor's office to help speed up the process, the commission completed its work just shy of six months. For Gehman, two significant realities were preventing Virginia from reaching its full potential in caring for its veterans. "The commission found that the federal government was slowly devolving veterans support to the states and, as in many other areas, the states were having a hard time finding resources," he said, adding as an example, "The federal government is no longer building national cemeteries, but is partially underwriting the states' efforts, at a time when World War II veterans are dying in increasingly large numbers."[16] Then there was the issue of an inefficient and uncoordinated bureaucracy. "The commission also found that the Virginia agencies responsible for supporting veterans were poorly organized, not run on a businesslike basis," said Gehman. "They could not provide any business analysis for how money was spent."[17]

In December, the commission announced its recommendations that if enacted would elevate veterans' services to the level it deserved

From Business Success to the Business of Governing

and establish statewide accountability for the services the state had committed to provide but had fallen short of for years. Chief among the recommendations was replacing the fractured Department of Veterans Affairs with services spread over two different agencies and three boards with a consolidated Department of Veterans Services. The new agency, led by a commissioner with a direct line to the governor, was given policymaking authority and designed to work in concert with a coalition of veterans groups. As a matter of principle, the commission also recommended that Virginia pay its fair share of the cost of the World War II Memorial in Washington, D.C. At the time, Virginia was the only holdout state.[18]

Garnering endorsements from veterans' advocates, Warner immediately adopted the recommendations into his 2003 government reform package. "It is significant that this commission worked with and gained the unanimous support of the leading veterans service organizations," said Gehman, "including American Ex-POW, American Legion, American Veterans (formerly AMVETS), Disabled American Veterans, Military Officers Association of America (formerly Retired Officers Association) and the Veterans of Foreign Wars."[19] By March, Warner was signing the bills passed by the legislature, leading the state in a historic step of upgrading veterans' services and care for the twenty-first century.[20]

Long Time Coming

Under the direction of the new commissioner, Jon Mangis, a thirty-three-year veteran of the Oregon's Department of Veterans Affairs and past president of the National Association of State Directors of Veterans Affairs, Virginia's new agency was in good hands. Following in his father's footsteps, Mangis joined the military, serving a tour in Southeast Asia in the air force and later retired as a sergeant major in 1995 from the Oregon Army National Guard. His father was a World War II B-17 pilot who died after being shot down in Holland.[21]

The main concern for Mangis and Warner was making customer service the agency's highest priority. Working with veterans and their families seeking assistance from the U.S. Department of Veterans Affairs, the agency reestablished itself as an advocate for these individuals in securing the benefits they are entitled to under the law. For years, this core service was

battered around whenever previous governors needed to make cuts. Warner put a stop to it.

With the Roanoke Veterans Care Center on the right track, Warner pushed for an additional facility to be located in Richmond. On the campaign trail in 2001, Warner heard from veterans that, more than anything else, the state needed to expand its long-term care operation. Thanks to a two-to-one federal match grant for construction, the Sitter & Barfoot Veterans Care Center—named for two recipients of the Congressional Medal of Honor, Colonel Van T. Barfoot of Dinwiddie County and the late Captain Carl Sitter of Richmond—broke ground in 2005 at the tail end of Warner's term.[22] The 160-bed facility, built next to the Hunter Holmes McGuire Veterans Administration Medical Center, opened in 2008.

"The ground breaking was the first thing I got involved with and the last he did in office," said Vince Burgess, who stepped in as acting commissioner when Mangis retired. "In typical Warner fashion, at the ceremony, the governor leaned in and said in a way that only I could hear, 'Vince, I know you are just the acting commissioner. Now I want you to understand...I don't want you screwing this up. We worked hard to get this.'"[23] Burgess could see the smile on Warner's face but knew he was serious. The collective effort of hundreds of people to restore faith in the state's ability to properly serve its veterans after the series of missteps was not lost on anyone.

A new care center would not be the only capital project Warner shepherded from dream to reality. Prior to 2004, the only state-operated veterans' cemetery was located in Amelia County just an hour southwest of Richmond. For many veterans and their families living outside central Virginia, the distance was a problem. Winning approval from the legislature, Warner was successful in securing the land and a $6.5 million construction grant in Suffolk. The Albert G. Horton Jr. Memorial Veterans Cemetery, named for the late navy veteran who worked tirelessly for the development of the Hampton Roads cemetery, opened on time and on budget a year after breaking ground.[24] The success of Suffolk's burial and internment operation prompted the opening of a third cemetery in 2011, located in Southwest Virginia's town of Dublin.

Warner made good on his other promises as well. He personally delivered a check in 2004 for $334,000 to General P.X. Kelley, USMC (Ret.), chairman of the American Battle Monuments Commission. The symbolic donation represented $1 for every one of the 334,000 Virginians who served in the armed forces during World War II.[25] Beginning in 2003,

the Department of Veterans Services hosted a series of awareness events that provided "one-stop-shopping" experiences for veterans "seeking information about state and federal benefits, loans, career and employment opportunities, education, and veterans service organizations."[26] Perhaps the most critical gesture came early on in the administration when Virginia was facing a massive shortfall. When Warner had to make 15 percent cuts across the board in state government, he shielded the Department of Veterans Services from the full impact, imposing just an 8 percent cut. Two years later, when Virginia's economy had rebounded, he increased operational support by an additional 50 percent, guaranteeing enough funds to meet the department's needs all across the state.[27]

Stronger Together

Every year, swarms of advocacy groups descend on Richmond, trolling the hallways of the General Assembly building and vying for a meeting with the governor, all in the hopes of staking their claim to a line in the budget. In many cases, as with public safety organizations like the Virginia State Police, sheriff's offices and local police departments, similarly focused groups compete for the same piece of the pie. Veterans are not immune to the process. As president of Virginia's Council of Chapters for the Military Officers Association of America (MOAA), Sam Wilder was prepared to discuss his organizations' legislative priorities with Warner on the afternoon before MOAA's annual "Storming the State Capitol" lobbying day in 2003. The retired army colonel entered the governor's office with no clue that he would be walking out with an idea that would for the first time unite veterans in a formal way on policy matters and lobbying efforts in the General Assembly.

Going back early in the administration, Paul Galanti and Warner had discussed strategy for fixing the state's chaotic organization of veterans services programs. Out of those talks came a clear understanding that the transformation could not operate in a bubble. "I recommended that if he wanted to get the people who know veterans best and understood what they needed most," said Galanti, "then Warner needed to get the folks in the veterans service organizations involved in the process."[28] That's exactly what happened, but Warner would first have to sell them on the idea, starting with Sam Wilder.

Warner helped unite veterans service organizations under the Joint Leadership Council with leaders representing over a quarter of a million of Virginia's veterans. *Michaele White.*

From Business Success to the Business of Governing

Seated around the governor's conference table, the conversation quickly turned to a discussion of, with every different veterans' group coming in one after another, how could Warner figure out what were the most pressing needs? He looked at Wilder and said, "You guys can't have twenty-four different messages. You have to have one place where you can prioritize your requests. If veterans' groups could all advocate for the same agenda, you would be the most potent political force in the state."[29] Warner added somewhat in jest that getting Democrats and Republicans to talk is a lot easier than getting veterans' organizations to work together. In many respects, Warner was right. Each organization has a slightly different mission and mindset and represents a specific constituency. However unintended, rivalries are going to exist.[30]

"We all came back and looked right at each other," said Wilder. "It was like a blinding flash of the obvious. We said yeah…Warner's probably right."[31] Months of discussions and developing a workable structure produced what Warner's blue ribbon commission announced in December 2003 as the Joint Leadership Council of Veterans Service Organizations (JLC), an advisory board with leaders from twenty-four organization representing over a quarter of a million of Virginia's veterans. "Within the JLC we all agreed that we need to debate the most important issues, prioritize them and present a joint agenda," said Wilder.[32] As simple as that sounds, it is not an easy process, but over the last eight years, the decision for the veterans' organizations to unite has forged a new kind of relationship between government and the people it serves. From real estate tax relief for 100 percent disabled veterans to in-state tuition for children of soldiers injured or killed in combat, the JLC's legislative victories have proven that through cooperation and being given a seat at the table, both can be partners in making government work and improving lives.

16
THE DREAM TEAM

In 1969, as legislators stripped Virginia's Constitution of discriminatory provisions, the General Assembly added a clear responsibility to environmental stewardship. Article XI Section 1 says, "It shall be the policy of the Commonwealth to conserve, develop, and utilize its natural resources, its public lands, and its historical sites and buildings. Further, it shall be the Commonwealth's policy to protect its atmosphere, lands, and waters from pollution, impairment, or destruction, for the benefit, enjoyment, and general welfare of the people of the Commonwealth." More than thirty years later, as newly elected governor Warner was just getting settled in, he'd have to add teeth to the broad language if he wanted to make protecting the environment part of his own legacy. Doing more with less was the administration's new motto. In the case of natural resources, which claims less than 1 percent of the state's budget, it was going to take a seasoned team with an aggressive agenda to pull off this feat. That's where Tayloe Murphy came in.

Warner appointed the Northern Neck native as his secretary of natural resources. Murphy, who served nearly two decades in the House of Delegates, was not angling for the job as others with his background would have. But that didn't discourage his allies from chiming in. Murphy's friends in the environmental community started a letter-writing campaign. It didn't take long for John Milliken, Warner's transition director, to invite Murphy into his office for a chat. Milliken pointed and said, "Do you see that stack of papers over there on the shelf? Do you know what they are? Every one of

them is a letter recommending that the governor-elect appoint you secretary of natural resources. We are inundated with mail about you. You've got more friends than anyone in Virginia."[1]

Murphy was a known commodity, having chaired the Chesapeake Bay Commission three times during his eighteen-year stint and whose work in the General Assembly made him Virginia's oracle of environmental policy. Warner says of his decision:

> *I felt that while Tayloe was an ardent environmentalist, he was also practical. He had enormous respect in the environmental community. I knew that after eight years of the two previous administrations, there was going to be tremendous pressure to make a dramatic change. I wanted someone who people in the environmental community totally trusted. I wanted someone who, if I said, "No," he would fight me on it. And he did that.*[2]

Murphy's appointment was just the beginning. Warner made a campaign promise to bring respected environmental professionals into leadership positions. He kept it. The governor tapped Bob Burnley as director of the Department of Environmental Quality. He had a long history of service to the agency and knew the issues backward and forward. Warner selected David Paylor, a twenty-eight-year veteran of state environmental policy who would quickly be called on to lead Virginia out of a water supply crisis, as Murphy's deputy secretary. "We tried to strike a balance," said Warner. "You had Tayloe on one side as the environmentalist. And then you had Bob Burnley on the other side with the government expertise. David Paylor was the business check in between. All three ended up being a really good team."[3]

Warner made other critical appointments, including Scott Reed as an assistant secretary of natural resources, Joseph Maroon as director of conservation and recreation, Russ Baxter as the Chesapeake Bay Program coordinator, Bill Pruitt as Virginia Marine Resources commissioner and Scott Crafton as executive director of the Virginia Chesapeake Bay Local Assistance Department. "All of the agency heads were people whom I had known well and had worked with before," said Murphy. "We did not need to get to know each other. So we hit the ground running because everybody at the agency level had been working on these issues for years. There was no on-the-job training. There could not have been a better situation as far as I was concerned."[4]

As a result, expectations were high. But given the budget constraints, the team had to be creative. Nevertheless, they were going to be bold. On the

From Business Success to the Business of Governing

boat ride back from Tangier Island following a legislative retreat, Joe Maroon had an idea. The former sixteen-year veteran Virginia executive director of the Chesapeake Bay Foundation pitched a plan to make measurable conservation and environmental protection gains in the four short years of the Warner administration. "After some brainstorming, it came to me on the way back that we should have a leadership summit on natural resources that would bring together professionals and key stakeholders to advise the administration and help set an agenda," said Maroon.[5] Warner was all over the idea, given its collaborative nature. "He believes that if you bring everyone together and talk it through, you can find a solution," said Michael Lipford, state director of the Nature Conservancy's operation in Virginia.[6]

Challenge Accepted

The Governor's Natural Resources Leadership Summit held in 2003 sparked interest from the private and public sectors, local governments, NGOs, lobbyists and state agencies. "Mark Warner was the first governor to pull together all of these interests in one room," said Paylor. "We knew we had to come out of that meeting with an action plan for natural resources."[7] Over one hundred Virginia leaders in agriculture, business, land conservation, hunting, fishing, clean water, clean air and historic preservation descended on Williamsburg for the three-day strategic planning session that was facilitated by Frank Dukes of the Institute for Environmental Negotiation. The collective wisdom of the group helped develop a plan that was achievable by the end of the administration, and Tayloe Murphy and his team used it as a roadmap for success.

It helped that Warner set the tone from the beginning. "He said, 'Let's determine what our funding priorities are…the core functions of state government.' He considers natural resources a core function of state government."[8] In his first State of the Commonwealth address to both houses of the General Assembly, Warner reinforced Virginia's long-standing commitment to conservation, historic preservation and outdoor recreation. Accordingly, he committed to preserving open space, a passion shared by then Republican Speaker Vance Wilkins. He also pledged Virginia would pull its weight with the Chesapeake Bay Program's Mid-Atlantic partners. Finally, Warner committed to developing a comprehensive drinking water strategy, adding the self-evident line at the end of his remarks, "Clean drinking water should not be an issue in the 21st century."[9]

As Murphy had already declared water quality a defining initiative from day one, Warner was eager to talk it up publicly. There was a major snag, however: how was he going to pay for it? The first two years of the administration were dedicated to cuts and reforms with the hope of getting a structurally balanced budget. So before he could tackle an ambitious environmental venture at the taxpayers' expense, Warner started with some long-overdue improvements financed prudently by Virginia's coveted AAA credit rating. Partnering with Senator John Warner, he led a $119 million bond campaign that the voters overwhelmingly approved. "It ended up being the largest bond package ever passed for state parks and natural areas in Virginia," said Joe Maroon. "It gave us enough money to undertake the biggest expansion and modernization of state park facilities in the commonwealth's history."[10] Cabins, meeting facilities and campsites were constructed; existing state parks were upgraded; and land was acquired for new state parks and natural preserves.

Then there was the issue of the James River Reserve Fleet, the so-called Ghost Fleet of nearly one hundred decommissioned ships dating back as far as World War I anchored off the army's Fort Eustis installation in Newport News. Years ago, the Environmental Protection Agency (EPA) put a halt to the Maritime Administration's efforts to sell these ships oversees for mothballing or for scrap. The fleet held nearly eight million gallons of fuel and contained oil, asbestos, lead and other cancer-causing toxins in 2002.[11] "The governor was also concerned about the massive potential for oil spills, especially in the event of a hurricane," said Paylor.[12] That risk was unacceptable, and Warner declared the fleet an environmental time bomb. He enlisted the services of Virginia's senior U.S. senator once again as well as Congresswoman Jo Ann Davis on the House side to secure funding for scrapping most of the fleet. Now only a fraction of what existed during the Warner administration remains today.[13]

Regulatory reform was also a crucial component to Secretary Murphy's plan, especially in the case of water supply. By August 2002, freshwater reserves had been so depleted that there were at least five actual or imminent failures of local water systems. Charlottesville projected seventy-five days worth of remaining water, and Portsmouth did not know how much water it had left. The Town of Orange had a precipitous drop in water supply and came within twenty-four hours of failure. The Town of Gordonsville let its restaurants stay open only if they installed portable toilets in their parking lots, and Charlottesville could not serve water in restaurants. Amherst was vigorously digging a seventeen-mile pipeline to the James River. At various

From Business Success to the Business of Governing

times during the drought, there were more than five thousand private well failures. Warner had a crisis on his hands, and there was no existing playbook. So with the DEQ's Paylor as the executive branch drought coordinator, the governor had eyes and ears on the situation, and he was able to take swift action if necessary.[14]

Accordingly, Warner issued Executive Order 33 just before Labor Day, limiting surface and ground water use, essentially prohibiting lawn and golf course watering, personal car washing and the filling of swimming pools. Although unpopular with many homeowners and businesses, it was intended to be protective, not punitive. This order also did not come as a surprise. Warner had already convened a drought summit earlier in the summer and then signed Executive Order 19 weeks later that continued the Gilmore administration's statewide emergency declaration. Paylor was on top of the situation, leading the Drought Monitoring Task Force, synchronizing efforts with the Agriculture and Forestry Secretariats as well as local governments, making plans for water distribution centers around the state, and even arranging for milk trucks to haul water during the day if the situation took a turn for the worse.[15]

All of the preparations ended up being a drill, as it turned out, with the next twenty-four-month period being among the wettest on record. But what resulted from this crisis was a statewide drought-monitoring framework that would require locally developed plans with metrics and an early warning system so that the State Water Control Board could communicate with local governments in advance of future water supply crises. "The drought proved that a lack of knowledge, data and information about water resources left the Commonwealth powerless to plan and prepare not only for future droughts but also for inevitable increased demands on water for both instream and offstream uses," said Mark Rubin, executive director of the Virginia Center for Consensus Building. "Consequently, future environmental, economic and health needs of the Commonwealth were all at risk of not being met."[16] Virginia's preeminent alternative dispute resolution practitioner, Rubin successfully mediated the regulation overhaul process after bringing a host of stakeholders together. The legislature signed off on the plan a year later.[17]

Warner took a similar approach with storm water management, which for years had been handled by three state agencies and four boards. The process was clearly in need of reform. Out of the Natural Resources Leadership Summit came the recommendation that a study be conducted

to consolidate and streamline the process within state government. The interagency team, led by Maroon, went to work. By 2004, stakeholders had an agreement to consolidate the state storm water program into a single state agency and single board, and the General Assembly unanimously codified it.[18]

GAME CHANGE

At the end of Warner's first legislative session, when budget woes had worsened, Murphy laid out a vision for managing natural resources in the event that the commonwealth's financial situation improved. "I told the governor that we needed to reduce nitrogen and phosphorous as far as the Bay is concerned," said Murphy. "I also advised him that we needed to do something to help sewage treatment plants reduce their nutrient content, and we had to develop programs to reduce nonpoint source pollution resulting from agriculture and urban lands."[19]

Relentless in his pursuit of environmental causes, Murphy is direct. After all, he knows the subject well, having penned the Chesapeake Bay Preservation Act while sitting at his kitchen table. "When you talk to him," said Warner, "Tayloe so quickly goes into the weeds that unless you are an expert, you can't follow him."[20] It's a character trait that Murphy embraces. "Warner always accused me of getting into so much detail that he didn't understand what I was saying," said Murphy. "He was fond of telling others that I was the most passive aggressive member of his administration. He'd say, 'Tayloe would come in and just barrage me with details that I was not familiar with, and I'd say OK, just go ahead and do it.'"[21]

Before Warner took office, Virginia signed on to the Chesapeake 2000 Agreement to do its part in reducing nutrient pollution resulting from a number of sources, including fertilizer, soil erosion, storm water runoff and wastewater. "It went much further than its predecessors, and it is a detailed document with commitments ranging from land use to water quality to habitat protection," said Murphy. "It also set forth a process to remove the Bay and its tidal tributaries from EPA's 'dirty waters' list by 2010."[22]

By 2003, it was clear that Chesapeake Bay cleanup efforts, like much of the bay itself, had grown stagnant. It was time for Virginia to take the lead in the region. Fortunately, Warner and Murphy were in charge of the Chesapeake Bay Program's policymaking boards. While Warner chaired

the Chesapeake Executive Council, Murphy was his counterpart on the Principals' Staff Committee, which included advisors to each of the council members. In addition, Delegate Bob Bloxom was chair of the Chesapeake Bay Commission and had a seat on the council. Bloxom, a Republican from the Eastern Shore, would later join the Warner administration as Virginia's first secretary of agriculture and forestry.[23]

Commemorating the twentieth anniversary of the first Chesapeake Bay Agreement in 1983, Virginia hosted the council's annual meeting at George Mason University in Fairfax. Murphy presented a plan that was purely voluntary but asked for a shared commitment to accept individual pollution caps and agree on the reductions needed to reach those caps. He worked diligently to lay the groundwork, and as a result, Murphy's calm disposition and traditional Virginia-gentleman persona paved the way for an agreement. By the time the meeting was over, representatives from the District of Columbia and six bay states, including Delaware, Maryland, New York, Pennsylvania, Virginia and West Virginia, entered into a memorandum of agreement. It was solidified by the end of the year. For certain, the commitment was not going to be cheap. "In order to achieve its reduction goals and thereafter stay within its cap," said Murphy, "each jurisdiction had to change agricultural practices, land development standards, wastewater treatment and storm water management requirements and the way in which septic tanks were used. They even had to change the way they controlled air pollution in order to protect the bay from harmful nutrients."[24]

Warner was determined to keep the promise he made in his first address to the General Assembly. Clean water was no longer going to be a luxury. So in his outgoing budget, the governor proposed an unprecedented one-time, $200 million deposit to the Water Quality Improvement Fund.[25] Enacted in 1997 and drafted by Murphy while he served in the House of Delegates, the fund helps local governments pay for improvements to wastewater treatment plants in the Chesapeake Bay watershed.

Warner's funding pitch complemented a multiyear regulatory process that began in the early days of his term. "We were breaking new ground, because no state had ever adopted regulations requiring nutrient limits to be placed on wastewater treatment plants," said Murphy, who even got the EPA on board.[26] Rebecca Hanmer, a charter member of the agency who became executive director of the EPA's Chesapeake Bay Program in 2002, testified to a legislative committee in favor of Virginia's regulations. Hanmer's trip from Annapolis to Richmond was unconventional because the EPA doesn't typically get involved in the regulatory process at the state

Under Warner's leadership, a series of regulatory and legislative wins helped Virginia achieve the cleanest water standards in the country. *Michaele White.*

level until regulations have been adopted. Once that happens, the agency reviews the regulations to ensure they comply with the Clean Water Act. The traditional after-the-fact input would not have helped in this case and did not apply in the first place since the Clean Water Act does not require nutrient limits. "Hanmer's testimony was really quite a coup," said Murphy.[27] The administration also backed a creative nutrient credit-trading program, so smaller dischargers could buy or exchange credits from larger ones in order to stay below their limits.[28] Adding that to the long list of regulatory and legislative wins under the intrepid leadership of Tayloe Murphy, the Old Dominion had realized its vision for a healthier bay and a bold environmental agenda. "Before I knew it," said Warner, "Virginia had the cleanest water standards in the country."[29]

17
HANDS-ON POLICYMAKING

Agenda Setting

When President George W. Bush signed the No Child Left Behind Act (NCLB) into law in early 2002, Virginia's education policymakers went into overdrive. Jo Lynne DeMary, a Republican appointee under Governor Gilmore whom Mark Warner tapped to serve in his own administration, was the linchpin. As superintendent of public instruction, she was the state's top K-12 education administrator and the first woman to hold the job since the public school system was created in 1870. DeMary initially joined the Department of Education as an assistant superintendent under the Allen administration. For nearly a decade thereafter, she spearheaded what became the Standards of Learning (SOL) program, establishing achievement benchmarks in core subjects for all students. So it was only natural, given her previous service under two Republicans, that there be some fear of political friction. "I think she was so afraid that I was going to come in as a Democrat and weaken the SOLs," said Warner. "Instead, we didn't retreat on the SOLs. We became great partners."[1]

DeMary spent almost the entire summer during Warner's first year with her senior-level staff on the third floor of the capitol, which at the time housed the governor's office. Dr. Belle Wheelan, secretary of education, as well as members of the governor's policy team joined the brainstorming sessions. And of course, the governor was there, too. "We'd spend hours in my conference room trying to work through ideas," said Warner, who wanted

to make sure DeMary's staff knew their roles were critical and that they had his attention. Likewise, Warner would also make visits over to the Department of Education to speak with employees and get their buy in. "We were trying to break through the notion that the state bureaucracy wasn't always just going to be a pain in the neck to the local school divisions," he says.[2]

The lack of funding was the driving force behind Warner's strategy sessions. "It became obvious within the first couple of months that we weren't going to have money for education, at least in the short run," recalled Warner, "but I thought, 'How could we take a more entrepreneurial approach?'"[3] It was that thinking that became the basis for his Education for a Lifetime initiative, a series of reform measures tested out over the course of the administration. In Warner's more or less education incubator, all ideas were welcome, but they needed to be carefully planned with a way to evaluate effectiveness. "This man, he works 20 hours a day and he expects everyone who works for him to work that much, too," said DeMary. "He was very much a hands-on governor. He wanted to know what was working and how do you know this is working. If you couldn't give him that data, you were going to have a hard time seeing it funded in the future."[4]

During this process of basically throwing ideas at the wall to see what would stick, there was no single area of focus. While K-12 education

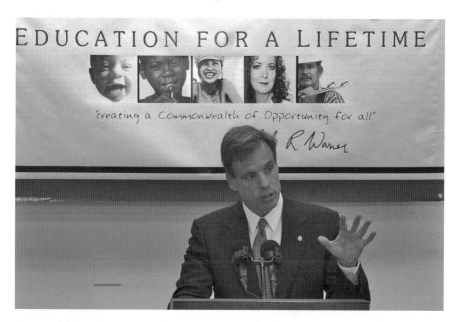

Under his Education for a Lifetime initiative, Warner focused on early childhood learning to job retraining and higher education. *Michaele White.*

reform was the centerpiece, it didn't begin or end there. "First, we all must acknowledge that a child's education does not start with kindergarten, or even pre-kindergarten," said Warner. "It starts much earlier. In the formative years, research overwhelmingly demonstrates that a system focusing on the first five years of a child's life can dramatically improve school performance in later years. If children are going to succeed in school, they must come ready to learn."[5] Warner worked closely with members of his Virginia Early Learning Council and dedicated resources from his cabinet to help form the Virginia Early Childhood Foundation, a statewide public-private partnership that marries prekindergarten education with future workforce and economic development goals.[6]

At the other end of the spectrum, higher education was in need of some attention. Warner signed Executive Order 8 a month into his term, establishing the Advisory Commission on Higher Education Board Appointments and tapped his former Columbia Capital partner Jim Murray as chairman. "He had been concerned for a long time that some appointments seem to have been made with the goal of promoting a certain political ideology rather than advancing the best interests of higher education in Virginia," said Peter Blake, who served as secretary of education at the end of the Warner administration.[7] While the commission's recommendations are nonbinding, they do help provide a buffer and an effective screening process to review qualifications and ensure diversity on all levels. The idea has made an already politicized process less partisan, and as a result, subsequent administrations followed suit by continuing the practice, prompting the General Assembly to codify it.

For years, state dollars to Virginia's two- and four-year institutions have steadily declined. At the same time, the legislature worked to limit the number of out-of-state students and maintained pressure on governing boards to keep tuition low. "As growing financial strain was put on the universities, they would go through these periods of feast or famine," said Warner, "where we would fund maybe not the most worthy project one year or cut a good project another."[8] In 2002, he spearheaded an effort with Senator John Chichester to alleviate some stress on schools in the form of a $900 million bond capital package, which the voters overwhelmingly approved.[9] But it would take a major policy shift with bipartisan support to give schools the opportunity for the long-term operating sustainability they desired.

Almost two decades of study and bargaining led to a creative strategy the General Assembly would ultimately have to approve in 2005. That is when the concept of higher education restructuring came into the picture, and it hinged on giving universities flexibility in budgeting, operations and setting tuition rates among other items on their wish lists. Decentralizing some of

the decision-making power in Richmond, however, would not come easily. "Government agencies wanted to hold on to their authority," said Blake. "Legislators wanted to make sure they still retained control over issues such as access and affordability. Employee groups wanted to protect their salaries, benefits, and working conditions."[10]

As Warner and General Assembly leaders, principally Senator Tommy Norment, promised to keep a watchful eye on accountability, there would have to be a trade-off. In exchange for more financial and administrative autonomy, schools operating under the Restructuring Act would sign management agreements with the commonwealth and commit to a number of goals, including but not limited to making tuition more affordable, increasing access, instituting strategic and six-year financial plans, investing in research, helping spur economic development in their regions and developing universal articulation agreements with community colleges so students wishing to transfer would do so with their credits intact.[11]

Since the law went info effect, the College of William & Mary has launched an ambitious initiative, taking its management agreement authority to unchartered territory. Maintaining its distinctive "public ivy" reputation is paramount for America's second-oldest college and the first to become a university. The William & Mary Promise seeks to make college more affordable and attainable for middle-income families by locking in tuition rates for in-state students. "We're going to tell you upfront and give you that ironclad contract, that your tuition will be the same in year four as it was in year one," said Todd Stottlemyer, a top Northern Virginia technology CEO and rector of William & Mary's Board of Visitors.[12] The new model for higher education takes direct aim at the burden of student debt by providing tuition predictability and increasing need-based financial aid. The promise also commits William & Mary to accepting a greater number of in-state students, raising faculty salaries to a more competitive level and pursuing a business innovation strategy to help the university both realize savings and generate revenue.[13] The University of Virginia followed William & Mary's lead in March 2015 by approving a similar model called "Affordable Excellence."

Reforms and Results

Warner's education reform summer boot camp produced a series of initiatives that would benefit from lengthier development stages. But there

was one that didn't have the luxury of time: Partnership for Achieving Successful Schools, or PASS. DeMary explains:

> *It was his first effort to address what to do with the lowest-performing schools. Warner's idea was to take the highest-performing schools and partner them with the lowest-performing schools. No one but the governor could meet with superintendents and convince them to lend their most effective teachers and principals to other schools not in their district—or even their region of the state—to work with PASS schools on what they needed to do to improve.*[14]

Launched in July 2002 in the advent of NCLB, PASS was partially inspired by Warner's involvement with Governor Allen in the Communities in Schools program during the '90s. Private-sector buy in was fundamental. That meant engaging the business community, faith-based groups and community leaders. But at the heart of the issue was getting superintendents, principals and teachers from PASS-targeted schools to understand Warner's intentions. "We put a lot of time into thinking about PASS and convincing school divisions that we were not going to bash them," he says. "That was the whole key. The message was, 'We actually want to help you, not try to embarrass you.'"[15]

In addition to seeking direct community involvement in the schools, PASS had three main objectives: increase student reading and math SOL achievement levels, promote stronger parental engagement and build the capacity for success through professional development and institutional support measures.[16] "And while it seemed like it was a small thing at first," said Warner, "I made sure that I visited all of these schools and oftentimes these were the schools, [both urban and rural, that] not only had never seen a governor, but oftentimes had never seen a mayor, a councilperson, and in some cases I don't think had even seen a local school board member."[17]

Warner kept that commitment and even made return visits when schools dramatically improved SOL scores or became fully accredited. That was indeed the case with Covington's Jeter-Watson Intermediate School in Southwest Virginia. Making good on a promise from 2002, Warner came back and danced with all of the students in the gym. Soon thereafter, late-night comedian Dennis Miller poked fun at his rendition of the Funky Chicken. When it came to education reform, Warner had no shame, and it showed in the results. By 2005, PASS had proved its effectiveness with dramatic double-digit increases in SOL passage rates. In reading, it jumped

Warner promised to return to schools that dramatically improved their SOL scores and celebrate with the students and teachers. *Michaele White.*

twenty points from 47 percent to 67. At the same time, math passage rates increased by twenty-eight points from 44 percent to 72.[18]

The approach used with PASS was also applied on the individual student level with a program called Project Graduation. Just as Warner was not willing to let schools falter without a fight, he declared all hands on deck for juniors and seniors in danger of failing or dropping out. "The question we faced in Virginia was how to assist those students at risk of failure without sacrificing accountability or gutting the standards that are so important," he says.[19] A critical deadline was looming in 2004. It was the first year that students could not graduate unless they passed their SOL assessments. The Warner-DeMary team churned out a hands-on initiative targeting thousands of students with the aid of summer course work, online learning and one-on-one tutoring.

Project Graduation would once again ask more of teachers and administrators in a resource-strapped system, but they were willing to give more of their time if it meant the difference between a student graduating or falling between the cracks. DeMary recalls Warner saying, "We had to be prepared to walk the extra mile with students who needed help and were willing to do their part."[20] The hard work all around paid off, and Virginia's graduation rate skyrocketed over the next couple of years to 94.6 percent in 2005.[21]

From Business Success to the Business of Governing

With Education for a Lifetime in full effect, the reforms kept rolling out. Warner was operating under the premise that his team could still make meaningful changes on the cheap. He had already asked all state agencies to tighten their belts, as Virginia's financial outlook did not look promising. So right out of his business playbook and on a voluntary basis, Warner offered up his Efficiency Review pilot project to superintendents. School divisions have traditionally been bashed, perhaps unfairly, about their overhead costs. Warner wanted to see if that was truly the case. The only way to know was for auditors to get the facts and drill down on the data.

Just as it was with PASS, this accountability review process was collaborative; it was not intended to create a gotcha situation. "My argument to the superintendents was, 'If you want me to fight for more school assistance, you've got to be willing to let us take a look and let us see that you're not wasting a lot of money.'"[22] At the close of the Warner administration, nine school divisions had participated in the review process, racking up the potential for nearly $10 million in annual savings, which ranged from school bus procurement and route efficiency to reducing overtime expenses and energy costs.[23]

Also building on PASS principles, Warner came up with an idea that relied on a proven business practice. He delivered a speech to the Education Commission of the States in early 2004 entitled "High-Quality Teachers for Hard-to-Staff Schools," and Jo Lynne DeMary was sitting in the audience. It was almost as if Warner was speaking directly to her when he asked aloud, "Why doesn't education borrow concepts from business and apply them to some of our schools?...When we have a business that's failing, we say the business is failing and hire a turnaround specialist to turn it around. And if they don't, we close it. Why don't we apply that principal to education?"[24]

Warner gave DeMary a new mission upon her return to Richmond. "He said he wanted to have ten turnaround specialists when school started the next fall."[25] It was the first she had heard of a sub-specialist group of principals who would be trained to go into a school and turn it around in a relatively short amount of time with the idea that then someone would take over in a more sustainable role. The state would then deploy that specialist to another school with the same expectation. To be successful in this role, these educator executives would be "armed with skills from the business world, such as finance and accounting, organizational and crisis management, and business law," said Warner.[26]

With just months to pull the program together, DeMary turned to the University of Virginia's Curry School of Education and the Darden School of Business for help. The professional schools used a previously established

Mark Warner the Dealmaker

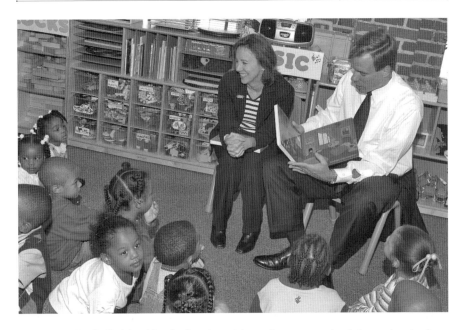

First Lady Lisa Collis joined her husband on visits to elementary schools in rural and urban areas alike. *Michaele White.*

joint venture, the Darden/Curry Partnership for Leaders in Education, as the vehicle for launching the Virginia School Turnaround Specialist Program. While the first two cohorts were initially funded with state Department of Education dollars, Microsoft provided a multimillion-dollar expansion investment in 2004.[27] Today, the Warner-initiated reform measure, now called the University of Virginia School Turnaround Program, is the only one of its kind in the country. Taking a two-pronged approach, it not only helps school districts build capacity but also provides support, resources and training for turnaround principals.

Head Starts and Second Chances

On the heels of an education summit in Washington, D.C., with fellow governors, top business leaders, and education experts from around the country, Mark Warner launched an action agenda unlike anything that had been seen before. It was the winter of 2005, and he was chairman of the National Governors Association (NGA). Heading up this bipartisan group

of the country's chief executives afforded him at least one perk—a pet policy project. "I chose the high school as an area for focus," he says, "because my belief is that the high school has been really kind of the forgotten part of our whole education system and not the subject of a great deal of scrutiny, reform, or review over the last couple of decades."[28]

For Warner, the concept was inspired by his own experience as a young man. In fact, once he was accepted to college, he already had one foot out the door. "For too many students the senior year lacks academic challenges and adequate preparation for the workplace," he says. "For those students going to college, the day that acceptance letter arrives in the mail is usually the day their interest in high school vanishes. For those students not going to college, a high school diploma is simply not enough preparation for what is to come when they enter the workforce."[29]

Before he launched the NGA's nationwide high school reform agenda, Warner used Virginia as his proving ground. Working with his advisors and the DeMary-led Department of Education team, Warner unveiled his Senior Year Plus program. A key component dubbed Early College Scholars offered students an opportunity to get a head start while saving money. With the rising costs of college, [we wanted to] somehow give a kid the option to graduate in seven semesters instead of eight by earning a semester's worth in high school," said Warner.[30] Students could pursue credits through advanced placement (AP) and dual enrollment courses, distance-learning classes, the International Baccalaureate program and the College-Level Examination Program."[31]

In many cases around the state, AP course offerings were limited. As a result, Warner pushed for a web-based option called the Virtual Advanced Placement School that, after merging with the existing Virginia Satellite Educational Network, is known today as Virtual Virginia.[32] A combination of this emerging technology and buy in from education stakeholders—students, teachers, administrators and parents—Warner's expanded senior-year curriculum led to a surge in the number of students taking AP tests, including a 24 percent increase for African Americans and a 21 percent jump for Latinos.[33]

Senior Year Plus also developed an option for non-college-bound students called the Path to Industry Certification. Warner tied it to workforce development. "The bottom line is simple," he said. "Even if seniors have not planned to continue their education beyond high school, they must be prepared to enter the working world."[34] The program asked students to commit to graduating high school and, during their senior year, pursue technical training with the goal of receiving an industry certification or professional license. "We also established a statewide Career and Technical

Education Foundation," added Warner, "to help bridge the gap between the large number of technical jobs available throughout Virginia and the comparatively small number of qualified applicants to fill them."[35]

While not necessarily under the Senior Year Plus umbrella, Warner took immediate action at the onset of his term to help swaths of Southside and Southwest Virginia hit hard by sudden unemployment. Called Race to GED, the partnership with the motorsports industry encourages adults lacking a high school diploma to obtain their General Educational Development certificate, or GED, in a matter of several months instead of a year. "The economic benefits of a GED are indisputable," said Warner, who estimates that more than 800,000 adult Virginians lack the certificate or even a high school diploma.[36] Using the "Accelerate Your Earnings" slogan, Warner recruited NASCAR teams to spread the word and even named Emporia-native driver Elliott Sadler as the official spokesman. The marketing plan proved to be a success, with 35,000 Virginians earning their GEDs by the end of Warner's term.[37] "It has been especially popular with men and women who have lost jobs in traditional industries, such as textiles, and who need a GED to take advantage of educational benefits under the federal trade act of 2002," he said.[38]

Warner's education policy team also worked with community colleges and workforce centers to offer a Career Readiness Certificate so that individuals have evidence of a range of workforce skills in order to expedite their job-seeking process. As someone who made hard sells on a daily basis trying to lure CEOs, Warner saw the necessity early on to connect education reforms to the commonwealth's economic development needs. "When we recruit new industries to Virginia," he said, "the first questions employers ask is about our workforce. They want to know not just about our K-12 system and the quality of our high school graduates, but also about continuing education opportunities available at our community colleges or four-year institutions. They are also interested in the flexibility of our workforce development programs to respond to changing needs from industry."[39] Looking at the numbers, it is easy to measure the success of Warner's education reforms, which spanned the learning continuum. What's more significant is the way in which he and Jo Lynne DeMary's team went about it. After four years of trial and error, the administration set a precedent that creative problem solving and stakeholder deal making with little funds can pay off in a large education bureaucracy. "He clearly understands that there's no one silver bullet," said DeMary of Warner. "That's why Education for a Lifetime was so significant, with its focus from early childhood learning to job retraining and higher education."[40]

18
BREAKING GROUND

The first inscription reads, "It seemed like reaching for the moon." The second says, "The legal system can force open doors and sometimes even knock down walls, but it cannot build bridges. That job belongs to you and me."[1] In the northeast corner of Virginia's Capitol Square, just a few steps from the Executive Mansion's gates, sits a bronze-and-granite memorial honoring civil rights pioneers whose impact extends well beyond the borders of the Old Dominion. Until 2008, the square featured many prominent Virginians, including Thomas Jefferson, George Washington, Stonewall Jackson and Edgar Allen Poe. All male. All white. All dead.

On a blistering hot July morning in 2008, that all changed. It had been three years since First Lady Lisa Collis kicked off a campaign to raise funds for the first-of-its-kind tribute to ordinary Virginians with extraordinary courage. The idea originated in the Collis-Warner household. "During our first years in the Executive Mansion, my youngest daughter and I would take evening walks around Capitol Square and discuss the individuals and history represented by the statues," said Collis. "It struck me, as I'm sure it has many Virginians, that an important piece of Virginia's history was not represented there."[2] Seven-year-old Eliza Warner wondered why civil rights figures were not among those honored. "And know-it-all mom that I am or not, I realized I really couldn't explain why to my child," said Collis. "And so I worked to rectify that."[3]

In 2005, through executive order and later by General Assembly action, the planning process began. In a matter of three years, a commission

was appointed, $2.8 million was raised and sculptor Stanley Bleifeld had finalized a design intended to be "a living memorial."[4] Perhaps in contrast to existing landmarks, Bliefeld's concept for the Civil Rights Memorial conveys optimism and sparks conversation. "This is the first statue on the grounds that isn't just about yesterday," said Tim Kaine, who succeeded Warner as governor and was later elected to the U.S. Senate in 2012. "It is about today and tomorrow."[5] Kaine presided over the dedication, which attracted a crowd of over four thousand people. In stark contrast to the existing memorials, the civil rights counterpart features children who fought for equality that segregation had denied them. "We decided to start acknowledging these moments in history when unsung Virginians, everyday citizens, were at the forefront," said Viola Baskerville, who, as secretary of administration under Kaine, oversaw the memorial's construction from start to finish.[6] An outspoken civil rights leader, Baskerville previously served on Richmond City Council and as a member of the House of Delegates.

Protest and Defiance

Four years before Rosa Parks refused a Montgomery, Alabama bus driver's demand that she give up her seat for a white passenger, there was Barbara Rose Johns, a sixteen-year-old student at Robert R. Moton High in Southside Virginia. On April 23, 1951, Johns led a walkout of 450 classmates as conditions at her dilapidated Prince Edward County school reached a tipping point. The school was overcrowded, underfunded and rundown. "If it rained, it rained on your papers," said John Watson, who was a junior at the time. "If it were cold, you had to sit around a pot-belly stove in order to get warm, and then you're too hot around the pot belly stove. I mean the conditions were atrocious. They treated us worse then they treated their animals."[7]

Racial segregation was alive and well. While all African American students attended Moton, a separate whites-only high school was opened on the other side of Farmville. Under the Supreme Court's 1896 *Plessy v. Ferguson* decision, the "separate but equal" doctrine was in full effect in Prince Edward County. The inequity had gone too far, and Johns took a stand. The walkout prompted National Association for the Advancement of Colored People (NAACP) attorneys Oliver Hill Sr. and Spottswood Robinson III to pay the students a visit. However, the legal duo had every intention of asking them to call off the strike. "But we got there, they had such high morale…we didn't have

the heart to turn them down," said Hill.[8] Johns's daughter Terry Harrison recalls her mother's tenacity. "She said to me that 'It was something that I saw that was wrong that I felt that I had to do,' and that was it. And in a way that's kind of how she was. If she saw an injustice, she would correct it, she would change it. She had a strong sense of right and wrong."[9]

Hill and Robinson took the *Davis v. County School Board of Prince Edward County* case all the way to the Supreme Court. It was the only one of its kind to have originated from a student protest, and *Davis* was combined with four others into *Brown v. Board of Education of Topeka, Kansas*, in which the court ultimately declared segregation in public education to be unconstitutional. Unfortunately for the students, the fight was far from over. Virginia's response in 1956 was to defy integration altogether through several legislative maneuvers known as "Massive Resistance."[10] For the next ten years, hundreds of Prince Edward students either moved away to attend school or abandoned their education entirely. A similar fate fell on children in the cities of Charlottesville and Norfolk, as well as those in Warren County. Furthermore, Prince Edward's board of supervisors defunded the schools in 1959, which affected not only African American students but all of the families unable to afford tuition at the private academies that subsequently opened.[11]

It wasn't until a decade after *Brown* that the Supreme Court forced schools to reopen with its *Griffin v. County School Board of Prince Edward* decision, citing a violation of the Equal Protection Clause under the Fourteenth Amendment. It was the second time a case originating in Prince Edward put the national spotlight on Virginia. And in the case of *Griffin*, the brave actions of a small town forced a civil rights victory for the rest of the country, guaranteeing all children the constitutional right to an education.[12]

Moving Forward

Breaking ground in the winter of 2008 signaled the memorial's impending reality. It also symbolized the weight of the actions taken by Barbara Johns and her fellow students over half a century earlier. "Had they not believed they could change things and could find a better world, I doubt they would have done it," said Kaine.[13] The memorial's power to inspire the next generation cannot be understated. "What better story to appeal to kids than a monument of kids taking some action," added Collis. "It's an inspiring story, and the idea that it was instigated by a 16-year-old is fascinating."[14]

Across Capitol Square, in the northwest corner, stands the figure of Harry F. Byrd Sr., former Virginia governor and U.S. Senate fixture for over thirty years. He was also the architect of Massive Resistance. It is only appropriate that the Civil Rights Memorial have equal billing on the people's grounds, which date back to the late eighteenth century. The four-sided memorial features Barbara Johns, Farmville civil rights activist Reverend L. Francis Griffin and Oliver Hill right alongside Spottswood Robinson and a group of white and African American children.[15] Warner previously honored Hill in 2005 by renaming the old finance building on Capitol Square in his honor, making him the first African American to be immortalized in a state-owned building.[16] At the beginning of his legal career in Richmond, Hill would borrow books from the law library at the Virginia Supreme Court of Appeals, which at the time was located in the Finance Building. Oliver Hill Jr. read his father's statement at the dedication, reflecting on how far he and the civil rights movement had come. Hill said, "Who would have thought back in 1939, given the racial climate that existed in Richmond at the time, that 66 years later that Supreme Court building would be named after me."[17] At 100, Hill passed away in 2007.

Warner's toughest challenge in overcoming Virginia's preceding racial intolerance came to a head in the heat of the 2004 General Assembly session. It started with an idea from Ken Woodley, editor of the *Farmville Herald*, as he was driving on Route 460 to work in February the year before. During the 2003 session, the General Assembly was considering expressing, as a body, its "profound regret" for Massive Resistance. At the same time, Prince Edward County's leaders were debating offering honorary diplomas to Moton High School students who were denied an education half a century earlier. Woodley thought to himself, "Education was stolen from these children, now adults, and we need to try to give back that which was stolen. The people were still among us, so there was a possibility of giving back the education."[18] Woodley knew he was on to something big, and it turned out to be a mission to help Virginia move beyond the past and look toward a more productive future.

Given the *Herald*'s segregationist history, he also had some internal healing to bring about in Farmville. "When I became editor it was something I felt called to do, to stay here and do what I could to help bring the community back together," said Woodley. "Racial harmony is always something I've believed in. When I learned that this paper had been a loud voice for what happened during Massive Resistance, I was determined that it would be a louder voice for change."[19] So the veteran

newsman got right to work. In an editorial, he proposed establishing a state-funded scholarship program and fund for the black and white students who were denied an education when schools were closed from 1959 to 1964. Eligible students would be able to pursue a variety of educational opportunities, including a GED certificate, adult high school diploma, career-technical skills training and an undergraduate degree from one of Virginia's institutions of higher education.

Woodley then sought patrons for legislation in Delegate Viola Baskerville and Senator Benjamin Lambert, who both agreed to introduce bills during the following session. Lambert was the first African American to serve on any money committee in the General Assembly.[20] After eight years in the House of Delegates, he took to the Senate when Doug Wilder was elected lieutenant governor. He retired at the end of a political career spanning three decades and later passed away in 2014.

Woodley's relentless pursuit continued beyond his legislative partners. As word was spreading around Prince Edward County, he called Oliver Hill and John Stokes, who was Moton's senior class president when Barbara Johns led the 1951 student walkout. He also reached out to Mark Warner. Back in 1999, Woodley and Warner had participated in a symposium at Hampden-Sydney College commemorating the fortieth anniversary of the Prince Edward school closings. "I knew that his heart beat for civil rights," said Woodley. "We spoke then, in fact, and he wondered aloud to me what specifically might be done some day; neither of us had a specific idea then—and I believed, correctly, that Mark would be crucial to getting state funding for the scholarships."[21] Given his previous conversations with Warner on the subject, Woodley pitched his plan to the governor over the phone in the spring of 2003 and then set up a meeting in Richmond, during which Warner looked directly at him said, "I will fight with you."[22] The fight was not going to be an easy one, and Warner knew it. But he believes that access to quality education is a fundamental American value, and a budget skirmish was not going to get in the way of doing the right thing.

It wasn't the first or last time Warner would take a stand on principle. He amended an executive order to ban the discrimination of state employees on the basis of sexual orientation.[23] He appointed the first liaison to the Latino community, held Virginia's inaugural Latino outreach summit and created a policy-driven commission to advise him on health, education and business issues.[24] Warner also sought reforms to boost women and minority participation in the state's procurement process.[25] He was going to do

everything in his power as chief executive to fight disparities, and in the situation of Moton, he was going to fight injustice.

Momentum for the scholarships continued to build and came to a head in 2004. At the beginning of the General Assembly session, Baskerville unveiled the legislation during a meeting of the *Brown v. Board of Education* Fiftieth Anniversary Commission. Five of Virginia's former governors endorsed the proposal a month later in a show of bipartisanship. Gerald Baliles and Chuck Robb first issued a joint statement with their Republican counterpart Linwood Holton in support of the measure's $2 million fund. And then in separate pronouncements, Governors George Allen and Jim Gilmore joined the cause.[26] Shortly thereafter, when the General Assembly appropriated a mere fraction of the requested amount, Warner balked and indicated he would send down a budget amendment for the full amount. The Senate Finance Committee had set aside only $100,000, and the House Appropriations Committee opted against it entirely.[27] With the fund's fate caught up in protracted budget debate, Warner held a ceremonial bill signing on the steps of the capitol and invited a couple hundred supporters of the cause from Prince Edward County to join him, most of whom were the very

Warner ceremonially signed legislation creating the *Brown v. Board of Education* Scholarship Program as a couple hundred Prince Edward County residents observed on the steps of the capitol. *Michaele White.*

From Business Success to the Business of Governing

ones denied an education so long ago. "It was a very emotional scene on the South Portico steps, realizing that these folks were suddenly getting a chance to get a college education," said Warner.[28] Days later, Virginia's senior U.S. senator stepped up to the plate.

"John Warner called me and said, 'Governor, I was talking to a friend of mine recently, and he said that he would put up $2 million for the scholarship.'"[29] At first, the elder Warner kept quiet the source of the generous offer—Albemarle philanthropist John Kluge, a self-made billionaire who passed away in 2010. Although grateful for the gesture, Mark Warner was adamant that the state should bear some responsibility. As a result, he brokered a deal in which Kluge offered a $1 million matching gift as long as the General Assembly did its part. And by mid-June, the legislature worked out its budget differences and appropriated its share of the scholarship fund by a near-unanimous vote.[30]

19
A STATESMAN EMERGES

CRISIS MANAGER

Mark Warner could not have imagined that public safety, particularly homeland security, would be a critical part of his governorship. "He dealt with more major disasters in his four years than any governor over the last forty years," said Michael Cline, former state director of the Department of Emergency Management.[1] Cline retired in 2014 after more than four decades with the agency, serving as point man on twenty-seven disasters. "There was never a week that went by that there wasn't something unexpected that would come up," added Warner. "I particularly remember those first 12 or 18 months when it seemed like there was almost divine interference in terms of the number of droughts and floods and avian flu and hurricanes and snipers and tire fires. You name the catastrophe, natural or man-made, and it seems like we had them all in those first months."[2]

Warner isn't exaggerating. Virginia was in an almost perpetual state of emergency response from the day he moved into the Governor's Mansion with his wife, Lisa, and their three daughters, Madison, Gillian and Eliza. As governor-elect, he was already directing Virginia's terrorism preparedness efforts and grappling with a growing state budget shortfall. He was also coordinating the state's immediate and long-term recovery plans for rural areas rocked by sudden, massive layoffs. But less than a week after the inauguration, the first domino fell.

An Appalachian Law School student went on a rampage, fatally shooting three and injuring three others. A couple months later, Mother Nature

stepped in. Warner declared a state of emergency in Southwest Virginia to assist areas hit hard by heavy rains, mudslides and flash flooding. The next week in Roanoke, an arsonist was responsible for the largest tire fire in the state that spread to nearly 4 million tires.[3] Tornadoes and subsequent flooding returned to Southwest Virginia in late April, causing serious damage to several hundred homes. An avian flu outbreak in the Shenandoah Valley dragged out through the summer, costing the poultry industry more than $130 million.[4] Then there was a statewide drought that peaked around Labor Day.

A year later, Warner readied Virginia for Hurricane Isabel, which began as a category 5 storm. In preparation, the navy ordered its ships in Hampton Roads out of harms way, officials at the Hampton Veterans Affairs Medical Center evacuated hundreds of patients, Amtrak canceled rail travel south of the nation's capital and Dominion primed seven thousand members of its workforce for power restoration. It also increased security measures at the Surry Power Station, home to two nuclear reactors.[5]

Warner was equally proactive. He declared a state of emergency three days in advance of the storm's reaching the coast, which was not the norm then but is now. He activated the National Guard and authorized mandatory evacuations in South Hampton Roads, including Virginia Beach and Norfolk.[6] Warner even got on a statewide conference call to reassure weary local government leaders that he would be with them through the recovery. "He made it clear that Virginia was taking all of the steps it could to prepare," said John Marshall, a former Virginia state trooper turned director of the U.S. Marshals Service who was secretary of public safety under Warner and Governor Kaine. "He reiterated that the Emergency Operations Center was there to support them and to not hesitate to call if they needed help."[7] On site, Warner's Chief of Staff Bill Leighty, a retired U.S. marine, was the quintessential problem solver. Members of the governor's cabinet were also on hand. John Marshall lent tactical and operational support in coordination with emergency management chief Michael Cline and Colonel Gerald Massengill, state police superintendent under Gilmore and Warner.

The Virginia Emergency Operations Center (VEOC) had traditionally been staffed by Cline's team, who would routinely report back to administration officials. That all changed during Hurricane Isabel. Cabinet officials and agency heads were hands on, and they weren't alone. "From the time Isabel hit Virginia and during the hours following when difficult decisions were going to have to be made, Mark Warner was at the State Police Academy with the people who had to make those decisions," said

From Business Success to the Business of Governing

Massengill, "For any red tape that needed to be cut through, he was there to cut through it."[8] Warner stayed so late into the night that he barely made it home. Isabel was creeping up the peninsula, and just before midnight, Richmond was feeling the impact. The fifteen-minute trip back was delayed due to high wind, heavy rain and a large branch blocking the road just shouting distance from Capitol Square. The debris was no match, however, for Warner's state police–issued Suburban, which barreled right over it.

Isabel resulted in thirty-three deaths. Half of Virginians were left without water or power. With a $1.6 billion price tag, over twelve thousand homes and businesses were either damaged or destroyed.[9] "Governor Warner had a crisis on his hands," said Mark Marshall, sheriff of Isle of Wight in Southside. "This was a major disaster. Clearly a lot of the localities were insufficiently prepared but trying to do the very best they could."[10] At the time, Marshall was chief of police for the small town of Smithfield, which was left paralyzed in Isabel's wake. It was unlike anything he had seen before. Several different neighborhoods were under water, power was gone except for generators, the public safety radio system was compromised and access roads to the two local hospitals were closed. Recovery became a logistical nightmare.

When the sun finally came up, Warner flew by chopper to survey the aftermath. It was the only way in or out. "Why did he come to Smithfield?"

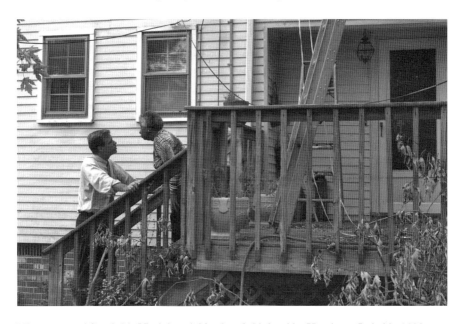

Warner toured Southside Virginia neighborhoods hit hard by Hurricane Isabel in 2003. *Michaele White.*

says Sheriff Marshall of Warner, "I think there was a certain level of frustration that the federal government was not moving quick enough. He wanted to let people know that he was trying to do everything he could and to assure them that help was on the way."[11] Seeing the desperation on people's faces taught Warner a valuable lesson at a time when they had probably lost everything. "I learned the importance of just showing up," he says. "From Poquoson to Rockbridge County, where homes were lost, to Fairfax, it was important just to show up."[12] As he arrived in Smithfield, the volunteers from the American Red Cross and the Salvation Army were scrambling to set up makeshift shelters. "I'll never forgot," remembered Marshall, "I had 400 people staged at the middle school. When the Salvation Army showed up, all the volunteers had were bologna sandwiches, but I'll tell you, at least we were able to get those people fed."[13]

Warner wasn't much for glad-handing and photo ops. He headed right over to the Smithfield Center, which Marshall estimates was feeding over five thousand people twice a day. Instead of standing around and causing a stir, he thanked all of the workers and was put to work. The gesture was more significant than Warner likely realized at the time. "He went in, rolled his sleeves up and helped hand out food," remembered Marshall. "But more importantly, he gave people

Warner worked alongside volunteers from the Salvation Army at a shelter in Smithfield after Hurricane Isabel left the small town paralyzed. *Michaele White.*

hope. They were scared. They were angry. They were experiencing all of the emotions that come with surviving a traumatic event. Mark Warner saying, 'I'm here to tell you that we are marshaling the resources that we need to get this community back on it feet' was absolutely critical."[14]

No amount of reassurance could hold back frustration in Isabel's aftermath. "There were a couple of days when ice trucks were the bane of my existence," recalled Warner. For an executive used to swift action, dealing with the Federal Emergency Management Agency's (FEMA) web of bureaucracy was daunting. "If we can't coordinate ice trucks, how can we coordinate the different levels of government in a much bigger emergency," Warner wondered at the time.[15] It turned out that trailers full of ice were parked at Langley Air Force Base in Hampton, but there was a paperwork holdup. "FEMA was on site with us, and we were able to work with them," said John Marshall. "But it was frustrating that we had resources that could not be released without the right paperwork. I know we had to document and account for everything, but it just seemed like we couldn't get things moving fast enough."[16]

Two weeks after the storm swept through Virginia, Warner appointed an assessment team to make recommendations for how both state and local

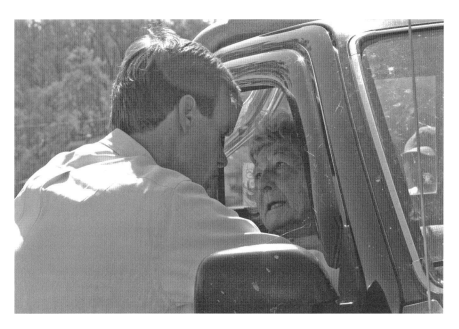

Warner reassured victims of Hurricane Isabel's destruction that help was on the way as he assessed the storm's damage all across Virginia. *Michaele White.*

response strategies could be improved for the future. He was determined to make sure in the case of another Isabel, or worse perhaps, that FEMA's shortcomings would not solely dictate the recovery process. That preparation almost came in handy when Hurricane Katrina ripped through Louisiana at the end of August 2005. Warner activated Virginia's EOC and lent Bill Leighty to Governor Kathleen Blanco to help her expedite roadblocks to federal aid and establish disaster assistance agreements with neighboring states. Warner set the tone in his own backyard by converting Fort Pickett, Virginia's Army National Guard base just south of Richmond, into "Town Pickett" as a temporary shelter for anyone displaced by the storm. It ended up being a fire drill, as FEMA did not send anyone, but the exercise proved Virginia had formalized a proactive response protocol and could expeditiously muster the resources to pull it off.[17]

Fighting Crime

Warner's public safety agenda was not just limited to disaster relief. It was also marked by a series of crime-fighting initiatives. He implemented the AMBER Alert System after bringing together broadcasters, transportation officials and law enforcement agencies to develop a coordinated response effort if a child went missing. He worked with the General Assembly to enact the Virginia Computer Crimes Act to criminalize high-volume, unsolicited bulk e-mail, or "spam," at a time when its abuse was just coming to a head. He created a task force months into the job that ended up proposing the toughest drunk driving laws in the county.[18] This was in response to statistics showing alcohol-related deaths were the highest they had been in almost a decade.[19] Warner was not alone in his crusade. First Lady Lisa Collis kicked off an Internet safety campaign to help educate children and their parents on ways to safely surf the web. Children were also at risk of falling victim to gang violence. It was a growing problem particularly among teenagers and was concentrated primarily in Northern Virginia. In response, Warner formed a state police strike force to work with local law enforcement to track gang activity and prosecute offenders. He put equal emphasis on crime prevention by launching KIDsafe Virginia, an initiative expanding in-school and community-based safety programs.[20]

Sheriff Fred Newman was at a loss on how to handle an addictive, destructive and relatively inexpensive drug that was popping up all over Washington

From Business Success to the Business of Governing

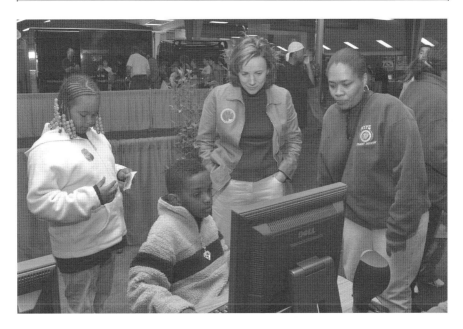

First Lady Lisa Collis kicked off an Internet safety campaign to help educate children and their parents on ways to safely surf the web. *Michaele White.*

County. Soon after he took office in 2001, methamphetamine production in "mom and pop" labs escalated. Law enforcement busted thirty-four meth labs in 2003. That number ballooned to eighty-two during the following year. It was quickly becoming an epidemic in Southwest Virginia.[21] The drug's active ingredients include ephedrine and pseudoephedrine, nonprescription decongestants contained in cold medications such as Sudafed. Newman knew there was only one way to fight back: cut off the supply. At that point in time, there was no limit to the number of bottles or boxes of Sudafed and other similar drugs shoppers could bring through the checkout line. "You could go into any grocery store or pharmacy and buy out the inventory in one sale," he says. "We had people going into Wal-Mart and pretty much clearing off the shelves, coming back a couple hours later when the shelves had been restocked and then doing it again."[22]

Producing meth is as dangerous an operation as it is a mobile and compact one. The instructions are readily available online, and the ingredients can be secured with ease. As a result, the drug spreads like wildfire. "It's a very democratic thing," said Doug King, Wythe County sheriff. "If it shows up in one place and becomes popular, it's going to become popular everywhere."[23] King served over three decades in law enforcement in Southwest Virginia

before retiring in 2014. Sheriff Shannon Zeman in neighboring Floyd County attributes the bulk of his office's investigations—break-ins, thefts and domestic disputes—to the drug. "Every time we talk to people, we say how bad meth is," added Zeman. "Statistically they say only seven percent totally recover from using meth."[24]

Warner stepped in when law enforcement's ability to manage the problem was hamstrung by the laws on the books. He determined methamphetamines to be an immediate threat to the health and safety of Virginians, and after consultation with Colonel Massengill and the state health commissioner, Dr. Bob Stroube, Warner knew he was on solid footing to take rare and somewhat controversial action. In September 2005, he signed Executive Directive 8, requiring that all corresponding precursor drugs containing ephedrine and pseudoephedrine be placed behind the counter with their sales being limited and monitored. Although the General Assembly codified the regulations during its next legislative session, law enforcement noticed an immediate impact after Warner's signature. "We saw a dramatic decline in meth cases from the day he issued the order," recalled Sheriff Newman. "In 2004 our office busted twenty-six labs. The number nosedived to six during the following year. I certainly credit that to Mark Warner's decisive action."[25]

Protecting the Integrity of the Criminal Justice System

It was important, too, for Warner that the integrity of the criminal justice system stay intact. The Virginia State Police completed a study in 2001 to try to determine whether there was a prevailing problem with discrimination by law enforcement officers in the performance of their duties on the street. The Virginia Sheriffs' Association and the Virginia Association of Chiefs of Police participated as well. The report's results were encouraging. "We had no evidence that biased policing, which includes racial profiling, appeared to be a widespread, serious problem in Virginia," he says. "However, citizens had complained to advocacy groups, legislators, and government officials that bias led to deprivations of constitutionally protected rights."[26]

Warner took those concerns seriously and addressed them head on. He tapped Secretary John Marshall to lead an advisory panel on bias-based policing, bringing together all the relevant stakeholders. He also had legislation introduced during the 2002 General Assembly session directing

the Department of Criminal Justice Services to develop a model policy and implement uniform training standards. "Professional law enforcement officers told me they had supported HB 1053 because they wanted to make sure there was not even a perception of racial profiling," recalled Warner. "They knew that perception could harm their ability to perform their duties."[27] Marshall concurred. "The commitment of law enforcement agencies to act fairly is an important ingredient to maintaining the public's trust and support, without which officers cannot be as effective as they need to be."[28]

Marshall's role was particularly critical in passage of HB 1053, because many legislators needed some convincing, having believed the bill was a slam to police. He roamed the halls of the General Assembly building to promptly eliminate any concerns. "I told them, 'No, it's not a slam. If it was, I wouldn't be supporting it because my background was in law enforcement.' I added the important point, 'We were putting in place what other states were forced to do to fix a problem. Virginia was instead taking a proactive approach.'"[29] Wanting to prevent a situation from becoming systemic, the politicians concurred by passing the bill unanimously.

At the close of his term, Warner was at the height of a contentious and drawn-out process to ensure that Virginia was balancing the scales of justice. Since taking office, he had pardoned several men wrongfully convicted of rape in separate instances, each having served significant time in prison. The clear-cut exonerations were made possible by evidence retained during the pre-DNA era of decades past. Mary Jane Burton, a well-respected forensic scientist who headed up the state's crime lab's serology department in 1970s, stored remnants of cotton swabs and samples of clothing she tested that contained blood, saliva and semen in case files on her own accord. Burton's evidence preservation was not required at the time. In fact, it broke protocol. That practice ended in 1989, when national accreditation standards required labs to return all biological evidence to the originating law enforcement agency.[30] Today, an individual arrested for a violent felony in Virginia is required to provide a saliva sample, which is entered into the state's DNA databank. Burton's work, whether anticipatory of technological advances or simply just a matter of meticulous recordkeeping, was ahead of its time.

The matter first came to Warner's attention in 2002 when he reviewed Marvin Anderson's petition for clemency. Anderson was convicted of rape two decades earlier despite an alibi corroborated by witnesses and a lack of convincing physical evidence. He was sentenced to 210 years in prison but was released on parole in 1997.[31] Anderson maintained his innocence

all along. Advances in DNA testing technology prompted his attorney, Innocence Project co-founder Peter Neufeld, to get a hold of the original case file, which included a swab taped to the paperwork—thanks to Mary Jane Burton. Retesting not only cleared Anderson but also identified the actual rapist, who was duly convicted and imprisoned. Anderson became the first Virginian to be cleared of all wrongdoing with the use of modern DNA testing.[32]

Warner directed the Department of Forensic Science, in coordination with an independent lab, to review a sample of cases on file in which DNA evidence was available but had not been tested. The result in Marvin Anderson's case was not a random occurrence. The review showed that Burton's evidence also cleared Julius Ruffin and Arthur Lee Whitfield, each wrongfully convicted of rape. As all of this was happening, the state's lab was already under scrutiny. Warner requested that the national forensic lab accrediting body perform a procedural audit of Virginia's operation, and he appointed a team of scientists to implement the report's recommendations. As the initial review of Burton's cases continued, two more men were cleared in December 2005. Warner issued absolute pardons for Willie Davidson and Phillip Thurman.[33]

The next step showed the true measure of the man. With just a month left in his term, Warner ordered an examination of thousands of remaining case files and the subsequent DNA testing of any biological evidence saved by the lab's former serologists.[34] He was the first governor to take such unprecedented action and, in doing so, opened himself up to significant personal political risk. "There was also the risk of shaking the foundations of the criminal justice system," said Bob Crouch, who served as Warner's chief deputy secretary of public safety and counselor to the governor. "I think the driving impulse was to serve the ends of justice and to affirm the public confidence in the criminal justice system by being as transparent as possible."[35]

In one of his last official actions, Warner stunned many by authorizing the nation's first post-execution genetic review of evidence. Roger Keith Coleman was executed in 1992 for the rape and murder of a family member. "Just days before his execution," recalled Warner, "Coleman's photo appeared on the cover of *TIME* magazine beneath the caption 'This Man Might Be Innocent.'"[36] Anti-death penalty advocates were convinced that the Coleman case would finally refute the argument that an innocent person had never been executed. Alternatively, some of Warner's advisors deemed the retesting too great of a gamble. The boss went with his gut. "As a governor, I presided over executions and I

considered this to be the most serious and solemn responsibility of the job," he says. "That obligation also entails a special duty to seek out the truth, no matter where it takes you."[37] Warner's roll of the dice ultimately reaffirmed Coleman's guilt. With two days to go before he left office, absolute DNA results closed the case for good.[38]

The Bipartisan Troubleshooter

Lieutenant Governor John Hager was surprised when Mark Warner asked him to serve in his cabinet. It was two days after the 2001 election, and both gentlemen were up in New York City with Governor Jim Gilmore and a team of Virginia economic development officials. The outgoing and incoming governors spoke at a luncheon for three hundred business leaders sponsored by the Virginia Chamber of Commerce called "Virginia and New York, United in Our Resolve." Before the event, members of the Virginia delegation privately toured ground zero at the Word Trade Center.[39] As the luncheon came to a close, Warner leaned over and caught Hager off guard when he asked the Republican to consider a position in the new Democratic administration. Just a few months earlier, Hager was vying for the GOP nomination for governor, losing in a convention to Attorney General Mark Earley. "I said, 'Well, that's an intriguing question…let me think about it,'" remembered Hager. "When he asked, I was passing the knife. And so I said, 'I'll certainly consider it.'"[40]

A couple weeks went by, and the two got together again. This time, Warner had a specific role in mind inspired by his own experience on 9/11. On that morning, he was in Alexandria getting ready for an upcoming debate when a friend alerted him that a plane that had crashed into the World Trade Center. After turning on the TV and watching the second plane, United Airlines Flight 175, crash into the South Tower, he got into the car and headed to his campaign headquarters, which was located about a mile from the border of Alexandria and Arlington. Warner knew he had to be with his young staffers in the midst of fear and uncertainty. Less than thirty minutes later, he was on the roof of his office building with many of them in the aftermath of the American Airlines Flight 77 crash just down the street. "To go out there and see the smoke billowing out of the Pentagon…is something that I will never forget," he recalled.[41] At that point, the debate didn't matter anymore. He was just like everyone else, concerned about his

family's safety. "All I could think about was how I was going to get my kids home, whether my wife was going to come back from campaigning on the road," said Warner.[42] Lisa Collis was headlining an event in Winchester that morning with former first ladies Jinks Holton and Lynda Johnson Robb. "At that point like virtually every other American," he said, "I realized that everything had changed in terms of where we were going to head as a country into the future.[43]

Warner needed a trusted, unifying figure to head up homeland security operations, so he pitched Hager the idea of managing Virginia's strategic and coordinated response to emerging terror threats. It came as a bit of a surprise, however. "I had thought that he was going to ask me take on something like Commerce and Trade, which I was really qualified for, having been a businessman all of my life and very interested in the future of Virginia," said Hager, who had retired as an executive vice-president with American Tobacco Company before running for elected office.[44] He knew adversity well, having contracted polio from the vaccine that nearly killed him thirty years prior. Hager was left without the use of his legs, but that did not slow him one bit. "Suddenly, my life completely changed. And I said, 'Well, how am I going to get going again? How am I going to prove myself? What can I do where I can at least still be involved?' So I tried everything."[45] Hager got involved with charities. He was a deacon in his church. He tried wheelchair racing. He also messed around with politics, working his way up the chain of responsibility from being a grass-roots volunteer to holding leadership positions.

He also worked his way back up the corporate ladder. Then, twenty years after he was diagnosed with polio—twenty years after he had been at the top, was knocked down to the bottom and then climbed his way to the top again—Hager got some startling news. American Tobacco Company had been sold. "We were all out of a job," he said. "I was just devastated. I loved my job. I loved the people I worked with."[46] By then, he had served on the Republican state central committee, run for state party chairman, served as Governor George Allen's statewide victory chairman and was involved with Ollie North's U.S. Senate campaign. For Hager, politics went from being a hobby to a serious avocation. So it was only natural, when he was suddenly no longer working, that Hager made the leap to becoming a candidate, elected in 1997 as lieutenant governor on the Gilmore-Hager-Earley ticket.

Warner saw Hager's background as an asset. He had earned the respect and admiration of Virginia's business community. He understood government operations and had deep relationships in the legislature across

party lines. He was also very well liked and known in every corner of the state from years of being on the road with civic duties. And most importantly, he had been in the middle of Virginia's response to 9/11 from the very beginning. That September morning, Hager was driving to Washington, D.C., for a meeting and got as far as Ashland before getting called back to the governor's office. There he joined Gilmore, who activated the VEOC and put the National Guard on standby. "My campaign for governor was over, and I was the available person, sort of the go-to person, because I didn't have any other constraints," said Hager. "So I started spending a lot of time beginning on 9/11 working in homeland security."[47] He was initially unconvinced of Warner's offer at the New York luncheon, but Hager decided that doing what was right for Virginia was far more important than the political consequences that could befall him.

Virginia Experts Lead 9/11 Response

Governor Gilmore acted quickly in the days following the 9/11 attacks by forming the Virginia Preparedness and Security Panel, tapping Charles Steger, the respected Virginia Tech president, to lead the fact-finding effort along with Hager as vice-chairman. Coordination among local and state government, federal partners and the private sector was a challenge from the start. The panel looked at the immediate response actions in Virginia both from a traditional standpoint as well as the defensive measures that needed to be put in place. Its work evolved from being centrally focused on the Pentagon attack to what was the overall impact for Virginia and how officials could manage and coordinate future incidents on the state level.[48]

The commonwealth's panel had a starting point in the work of the Gilmore-chaired federal Advisory Panel to Assess Domestic Response Capabilities for Terrorism Involving Weapons of Mass Destruction, otherwise known as the Gilmore Commission, whose vice-chair was Virginia's own George Foresman, a senior expert in emergency management and counterterrorism. He would later assume the role of Homeland Security advisor upon Hager's departure from the Warner administration after two and a half years. He subsequently became the country's first undersecretary of preparedness at the Department of Homeland Security (DHS). Foresman had a central role in Virginia's panel as a result of his work on the Gilmore Commission, which began its work in 1999. "The Federal government had

not been effectively organized on the issue of a terrorist attack on U.S. soil, particularly one of this scope and scale," he said. "That's not a criticism, but it was an observation the commission made. We frankly didn't have a playbook, so we were putting that together as we went along."[49]

Ironically on 9/11, Foresman was at a national conference on domestic terrorism and weapons of mass destruction when he got the news of the events in New York. "I scheduled an early morning horseback ride before the session started at the conference," he recalled, "and somebody came riding up the trail and said, 'Mr. Foresman, they need you back at the hotel. America's been attacked.'"[50] He knew he also needed to get back to his home state, but there was a major problem. The conference was in Big Sky, Montana, and all North American commercial air traffic was grounded. To complicate matters, VDEM's Michael Cline was also attending the conference. In their absence and in coordination with Governor Gilmore, Cline's deputy director, Ralph Jones, was directing on-the-ground efforts in Arlington County and with the Federal Emergency Management Agency, whose director, Joe Allbaugh, was also in Montana.[51]

An air force C-17 cargo plane departed Bozeman several hours later with a number of East Coast emergency management directors. "We realized that we were the only non–fighter jet flying in America that night," said Foresman. "When we flew over the tip of Manhattan and amid all of the darkness—because all of Lower Manhattan was dark—the only thing we could see from the aircraft was the glow of the lights at what became known as ground zero."[52] President George W. Bush had implemented the Continuity of Operations Plan, which even at the height of the cold war had not been done. There was a real fear that the government was at risk. It galvanized the situation for the Virginia team, which eventually got off the plane at Andrews Air Force Base in Maryland just after sunrise the next day. "You could still see the smoke rising from the Pentagon, and when we opened the door of the plane, you could smell the oak wood in the timbers of the roof of the Pentagon burning," remembered Foresman.[53] That was nearly twenty miles away.

New Level of Cooperation

Warner made several key decisions once election day was over. The first was appointing Hager as his assistant to the governor for commonwealth preparedness, a first-of-its-kind position in America. "Governor Gilmore

had actually put in place somebody who was going to advise him, and I thought it made enormous sense to go ahead and take what he had started and build it to an actual cabinet position," said Warner. "We also thought it was important to have greater collaboration among the state resources that would deal with crises and threats."[54] As a result, he launched the Secure Virginia Initiative through Executive Order 7, essentially continuing Gilmore's post-9/11 review effort, thus creating the Secure Virginia Panel to evaluate the state of emergency preparedness.

Warner did not want to impede progress for the sake of political gain. Rather, he deferred to the people with the expertise and the experience. "There is an impulse for folks at the state and national levels to try to put their own label and brand on things that may well be legacy items instead of just trying to build on them," said Bob Crouch, who was involved from the beginning of the administration in the unique partnership that developed from the melding of new counterterrorism tactics and traditional law enforcement practices. "It was another example of Mark Warner rising above partisanship."[55]

In 2001, the Virginia Military Advisory Council was eliminated. It took a top-to-bottom evaluation of the state's strategic partnerships to see that there was a need more than ever to continue the council's mission of keeping open the lines of communication with government officials and the heads of military installations within Virginia's borders. Warner resurrected it months later, during his first legislative session, with the help of Senator Ken Stolle. "From the governor to the legislature, they quit viewing preparedness and emergency readiness, irrespective of the cause, as being something that is operational, done at the agency level," said Foresman. "They realized that it had a strategic policy implication that crossed all of state government."[56]

It was that change in mindset that Hager believes was his team's legacy. "We took the up-front part of homeland security—prevention, intelligence, detection, coordination and cooperation—much more seriously than the out-back part, which is recovery and response after you have a disaster," he said. "We essentially took the police mode as opposed to the fire mode, and by being aggressively preventative, we accomplished a great deal for Virginia and the country."[57]

Naturally, there were some growing pains by creating a new office that overlapped with several others. Agencies under the Public Safety Secretariat, including the Virginia State Police, the National Guard and Emergency Management, were charged with handling operations. The Office of Commonwealth Preparedness served as a policy arm and liaison with DHS

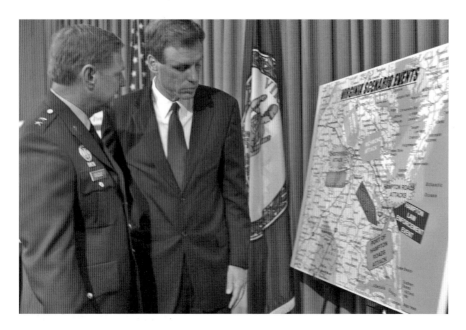

Warner announced Virginia's involvement in a major counterterrorism exercise as part of ongoing preparedness planning. *Michaele White.*

while also managing stakeholder relationships and administering the flood of grant funds coming into Virginia. "It was a challenge, but without a doubt, it was the right move to create that office," said John Marshall. "It would have been extremely difficult to handle that all in one cabinet office."[58] Hager agrees with the nature of the relationship. "We never tried to take over what somebody else did," he said, "but we tried to co-opt it in a way that we could accomplish our objectives with and through them. And a lot of it was the coordination with the federal level and what happened at the state and then carrying it out down through either industry or local government or all of the partners."[59]

There was a critical piece that only Warner, using his business credentials, could pull off. He understood the intersection of the public and private sectors. He also understood it was not going to be easy to change culture. "We were one of the first states to say, 'You can't just address homeland security from the public sector. You've got to build critical infrastructure.' So having Dominion at the table, having Verizon at the table, having other private sector players at the table was essential."[60] In recognition of that need, Warner created the Virginia Critical Infrastructure Protection Working Group. At the beginning of his administration, there was a conscious effort to knock

down walls. He put local and state government senior policy officials together. He also put the traditional law enforcement and fire agencies together with public health and the economic development officials so that everybody understood one another's perspectives. The pre-9/11 model was simple: the government was the regulator, the private sector was the regulatee and the two shall never meet. That relationship no longer applied. "This is one thing Mark Warner understood quite well," said Foresman, "that when you talk about Virginia being prepared, it's not just about state government being prepared. It's about all levels of government—local, state and federal—as well as the public sector, the private sector and the citizens."[61]

The same outdated thinking applied to Virginia's relationships with its neighboring governments. "If you look back prior to 9/11, traditions had taken over," said Hager. "Police didn't talk to the fire. The city didn't talk to the county. Virginia didn't talk to Maryland. You had all of these conflicts that had existed for years that had to be broken down. People suddenly needed to be able to communicate across county and state lines."[62] Hager and Foresman spent two days a week traveling up Interstate 95 in an attempt to bring together the governments of Virginia, Maryland and Washington, D.C., with federal agencies in what is now called the National Capital Region. "We literally overcame one hundred years of history and developed cooperation among those entities," said Hager.[63] By August 2002, Warner had participated in the first regional homeland security summit with Governor Parris Glendenning and Mayor Anthony Williams, committing to a series of action items building on Virginia's own response to 9/11. He continued the summit annually for the duration of his term.

INVESTING IN CRITICAL INFRASTRUCTURE

Warner's decision-making process changed little as he moved from being a CEO in the private sector to being chief executive in charge of the safety of over seven million Virginians. He recognized immediately after 9/11 the need to modernize the state's emergency operations center, the VEOC, which at the time was a cold war–era bunker prone to flooding. In order for law enforcement to manage the influx of possible terrorist-related threats, there needed to be one place to go for information and intelligence gathering and analysis. "He understood the dynamic that his desk was not where information needed to be fused," said Foresman. "It needed to be fused

before it came into his office so that people could present options to him."[64] That's when the idea of upgrading the VEOC to a state-of-the-art command and control center came about. It was all a matter of money, but given the deficiencies—including patchy wireless access, power unpredictability and overcrowding issues—the General Assembly supported Warner's vision for a new building located with the Virginia State Police administrative headquarters in Chesterfield County ten miles from Capitol Square.

Three months before leaving office, Warner was able to deliver on a promise by dedicating the new facility accompanied by a collaborative Virginia Fusion Center that has changed the face of law enforcement. "It's part of our world that we didn't have before 9/11 that now is an everyday function," said Colonel Steve Flaherty, state police superintendent. "The world got a lot smaller after 9/11, and Mark Warner had enough vision to see the Fusion Center was something that needed to be implemented on the public safety front."[65]

He returned to the state's law enforcement operations hub shortly after its dedication for another announcement. This time was to conduct the first live public transmission of the Statewide Agencies Radio System (STARS), a shared digital voice and wireless data communications network that provides inoperability for state and local public safety agencies. The inability for first responders to communicate in emergency situations under the old system was unacceptable. STARS replaced antiquated, low-tech land mobile radio and microwave radio networks of the past. In some cases, the infrastructure had been installed as far back as the 1950s. "When seconds count, so does clear, effective communication," said Warner. "Being heard the first time is critical, especially when an officer is calling a dispatcher for an injured motorist, a crime victim, or in the case of Virginia State Police Trooper Gary Horner, for himself."[66]

Warner tested the system launch with Trooper Horner, who in late November 2002, was shot seven times while performing a routine security check at a stop near New Kent County off Interstate 64. "The radio transmission between Horner and the dispatcher was in such poor quality that, once Governor Warner heard that tape, he knew something had to be done," said Colonel Gerald Massengill, who preceded Flaherty as state police superintendent.[67] Three years after the shooting, Warner could hear Horner loud and clear as the young trooper transmitted from the same rest stop. The two gentlemen connected on the first attempt as opposed to the four tries Horner made in the middle of gunfire.[68]

Warner's wireless expertise helped propel STARS from the planning stage, where it had stalled, to its implementation. He also helped secure funding

From Business Success to the Business of Governing

Warner conducted the first live public transmission of the Statewide Agencies Radio System with Trooper Gary Horner on the other end. *Michaele White.*

from the legislature. "His background in radio technology is what drove the STARS project," added Flaherty. "The problem was that we didn't have anybody politically before, whether they supported the idea or not, who understood the technology."[69] In fact, Warner took a hands-on approach with Motorola engineers because he could speak their language and hold their feet to the fire. "My line, which I used a thousand times," joked Warner, "was that it's easier to get Democrats and Republicans to agree than it is to get radio engineers to agree."[70]

Fighting Off BRAC

Tending to homeland security needs also meant protecting military assets. In 1988, the Department of Defense (DOD) instituted a process to promote efficiency in its post–cold war operations, resulting in consolidating resources and shuttering facilities around the country. The independent Defense Base

Closure and Realignment Commission (BRAC) is charged periodically with reviewing the Pentagon's recommendations and preparing a report for the president's consideration. It is designed to remove politics from the decision-making process. In the summer of 2005, that all changed, and Warner pulled out all the stops to prevent what could have been a massive blow to Virginia's economy, let alone its ego. Ever the planner, he already had Virginia at the ready.

Warner formed the Virginia Commission on Base Retention earlier in his term and stacked it with a team of retired military officers and political muscle, including co-chairmen Owen Pickett and Joe Reeder. Pickett represented the Second District in the heart of Hampton Roads during his fourteen years in Congress, later passing away in 2010, and Reeder was under secretary of the army during the Clinton administration.[71] The group's expertise was vital as administration officials and members of the congressional delegation, particularly Senator John Warner, prepared for the potential loss of jobs and infrastructure. To the surprise of both Warners, Naval Air Station Oceana in Virginia Beach was on the chopping block. At that point, Fort Monroe in Hampton was already on the list for closure, and thousands of jobs in Northern Virginia were in jeopardy.

Virginia's team presented its case for protecting Oceana to the nine-member BRAC panel, but the process was complicated by an attempt to transfer operations to the once decommissioned Cecil Field in Jacksonville, Florida. All of a sudden, Oceana's assets were up for auction. Mark Warner was no stranger to last-minute revelations in business deals, but the process was alarming nevertheless. "There were some unprecedented activities," he recalls. "Never before has a closed base been allowed, in effect, to make an economic development proposal to a BRAC commission."[72] Notwithstanding the political noise and sales pitches from Florida, the navy was on Virginia's side. Admiral Mike Mullen, chief of naval operations who later served as chairman of the Joint Chiefs of Staff, testified that the navy had explored other options but determined that the fighter jets should remain in Virginia Beach.[73] Warner joined Mullen and both Senators George Allen and John Warner in arguing that Oceana's location on the East Coast was strategic due to its unencumbered airspace and proximity to the navy's Atlantic Fleet. He also drove home the economic argument that closing the master jet base would send a shockwave through the South Hampton Roads economy. With nearly seventeen thousand military and civilian jobs at the time, Oceana was and remains Virginia Beach's largest employer.[74] Furthermore, the DOD estimated the move to Cecil Field would cost the taxpayers $1.6 billion.[75]

Virginia Beach still had a serious problem that the BRAC Commission—namely, its chairman Anthony Principi—considered a deal breaker. Navy officials were troubled by the growing encroachment of commercial and residential development around the base, specifically in the accident potential zones commonly referred to as "crash zones." This did not come as a surprise. In fact, it was a well-established concern. It was significant enough that local government leaders in Chesapeake, Norfolk and Virginia Beach ordered a joint land use study seeking ways to address the navy's objections in order to ensure a way forward together.

Following BRAC hearings on Capitol Hill, Virginia officials scrambled to save Oceana, but one development project seemed to put a halt to progress. The six-acre Near Post property adjacent to Virginia Beach's oceanfront resort area was slated for a seventy-two-unit condominium project, and the city council had no legal right to put a stop to it. Backchannel communications from the DOD's panel were direct. Virginia Beach had forty-eight hours to halt its development or negotiations were dead. "Mark Warner understands when a deal is on the verge of success or collapse, and he knew that's where we were," said George Foresman. "He knew that he had to take that off the table."[76] Warner dispatched Foresman and Secretary of Commerce and Trade Mike Schewel to Virginia Beach to hammer out a solution with city leaders. "He had a very clear message and gave a clear commitment on the commonwealth's behalf," recalled Foresman. "The City of Virginia Beach did exceptional work on its end, and we just helped get it to where it needed to be."[77]

Just in time, the city council approved a comprehensive plan to not only neutralize concerns about the Near Post development and others around the base but also enter into a long-term agreement with the state. Among other one-time financial commitments in the amount of $182 million, the deal called for both parties to share the burden of spending at least $15 million annually to rollback encroachment by purchasing land and development rights.[78] Even after making the steep financial commitment, Virginia Beach was not out of the woods. The BRAC Commission made an impossible demand that the city council condemn and buy more than 3,400 homes and businesses located in the crash zones.[79] No politician at the state or local level was willing to support such a gross misuse of eminent domain powers. Virginia Beach's resolve remained undeterred while Florida's essentially crumbled. Mayor John Peyton officially halted Jacksonville's lobbying efforts to poach Oceana's squadrons, and months later, the Duval County voters defeated a referendum calling for Cecil Field's resurrection.[80] BRAC's power was neutralized, and Virginia Beach was safe, at least until the next round.

Patriotism and Community Action

"Nothing reflects American values better than a community working together," Warner told a captive audience of teenagers on the first anniversary of 9/11, adding, "'United we stand' means we all have to do our part."[81] He used the opportunity at Cox High School in Virginia Beach to launch Virginia Corps, an initiative promoting all levels of volunteerism at a time when Americans were searching for ways to turn patriotism into action. The idea came several months earlier while he was watching the State of the Union address. In January 2002, President Bush delivered a moving tribute to the victims of the previous September's attacks and reported on the escalating war on terrorism. He also encouraged community engagement and emergency preparedness at home.

Rather than wait for the federal government to implement a nationwide plan, Warner co-opted the concept. "He didn't want to miss an opportunity to leverage the desires and the wants of Virginians who had gone through such a horrendous emotional event," said George Foresman. "This is where Mark Warner's political instincts, and I mean 'political' in the most admirable sense, were smack on point. I even got in a little bit of trouble, when I went to work in the Bush administration, because I said this in a couple of venues that I probably shouldn't have."[82]

Warner recognized that the heroism from first responders at home and active duty military serving overseas was matched by the shared desire from everyday citizens to strengthen their own communities. "Virginia Corps stemmed from a belief that we could show the world that we weren't going to let what happened on 9/11 stop our resolve to come together and be prepared," said Janet Clements, a veteran of the Department of Emergency Management tasked with implementing Warner's vision.[83]

For communities in fear, the best antidote was action, and Warner brought the resources of his administration to bear. In the wake of a tragedy, politicians often respond with rhetoric. Instead, Warner offered a meaningful and immediate way to get involved. "People wanted to do more than just shop and support the economy," he said. "They wanted to show support for their country, and they wanted to show support for their community. And they needed help focusing that energy."[84] Clements created a series of partnerships with public safety agencies, health departments, social services providers and private sector partners all across the commonwealth. Just as Warner envisioned his SeniorNavigator brainchild to be a clearinghouse for families seeking senior care options, Virginia Corps has connected nearly one million people directly to volunteer opportunities of their choosing using a double-tiered approach.

From Business Success to the Business of Governing

In the wake of 9/11, Warner launched Virginia Corps, an initiative promoting volunteerism at a time when Americans were searching for ways to turn patriotism into action. *Michaele White.*

"If you wanted to get involved with Meals on Wheels, you could find opportunities on the website," said Clements. "And if you wanted to really get engaged and help prepare your neighborhood for an emergency, we would personally connect you to a Community Emergency Response Team (CERT), the first of which was formed in Arlington—home to the Pentagon."[85] These teams, still active today, teach basic preparedness and disaster-relief techniques, from first aid to search-and-rescue procedures, and fall under the Citizen Corps umbrella. In the event of a disaster, local CERT council members assist first responders and other community leaders recruited through Citizen Corps' complementary police, fire, healthcare and neighborhood watch programs.[86]

Snipers

Virginia was in crisis mode for twenty-three days in October 2002 as a pair of gunmen with a Bushmaster .223-caliber rifle went on a shooting rampage up and down Interstate 95. The mastermind of the Beltway sniper attacks

was John Allen Muhammad. He was convicted of capital murder, sentenced to death and executed in 2009. His young accomplice, seventeen-year-old Lee Boyd Malvo, received life in prison without the possibility of parole. The two were responsible for fourteen shootings in Maryland and Virginia that ultimately claimed ten lives. The attacks were haphazard, and the shooters left confusing, often taunting clues along the way. There was no pattern to their destruction. During the three weeks that left the region paralyzed, a multi-jurisdictional manhunt ensued with local, state and federal law enforcement agencies spread across two teams working in tandem with the Federal Bureau of Investigation (FBI). Chief Charles Moose led the Maryland operation from his Montgomery County Police Department in Rockville, while Sheriff Stuart Cook headed up Virginia's task force out of the FBI's Richmond office. The Hanover County sheriff brought nearly four decades of experience to the task and welcomed Secretary John Marshall and Colonel Massengill to the team along with other chiefs and sheriffs from the region.

As the manhunt progressed, Mark Warner was right in the middle of it. "The governor, in the early days, was the information integrator. He was the option developer, and he was the option decider," said George Foresman.[87] There was no shortage of advice flowing in his direction. That meant trusting the people who had expertise that was gained by experience. Warner could do that because he had the self-confidence to rely on experts without feeling threatened. That's not to say he did so blindly. The shrewd businessman and trained lawyer employed a prosecutorial style in order to extract information, but he didn't get mired in the details. Rather, he kept a strategic perspective and directed his energy to not only understanding the implications of what was happening on the ground but also scrutinizing the options his law enforcement team presented. "In a lot of cases, the options that were put in front of him were not the options he chose," added Foresman. "He would take a little of the first, a little of the second and a little of the third. That would become the Mark Warner response, and that's what we expected out of a chief executive in a crisis."[88]

Warner also understood well the public relations side of managing a crisis. People were scared to take their kids to school or go to work or even just go outside. Gas stations in Northern Virginia erected large tarps around the pumps to conceal customers. The fear was palpable. Warner knew that he had to set an example. He wanted to send the message that the snipers were not going to win. It was easier said than done. "Law enforcement was telling me to…keep a low profile so I wouldn't encourage more attacks.

From Business Success to the Business of Governing

While at the same time, I recognized that there were a lot of people looking for reassurance."[89] He was scheduled to walk the Fall Festival parade route in King George County on Saturday, October 5. Muhammad and Malvo had carried out their first Virginia shooting the day before, injuring a woman in a Spotsylvania shopping center parking lot.[90] King George officials did not cancel the parade, and Warner kept his word—against the wishes of his state police–assigned security detail. "The Executive Protection Unit didn't want me to march. I said, 'No, I've got to do this. I do it every year. I have a home here.' You can't tell people, 'Go about your daily lives…but I'm not.'"[91]

The shootings continued, and no one was safe. Warner had already scheduled a televised address to inform Virginians of forthcoming layoffs and drastic budget cuts to address the state's ballooning shortfall, including a 20 percent cut in his own salary.[92] He wanted to open with an update on the sniper case and was confident he could offer words of reassurance. "The political instincts aside, Mark Warner knew what the people of Virginia needed in a time of crisis," said Foresman.[93] Even so, he sought input from his team. Warner grabbed John Marshall outside the mansion after an event.

> He said, "Give me some suggestions here…what in the world do I tell the people of Virginia?" And before I could even blurt anything out, he said, "And don't say I should tell them to go on living their lives as they normally would." He added, "I can't go out there and say that when there are people being gunned down while putting gas in their car." That was one of the few instances that I didn't have very good guidance because it was such an unprecedented time. I wish I could have given him a better answer.[94]

Like Marshall, Massengill was in contact with Warner all the time. "I went by the mansion after hours almost every day to give him a briefing as to where we were and what we thought we knew," he recalled. "He had my cellphone number, and I had his. So we would talk several times a day."[95] Those conversations also helped Warner formulate his remarks for the address, and he was mindful of the sensitive nature of the information he possessed. "He knew what we in law enforcement wanted him to say and didn't want him to say," said Massengill. "And I think he fulfilled that role of giving the people comfort that everything that could be done was being done…and that he was totally engaged in this tragic event that was playing out."[96] Warner has not forgotten Massengill's chilling words. "I will always remember him saying to me, 'Governor, we've dealt with serial killers before.

Mark Warner the Dealmaker

Secretary of Public Safety John Marshall developed a close relationship with Warner during a term consumed by post-9/11 preparedness and response to natural disasters. *Michaele White.*

We've dealt with snipers before. But we've never dealt with something that seems this random.'"[97]

Several days later, Warner got a call that there had been another shooting. This time, it was outside a restaurant in the town of Ashland less than twenty miles from the capitol. The victim survived but was critically wounded in the abdomen. Marshall and Massengill came over to the mansion that night with FBI officials and other members of Virginia's task force. Investigators found a note near the scene with a postscript that read, "Your children are not safe anywhere, at any time."[98] It prompted Sheriff Cook, Marshall and Massengill to bring the school superintendents in the Central Virginia region together that night. "We made a decision to share with them what we had in a confidential way," said Massengill. "They needed to make informed decisions about security around their schools, and there was not a lot of time."[99] The task force ruled out ordering a mandatory region-wide school closing and left the decision in the hands of each superintendent. The meeting resulted in about a dozen public school jurisdictions and nearly all private schools in the area closing their doors for the next two days.[100]

Like any investigation, there were some close calls. "Those last few days were really challenging to manage, especially when we thought we had

From Business Success to the Business of Governing

caught the guys," said Warner, referring to a case of misidentification.[101] After Muhammad used a gas station payphone in Henrico County just outside Richmond, he left before the response team arrived, although officers were on the scene in a matter of minutes. In the interim, a white van pulled up. "There was a lot of anxiety at that time, because we were looking for a white van based on witness accounts from previous crime scenes," said Massengill.[102] As far as the media was concerned, it looked like the snipers had been caught. Marshall and Massengill were at the FBI's command post but were in constant contact with law enforcement on the scene. Warner was watching the news unfold on TV. "For whatever reason, camera crews were not showing what we were telling the governor was happening," said Massengill. "They were only showing part of the scene, and as I recall, they were not showing the telephone booth. Mark Warner is a tremendous guy to work for, but one that wants what he wants, and he wanted to see that telephone booth."[103] Marshall and Massengill accommodated the governor's request but won't say how, and within minutes, the live camera shot changed, giving Warner the picture he needed. A few hours later, authorities reported that the men in custody were not in fact the snipers.

The news everyone was waiting for came three days later. Muhammad and Malvo were captured in almost an anticlimactic way. Their blue Chevy Caprice was spotted shortly before 1:00 a.m. on October 24 at a rest stop off Interstate 70 near Frederick, Maryland. They were asleep in the car. Two hours later, the Beltway snipers were in custody. Their reign of terror was over. Later that day, Chief Moose scheduled a press conference to announce the news to the world. Members of Virginia's law enforcement team, holed up in their own operations center, planned an event closer to home. They wanted Warner to be there because he had been so engaged from the outset. "It was not unusual for the phone to ring, as we were discussing different leads, and it would be Mark Warner, who would call while on the road or going from one meeting to another," remembered Massengill. "He would say, 'Colonel, I'm just checking in. Is anything going on? Are there any new leads? Does anything look good?' The chiefs and sheriffs sitting around the table found it almost unbelievable that he was that involved."[104]

When Massengill called up Warner hours before the press conference, there was excitement on the line. Then there was a long pause. In a sincere tone, Warner said, "If I go over there, it will become a political event. It's too important to the people of Virginia."[105] John Marshall took the phone but got the same answer. Warner was clear. "He told me, 'With all due respect, absolutely no.' And when I questioned his response, he immediately said,

'This is not about politics. This is the result of law enforcement working together to end a very dangerous situation. And it should be law enforcement at the press conference. I don't need to be there.'"[106]

Massengill had been around politics enough to expect even Mark Warner to say otherwise. After all, every major news outlet in Virginia was going to be there. "I've always felt that it would be difficult to find a politician who would have turned down the opportunity to get that kind of exposure," he said.[107] Marshall was surprised, too, given the spotlight on Virginia and the role Warner's task force played throughout the investigation. But it was Warner's sincerity that made a lasting impression on the veteran lawman. "He was more concerned that not coming would offend the chiefs and sheriffs. He said, 'Tell them that I'm doing it out of respect for law enforcement and the job they do. They did all of the hard work. They deserve all of the credit.'"[108]

The governor trusted his gut and didn't go to the press conference. Instead, he watched it on TV like everybody else. Warner's reaction to this tragedy early in his administration showed others that he had chosen statesmanship over ambition. To him, there was no choice to be made in the first place.

Afterword
CRAFTING THE NEXT DEAL

Oftentimes in politics, electoral success is the result of a broad combination of factors that are mostly beyond the control of the candidate or their campaign. For one, the political environment must be right—or as close to right as possible. Many a failed candidate for office has failed simply because he or she ran at the wrong time, when the political environment was not right. Yet running at the right time, in and of itself, is not always enough. A candidate must also find the right message for that time, and voters must perceive the message to be genuine. The right message resonates with voters, speaking to their basic concerns and giving them confidence that the candidate understands those concerns. The person delivering the message—the candidate himself—drives a large part of voter perception about how genuine a message is. The right candidate best delivers the right message. Finally, while it is not impossible to win without having enough money, in today's politics, it is very difficult to do so. The well-funded campaign has the resources to reach much deeper into the electorate with its message and to go to geographical parts of the electorate that might—from a cost-benefit analysis—be bypassed by a lesser-funded campaign.

While Mark Warner ran for U.S. Senate in 1996 against Senator John Warner, few of these factors worked in his favor. They all seemed to work in his favor in his run for governor in 2001. Mark Warner was close to the perfect Democratic candidate for the Virginia political environment of 2001. He was a moderate Democrat with a practical bent, a very successful businessman who made his fortune in technology and someone who was

a known quantity in the rural Southside and Southwest parts of the state thanks to his campaign efforts in 1996 and continued presence in the region after that failed bid. It was also in 2001 when the full implications of Governor Jim Gilmore's car tax cut strategy started to become clear, and as tax revenues ebbed, Gilmore's push to find any way to continue to cut the car tax caused dissention—even within his own party—and a corrosive political environment in Richmond. Warner's promise of a bipartisan approach contrasted with the politics of the day in Richmond. His business background and successes gave voters hope that he knew how to manage state government. His genuinely approachable style and willingness to talk to and work with anyone from any side of the political spectrum attracted voters eager for a less partisan governor, and his willingness to invest time and resources gaining the confidence of voters in Southwest contrasted with standard assumptions that said the region was not fertile territory for a Democratic statewide candidate.

As governor, Warner managed to do what very few governors ever manage to pull off, in Virginia or anywhere: he left office more popular than he came in. Having beat Mark Earley in November 2001 with 52 percent of the vote, he left office in January 2006 with an 80 percent approval rating. Voters held him in high regard despite the fact that he spent much of his first year in office cutting budgets and managing depressing revenue numbers; campaigned for regional sales tax increases in Northern Virginia and Hampton Roads that voters rejected; crafted a tax code overhaul that, while cutting taxes for about 65 percent of Virginia households, effectively increased net tax revenue; and worked to cap the car tax reimbursement to local government, which effectively increased local taxes for many Virginians. Having had four years to judge him, what were voters so approving of as Warner prepared to move out of Capitol Square? In sum, they judged Warner a very competent manager during a very difficult time. They judged him a very genuine and likeable guy who spoke plainly about the problems the commonwealth faced and his ideas for addressing them. They appreciated that he tried to work with Republicans. Ultimately, they approved of his general approach to governing, and despite his personal wealth, they viewed him as an "average" guy.

In any other state of the Union, Warner would have run for reelection and would have easily won. But Virginia remains steadfast—and alone—in its resistance to letting a sitting governor even attempt to serve two consecutive terms. Warner clearly enjoyed being governor, and he clearly was not ready to exit politics. But the question about what he would do next was not clear.

Afterword

After toying with and rejecting the idea of running for president in 2008, his former 1996 political rival turned friend Senator John Warner gave him the answer when he announced that he would not run for a sixth term in the U.S. Senate. Within a couple weeks, Mark Warner announced that he would run to fill John Warner's Senate seat.

The 2008 Senate matchup could not have been any better for Warner, as Republicans nominated former governor Jim Gilmore to run against him. The 2008 race essentially became a referendum on the two men and their approaches to governing and politics and on their terms as governor. Warner pressed his case hard against Gilmore, and won by a big margin: 65 percent to Gilmore's 34 percent. Warner carried all but six cities and counties in the commonwealth and won by surprisingly large margins in many counties in the rural Southside and Southwest. The message voters sent was clear: they liked Warner's moderate bipartisan style over Gilmore's more partisan and combative style. It was a comforting affirmation for Warner. With several years of hindsight to draw on, voters said they viewed Warner's term as governor far more favorably than they did Gilmore's.

Mark Warner promised to bring the same style and approach to his new job as U.S. senator from Virginia that he had brought to his old job as governor of Virginia. He spoke often about using common sense solutions to solve problems and about bridging the partisan divide in Washington in a human way—by working with Republicans. He became part of a bipartisan group of senators known as the "Gang of Six" who often stood in the gap between Democrats and Republicans attempting to avert government shutdowns or other policy failures. But he found himself frustrated. Washington was not like Richmond. Being a U.S. senator was not like being His Excellency, the governor of Virginia. Being a moderate in Washington was no easy job. As often as he could, he headed south and west across the Potomac, back to the familiar and comfortable territory of the commonwealth, to the Rotary Club meetings in Roanoke and the civic league gatherings in Virginia Beach. In small meeting rooms across Virginia, standing in front of familiar faces and with people he felt comfortable, he frequently expressed frustration with Washington, with its slow pace and hyper-partisanship. He often told a story to these friendly audiences about how being governor meant making decisions and having dozens of people immediately go about the job of implementing them but how being senator meant being one of a hundred voices in a chamber. There were no executive decisions to be made in the U.S. Senate, only debates to be had and very slow progress, if any, on the nation's big problems.

Afterword

As 2013 approached, one of the most talked-about topics in Virginia political circles was whether Warner would run for governor again. Was his frustration with Washington strong enough to send him back to the commonwealth to do the job he clearly loved doing? The answer was no. Warner understood that he would have a hard time reprising his very successful term as governor. For one, Republicans were far more partisan than they had been when Warner occupied the Governor's Mansion, and their hold on the General Assembly was far stronger. His ability to work across the aisle with Republicans would be much more difficult. In an interview just before announcing that he would not run for governor, Warned conceded the obvious: "You can't just put the band back together. Circumstances in Richmond and other things have changed."[1]

Having decided to not run for governor, Warner set about instead running for a second term in the U.S. Senate. The conventional wisdom was that he would win a second term easily. After all, the fundamentals on Mark Warner hadn't changed: voters across the political spectrum still approved of him, and his reputation as a straight talker who would work across party lines was still intact. However, early polls suggested there could be problems. A January 2014 poll of registered voters by the Wason Center for Public Policy at Christopher Newport University showed Warner with a 63 percent approval rating but only 56 percent saying he deserved reelection, and in a hypothetical head-to-head matchup with Ed Gillespie, who would become the Republican nominee a few months later, Warner garnered 50 percent of the vote to Gillespie's 30 percent, with 20 percent undecided or supporting another candidate. On election night, Warner beat Gillespie 49 percent to 48 percent.

Compared to his 2008 landslide win against Jim Gilmore, his 2014 squeaker demonstrated a different dynamic in Virginia for Warner than he had ever faced. The strong ties Warner had forged in Southside and Southwest Virginia seemingly evaporated as he lost most of the counties in the region to Gillespie. Moderates across the commonwealth wavered in their support of Warner, and Democratic enthusiasm struggled. In the election of 2014, Warner had to answer not only for himself but also for the Washington politics that he found so frustrating. Many voters took their frustration of President Obama and Washington out on Warner. While the victory was the narrowest of his political career, it was nevertheless an affirmation of Warner's political core. He campaigned the same fundamental way in 2014 as he had in 2001 and 2008, making bipartisanship and practical results the focus of his appeal to voters, and was able to win in a wave election

Afterword

that knocked off across the country many Democrats who followed a more traditional partisan strategy.

The challenge for Mark Warner going forward is to find a comfortable footing in Washington, one that makes it possible for him to be the dealmaker that he naturally wants to be. The politics of Washington are vastly different from the politics of Richmond. The players are more numerous on both sides and far less interested in working across the aisle with one another. The power of lobbyists is greater in Washington than in Richmond. Yet if ever there was a need for more leaders like Warner in Washington, it is now. Washington needs dealmakers whose purpose is less partisan interest and more public interest. The challenge going forward is to find a way to make the deal work, like Warner has done his whole career, whether in business or politics.

QUENTIN KIDD

NOTES

Chapter 1

1. Baker and Hsu, "No Substitute for Knowing Your Warner."
2. Ibid.
3. Clinton, *Between Hope and History*, 23–24.
4. Sabato, "1996 Presidential and Congressional Contests."
5. Cain, "Warner's Their Name, Disparity Is Their Game."
6. Baker and Hsu, "No Substitute for Knowing Your Warner."
7. Lerman, "Incumbent Leads Poll in Race Between Warners."
8. *Washington Times*, "Latest Polls in State Races."
9. Schapiro, "Poll Shows John Warner with Big Lead."
10. Sabato, "1996 Presidential and Congressional Contests in Virginia."
11. Hsu, "Status Quo Thrives on Both Sides of the Potomac."
12. Sabato, "1996 Presidential and Congressional Contests in Virginia."
13. Hsu, "Status Quo Thrives on Both Sides of the Potomac."
14. Ibid.
15. Ibid.
16. Little, "John Warner's Senate Victory a Close Call."
17. Little, "Report of Close Race a Snafu."
18. Hsu, "Status Quo Thrives on Both Sides of the Potomac."
19. Little, "John Warner's Senate Victory a Close Call."
20. Hishta, interview.
21. Ibid.
22. Ibid.
23. Hsu, "Status Quo Thrives on Both Sides of the Potomac."
24. Ibid.
25. Allen, "M. Warner Had to Fight Conventional Wisdom."
26. Ibid.
27. Ibid.
28. *New York Times*, "William Scott, 81, Congressman Symbolizing G.O.P. Rise in South."

29. Abramowitz, McGlennon and Rapoport, "1978 Virginia Senatorial Nominating Conventions."
30. Edwards and Baker, "Miller Wins as Foes Quit on 3rd Ballot."
31. McDowell, "Longest Day at the Coliseum."
32. *Washington Post*, "Novice at Seeking Office."
33. Edwards, "Holton Runs for Senate Seat."
34. Ibid.
35. Ibid.
36. Ibid.
37. Ibid.
38. John W. Warner, interview, June 27, 2012.
39. Ibid.
40. Ruberry, "John Warner Describes His Father."
41. Fiske, "At Last, Warner Has Some Respect."
42. John W. Warner, interview, June 27, 2012.
43. Whitley, "Warner Vs. Warner."
44. Brostoff, "John Warner '53."
45. Rosenfeld, "Wives Had a Role in Warner's Rise on Political Scene."
46. Holton, *Opportunity Time*, 182.
47. Ibid., 182.
48. Ibid., 182.
49. John W. Warner, interview, June 27, 2012.
50. Holton, *Opportunity Time*, 185.
51. Ibid., 185.
52. Edwards, "Warner Takes Hard Line in Va. GOP."
53. Latimer, "Obenshain Wins on Sixth Ballot."
54. Edwards, "Warner Interested in Running Again."
55. John W. Warner, interview, June 27, 2012.
56. Ibid.
57. Edwards and Rosenfeld, "Va. Democrats Hail Obenshain Victory."
58. Ibid.
59. Morris, "Contrasts in Styles in a Pair of Campaigns."
60. Holton, *Opportunity Time*, 188.
61. John W. Warner, interview, June 27, 2012.
62. Edwards and Rosenfeld, "Crash Kills Obenshain."
63. Harden, Darling and Rosenfeld, "Obenshain Died Pursuing a Dream."
64. Ibid.
65. John W. Warner, interview, June 27, 2012.
66. Holton, *Opportunity Time*.
67. Ringle, "Some in Va. GOP Seek Alternative to Warner Race."
68. Ibid.
69. Ibid.
70. Ringle, "'Friendly Chat' Helped to Set Warner Race."
71. Ibid.
72. Ibid.

73. John W. Warner, interview, June 27, 2012.
74. Ringle, "Virginia GOP Names Warner Senate Nominee by Acclamation."
75. Latimer, "Obenshain Wins on Sixth Ballot."
76. Rolfe, "Unite and Work."
77. Ibid.
78. Ringle, "Virginia GOP Names Warner Senate Nominee by Acclamation."
79. Jenkins, "John Warner's Charmed Life."
80. Ringle, "Virginia GOP Names Warner Senate Nominee by Acclamation."
81. *POLITICO*, "John Warner Exits Senate."
82. John W. Warner, interview, June 27, 2012.
83. Quinn, "John Warner: Rally Round the Flag."
84. Ringle, "Trail of Controversy Marks Warner's Past."
85. Quinn, "John Warner: Rally Round the Flag."
86. Rosenfeld, "Contrasting Styles on the Stump."
87. *Washington Post*, "Senate: Miller vs. Warner."
88. Ringle, "Trail of Controversy Marks Warner's Past."
89. Rosenfeld, "Contrasting Styles on the Stump."
90. Ibid.
91. Ibid.
92. Edwards, "Va. Senate Campaign Heats Up."
93. John W. Warner, interview, June 27, 2012.
94. Ibid.
95. John W. Warner, "Speech Receiving the Washington Award."
96. Ibid.
97. John W. Warner, interview, June 27, 2012
98. Ibid.
99. Ibid.
100. Ibid.
101. Edwards and Broder, "Warner Certified Victor."
102. John W. Warner, interview, June 27, 2012.
103. Sabato, "1978 Virginia Congressional Election."
104. John W. Warner, interview, June 27, 2012.
105. Ibid.
106. Magill, interview.
107. Ibid.
108. Fill, "Promoting the Life of George Washington."
109. Magill, interview.
110. Allen, "Gentleman from Virginia."
111. Ibid.
112. Ibid.
113. *POLITICO*, "John Warner Exits Senate at Peace."
114. Faulk, "How Doug Wilder Changed America."
115. Wilder, "When the Dream Became Reality," 1.
116. Ibid., 1.
117. Hardy, "Baliles, Wilder, Ms. Terry Elected as Democrats."

118. Wilder, "When the Dream Became Reality," 2.
119. Mark R. Warner, interview, September 1, 2010.
120. Fiske, "Personal side of Democrat Mark Warner."
121. Ibid.
122. Mark R. Warner, interview, September 1, 2010.
123. Ibid., September 1, 2010.
124. Schapiro, "Candidates Can't Agree on Format."
125. Edds, *Claiming the Dream*, 154.
126. Ibid., 156.
127. Schapiro, "Candidates Can't Agree on Format."
128. Mark R. Warner, interview, September 1, 2010.
129. Ibid., September 1, 2010.
130. Edds, *Claiming the Dream*, 169.
131. Ibid., 169-170.
132. Mark R. Warner, interview, September 1, 2010.
133. Edds, *Claiming the Dream*, 235.
134. Ibid., 235–36.
135. Faulk, "How Doug Wilder Changed America."
136. Wilder, "When the Dream Became Reality," 1.
137. Faulk, "How Doug Wilder Changed America."

Chapter 2

1. Morello, "Warner Blurs Political Lines."
2. Mark R. Warner, interview, September 1, 2010.
3. Ibid.
4. Whitley, "Democrats Outgoing Chief Upbeat."
5. Ibid.
6. Ibid.
7. Cain, "Battle of Warners Possible in '96."
8. Hsu, "Warner Takes on Warner for Senate."
9. Whitley, "Democrats Outgoing Chief Upbeat."
10. Ibid.
11. Cain, "Miller Begins Race to Unseat 'Clinton Republican' Warner."
12. Ibid.
13. Baker, "Warner's Moderation, Usually an Asset, Is Under Seige."
14. *Roanoke Times*, "Sen. Warner Mum on Farris."
15. Ibid.
16. Whitley, "Final Vote Tally Gives Allen 9 of 11 Districts."
17. John W. Warner, "Senator Warner's Stance Toward Michael Farris."
18. Winston, "Farris Says Abortion-Cancer Link Ignored."
19. Warner, "Senator Warner's Stance Toward Michael Farris."
20. Ibid.
21. Whitley, "Republican Group Formed in Support of Beyer."

22. Warner, "Senator Warner's Stance Toward Michael Farris."
23. Whitley, "Va. GOP Looks for Culprits."
24. Cain, "Miller Begins Race to Unseat 'Clinton Republican' Warner."
25. Ibid.
26. Baker, "Warner's Moderation, Usually an Asset, Is Under Seige."
27. Whitley, "Boy Wonder to Long Shot."
28. Ibid.
29. Klein, "North Camp Not Fazed by Nancy Reagan's Criticism."
30. Ibid.
31. Whitley, "Warner Talks of 'Duty' to Fight North's Senate Campaign."
32. Ibid.
33. *Virginian-Pilot*, "Warner's Growing Popularity."
34. *POLITICO*, "John Warner Exits Senate at Peace."
35. *Washington Times*, "Robb Captured 45.6 Percent of Votes."
36. Whitley, "Va. GOP Looks for Culprits."
37. Cain, "Miller Begins Race to Unseat 'Clinton Republican' Warner."
38. Ibid.
39. Ibid.
40. Baker, "Warner's Moderation, Usually an Asset, Is Under Seige."
41. *Virginian-Pilot*, "McSweeney and Byrne Protest Nomination Process to Sore Losers: Pack It In."
42. *New York Times*, "Warner Stills Conservative Opposition."
43. Ruberry, "John Warner Describes His Father as 'the Absolute Hero in My Life.'"
44. Ringle, "Trail of Controversy Marks Warner's Past."
45. Baker, "Warner's Moderation, Usually an Asset, Is Under Seige."
46. Magill, interview.
47. Davis, interview.
48. John W. Warner, interview, June 27, 2012.
49. Baker, "Warner's Moderation Usually an Asset, Is Under Seige."
50. Baker and Hsu, "Warner Crushes Miller in GOP Primary."
51. Hishta, interview.
52. Baker and Hsu, "Warner Crushes Miller in GOP Primary."
53. Wakefield Ruritan Club, "Shad Planking History."
54. *Roanoke Times*, "2 Warners Show Their Styles."
55. Magill, interview.
56. Ibid.
57. Ibid.
58. Whitley, "Senate Race Pits New Blood vs. Seniority."
59. Ibid.
60. Hishta, interview.
61. John W. Warner, interview, June 27, 2012.
62. Magill, interview.
63. Whitley, "Senate Race Pits New Blood vs. Seniority."
64. Ibid.
65. Mark R. Warner, interview, September 9, 2010.

66. Cain, "Battle of Warners Possible in '96."
67. Whitley, "Democrats Outgoing Chief Upbeat."
68. Ibid., "North Had Role in Senate Race."
69. Allen and Hardin, "Whiz Kid Takes on Firebrand Trying a Comeback."
70. Whitley, "Democrats Outgoing Chief Upbeat."
71. Cain, "Warner's Their Name, Disparity Is Their Game."
72. Hishta, interview.
73. Ibid.
74. Ibid.

Chapter 3

1. Allen, "Mark Warner: Back Up and Running."
2. Ibid.
3. Ibid.
4. Mark R. Warner, interview, September 9, 2010.
5. Ibid.
6. Ibid.
7. Sluss, "2 Warners Endorse Election's Bond Package."
8. Shaffray, "Sales-Tax Increase Not Going Away Soon."
9. Sluss, "2 Warners Endorse Election's Bond Package."
10. Barakat, "Warners Make Final Tax Push."
11. Fill, "Promoting the Life of George Washington."
12. John W. Warner, interview, June 25, 2012.
13. Timberg, "Earley Free to Back Referendum."
14. Drummond, "Anti-Tax Pledgers Scramble for Cover."
15. Shaffray, "Tax Foes Vow to Defeat Measure."
16. Baker and Melton, "Record Tax Package Voted for Virginia Roads."
17. Chase, "Political Will."
18. Baristic, "Warner: Tax Plan Too Good to Pass Up."
19. Sabato, "Virginia Votes 1999–2002, 192."
20. Rein and Ginsberg, "Gilmore Opposes N.Va. Tax Increase for Transportation."
21. Sluss, "2 Warners Endorse Election's Bond Package."
22. Ibid.
23. Sabato, "Virginia Votes 1999–2002, 191."
24. Sluss, "2 Warners Endorse Election's Bond Package."
25. *Virginian-Pilot*, "Baptism by Fire."
26. Stefani, *Audit of the Springfield Interchange Project*, 3.
27. Sluss, "2 Warners Endorse Election's Bond Package."
28. Shaffray, "Sales-Tax Increase Not Going Away Soon."
29. Sluss, "2 Warners Endorse Election's Bond Package."
30. Shaffray, "Sales-Tax Increase Not Going Away Soon."
31. Magill, interview.
32. Ibid.
33. Ibid.

34. Ibid.
35. John W. Warner, interview, June 27, 2012.
36. Hansen, "High-Stakes Campaigns Nearing End of the Road."
37. González, interview.
38. Hardy, "Colleges, Parks Bonds Approved."
39. Springston, "Colleges, Parks Bonds Approved."
40. Hardy and Schapiro, "GOP Savoring Sweep, Preparing a Wish List."
41. Geroux and Krishnamurthy, "Hampton Roads, N.Va. Reject Tax Increases."
42. Ibid.
43. Kidd, "Failed Transportation Tax: A Simple Message from Voters," 1.
44. Ibid., 4.
45. Ibid.
46. *Roanoke Times*, "Briefly Put."
47. Geroux, "New Solutions to Traffic Woes Sought."
48. Lewis, "Will Redirecting State Funds Solve Transportation Needs?"
49. Ibid.
50. Robillard, "Ken Cuccinelli Opposes Virginia Transportation Bill."
51. Shear and Layton, "Va. Still Seeks Transportation Solutions."
52. Ibid.
53. Fiske and Nuckols, "Senators Reject Effort to Institute Garbage Fee."

Chapter 4

1. Foster, "Virginia Leader Hosting Party."
2. Ibid.
3. Croall, interview.
4. Ibid.
5. Ibid.
6. Foster, "Virginia Leader Hosting Party."
7. Guldin, "Virginia's Man of the Moment."
8. Fiske, "Personal Side of Democrat Mark Warner."
9. Ibid.
10. Mark R. Warner, interview, September 1, 2010.
11. Ibid.
12. Graff, "Is Mark Warner the Next Bill Clinton?"
13. Lewis, "Candidate Profile of Mark Warner."
14. Fiske, "Personal Side of Democrat Mark Warner."
15. Morello, "Warner Blurs Political Lines."
16. Fiske, "Personal Side of Democrat Mark Warner."
17. Mark R. Warner, interview, September 1, 2010.
18. Lewis, "Candidate Profile of Mark Warner: Enterprising from the Start."
19. Fiske, "Personal Side of Democrat Mark Warner."
20. Ibid.
21. Mark R. Warner, interview, September 1, 2010.
22. Fiske, "Personal Side of Democrat Mark Warner."

23. Mark R. Warner, interview, November 6, 2005.
24. Ibid., September 1, 2010.
25. Ibid.
26. Ibid., November 6, 2005.
27. Ibid., September 1, 2010.
28. Guldin, "Virginia's Man of the Moment."
29. Lewis, "Candidate Profile of Mark Warner."
30. Morello, "Warner Blurs Political Lines."
31. Lewis, "Candidate Profile of Mark Warner: Enterprising from the Start."
32. Collins, "Making His Mark."
33. Mark R. Warner, interview, September 1, 2010.
34. Gentile, "Candidate in Virginia Has Vernon Ties."
35. Guldin, "Virginia's Man of the Moment."
36. Mark R. Warner, interview, November 6, 2005.
37. Ibid., September 1, 2010.
38. Ibid.
39. Fiske, "Personal Side of Democrat Mark Warner."
40. Mark R. Warner, interview, September 1, 2010.
41. Fiske, "Personal Side of Democrat Mark Warner."
42. Guldin, "Virginia's Man of the Moment."
43. Fiske, "Personal Side of Democrat Mark Warner."
44. Mark R. Warner, interview, September 1, 2010.
45. Ibid.
46. Ibid.
47. Ibid., November 6, 2005.
48. Ibid., September 1, 2010
49. Ibid., November 6, 2005.
50. Ibid.
51. Graff, "Is Mark Warner the Next Bill Clinton?"
52. Ibid.
53. Ibid.
54. Fiske, "Personal Side of Democrat Mark Warner."
55. Ibid.
56. Whitley, "Longest Job Application of My Life."
57. Fiske, "Personal Side of Democrat Mark Warner."
58. Mark R. Warner, interview, September 1, 2010.
59. Ibid.
60. Ibid.
61. Ibid.
62. Ibid.
63. Ibid.
64. McAuliffe, interview.
65. Mark R. Warner, interview, September 1, 2010.
66. Ibid.
67. Ibid.

68. Ibid.
69. Ibid.
70. Ibid.

Chapter 5

1. Ibid.
2. Ibid.
3. Fiske, "Personal Side of Democrat Mark Warner."
4. Ibid.
5. Mark R. Warner, interview, September 1, 2010.
6. Morello, "Warner Blurs Political Lines."
7. Mark R. Warner, interview, November 6, 2005.
8. Ibid., September 1, 2010.
9. Graff, "Is Mark Warner the Next Bill Clinton?"
10. Ibid.
11. Ibid.
12. Baker, "Before Politics, a Run for His Money."
13. Mark R. Warner, interview, November 6, 2005.
14. Johnson, "David & Rhoda Chase: Philanthropists Extraordinaire."
15. Baker, "Before Politics, a Run for His Money."
16. Mark R. Warner, interview, November 6, 2005.
17. Fiske, "Personal Side of Democrat Mark Warner."
18. Ibid.
19. Mark R. Warner, interview, November 6, 2005.
20. Fiske, "Personal Side of Democrat Mark Warner."
21. Skale, "15 Minutes with…Mark R. Warner."
22. Ibid.
23. Whitley, "Longest Job Application of My Life."
24. Fiske, "Personal Side of Democrat Mark Warner."
25. Baker, "Before Politics, a Run for His Money."
26. Mark R. Warner, interview, September 1, 2010.
27. Ibid.
28. Baker, "Before Politics."
29. Mark R. Warner, interview, September 1, 2010.
30. O'Brien, interview.
31. Mark R. Warner, interview, September 1, 2010.
32. Ibid., November 6, 2005.
33. Graff, "Is Mark Warner the Next Bill Clinton?"
34. Fiske, "Personal Side of Democrat Mark Warner."
35. Ibid.
36. Mark R. Warner, interview, September 1, 2010.
37. Ibid.
38. Ibid.
39. Murray, *Wireless Nation*, 148.

40. Chaddock, "Profile of Mark Warner: Ivy Leaguer with Rural NASCAR Draw."
41. Ibid.
42. Skale, "15 Minutes with…Mark R. Warner."

Chapter 6

1. Helm, "Fleet Thinking Helps Tiny Nextel Make Big Waves."
2. Murray, *Wireless Nation*, 258.
3. Ibid., 258.
4. O'Brien, interview.
5. Ibid.
6. Ibid.
7. Murray, *Wireless Nation*, 259.
8. O'Brien, interview.
9. Ibid.
10. Murray, *Wireless Nation*, 252.
11. O'Brien, interview.
12. Ibid.
13. Ibid.
14. Ibid.
15. Ibid.
16. Ibid.
17. Ibid.
18. Ibid.
19. Ibid.
20. Ibid.
21. Ibid.
22. Ibid.
23. Ibid.
24. Ibid.
25. Ibid.
26. Mark R. Warner, interview, September 1, 2010.
27. O'Brien, interview.
28. Ibid.
29. Ibid.
30. Ibid.
31. Ibid.
32. Ibid.
33. Murray, *Wireless Nation*, 253.
34. O'Brien, interview.
35. Ibid.
36. Ibid.
37. Mark R. Warner, interview, September 1, 2010.
38. O'Brien, "Looking Back While Going Forward: How the Early Days Of Nextel Reflect on Today."

39. Ibid., interview.
40. Beckman, "Morgan O'Brien: Idea Man."
41. O'Brien, interview.

CHAPTER 7

1. Wasik, *Columbia Capital Corporation: Summer 1998*, 3.
2. Kington, interview.
3. Mixer, interview.
4. Murray, *Wireless Nation*, 302–3.
5. Murray, interview.
6. Ibid.
7. Ibid.
8. Kington, interview.
9. Murray, interview.
10. Kington, interview.
11. Murray, *Wireless Nation*, 303.
12. Murray, interview.
13. Wasik, *Columbia Capital Corporation: Summer 1998*, 4.
14. Kington, interview.
15. Mark R. Warner, interview, September 1, 2010.
16. Murray, interview.
17. Ibid.
18. Wasik, *Columbia Capital Corporation: Summer 1998*, 3.
19. Ibid., 4.
20. Kington, interview.
21. Ibid.
22. Murray, interview.
23. Ibid.
24. Kington, interview.
25. Ibid.
26. Ibid.
27. Mixer, interview.
28. Murray, interview.
29. Ibid.
30. Mark R. Warner, interview, September 1, 2010.
31. Murray, interview.
32. Ibid.
33. Ibid.
34. Ibid.
35. Mark R. Warner, interview, September 1, 2010.
36. Kington, interview.
37. Murray, interview.
38. Ibid.
39. Kington, interview.

40. Murray, interview.
41. Ibid.
42. Wasik, *Columbia Capital Corporation: Summer 1998*, 6.
43. Murray, interview.
44. Mixer, interview.
45. Ibid.
46. Kington, interview.
47. Wasik, *Columbia Capital Corporation: Summer 1998*, 6.
48. Ibid.
49. O'Hara, "Columbia Capital Raises Its Fifth Venture Fund."
50. Murray, interview.
51. Wasik, *Columbia Capital Corporation: Summer 1998*, 6.
52. Kington, interview.
53. Murray, interview.
54. Ibid.
55. Ibid.
56. Mark R. Warner, interview, September 1, 2010.

Chapter 8

1. *Virginian-Pilot*, "Hire Me: John Warner."
2. Foster, "Politician Wows His Home Crowd."
3. Fiske, "Personal Side of Democrat Mark Warner."
4. Ibid.
5. *Roanoke Times*, "Foundation for Health Services."
6. Oswalt, interview.
7. Ibid.
8. Ibid.
9. Ibid.
10. Ibid.
11. Ibid.
12. Ibid.
13. Billingsley, "Wilder Planning Another Revision to Health Package."
14. Oswalt, interview.
15. Ibid.
16. Ibid.
17. Ibid.
18. Ibid.
19. Ibid.
20. Ibid.
21. Mark R. Warner, "Virginia's Model for Community-Based Solutions to Real Problems."
22. Ibid.
23. Oswalt, interview.

24. Ibid.
25. Ibid.
26. Ibid.
27. Ibid.
28. Ibid.
29. Ibid.
30. Ibid.
31. Ibid.
32. Ibid.
33. Ibid.
34. Virginia Health Care Foundation, *2014 Annual Report*, 3.
35. Ibid., 7.
36. Oswalt, interview.
37. Simpson, "Web Site Offers Lifeline for Seniors."
38. Mark R. Warner, "Address to Families USA."
39. Oswalt, interview.
40. Simpson, "Web Site Offers Lifeline for Seniors."
41. Oswalt, interview.
42. Ibid.
43. Ibid.
44. Ibid.
45. Simpson, "Web Site Offers Lifeline for Seniors."
46. Oswalt, interview.
47. Johnson, interview.
48. Ibid.
49. Henry, "Testing Liberal Arts Waters."
50. Healy, "Tech Skills Tested in New College Exam."
51. Dalch, interview.
52. Ibid.
53. Ibid.
54. McDougall, "Blackboard: Liberal Arts; I'm a Technogeek, Too."
55. Ibid.
56. Walzer, "College Group to Vouch for Students' High-Tech Skills."
57. Healy, "Tech Skills Tested in New College Exam."
58. Ibid.
59. Henry, "Testing Liberal Arts Waters."
60. Ibid.
61. Healy, "Tech Skills Tested in New College Exam."
62. *Business Wire*, "Tek.Xam Exam Becomes National Assessment Tool."
63. Healy, "Tech Skills Tested in New College Exam."
64. Dalch, interview.
65. Walzer, "High-Tech Linkup Launched."
66. Ibid.
67. Mark R. Warner, interview, September 9, 2010.
68. Ibid.

69. Ibid.
70. Ibid.
71. Parker, "Warner Stumps for High-Tech Partnership."
72. Ibid.
73. Price, interview.
74. Kelley, "Companies, Job Seekers Unite."
75. Price, interview.
76. Leffall, "Closing the Digital Divide."
77. Mark R. Warner, "Mark Warner on Technology and America's Future."
78. Ibid.
79. Ibid.
80. Ibid.
81. Ibid.
82. Price, interview.
83. Ibid.
84. Mark R. Warner, interview, September 9, 2010.
85. Price, interview.
86. Mark R. Warner, "Mark Warner on Technology and America's Future."
87. "Invest in Social Change," 3.
88. Bishop and Green, *Philanthrocapitalism*, 89.
89. "Invest in Social Change," 3.
90. Morino, interview.
91. "Invest in Social Change," 3.
92. Morino, interview.
93. Ibid.
94. Ibid.
95. Ibid.
96. Ibid.
97. Ibid.
98. Ibid.
99. Ibid.
100. Ibid.
101. Morris, interview.
102. Gabriela Smith, interview.
103. Morris, interview.
104. Morino, interview.
105. "Invest in Social Change," 4.
106. Morino, interview.
107. Henry, "Partners with a Strings Theory of Giving."
108. "Invest in Social Change," 5.
109. Ibid.
110. Ibid.
111. Morino, interview.

CHAPTER 9

1. Whitley, "Mark Warner Gears Up Early."
2. Mark R. Warner, interview, September 9, 2010.
3. Ibid.
4. *Virginian-Pilot*, "State Digging Hole for Itself."
5. Timberg, "Va. Campaign Strategies on Parade."
6. Matricardi, interview.
7. Mark R. Warner, interview, January 10, 2011.
8. Guldin, "Virginia's Man of the Moment."
9. Matricardi, interview.
10. Beiler, "Mark Warner's Five-Year Plan."
11. LaFay, "Attorney General: Earley Is First Local in Statewide Office in 1986."
12. Matricardi, interview.
13. Ibid.
14. O'Dell, "Warner Enters Battle."
15. Mark R. Warner, "Remarks of Gov. Mark Warner to the 2002 DLC National Conversation."
16. Dinan, "Warner Hopes to Keep 'Em Hummin.'"
17. *Washington Post*, "Warner Says Prosperity Eludes Some."
18. Grundon, "Mark Warner Campaigns in Bristol."
19. Ibid.
20. Dinan, "Warner Hopes to Keep 'Em Hummin.'"
21. Foster, "Politician Wows His Home Crowd."
22. Henry, interview.
23. Ibid.
24. Ibid.
25. Mark R. Warner, "Remarks of Gov. Mark Warner to the 2002 DLC National Conversation."
26. Henry, interview.
27. Davenport, interview.
28. Powell, "Solon of Southern Virginia."
29. Framme, interview.
30. Fiske, "Fall Governor's Race Shaping Up as Referendum on Budget Impasse."
31. Sabato, "Democratic Revival in Virginia," 6.
32. Ibid., 8.
33. Mark R. Warner, "Remarks of Gov. Mark Warner to the 2002 DLC National Conversation."
34. Guldin, "Virginia's Man of the Moment."
35. Sabato, "Virginia Votes 1999–2002," 141.
36. Howell, Sluss and Chittum, "Focus on Rural Localities Gave Warner Upper Hand."
37. Whitley, "Warner Victory Seen as a Model."
38. Ibid.
39. Sabato, "Democratic Revival in Virginia," 8.

40. Ibid., 6.
41. Mark R. Warner, "Remarks of Gov. Mark Warner to the 2002 DLC National Conversation."
42. Ibid.
43. Ibid.
44. Ibid.
45. Henry, interview.

Chapter 10

1. Medvic, "Good Campaign Slogans Can Kill Good Governance."
2. Sabato, "Key Factors Put Jim Gilmore Over the Top."
3. Sabato, "Century in the Making: The 1997 Republican Sweep," 5.
4. Ibid.
5. Hardy, "Tooting His Own Horn."
6. Medvic, "Good Campaign Slogans Can Kill Good Governance."
7. Hardy, "Tooting His Own Horn."
8. Fleenor, "Impact of Virginia's Gubernatorial Personal Property Tax Relief Plans Vary Widely by Locality," 3.
9. Hardy, "Tooting His Own Horn."
10. Hardy and Whitley, "Historic Session."
11. Hardy and Schapiro, "Car Tax's Price Tag Jumps."
12. Hsu, "Gilmore Targets Personal Property."
13. King, "Gilmore Says He Underestimated Cost of Tax Cut."
14. Lackey, "Gilmore's Seven Car-Tax Whoppers."
15. Hardy and Whitley, "Historic Session."
16. Hardy, "Allen Budget Plan Goes Far and Wide."
17. Hardy and Schapiro, "Car Tax's Price Tag Jumps."
18. Ibid.
19. King, "Gilmore Says He Underestimated Cost of Tax Cut."
20. Fiske, "Car-Tax Cut Would Cost Double What Gilmore Says, Group Claims."
21. Ibid.
22. Ibid.
23. Hsu, "Gilmore Tax Plan Legal, Va. Attorney General Says."
24. Melton, "Higher Costs of Car-Tax Cut Can Be Paid For, Gilmore Says."
25. Ibid.
26. King, "Gilmore Says He Underestimated Cost of Tax Cut."
27. Ibid.
28. Ibid.
29. Ibid.
30. Ibid.
31. McIntyre, "Taxonomist."
32. Sluss, "What Caused Budget Talks to Derail?"
33. Ibid.

34. *Washington Post*, "Gov. Gilmore's Empty-Till Plan."
35. Melton, "Va. Legislators Fume at Car-Tax Plan."
36. Fiske, "Gilmore Defends Using Loans to Continue Cutting Car Tax."
37. Sluss, "What Caused Budget Talks to Derail?"
38. Hardy and Whitley, "'Historic' Session."
39. Melton, "Va. Legislators Fume at Car-Tax Plan."
40. Lackey, "Gilmore's Seven Car-Tax Whoppers."
41. Reed Smith, "Report on the 2001 Virginia General Assembly."
42. Ibid.
43. Melton, "Va. Legislators Fume at Car-Tax Plan."
44. Ibid.
45. Ibid.
46. *Washington Post*, "Gov. Gilmore's Empty-Till Plan."
47. Gilmore, 2001 *State of the Commonwealth Address*.
48. Fiske, "Gilmore Defends Using Loans to Continue Cutting Car Tax."
49. Sluss, "What Caused Budget Talks to Derail?"
50. Melton, "Gilmore Bent on Car Tax Repeal."
51. Sluss and Walker, "Gilmore: Speed Car Tax Cut."
52. *Richmond Times-Dispatch*. "Mark L. Earley."
53. Fiske, "Gilmore Defends Using Loans to Continue Cutting Car Tax."
54. Nuckols, "Senators Warn a Funding Plan Too Costly, Risky."
55. Ibid.
56. Ibid.
57. *Roanoke Times*, "Gimore: Borrow the Money and Run."
58. Ibid.
59. Nuckols and Heyser, "Car-Tax Cut Questioned in Wake of Budget Hole."
60. Hardy, "Va. Gets Bad Revenue News."
61. Ibid.
62. Nuckols and Heyser, "Car-Tax Cut Questioned in Wake of Budget Hole."
63. Ibid.
64. Hardy, "Va. Gets Bad Revenue News."
65. Nuckols and Heyser, "Car-Tax Cut Questioned in Wake of Budget Hole."
66. *Washington Post*, "Gov. Gilmore's Empty-Till Plan."
67. Lessig, "Norment Slams E-mail About Car Tax."
68. Schapiro, "Gilmore-Controlled PAC Probed by State Police."
69. Ibid.
70. Ibid.
71. Ibid.
72. Schapiro, "Gilmore-Controlled PAC Probed by State Police."
73. Ibid.
74. Ibid.
75. *Richmond Times-Dispatch*, "Car-Tax Campaign Cost $100,000."
76. Nuckols and Fiske, "Politics Make Strange Bad Fellows."
77. Misselhorn and Heyser, "Gilmore Seeks Support on Car-Tax Cut."
78. Ibid.

79. Ibid.
80. *Virginian-Pilot*, "Sen. Stolle's Courage on Car Tax Phaseout."
81. Misselhorn and Heyser, "Gilmore Seeks Support on Car-Tax Cut."
82. Heyser, "The Governor's Immovable Challenge."
83. Ibid.
84. Heyser and Nuckols, "Senators Defy Gilmore on Car Tax."
85. Ibid.
86. Heyser, "The Governor's Immovable Challenge."
87. Edds, "Virginia's Budget: The Crisis That Keeps on Ticking."
88. Nuckols, "Battle Over the Budget."
89. Heyser and Nuckols, "Senators Defy Gilmore on Car Tax."
90. Nuckols and Heyser, "Governor Outlines Plan to Cut Millions to Save Car-Tax Relief."
91. Ibid.
92. Ibid.
93. Ibid.
94. Hardy and Schapiro, "Gilmore Will Call a Special Session."
95. Sluss, "What Caused Budget Talks to Derail?"
96. Fiske, "Car Tax Phaseout Splits Virginia Republicans."
97. Lewis, "State Budget Is Balanced, Gilmore Says."
98. Lackey, "Gilmore's Seven Car-Tax Whoppers."
99. Lewis, "State Budget Is Balanced, Gilmore Says."
100. Melton, "Sheriffs, Students Right Virginia Budget Cuts."
101. Ibid.
102. Hardy, "Quarreling Over Car Tax."
103. Heyser, "Budget Cuts Will Do Long Term Damage, College Presidents Say."
104. Ibid.
105. Whitson, "W&M Chief Blasts Budget Plan."
106. *Washington Times*, "Gilmore Vetoes Tax-Cut Foes' Bills."
107. Ibid.
108. Timberg, "House Breaks with Gilmore, Overrides 2 Vetoes."
109. Ibid.
110. Ibid.
111. Ibid.
112. Nuckols and Fiske, "Gilmore's Plan to Raise Salaries Killed."
113. Sluss, "Senators: Gilmore Plan May Not Be Constitutional."
114. Melton, "Va.'s GOP Splits at the Top."
115. Dinan, "Gilmore's Pay-Raise Plan Rejected."
116. Sluss, "Senators: Gilmore Plan May Not Be Constitutional."
117. Melton, "Va.'s GOP Splits at the Top."
118. Dinan, "Gilmore's Pay-Raise Plan Rejected."
119. Sluss, "Earley Asks Judge to Throw Out Car Tax Suit."
120. Schapiro, "Gilmore's Tax Foes Suit Up."
121. Ibid.
122. Ibid.

123. Sluss, "Earley Asks Judge to Throw Out Car Tax Suit."
124. Schapiro, "Gilmore Revels in Tax Win."
125. Sluss, "Earley Asks Judge to Throw Out Car Tax Suit."
126. Schapiro, "Gilmore Revels in Tax Win."
127. *Washington Post*, "Gilmore Is Hanging Us Out to Dry."
128. Heyser, "Stymied Va. Lawmakers Call It Quits."
129. Sluss, "Sparks Fly as Officials Try to Strike Budget Deal."
130. Ibid.
131. Lewis, "Gilmore Has Sharp Words for Senators."
132. Ibid.
133. Ibid.
134. *Roanoke Times*, "State's Budget Bliss Amiss."
135. Melton, "Gilmore Bearer of Bad Fiscal News."
136. *Roanoke Times*, "State's Budget Bliss Amiss."
137. Ibid.
138. Sluss and Howell, "Gilmore Feeling the Heat on Budget."
139. Timberg and Branigin, "Gilmore Fires Back in Clash Over Economy."
140. Kumar, "Budget Flap Is gilmore's Legacy in Va."
141. Ibid.
142. Ibid.

Chapter 11

1. Mark R. Warner, interview, September 9, 2010.
2. Ibid.
3. Hampton, "Turkey Shoot Targets Charity, but Not Birds."
4. Crumley, interview.
5. Jarding and Saunders, *Foxes in the Henhouse*, 103-104.
6. Crumley, interview.
7. Sabato, "Democratic Revival in Virginia," 2.
8. Jarding, interview.
9. Ibid.
10. Ibid.
11. Ibid.
12. Ibid.
13. Ibid.
14. Ibid.
15. Ibid.
16. Guldin, "Virginia's Man of the Moment."
17. Labash, "Hunting Bubba."
18. Jarding, interview.
19. Guldin, "Virginia's Man of the Moment."
20. Jarding, interview.
21. Ibid.

22. Ibid.
23. Mark R. Warner, interview, September 9, 2010.
24. Chaddock, "Profile of Mark Warner: Ivy Leaguer with Rural NASCAR Draw."
25. Mark R. Warner, interview, September 9, 2010.
26. Framme, interview.
27. Bai, "Mission: Take Back the Hills."
28. Mark R. Warner, interview, September 9, 2010.
29. Indiana Public Media, "WFIU Profiles."
30. Guldin, "Virginia's Man of the Moment."
31. Graff, "Is Mark Warner the Next Bill Clinton?"
32. Jarding and Saunders, *Foxes in the Henhouse*, 91.
33. Ibid.
34. Ibid., 91–92.
35. Dillard and Jayne, "Warner."
36. Mark R. Warner, "Remarks of Gov. Mark Warner to the 2002 DLC National Conversation."
37. Jarding, interview.
38. Llovio, "Losing NASCAR Race Would Cost Region Millions."
39. Mark R. Warner, interview, September 9, 2010.
40. Guldin, "Virginia's Man of the Moment."
41. Mark R. Warner, "Remarks of Gov. Mark Warner to the 2002 DLC National Conversation."
42. Guldin, "Virginia's Man of the Moment."
43. Sluss, "Behind Every Winner Is a Mudcat."
44. Jarding and Saunders, *Foxes in the Henhouse*, 84.
45. Ibid., 85.
46. Ibid., 85–86.
47. Ibid., 86.
48. Sluss, "Democrat Looks to NRA for Assistance, If Not for Endorsement."
49. Dinan, "NRA Urges Vote for Earley, Stops Short of Endorsement."
50. Schapiro, "Earley Gains NRA Support."
51. Redmon, "2 Gun Groups Target NRA-backed Earley."
52. Taylor, "Hunting for Your Vote."
53. Mark R. Warner, "Remarks of Gov. Mark Warner to the 2002 DLC National Conversation."
54. Jarding, interview.
55. Ibid.
56. Ibid.
57. Sabato, "Democratic Revival in Virginia," 8.
58. Timberg, "Warner Takes Risk with New Strategy."
59. Jarding, interview.
60. Crumley, interview.
61. Fisher, "Guns, Animals, Cash and Food for Thought."
62. Crumley, interview.
63. Ibid.

64. Ibid.
65. Cochran, "Most Demanding Role yet for Sherry Crumley."
66. Ibid.
67. Crumley, interview.
68. Crumley, "Straight Talk: Jim Crumley."
69. Ibid.
70. Ibid.
71. Crumley, interview.
72. Discover the Outdoors, "Role Models."
73. Stephy, "Brief History of Camouflage."
74. Crumley, interview.
75. Ibid.
76. Ibid.
77. Ginsberg, "Hunting Measure Aims to Preserve a Way of Life, Va. Supporters Say."
78. Winegar, "Returns Are In: Outdoorsmen Post Big Wins."
79. Hammack, "Pro-Hunting Amendment Could Be Cut from the Ballot."
80. Crumley, interview.
81. Ibid.
82. Ibid.
83. Ibid.
84. Ginsberg, "Hunting Measure Aims to Preserve a Way of Life."
85. Winegar, "Storm Is Brewing Over Proposed State Measure."
86. Ibid.
87. Ibid.
88. Ibid.
89. Ibid., "Animal-Rights Groups Seeking to Block Vote."
90. Crumley, interview.
91. Ibid.
92. Ibid.
93. Ibid.
94. Ibid.
95. Ibid.
96. Ibid.
97. Ibid.
98. Ibid.
99. Ibid.
100. Ibid.
101. Ibid.
102. Jarding and Saunders, *Foxes in the Henhouse*, 102–3.
103. Ibid., 103.
104. Crumley, interview.
105. Graff, "Is Mark Warner the Next Bill Clinton?"
106. Schapiro, "Campaign Ad Watch."
107. Harris, "God Gave U.S. 'What We Deserve.'"
108. Ibid.

109. Virginia Public Access Project, "Mark Earley."
110. Harris, "God Gave U.S. 'What We Deserve,' Falwell Says."
111. Ibid.
112. Ibid.
113. Melton, "After a Break, Va. Campaign Regains Its Edge."
114. Harris, "God Gave U.S. 'What We Deserve,' Falwell Says."
115. Ibid.
116. Geroux and Stallsmith, "Robertson Runs with Torch with Torch That Falwell Lighted."
117. Wharton, "Group Seeks IRS Inquiry of Pastors' Backing of Earley."
118. Fiske and Little, "Stolle's Backers Say Coalition's Ballot Unfair."
119. Sizemore, "Christian Coalition, Employees Settle Discrimination Suit."
120. Ibid., "Letters Force Robertson to Get Out of Horse Racing."
121. Ibid., "Agency: Robertson Misled Donors."
122. Ibid.
123. Szabo, "Robertson: Pilot's Report on Inquiry Is 'Wrong.'"
124. Jarding, interview.
125. Melton, "Police and Veterans Give Boost to Warner."
126. Ibid.
127. Wheeler, interview.
128. Ibid.
129. Ibid.
130. Ibid.
131. Ibid.
132. Dinan, "Warner, Earley Get Key Endorsements."
133. Beiler, "Mark Warner's Five-Year Plan."
134. Whitley, "Former GOP Governor Holton Endorses Warner."
135. Ibid.
136. Dinan, "2 Republicans Back Warner's Campaign."
137. Sluss, "Republican State Senator Endorses Warner in Governor's Race."
138. Wason, interview.
139. Whitley, "GOP-Leaning Businesspeople Pick Warner."
140. Wason, interview.
141. Fiske, "Fall Governor's Race Shaping Up as Referendum on Budget Impasse."
142. Ibid.
143. Lewis, "GOP Anger at Gilmore May Tilt Governor's Race."
144. Fiske, "Fall Governor's Race Shaping Up as Referendum on Budget Impasse."
145. O'Dell, "Delegate in GOP Endorses Warner."
146. Rhodes, interview.
147. Hardin, "Warner Assails GOP Effort to Defeat Rhodes."
148. Ibid.
149. Virginia Public Access Project, "Mark Earley for Governor—Top Donors."
150. Hardy and Whitley, "'Historic' Session."
151. Brookins, "Rhodes Kill."
152. Matricardi, interview.

153. Morello, "Warner Blurs Political Lines."
154. Whitley, "GOP-Leaning Businesspeople Pick Warner."
155. Ukrop, interview.
156. Whitley, "GOP-Leaning Businesspeople Pick Warner."
157. Sluss, "Some Members of GOP, Independents to Back Warner."
158. Framme, interview.
159. Whoriskey, "Democratic Cadre Tests Warner Vow of Bipartisanship."

CHAPTER 12

1. Shear and Deane, "Kaine Inches Ahead in Va. Race, Poll Finds."
2. Edwards, "'Jobs' Governor."
3. Fiske, "Warner's Virginia Sory Could Be First Chapter."
4. Schapiro and Stallsmith, "Budget at Last."
5. Morris, interview.
6. Bennett, interview.
7. Warner, *Virginia Excels: The Commonwealth's Response to "Show Me the Money"*, 2.
8. Ibid.
9. Newstrom, interview.
10. Leighty, "Looking Back…Governor Warner Leaves Successor Solid Foundation."
11. Mark R. Warner, interview, November 5, 2010.
12. Kohli, *Golden Goals for Government Performance*, 12.
13. Warner, *Virginia Excels: The Commonwealth's Response to "Show Me the Money"*, 3.
14. Whitley, "State to Cut Jobs, Services."
15. Mark R. Warner, interview, November 6, 2005.
16. Bennett, interview.
17. Hardy, "Warner Slashes 1,800 Jobs."
18. Champion and Kaboolian, "Virginia Tax and Budget Reform 2004: Finding the Sensible Center," 17.
19. Bennett, interview.
20. Mark R. Warner, interview, November 5, 2010.
21. Ibid.
22. Ibid.
23. Bennett, interview.
24. Greenblatt, "Governing's Public Officials of the Year."
25. Champion and Kaboolian, "Virginia Tax and Budget Reform 2004: Finding the Sensible Center," 8.
26. Chichester, interview.
27. Ibid.
28. Bennett, interview.
29. Mark R. Warner, interview, November 5, 2010.
30. Stolle, interview.
31. Hardy, "Chichester Seeks Big Tax Increase."

32. Champion and Kaboolian, "Virginia Tax and Budget Reform 2004: Finding the Sensible Center," 11.
33. Stosch, interview.
34. Peterson, "Rainy Day Man."
35. Stolle, interview.
36. Norment, interview.
37. Stosch, interview.
38. Stolle, interview.
39. Chichester, interview.
40. Stolle, interview.
41. Stosch, interview.
42. Saslaw, interview.
43. Stolle, interview.
44. Ibid.
45. Ibid.
46. Ibid.
47. Bennett, interview.
48. Office of Governor Mark R. Warner, "Governor Warner Encourages Virginians to Test Effects of His Tax Reform Plan."
49. Champion and Kaboolian, "Virginia Tax and Budget Reform 2004: Finding the Sensible Center," 9.
50. Mark R. Warner, interview, November 6, 2005.
51. Champion and Kaboolian, "Virginia Tax and Budget Reform 2004: Finding the Sensible Center," 18.
52. Doug Smith, interview.
53. Champion and Kaboolian, "Virginia Tax and Budget Reform 2004: Finding the Sensible Center," 10–11.
54. Moss, interview.
55. Robley Jones, interview.
56. Webb, interview.
57. Champion and Kaboolian, "Virginia Tax and Budget Reform 2004: Finding the Sensible Center," 10–11.
58. Stolle, interview.
59. Doug Smith, interview.
60. Bush, interview.
61. Schrad, interview.
62. Huggins, interview.
63. John Jones, interview.
64. Ibid.
65. Ibid.
66. Ibid.
67. Shear and Jenkins, "Warner and Shaky Coalition Edge Toward Budget."
68. John Jones, interview.
69. *Virginian-Pilot*, "Virginia Business Group Ruffles Capitol Feathers."
70. Ibid.

71. Roberts, interview.
72. Keogh, interview.
73. Lewis, "Against All Odds, Warner Prevails in Lengthy Tax Debate."
74. Archer, interview.
75. Keogh, interview.
76. Ibid.
77. Archer, interview.
78. Fiske and Nuckols, "Ex-Governors Assail Tax Plan."
79. Schapiro, "Earley Launches Abortion Attack."
80. Fiske, "Warner's Virginia Story Could Be First Chapter."
81. Craig, "Former Ally of Gilmore to Endorse Warner."
82. Hardy, "J. Warner on Taxes: 'Politics Be Damned!'"
83. Ibid.
84. Dillard, interview.
85. Ibid.
86. Ibid.
87. Bryant, interview.
88. Mark R. Warner, interview, November 5, 2010.
89. Bryant, interview.
90. Ibid.
91. Norment, interview.
92. Chichester, interview.
93. Champion and Kaboolian, "Virginia Tax and Budget Reform 2004: Finding the Sensible Center," 17.
94. Bryant, interview.
95. Shear, "Budget Crafted Out of Overtures, Frays."
96. Mark R. Warner, interview, November 5, 2010.
97. Ibid.
98. Norment, interview.
99. Stolle, interview.
100. Ibid.
101. Mark R. Warner, interview, November 5, 2010.
102. Ibid.
103. Stolle, interview.
104. Fiske, "Historic Tax Increase Seen as Evidence of Warner's Growth."

Chapter 13

1. Melton, "Gilmore Vetoes Insurance Plan for Children."
2. Hsu, "Gilmore Vows to Veto Children's Health Bill."
3. Bergman, Williams and Pernice, *SCHIP Changes in a Difficult Budget Climate*, 29.
4. Branch, "Success Brings Warner Home."
5. Joint Legislative Audit and Review Commission, *A Review of Selected Programs in the Department of Medical Assistance Services*, 9.

6. Martel, "Noticeable Increase in Health Insurance Enrollment for Low-Income Children."
7. Mark R. Warner, interview, November 5, 2010.
8. Ibid., "Health Care Coverage for Uninsured Children Should Be on the Agenda."
9. Ibid.
10. Ibid.
11. Joint Legislative Audit and Review Commission, *Review of Selected Programs in the Department of Medical Assistance Services*, 10–11.
12. Mark R. Warner, "Action Plan for Virginia," 67.
13. Woods, interview.
14. Bergman, Williams and Pernice, *SCHIP Changes in a Difficult Budget Climate: A Three-State Site Visit Report*, 33.
15. Ibid., 33.
16. Oswalt, interview.
17. Mark R. Warner, interview, November 5, 2010.
18. Ibid.
19. Branch, "Success Brings Warner Home."
20. Office of Governor Mark R. Warner, "Governor Warner Announces FAMIS Enrollment Now Tops 50,000 Children."
21. Mark R. Warner, "Address to Families USA."
22. *Roanoke Times*, "Through Leadership, Promises Come True."
23. Office of Governor Mark R. Warner, "Governor Warner Sets a Goal of 100,000 Children Insured by His Administration."
24. Oswalt, interview.
25. Ibid.
26. Ibid.
27. Mark R. Warner, "Address to Families USA."

Chapter 14

1. Homer, interview.
2. Clement, interview.
3. Schapiro, "Warner Fills Two Cabinet Positions."
4. Homer, interview.
5. Ibid.
6. Mark R. Warner, interview, November 5, 2010.
7. Fiske, "New Director Makes Inroads in Reforming VDOT."
8. Bacque, "How Did We Get Here?"
9. Ibid.
10. Clawson and Yemen, *Virginia Department of Transportation: Trying to Keep Virginia Moving*, 3.
11. Bacque, "How Did We Get Here?"
12. Allen, interview.
13. Ibid.

14. Mark R. Warner, interview, November 5, 2010.
15. Shear, "New Bridges to Make Commute Smoother in Springfield Mixing Bowl."
16. Ibid., "VDOT Crisis Worsened Even as Gilmore Boasted."
17. Ibid.
18. Ibid.
19. Ibid.
20. Ibid.
21. Ibid.
22. Clement, "Sound Business Practices Mean a More Accountable VDOT."
23. Bacque, "How Did We Get Here?"
24. Clement, "Sound Business Practices Mean a More Accountable VDOT."
25. Office of Governor Mark R. Warner, "Warner Addresses Commonwealth Transportation Board."
26. Office of Governor Mark R. Warner, "Governor Warner Requests Audit of VDOT, Scales Back Six-Year Plan."
27. Clement, "Sound Business Practices Mean a More Accountable VDOT."
28. Mark R. Warner, "Restoring Trust," 2.
29. Shucet, interview.
30. Ibid.
31. Bacque and Schapiro, "Roads Chief to Be Named Today."
32. Clawson and Yemen, *Virginia Department of Transportation: Trying to Keep Virginia Moving*, 6.
33. Shucet, interview.
34. Fiske, "New Director Makes Inroads in Reforming VDOT."
35. Shucet, interview.
36. Ibid.
37. Ibid.
38. Homer, interview.
39. Shucet, interview.
40. Ibid.
41. Ibid.
42. Ibid.
43. Ibid.
44. Shear, "Bumpy Road Ahead for New Chief of Cash-Poor VDOT."
45. Fiske, "New Director Makes Inroads in Reforming VDOT."
46. Shear, "Bumpy Road Ahead for New Chief of Cash-Poor VDOT."
47. Shucet, interview.
48. Ibid.
49. Edds, "Long and Winding Road for VDOT Chief."
50. Clawson and Yemen, *Virginia Department of Transportation: Trying to Keep Virginia Moving*, 7.
51. Clement, "VDOT Has Tailored Its Projects, Goals Closer to Reality."
52. Edds, "Long and Winding Road for VDOT Chief."
53. Clawson and Yemen, *Virginia Department of Transportation: Trying to Keep Virginia Moving*, 5.

54. Shucet, interview.
55. Ibid.
56. Fiske, "New Director Makes Inroads in Reforming VDOT."
57. Mark R. Warner, interview, November 5, 2010.
58. Ibid.
59. Bacon, "Shucet Effect."
60. Clawson and Yemen, *Virginia Department of Transportation: Trying to Keep Virginia Moving*, 4.
61. Fiske, "New Director Makes Inroads in Reforming VDOT."
62. Clawson and Yemen, *Virginia Department of Transportation: Trying to Keep Virginia Moving*, 4.
63. Shucet, interview.
64. Ibid.
65. Virginia Department of Transportation, "VDOT Meets or Exceeds All Project Completion."
66. *Virginian-Pilot*, "VDOT Reports On-Time Rate for July 1–Dec. 31."
67. Allen, interview.
68. Mayes, "Virginia Gains Public Trust."
69. Allen, interview.
70. Mayes, "Virginia Gains Public Trust."
71. Shucet, interview.
72. Allen, interview.
73. Mayes, "Virginia Gains Public Trust."
74. Clement, "VDOT Has Tailored Its Projects, Goals Closer to Reality."
75. Homer, interview.
76. Mayes, "Virginia Gains Public Trust."
77. Allen, interview.
78. Shucet, interview.
79. Ibid.
80. Ginsberg, "Transportation Chief in Va. to Step Down."
81. Shucet, interview.
82. Clement, interview.

CHAPTER 15

1. Virginia Department of Veterans Services, *2014 Annual Report*, 4.
2. Virginia Auditor of Public Accounts, *Virginia Veterans Care Center Special Report: January 1, 1998 to February 6, 2002*.
3. Sturgeon and Sluss, "Audit Details Misspending at Vet Center."
4. Sturgeon, "State Probes Nursing Facility."
5. Sturgeon, "Veterans Center Seeks to End Its Insurance Woes."
6. Virginia Auditor of Public Accounts, "Virginia Veterans Care Center Special Report."
7. Ibid.
8. Kelly and Taylor, "Can VA Center Ills Be Cured?"

9. Ibid.
10. Sturgeon and Sluss, "Audit Details Misspending."
11. Bailey, interview.
12. Sturgeon, "Changes Coming to Home for Veterans."
13. Ibid., "Virginia to Take Over Veterans Care Center."
14. Nuckols, "Proposal to Bring Veterans Facility Under Increased State Control Fails."
15. Bailey, interview.
16. Gehman, "Veterans Have Earned Our Support."
17. Ibid.
18. Ibid.
19. Ibid.
20. Office of Governor Mark R. Warner, "Veterans Organizations Support Governor Warner's Reform Agenda for Veterans Services."
21. Stallsmith, "Veterans Director Selected."
22. Office of Governor Mark R. Warner, "Governor Warner Breaks Ground for Second Virginia Veterans Care Center."
23. Burgess, interview.
24. Bailey, interview.
25. Office of Governor Mark R. Warner, "Governor Warner Presents Virginia's Contribution to National World War II Memorial."
26. Office of Governor Mark R. Warner, "Virginia Department of Veterans Services to Host Informational Event."
27. Bailey, interview.
28. Galanti, interview.
29. Mark R. Warner, interview, January 10, 2011.
30. Ibid.
31. Wilder, interview.
32. Ibid.

Chapter 16

1. Murphy, interview, October 18, 2010.
2. Mark R. Warner, interview, January 10, 2011.
3. Ibid.
4. Murphy, interview, October 18, 2010.
5. Maroon, interview.
6. Lipford, interview.
7. Paylor, interview.
8. Lipford, interview.
9. Mark R. Warner, "2002 State of the Commonwealth Address."
10. Maroon, interview.
11. Office of Governor Mark R. Warner, "Governor Warner Praises Agreement on Funding for James River Reserve Fleet."
12. Paylor, interview.

13. Office of Governor Mark R. Warner, "Governor Warner Praises Agreement on Funding for James River Reserve Fleet."
14. Paylor, interview.
15. Ibid.
16. Rubin, "Solving Problem by Consensus: Water Planning for Virginia," 1–2.
17. Paylor, interview.
18. Maroon, interview.
19. Murphy, interview, October 18, 2010.
20. Mark R. Warner, interview, January 10, 2011.
21. Murphy, interview, October 18, 2010.
22. Murphy, "Testimony Before the U.S. House Subcommittee on Water Resources and Environment."
23. Murphy, interview, October 18, 2010.
24. Ibid.
25. Shear and Jenkins, "Warner's Budget Plan Reflects Va.'s Turnaround."
26. Murphy, interview, April 3, 2015.
27. Ibid.
28. Murphy, interview, October 18, 2010.
29. Mark R. Warner, interview, January 10, 2011.

Chapter 17

1. Ibid., June 13, 2011.
2. Ibid.
3. Ibid.
4. Craig, "Warner a Hands-On Dealmaker, Though Critics Question the Need."
5. Mark R. Warner, "Address to the Virginia Association of Secondary School Principals."
6. Hirschbiel, interview.
7. Blake, "Restructuring Relationships in Virginia: The Changing Compact Between Higher Education Institutions and the State," 29.
8. Mark R. Warner, interview, January 10, 2011.
9. Sluss, "2 Warners Endorse Election's Bond Package."
10. Blake, "Restructuring Relationships in Virginia: The Changing Compact Between Higher Education Institutions and the State," 31.
11. Ibid., 32.
12. Kapsidelis, "W&M Approves Tuition Guaruntee."
13. Ibid.
14. DeMary, interview.
15. Mark R. Warner, interview, June 13, 2011.
16. Office of Governor Mark R. Warner, "Governor Warner Launches Partnership to Raise Student Achievement at Lowest Performing Schools in Virginia."
17. Mark R. Warner, "Education Reform: An Economic Imperative."
18. Ibid., interview, June 13, 2011.

19. Ibid., *High School Reform: An Urgent Priority in a Changing Economy*, 107–8.
20. DeMary, interview.
21. Helderman, "Virginia's Graduation Rate Steady."
22. Mark R. Warner, interview, June 13, 2011.
23. Shannon, "Efficiency, Accountability in Virginia Schools."
24. DeMary, interview.
25. Ibid.
26. Mark R. Warner, "Business Approach."
27. Sampson, "Microsoft Invests in Schools."
28. Mark R. Warner, "Education Reform: An Economic Imperative."
29. Ibid., *High School Reform: An Urgent Priority in a Changing Economy*, 104.
30. Graff, "Senior Year Plus."
31. Mark R. Warner, *High School Reform: An Urgent Priority in a Changing Economy*, 107.
32. Hannon, "Students Surf for Hard-to-Find Classes."
33. Mark R. Warner, "Address to Virginia Association of Superintendents."
34. Ibid., *High School Reform: An Urgent Priority in a Changing Economy*, 105.
35. Ibid., *Governor's Approach to Improving Secondary Career Education*, 30.
36. Sluss, "Warner Wants GED Numbers Doubled."
37. Mark R. Warner, "Address to Virginia Association of Superintendents."
38. Ibid., *Governor's Approach Approach to Improving Secondary Career Education*, 31.
39. Ibid., 29.
40. DeMary, interview.

Chapter 18

1. Fiske, "Civil Rights Monument Will Honor Fight Led by Students."
2. Office of Governor Mark R. Warner, "First Lady Lisa Collis Launches Fundraising Campaign for Virginia Civil Rights Memorial."
3. Sluss, "Capitol Asset."
4. Ibid.
5. Ibid.
6. Baskerville, interview.
7. Meola, "Honoring Civil-Rights Figures."
8. Batts, "Barbara Johns: Quiet Teen Made a Loud Statement Against Injustice."
9. Sluss, "Kaine Helps Break Ground for Civil Rights Memorial."
10. Perilli, "Virginia Civil Rights Memorial Timeline."
11. Ibid.
12. Mundy, "Making Up for Lost Time."
13. Sluss, "Kaine Helps Break Ground for Civil Rights Memorial."
14. Batts, "Barbara Johns: Quiet Teen Made a Loud Statement Against Injustice."
15. Fiske, "Civil Rights Monument Will Honor Fight Led by Students."
16. Office of Governor Mark R. Warner, "Governor Warner Dedicates the Old Finance Building in Honor of Civil Rights Advocate Oliver W. Hill."
17. Sluss, "Historic Building Renamed for Civil Rights Lawyer."

18. Woodley, interview.
19. Laveist, "New Voice, a New Age."
20. Lambert, "Gentlemen of the Senate."
21. Woodley, interview.
22. Ibid.
23. *Virginian-Pilot*, "Gimmick Justified to End Hiring Bias."
24. Lizama, "Warner Welcomes Latino Advisors."
25. Grace, "Getting Their Dues."
26. Schapiro, "Warner Asks for Education Funding."
27. Becker, "Va. Massive Resistance Victims Get Scholarships, but Not Funds."
28. Mark R. Warner, interview, January 10, 2011.
29. Ibid.
30. Stallsmith and Whitley, "State Funds Scholarships for Those Denied Schooling."

Chapter 19

1. Cline, interview.
2. Davis, "Notable Term for Gov. Warner."
3. Thornton, "Tire Fire Left Man's World in Limbo."
4. Lewis, "Good Year for Disaster."
5. *Virginian-Pilot*, "Hurricane Isabel: Around Hampton Roads."
6. Germanotta, "Evacuations, Rarely Ordered Here, Move Along Smoothly."
7. John Marshall, interview.
8. Massengill, interview.
9. Office of Governor Mark R. Warner, *An Assessment: Virginia's Response to Hurricane Isabel*, 1.
10. Mark Marshall, interview.
11. Ibid.
12. Atwood, "Virginia's 'High Tech' Governor: Mark Warner," 2.
13. Mark Marshall, interview.
14. Ibid.
15. Martz, "Va.'s Anti-Terror Efforts Must Strike Balance, Warner Says."
16. John Marshall, interview.
17. Mark R. Warner, interview, June 13, 2011.
18. Ibid.
19. Office of Governor Mark R. Warner, *Report and Recommendations*, 4.
20. Mark R. Warner, interview, June 13, 2011.
21. Hammack, "Meth Lab Raids Fall Sharply in State."
22. Newman, interview.
23. Wessol, "Methamphetamine: A New Drug Crisis Is Growing in Southwest Virginia."
24. Combs, "Meth Film and Speakers Will Be Part of Meeting October 14 at High School."
25. Newman, interview.
26. Cooke, "Reducing Bias in Policing: A Model Approach in Virginia."

27. Ibid.
28. Ibid.
29. John Marshall, interview.
30. Green, "DNA Tests Clear Convicts."
31. Piazza, "Prosecutor Backs Plea for Pardon."
32. Brooks, "Virginia Case Review Revives DNA Debate."
33. Felberbaum, "Warner Pardons Men Cleared by DNA."
34. Brooks, "Virginia Case Review Revives DNA Debate."
35. Crouch, interview.
36. Mark R. Warner, "Important Step Forward in Protecting the Innocent."
37. Ibid.
38. Green, "DNA Tests Prove Coleman's Guilt."
39. Whitley, "Gilmore, Warner Unified in N.Y."
40. Hager, interview.
41. Scanlon, "Gov. Warner Urges Beach Students to Volunteer."
42. Mark R. Warner, interview by Rodney Slater.
43. Ibid.
44. Hager, interview.
45. Ibid.
46. Ibid.
47. Ibid.
48. Foresman, interview.
49. Ibid.
50. Ibid.
51. Ibid.
52. Ibid.
53. Ibid.
54. Mark R. Warner, interview, June 13, 2011.
55. Crouch, interview.
56. Foresman, interview.
57. Hager, interview.
58. John Marshall, interview.
59. Hager, interview.
60. Mark R. Warner, interview, June 13, 2011.
61. Foresman, interview.
62. Hager, interview.
63. Ibid.
64. Foresman, interview.
65. Flaherty, interview.
66. Office of Governor Mark R. Warner, "Governor Warner Launches Commonwealth's New Multi-Agency Communications System."
67. Massengill, interview.
68. *Roanoke Times*, "Can You Hear Me Now?"
69. Flaherty, interview.
70. Mark R. Warner, interview, June 13, 2011.

Notes to Pages 292–304

71. Petkofsky, "New Panel to Defend Va. Military Bases."
72. Hardin, "Struggle for Oceana Isn't Over."
73. Lindsey, "Beach Moves to Guard Oceana."
74. Ibid.
75. Hardin, "Struggle for Oceana Isn't Over."
76. Foresman, interview.
77. Ibid.
78. Lindsey, "Beach Moves to Guard Oceana."
79. *Virginian-Pilot*, "Oceana's Brush with BRAC."
80. El Nasser, "Voters Say No to Jet Base."
81. Scanlon, "Gov. Warner Urges Beach Students to Volunteer."
82. Foresman, interview.
83. Clements, interview.
84. Mark R. Warner, interview, June 13, 2011.
85. Clements, interview.
86. Ibid.
87. Foresman, interview.
88. Ibid.
89. Weatherford, "Getting to Yes."
90. Bradley, Green and McKelway, "Captured."
91. Mark R. Warner, interview, June 13, 2011.
92. *Richmond Times-Dispatch*, "Excerpts from Warner's Speech on TV."
93. Foresman, interview.
94. John Marshall, interview.
95. Massengill, interview.
96. Ibid.
97. Mark R. Warner, interview, June 13, 2011.
98. McKelway, "Anatomy of a Fierce Manhunt."
99. Massengill, interview.
100. Fischer and Akin, "Notes Threat Tied to Closing of Area Schools."
101. Mark R. Warner, interview, June 13, 2011.
102. Massengill, interview.
103. Ibid.
104. Ibid.
105. Ibid.
106. John Marshall, interview.
107. Massengill, interview.
108. John Marshall, interview.

Afterword

1. Trygstad, "Warner Won't Run for Governor."

BIBLIOGRAPHY

Abramowitz, Alan, John McGlennon and Ronald Rapoport. "The 1978 Virginia Senatorial Nominating Conventions." *University of Virginia News Letter* 55, no. 4 (December 1978): 13.
Allen, Gary. Interview by Will Payne. September 30, 2010.
Allen, George. "The Gentleman from Virginia." *Richmond Times-Dispatch*, December 14, 2008.
Allen, Mike. "Mark Warner: Back Up and Running." *Washington Post*, February 6, 1997.
———. "M. Warner Had to Fight 'Conventional Wisdom'." *Richmond Times-Dispatch*, November 7, 1996.
Allen, Mike, and Peter Hardin. "Whiz Kid Takes on Firebrand Trying a Comeback." *Richmond Times-Dispatch*, April 7, 1996.
Archer, Bob. Interview by Will Payne. September 28, 2010.
Atwood, Bonnie. "Virginia's 'High Tech' Governor: Mark Warner." *Virginia Capitol Connections Quarterly*, Fall 2005: 2.
Bacon, James. "The Shucet Effect." Bacon's Rebellion. August 8, 2005. http://www.baconsrebellion.com/Issues05/08-08/Bacon.php.
Bacque, Peter. "How Did We Get Here?" *Richmond Times-Dispatch*, June 8, 2004.
Bacque, Peter, and Jeff Schapiro. "Roads Chief to Be Named Today." *Richmond Times-Dispatch*, April 2004.
Bai, Matt. "Mission: Take Back the Hills." *Newsweek* magazine, September 3, 2001.
Bailey, Sheryl. Interview by Will Payne. October 28, 2010.
Baker, Donald, and R.H. Melton. "Record Tax Package Voted for Virginia Roads." *Washington Post*, September 28, 1986.
Baker, Peter. "Before Politics, a Run for His Money." *Washington Post*, September 2, 1996.
———. "Warner's Moderation, Usually an Asset, Is Under Siege." *Washington Post*, June 6, 1996.

BIBLIOGRAPHY

Baker, Peter, and Spencer Hsu. "No Substitute for Knowing Your Warner." *Washington Post*, June 15, 1996.

———. "Warner Crushes Miller in GOP Primary." *Washington Post*, June 12, 1996.

Barakat, Matthew. "Warners Make Final Tax Push." *Winchester Star*, November 5, 2002.

Baristic, Sonja. "Warner: Tax Plan Too Good to Pass Up." *Richmond Times-Dispatch*, August 2, 2002.

Baskerville, Viola. Interview by Will Payne. October 20, 2010.

Batts, Denise Watson. "Barbara Johns: Quiet Teen Made a Loud Statement Against Injustice." *Virginian-Pilot*, February 10, 2008.

Becker, Jo. "Va. Massive Resistance Victims Get Scholarships, but Not Funds." *Washington Post*, February 26, 2004.

Beckman, Kristen. "Morgan O'Brien: Idea Man." *RCR Wireless*, May 7, 2001.

Beiler, David. "Mark Warner's Five-Year Plan." *Campaigns & Elections* 22, no. 10 (December 2001): 34–42.

Bennett, John. Interview by Will Payne. October 22, 2010.

Bergman, David, Claudia Williams and Cynthia Pernice. *SCHIP Changes in a Difficult Budget Climate: A Three-State Site Visit Report*. Washington, D.C.: National Academy for State Health Policy, 2004, 29, 33.

Billingsley, Anna Barron. "Wilder Planning Another Revision to Health Package." *Richmond Times-Dispatch*, June 9, 1992.

Bishop, Matthew, and Michael Green. *Philanthrocapitalism*. London: A.&C. Black, 2008.

Blake, Peter. "Restructuring Relationships in Virginia: The Changing Compact Between Higher Education Institutions and the State." *Change*, January/February 2006: 29–32.

Bradley, Paul, Frank Green and Bill McKelway. "Captured." *Richmond Times-Dispatch*, October 25, 2002.

Branch, Carla. "Success Brings Warner Home." *Alexandria Gazette Packet*, October 1, 2004.

Brookins, Gary. "Rhodes Kill." *Richmond Times-Dispatch*, June 10, 1999.

Brooks, Anthony. "Virginia Case Review Revives DNA Debate." National Public Radio, January 25, 2006.

Brostoff, Beth. "John Warner '53: Statesman and Son of Virginia." *Virginia Law Weekly* 59, no. 6 (October 2006).

Bryant, Preston. Interview by Will Payne. September 20, 2010.

Burgess, Vince. Interview by Will Payne. November 4, 2010.

Bush, Madge. Interview by Will Payne. September 22, 2010.

Business Wire. "Tek.Xam Exam Becomes National Assessment Tool." July 18, 2000.

Cain, Andrew. "Battle of Warners Possible in '96." *Washington Times*, May 11, 1995.

———. "Miller Begins Race to Unseat 'Clinton Republican' Warner." *Washington Times*, December 6, 1996.

———. "Warner's Their Name, Disparity Is Their Game." *Washington Times*, June 13, 1996.

Chaddock, Gail Russell. "Profile of Mark Warner: Ivy Leaguer with Rural NASCAR Draw." *Christian Science Monitor*, August 25, 2008.

Bibliography

Champion, Thomas P., and Linda Kaboolian. "Virginia Tax and Budget Reform 2004: Finding the Sensible Center." Public Sector Labor-Management Committee and Kennedy School, Harvard University, 2004, 8–11, 17–18.
Chase, Bob. "Political Will." *Virginia Issues & Answers*, 2010: 13.
Chichester, John. Interview by Will Payne. October 26, 2010.
Clawson, James, and Gerry Yemen. *Virginia Department of Transportation: Trying to Keep Virginia Moving.* Charlottesville, VA: Darden Business Publishing, 2005, 3, 5–7.
Clement, Whitt. Interview by Will Payne. October 5, 2010.
———. "Sound Business Practices Mean a More Accountable VDOT." 2002.
———. "VDOT Has Tailored Its Projects, Goals Closer to Reality." *Richmond Times-Dispatch*, March 21, 2004.
Clements, Janet. Interview by Will Payne. November 19, 2010.
Cline, Michael. Interview by Will Payne. November 4, 2010.
Clinton, Bill. *Between Hope and History.* New York: Random House, 1996.
Cochran, Bill. "Most Demanding Role yet for Sherry Crumley." *Roanoke Times*, March 28, 2005.
Collins, Amy Fine. "Making His Mark." *Vanity Fair*, August 20, 2008.
Combs, Wanda. "Meth Film and Speakers Will Be Part of Meeting October 14 at High School." *Smyth County News & Messenger*, October 14, 2010.
Cooke, Leonard. "Reducing Bias in Policing: A Model Approach in Virginia." *Police Chief*, June 2004.
Craig, Tim. "Former Ally of Gilmore to Endorse Warner." *Washington Post*, June 9, 2008.
———. "Warner a Hands-On Dealmaker, Though Critics Question the Need." *Washington Post*, October 30, 2008.
Croall, Dave. Interview by Will Payne. January 15, 2013.
Crouch, Bob. Interview by Will Payne. November 24, 2010.
Crumley, Jim. Interview by Frank Addington. "Straight Talk: Jim Crumley." Bowhunting.net, September 26, 2006.
Crumley, Sherry. Interview by Will Payne. March 22, 2010.
Dalch, Linda. Interview by Will Payne. October 15, 2010.
Davenport, Ben. Interview by Will Payne. October 14, 2010.
Davis, Chelyen. "Notable Term for Gov. Warner." *Free Lance-Star*, January 1, 2006.
Davis, Tom. Interview by Will Payne. June 27, 2012.
DeMary, Jo Lynne. Interview by Will Payne. October 19, 2010.
Dillard, Jim. Interview by Will Payne. June 27, 2012.
Dillard, Rodney, and Mitch Jayne. "Warner." Lansdowne Music/Winston Music Publishers. 2001.
Dinan, Stephen. "Gilmore's Pay-Raise Plan Rejected." *Washington Times*, April 5, 2001.
———. "NRA Urges Vote for Earley, Stops Short of Endorsement." *Wasington Times*, October 26, 2001.
———. "2 Republicans Back Warner's Campaign." *Washington Times*, October 17, 2001.
———. "Warner, Earley Get Key Endorsements." *Washington Times*, October 28, 2001.
———. "Warner Hopes to Keep "Em Hummin'." *Washington Times*, June 12, 2001.

BIBLIOGRAPHY

Discover the Outdoors. "Role Models: Sherry Crumley." 2001. http://www.dto.com/women/rolemodels/crumley.

Drummond, Daniel. "Anti-Tax Pledgers Scramble for Cover." *Washington Times*, February 28, 2002.

Edds, Margaret. *Claiming the Dream: The Victorious Campaign of Douglas Wilder of Virginia*. Chapel Hill, NC: Algonquin Books, 1990.

———. "A Long and Winding Road for VDOT Chief." *Virginian-Pilot*, October 19, 2003.

———. "Virginia's Budget: The Crisis That Keeps on Ticking." *Virginian-Pilot*, March 18, 2001.

Edwards, Greg. "The 'Jobs' Governor." *Richmond Times-Dispatch*, January 2, 2006.

Edwards, Paul. "Holton Runs for Senate Seat in Va." *Washington Post*, December 20, 1997.

———. "Obenshain Gains Narrow Edge in Va. Senate Bid." *Washington Post*, June 4, 1978.

———. "Va. Senate Campaign Heats Up on TV." *Washington Post*, October 30, 1978.

———. "Warner Interested in Running Again." *Washington Post*, June 6, 1978.

———. "Warner Takes Hard Line in Va. GOP Bid." *Washington Post*, February 12, 1978.

Edwards, Paul, and David Broder. "Warner Certified Victor." *Washington Post*, November 28, 1978.

Edwards, Paul, and Donald Baker. "Miller Wins as Foes Quit on 3rd Ballot." *Washington Post*, June 11, 1978.

Edwards, Paul, and Megan Rosenfeld. "Crash Kills Obenshain." *Washington Post*, August 4, 1978.

———. "Va. Democrats Hail Obenshain Victory." *Washington Post*, June 5, 1978.

Eggers, William D. "Show Me the Money: Budget-Cutting Strategies for Cash-strapped States." New York: American Legislative Exchange Council, 2002, 2.

El Nasser, Haya. "Voters Say No to Jet Base." *USA Today*, November 15, 2006.

Faulk, Cordel. "How Doug Wilder Changed America." *Richmond Times-Dispatch*, October 25, 2009.

Felberbaum, Michael. "Warner Pardons Men Cleared by DNA." *Winchester Star*, December 23, 2005.

Fill, Gerald. "Promoting the Life of George Washington." *Mount Vernon Gazette*, August 18, 2011.

Fischer, Meredith, and Paige Akin. "Note's Threat Tied to Closing of Area Schools." *Richmond Times-Dispatch*, October 22, 2002.

Fisher, Marc. "Guns, Animals, Cash and Food for Thought." *Washington Post*, November 4, 2000.

Fiske, Warren. "At Last, Warner Has Some Respect." *Virginian-Pilot*, June 10, 1990.

———. "Car-Tax Cut Would Cost Double What Gilmore Says, Group Claims." *Virginian-Pilot*, June 24, 1996.

———. "Car Tax Phaseout Splits Virginia Republicans." Stateline.org, April 6, 2001.

———. "Civil Rights Monument Will Honor Fight Led by Students." *Virginian-Pilot*, May 17, 2005.

Bibliography

———. "Fall Governor's Race Shaping Up as Referendum on Budget Impasse." *Virginian-Pilot*, September 9, 2001.

———. "Gilmore Defends Using Loans to Continue Cutting Car Tax." *Virginian-Pilot*, January 10, 2001.

———. "Historic Tax Increase Seen as Evidence of Warner's Growth." *Virginian-Pilot*, May 2, 2004.

———. "New Director Makes Inroads in Reforming VDOT." *Virginian-Pilot*, November 18, 2002.

———. "The Personal Side of Democrat Mark Warner." *Virginian-Pilot*, October 21, 2001.

———. "Warner's Virginia Story Could Be First Chapter." *Virginian-Pilot*, January 13, 2006.

Fiske, Warren, and Christina Nuckols. "Ex-Governors Assail Tax Plan." *Virginian-Pilot*, March 2, 2004.

———. "Senators Reject Effort to Institute Garbage Fee." *Virginian-Pilot*, April 18, 2002.

Fiske, Warren, and Robert Little. "Stolle's Backers Say Coalition's Ballot Unfair." *Roanoke Times*, June 7, 1997.

Flaherty, Steve. Interview by Will Payne. November 2, 2010.

Fleenor, Patrick. "Impact of Virginia's Gubernatorial Personal Property Tax Relief Plans Vary Widely by Locality." *Tax Foundation Speical Report*, no. 73 (October 1997): 3.

Foresman, George. Interview by Will Payne. October 14, 2012.

Foster, Lee. "Politician Wows His Home Crowd." *Hartford Courant*, September 13, 2003.

———. "Virginia Leader Hosting Party." *Hartford Courant*, April 13, 2004.

Framme, Larry. Interview by Will Payne. October 14, 2010.

Galanti, Paul. Interview by Will Payne. November 14, 2010.

Gehman, Harold W., Jr. "Veterans Have Earned Our Support." *Virginian-Pilot*, January 28, 2003.

Gentile, Gary. "Candidate in Virginia Has Vernon Ties." *Harford Courant*, September 20, 1995.

Germanotta, Tony. "Evacuations, Rarely Ordered Here, Move Along Smoothly." *Virginian-Pilot*, September 18, 2003.

Geroux, Bill. "New Solutions to Traffic Woes Sought." *Richmond Times-Dispatch*, November 7, 2002.

Geroux, Bill, and Kiran Krishnamurthy. "Hampton Roads, N.Va. Reject Tax Increases." *Richmond Times-Dispatch*, November 6, 2002.

Geroux, Bill, and Pamela Stallsmith. "Robertson Runs with Torch That Falwell Lighted." *Richmond Times-Dispatch*, May 30, 1993.

Gilmore, James S. *2001 State of the Commonwealth Address*. Richmond, VA: Office of Governor James S. Gilmore, January 10, 2001.

Ginsberg, Steven. "Hunting Measure Aims to Preserve a Way of Life, Va. Supporters Say." *Washington Post*, October 29, 2000.

———. "Transportation Chief in Va. to Step Down." *Washington Post*, June 1, 2005.

González, Bea. Interview by Will Payne. September 30, 2010.

Grace, Kerry. "Getting Their Dues." *Richmond Times-Dispatch*, December 13, 2004.

Bibliography

Graff, Garrett. "Is Mark Warner the Next Bill Clinton?" *Washingtonian Magazine*, February 1, 2006.

Graff, Michael. "Senior Year Plus." *Winchester Star*, October 6, 2004.

Green, Frank. "DNA Tests Clear Convicts." *Richmond Times-Dispatch*, December 15, 2005.

———. "DNA Tests Prove Coleman's Guilt." *Richmond Times-Dispatch*, January 13, 2006.

Greenblatt, Alan. "Governing's Public Officials of the Year." *Governing*, November 2004.

Grundon, Anne. "Mark Warner Campaigns in Bristol." *Bristol Herald Courier*, August 12, 2000.

Guldin, Bob. "Virginia's Man of the Moment." *GW Magazine*, 2002.

Hager, John. Interview by Will Payne. March 16, 2010.

Hammack, Laurence. "Meth Lab Raids Fall Sharply in State." *Roanoke Times*, February 3, 2006.

———. "Pro-Hunting Amendment Could Be Cut from the Ballot." *Roanoke Times*, October 20, 2000.

Hampton, Jeff. "Turkey Shoot Targets Charity, but Not Birds." *Virginian-Pilot*, December 10, 2007.

Hannon, Kelly. "Students Surf for Hard-to-Find Classes." *Free Lance-Star*, September 28, 2004.

Hansen, Louis. "High-Stakes Campaigns Nearing End of the Road." *Virginian-Pilot*, November 3, 2001.

Harden, Blaine, Lynn Darling and Megan Rosenfeld. "Obenshain Died Pursuing a Dream." *Washington Post*, August 6, 1978.

Hardin, Peter. "Struggle for Oceana Isn't Over." *Richmond Times-Dispatch*, September 5, 2005.

———. "Warner Assails GOP Effort to Defeat Rhodes." *Richmond Times-Dispatch*, June 11, 1999.

Hardy, Michael. "Allen Budget Plan Goes Far and Wide." *Richmond Times-Dispatch*, December 31, 1997.

———. "Baliles, Wilder, Ms. Terry Elected as Democrats." *Richmond Times-Dispatch*, November 6, 1985.

———. "Chichester Seeks Big Tax Increase." *Richmond Times-Dispatch*, January 13, 2004.

———. "Colleges, Parks Bonds Approved." *Richmond Times-Dispatch*, November 6, 2002.

———. "J. Warner on Taxes: 'Politics Be Damned!'." *Richmond Times-Dispatch*, February 7, 2004.

———. "Quarreling Over Car Tax." *Richmond Times-Dispatch*, March 25, 2001.

———. "Tooting His Own Horn." *Richmond Times-Dispatch*, May 1998.

———. "Va. Gets Bad Revenue News." *Richmond Times-Dispatch*, January 17, 2001.

———. "Warner Slashes 1,800 Jobs." *Richmond Times-Dispatch*, October 16, 2002.

Hardy, Michael, and Jeff Schapiro. "Car Tax's Price Tag Jumps." *Richmond Times-Dispatch*, January 24, 1998.

———. "Gilmore Will Call a Special Session." *Richmond Times-Dispatch*, February 24, 2001.

Bibliography

———. "GOP Savoring Sweep, Preparing a Wish List." *Richmond Times-Dispatch*, November 7, 2002.

Hardy, Michael, and Tyler Whitley. "A 'Historic' Session." *Richmond Times-Dispatch*, April 26, 1998.

Harris, John. "God Gave U.S. 'What We Deserve,' Falwell Says." *Washington Post*, September 14, 2001.

Healy, Melissa. "Tech Skills Tested in New College Exam." *Los Angeles Times*, October 27, 1997.

Helderman, Rosalind. "Virginia's Graduation Rate Steady." *Washington Post*, October 18, 2005.

Helm, Leslie. "Fleet Thinking Helps Tiny Nextel Make Big Waves." *Los Angles Times*, December 5, 1993.

Henry, Mike. Interview by Will Payne. June 10, 2010.

Henry, Shannon. "Partners with a Strings Theory of Giving." *Washington Post*, January 25, 2001.

———. "Testing Liberal Arts Waters." *Washington Post*, January 14, 1999.

Heyser, Holly. "Budget Cuts Will Do Long Term Damage, College Presidents Say." *Virginian-Pilot*, March 14, 2001.

———. "The Governor's Immovable Challenge." *Virginian-Pilot*, April 27, 2001.

———. "Stymied Va. Lawmakers Call It Quits." *Virginian-Pilot*, May 10, 2001.

Heyser, Holly, and Christina Nuckols. "Senators Defy Gilmore on Car Tax." *Virginian-Pilot*, February 5, 2001.

Hirschbiel, Paul. Interview by Will Payne. September 24, 2010.

Hishta, John. Interview by Will Payne. June 27, 2012.

Holton, Linwood. *Opportunity Time*. Charlottesville: University of Virginia Press, 2008.

Homer, Pierce. Interview by Will Payne. October 6, 2010.

Howell, Isak, Mike Sluss and Matt Chittum. "Focus on Rural Localities Gave Warner Upper Hand." *Roanoke Times*, November 8, 2001.

Hsu, Spencer. "Gilmore Targets Personal Property." *Washington Post*, May 9, 1997.

———. "Gilmore Tax Plan Legal, Va. Attorney General Says." *Washington Post*, September 17, 1997.

———. "Gilmore Vows to Veto Children's Health Bill." *Washington Post*, March 12, 1998.

———. "Status Quo Thrives on Both Sides of the Potomac." *Washington Post*, November 6, 1996.

———. "Warner Takes on Warner for Senate." *Washington Post*, March 12, 1996.

Huggins, Wayne. Interview by Will Payne. March 30, 2010.

Indiana Public Media. "WFIU Profiles: Birch Bayh." *Weekly Special*, January 1, 2011. http://youtu.be/84TT2sgOEms.

"Invest in Social Change." *Washington Life*, May 2006: 3–5.

Jarding, Steve. Interview by Will Payne. December 21, 2010.

Jarding, Steve, and Dave "Mudcat" Saunders. *Foxes in the Henhouse: How the Republicans Stole the South and the Heartland and What the Democrats Must Do to Run 'Em Out*. New York: Touchstone, 2006.

BIBLIOGRAPHY

Jenkins, Kent. "John Warner's Charmed Life." *Washington Post*, September 11, 1990.

Johnson, Adrienne. Interview by Will Payne. July 10, 2014.

Johnson, Ronald Tee. "David & Rhoda Chase: Philanthropists Extraordinaire." *Palm Beach Today*, April 5, 2008.

Joint Legislative Audit and Review Commission. *A Review of Selected Programs in the Department of Medical Assistance Services*. Richmond, VA, 2002, 9–11.

Jones, John W. Interview by Will Payne. March 30, 2010.

Jones, Robley. Interview by Will Payne. March 29, 2010.

Kapsidelis, Karin. "W&M Approves Tuition Guarantee." *Richmond Times-Dispatch*, April 20, 2013.

Kelley, Jeffrey. "Companies, Job Seekers Unite." *Richmond Times-Dispatch*, February 17, 2006.

Kelly, Sandra Brown, and Leslie Taylor. "Can VA Center Ills Be Cured?" July 23, 1995.

Keogh, Hugh. Interview by Will Payne. April 19, 2010.

Kidd, Quentin. "The Failed Transportation Tax: A Simple Message from Voters?" *Virginia News Letter* 79, no. 1 (2003): 1–4.

King, Ledyard. "Gilmore Says He Underestimated Cost of Tax Cut." *Roanoke Times*, January 8, 1998.

Kington, Mark. Interview by Will Payne. April 22, 2014.

Klein, Alec. "North Camp Not Fazed by Nancy Reagan's Criticism." *Roanoke Times*, October 29, 1994.

Knapp, John L. "Virginia's Fiscal Condition—More Than a Short-Term Problem." *Virginia News Letter* 78, no. 1 (January 2002): 2–6.

Kohli, Jitinder. *Golden Goals for Government Performance*. Washington, D.C.: Center for American Progress, 2010, 12.

Kumar, Anita. "Budget Flap Is Gilmore's Legacy in Va." *Washington Post*, October 29, 2008.

Labash, Matt. "Hunting Bubba." *Weekly Standard* 10, no. 38 (June 2005).

Lackey, Patrick. "Gilmore's Seven Car-Tax Whoppers." *Roanoke Times*, March 6, 2001.

LaFay, Laura. "Attorney General: Earley Is First Local in Statewide Office in 1986." *Virginian-Pilot*, November 5, 1997.

Lambert, Benjamin, III. "Gentlemen of the Senate." *Richmond Times-Dispatch*, November 18, 2007.

Latimer, James. "Obenshain Wins on Sixth Ballot." *Richmond Times-Dispatch*, June 4, 1978.

Laveist, Wil. "A New Voice, a New Age." *Daily Press*, June 18, 2004.

Leffall, J. "Closing the Digital Divide." *Richmond Times-Dispatch*, April 5, 1999.

Leighty, Bill. "Looking Back…Governor Warner Leaves Successor Solid Foundation." *Richmond Times-Dispatch*, January 8, 2006.

Lerman, David. "Incumbent Leads Poll in Race Between Warners." *Daily Press*, July 31, 1996.

Lessig, Hugh. "Norment Slams E-mail About Car Tax." *Daily Press*, January 23, 2001.

Lewis, Bob. "Against All Odds, Warner Prevails in Lengthy Tax Debate." *Daily Press*, May 1, 2004.

Bibliography

———. "Candidate Profile of Mark Warner: Enterprising from the Start." *Daily Press*, October 7, 2001.
———. "Gilmore Has Sharp Words for Senators." *Winchester Star*, May 15, 2001.
———. "GOP Anger at Gilmore May Tilt Governor's Race." *Roanoke Times*, September 7, 2001.
———. "State Budget Is Balanced, Gilmore Says." *Winchester Star*, March 13, 2001.
———. "Will Redirecting State Funds Solve Transportation Needs?" *Winchester Star*, November 7, 2002.
Lewis, Katie. "A Good Year for Disaster." *Daily News-Record*, December 31, 2002.
Lindsey, Sue. "Beach Moves to Guard Oceana." *Richmond Times-Dispatch*, August 17, 2005.
Lipford, Michael. Interview by Will Payne. November 22, 2010.
Little, Robert. "John Warner's Senate Victory a Close Call." *Virginian-Pilot*, November 6, 1996.
———. "Report of Close Race a Snafu." *Roanoke Times*, November 7, 1996.
Lizama, Juan Antonio. "Warner Welcomes Latino Advisors." *Richmond Times-Dispatch*, October 8, 2003.
Llovio, Louis. "Losing NASCAR Race Would Cost Region Millions." *Danville Register & Bee*, April 25, 2011.
Magill, Susan. Interview by Will Payne. May 7, 2010.
Maroon, Joe. Interview by Will Payne. October 19, 2010.
Marshall, John. Interview by Will Payne. October 25, 2010.
Marshall, Mark. Interview by Will Payne. July 13, 2010.
Martel, Andrew. "Noticeable Increase in Health Insurance Enrollment for Low-Income Children." *Winchester Star*, August 8, 2003.
Martz, Michael. "Va.'s Anti-Terror Efforts Must Strike Balance, Warner Says." *Richmond Times-Dispatch*, October 29, 2003.
Massengill, Gerald. Interview by Will Payne. March 29, 2010.
Matricardi, Ed. Interview by Will Payne. September 22, 2010.
Mayes, Donna Purcell. "Virginia Gains Public Trust." *Public Roads* (Federal Highway Administration) 67, no. 3 (Nov/Dec 3003).
McAuliffe, Terry R. Interview by Will Payne. June 11, 2010.
McDougall, Christopher. "Blackboard: Liberal Arts; I'm a Technogeek, Too." *New York Times*, April 4, 1999.
McDowell, Charles. "The Longest Day at the Coliseum." *Richmond Times-Dispatch*, June 4, 1978.
McIntyre, Robert. "The Taxonomist." *American Prospect*, February 26, 2001.
McKelway, Bill. "Anatomy of a Fierce Manhunt." *Richmond Times-Dispatch*, October 27, 2002.
Medvic, Stephen. "Good Campaign Slogans Can Kill Good Governance." *Virginian-Pilot*, March 6, 2001.
Melton, R.H. "After a Break, Va. Campaign Regains Its Edge." *Washington Post*, September 23, 2001.
———. "Gilmore Bearer of Bad Fiscal News." *Washington Post*, August 8, 2001.
———. "Gilmore Bent on Car Tax Repeal." *Washington Post*, January 11, 2001.

Bibliography

———. "Gilmore Vetoes Insurance Plan for Children." *Washington Post*, April 8, 1998.

———. "Higher Costs of Car-Tax Cut Can Be Paid For, Gilmore Says." *Washington Post*, Janaury 24, 1998.

———. "Police and Veterans Give Boost to Warner." *Washington Post*, October 3, 2001.

———. "Sheriffs, Students Right Virginia Budget Cuts." *Washington Post*, March 22, 2001.

———. "Va. Legislators Fume at Car-Tax Plan." *Washington Post*, December 21, 2001.

———. "Va.'s GOP Splits at the Top." *Washington Post*, April 5, 2001.

Meola, Olympia. "Honoring Civil-Rights Figures." *Richmond Times-Dispatch*, February 20, 2008.

Misselhorn, Lou, and Holly Heyser. "Gilmore Seeks Support on Car-Tax Cut." *Virginian-Pilot*, February 7, 2001.

Mixer, Dave. Interview by Will Payne. April 14, 2014.

Morello, Carol. "Warner Blurs Political Lines." *Washington Post*, October 26, 2001.

Morino, Mario. Interview by Will Payne. October 27, 2010.

Morris, Nigel. Interview by Will Payne. November 10, 2010.

Morris, Wilson. "Contrasts in Styles in a Pair of Campaigns." *Washington Post*, July 31, 1978.

Moss, Princess. Interview by Will Payne. October 12, 2010.

Mundy, Liza. "Making Up for Lost Time." *Washington Post*, November 5, 2006.

Murphy, Tayloe. Interviews by Will Payne. October 18, 2010; April 3, 2015.

———. "Testimony Before the U.S. House Subcommittee on Water Resources and Environment." July 30, 2008.

Murray, Jim. Interview by Will Payne. October 1, 2010.

———. *Wireless Nation: The Frenzied Launch of the Cellular Revolution in America*. Boston: Perseus Books Group, 2002.

Newman, Fred. Interview by Will Payne. September 22, 2010.

Newstrom, George. Interview by Will Payne. October 8, 2010.

New York Times. "Warner Stills Conservative Opposition in Primary." June 12, 1996.

———. "William Scott, 81, Congressman Symbolizing G.O.P. Rise in South." February 16, 1997.

Norment, Tommy. Interview by Will Payne. May 4, 2010.

Nuckols, Christina. "Battle Over the Budget." *Virginian-Pilot*, February 9, 2001.

———. "Proposal to Bring Veterans Facility Under Increased State Control Fails." *Roanoke Times*, January 31, 1999.

———. "Senators Warn a Funding Plan Too Costly, Risky." *Virginian-Pilot*, January 11, 2001.

Nuckols, Christina, and Holly Heyser. "Car-Tax Cut Questioned in Wake of Budget Hole." *Virginian-Pilot*, January 17, 2001.

———. "Governor Outlines Plan to Cut Millions to Save Car-Tax Relief." *Virginian-Pilot*, February 17, 2001.

Nuckols, Christina, and Warren Fiske. "Gilmore's Plan to Raise Salaries Killed." *Virginian-Pilot*, April 5, 2001.

———. "Politics Make Strange Bad Fellows." *Roanoke Times*, May 7, 2001.

O'Brien, Morgan. Interview by Will Payne. October 27, 2010.

Bibliography

———. "Looking Back While Going Forward: How the Early Days Of Nextel Reflect on Today." *RCR Wireless*, February 17, 2009.

O'Dell, Larry. "Delegate in GOP Endorses Warner." *Winchester Star*, August 31, 2001.

———. "Warner Enters Battle." *Winchester Star*, March 9, 2001.

Office of Governor Mark R. Warner. *An Assessment: Virginia's Response to Hurricane Isabel*. Richmond, VA: Hurricane Isabel Assessment Team, 2003, 1.

———. "First Lady Lisa Collis Launches Fundraising Campaign for Virginia Civil Rights Memorial." December 1, 2005.

———. "Governor Warner Announces FAMIS Enrollment Now Tops 50,000 Children." January 29, 2003.

———. "Governor Warner Breaks Ground for Second Virginia Veterans Care Center." November 1, 2005.

———. "Governor Warner Dedicates the Old Finance Building in Honor of Civil Rights Advocate Oliver W. Hill." October 28, 2005.

———. "Governor Warner Encourages Virginians to Test Effects of His Tax Reform Plan." December 15, 2003.

———. "Governor Warner Launches Commonwealth's New Multi-Agency Communications System." December 20, 2005.

———. "Governor Warner Launches Partnership to Raise Student Achievement at Lowest Performing Schools in Virginia." July 11, 2002.

———. "Governor Warner Praises Agreement on Funding for James River Reserve Fleet." October 10, 2002.

———. "Governor Warner Presents Virginia's Contribution to National World War II Memorial." May 13, 2004.

———. "Governor Warner Requests Audit of VDOT, Scales Back Six-Year Plan." February 12, 2002.

———. "Governor Warner Sets a Goal of 100,000 Children Insured by His Administration." May 10, 2004.

———. *Report and Recommendations*. Richmond, VA: Task Force to Combat Driving Under the Influence of Drugs and Alcohol, 2003, 4.

———. "Veterans Organizations Support Governor Warner's Reform Agenda for Veterans Services." January 15, 2003.

———. "Virginia Department of Veterans Services to Host Informational Event." October 30, 2003.

———. "Warner Addresses Commonwealth Transportation Board." January 17, 2002.

O'Hara, Terence. "Columbia Capital Raises Its Fifth Venture Fund." *Washington Post*, September 12, 2005.

Oswalt, Debbie. Interview by Will Payne. September 22, 2010.

Parker, Akweli. "Warner Stumps for High-Tech Partnership." *Virginian-Pilot*, November 14, 1998.

Paylor, David. Interview by Will Payne. October 5, 2010.

Perilli, Jennifer. "Virginia Civil Rights Memorial Timeline." *Richmond Times-Dispatch*, July 19, 2008.

Peterson, Dennis. "The Rainy Day Man." *Virginia Capitol Connections Quarterly*, Spring 2006: 7.

Bibliography

Petkofsky, Andrew. "New Panel to Defend Va. Military Bases." *Richmond Times-Dispatch*, June 7, 2003.

Piaza, Bob. "Prosecutor Backs Plea for Pardon." *Richmond Times-Dispatch*, February 28, 2002.

POLITICO. "John Warner Exits Senate at Peace." December 28, 2008.

Powell, Robert. "Solon of Southern Virginia." *Virginia Business*, June 2012.

Price, Scott. Interview by Will Payne. October 4, 2010.

Quinn, Sally. "John Warner: Rally Round the Flag." *Washington Post*, April 16, 1976.

Redmon, Jeremy. "2 Gun Groups Target NRA-backed Earley." *Washington Times*, November 1, 1997.

Reed Smith LLP. "Report on the 2001 Virginia General Assembly." *Richmond Letter*, January 11, 2001. http://www.reedsmith.com/the-richmond-letter--a-report-on-the-2001-virginia-general-assembly-01-11-2001/?nomobile=perm.

Rein, Lisa, and Steven Ginsberg. "Gilmore Opposes N.Va. Tax Increase for Transportation." *Washington Post*, November 3, 2002.

Rhodes, Panny. Interview by Will Payne. March 9, 2010.

Richmond Times-Dispatch. "Car-Tax Campaign Cost $100,000." April 27, 2001.

———. "Excerpts from Warner's Speech on TV." October 16, 2002.

———. "Mark L. Earley." October 7, 2001.

Ringle, Ken. "'Friendly Chat' Helped to Set Warner Race." *Washington Post*, August 20, 1978.

———. "Some in Va. GOP Seek Alternative to Warner Race." *Washington Post*, August 8, 1978.

———. "Trail of Controversy Marks Warner's Past." *Washington Post*, October 8, 1978.

———. "Virginia GOP Names Warner Senate Nominee by Acclamation." *Washington Post*, August 13, 1978.

Roanoke Times. "Briefly Put…" November 8, 2002.

———. "Can You Hear Me Now?" December 26, 2005.

———. "A Foundation for Health Services." March 14, 1998.

———. "Gimore: Borrow the Money and Run." January 12, 2001.

———. "Sen. Warner Mum on Farris." September 25, 1993.

———. "State's Budget Bliss Amiss." August 16, 2001.

———. "Through Leadership, Promises Come True." August 29, 2005.

———. "2 Warners Show Their Styles." September 3, 1996.

Roberts, K. Clayton. Interview by Will Payne. September 23, 2010.

Robillard, Kevin. "Ken Cuccinelli Opposes Virginia Transportation Bill." *POLITICO*, February 21, 2013.

Rolfe, Shelley. "Unite and Work, Widow Advises." *Richmond Times-Dispatch*, August 13, 1978.

Rosenfeld, Megan. "Contrasting Styles on the Stump." *Washington Post*, October 22, 1978.

———. "Wives Had a Role in Warner's Rise on Political Scene." *Washington Post*, August 13, 1978.

Ruberry, William. "John Warner Describes His Father as 'the Absolute Hero in My Life'." *Richmond Times-Dispatch*, October 5, 1986.

BIBLIOGRAPHY

Rubin, Mark. "Solving Problem by Consensus: Water Planning for Virginia." *Virginia News Letter* 81, no. 3 (May 2005): 1–2.

Sabato, Larry. "A Century in the Making: The 1997 Republican Sweep." *Virginia News Letter* 74, no. 1 (1998).

———. "A Democratic Revival in Virginia." *Virginia News Letter* 78, no. 2 (February 2002): 2, 6–8.

———. "Key Factors Put Jim Gilmore Over the Top." *Richmond Times-Dispatch*, November 23, 1997.

———. "The 1996 Presidential and Congressional Contests in Virginia." *Virginia News Letter*, February 1997: 1.

———. "The 1978 Virginia Congressional Elections." *Virginia News Letter* 55, no. 7 (March 1979): 25.

———. "Virginia Votes 1999–2002." Charlottesville: University of Virginia Center for Politics, 2002: 141, 191–192.

Sampson, Zinie Chen. "Microsoft Invests in Schools." *Richmond Times-Dispatch*, September 24, 2004.

Saslaw, Dick. Interview by Will Payne. May 7, 2010.

Scanlon, Terry. "Gov. Warner Urges Beach Students to Volunteer." *Daily Press*, September 11, 2002.

Schapiro, Jeff. "Campaign Ad Watch." *Richmond Times-Dispatch*, September 22, 2001.

———. "Candidates Can't Agree on Format." *Richmond Times-Dispatch*, July 23, 1989.

———. "Earley Gains NRA Support." *Richmond Times-Dispatch*, October 26, 2001.

———. "Earley Launches Abortion Attack." *Richmond Times-Dispatch*, October 20, 2001.

———. "Gilmore-Controlled PAC Probed by State Police." *Richmond Times-Dispatch*, February 2, 2001.

———. "Gilmore Revels in Tax Win." *Richmond Times-Dispatch*, August 14, 2001.

———. "Gilmore's Tax Foes Suit Up." *Richmond Times-Dispatch*, April 22, 2001.

———. "Poll Shows John Warner with Big Lead." *Richmond Times-Dispatch*, October 14, 1996.

———. "Warner Asks for Education Funding." *Richmond Times-Dispatch*, February 26, 2004.

———. "Warner Fills Two Cabinet Positions." *Richmond Times-Dispatch*, December 21, 2001.

Schapiro, Jeff, and Pamela Stallsmith. "A Budget at Last." *Richmond Times-Dispatch*, May 8, 2004.

Schrad, Dana. Interview by Will Payne. March 30, 2010.

Shaffray, Mary. "Sales-Tax Increase Not Going Away Soon." *Washington Times*, October 31, 2002.

———. "Tax Foes Vow to Defeat Measure." *Washington Times*, April 16, 2002.

Shannon, Steve. "Efficiency, Accountability in Virginia Schools." *Vienna-Oakton Connection*, January 27, 2005.

Shear, Mike. "A Budget Crafted Out of Overtures, Frays." *Washington Post*, May 9, 2004.

———. "Bumpy Road Ahead for New Chief of Cash-Poor VDOT." *Washington Post*, April 11, 2002.

Bibliography

———. "New Bridges to Make Commute Smoother in Springfield Mixing Bowl." *Washington Post*, August 3, 2001.

———. "VDOT Crisis Worsened Even as Gilmore Boasted." *Washington Post*, October 20, 2002.

Shear, Mike, and Chris Jenkins. "Warner and Shaky Coalition Edge Toward Budget." *Washington Post*, April 12, 2004.

———. "Warner's Budget Plan Reflects Va.'s Turnaround." *Washington Post*, December 17, 2005.

Shear, Mike, and Claudia Deane. "Kaine Inches Ahead in Va. Race, Poll Finds." *Washington Post*, October 30, 2005.

Shear, Mike, and Lyndsey Layton. "Va. Still Seeks Transportation Solutions." *Washington Post*, November 10, 2002.

Shucet, Philip. Interview by Will Payne. April 22, 2010.

Simpson, Elizabeth. "Web Site Offers Lifeline for Seniors." *Virginian-Pilot*, March 3, 2001.

Sizemore, Bill. "Agency: Robertson Misled Donors." *Virginian-Pilot*, July 15, 1999.

———. "Christian Coalition, Employees Settle Discrimination Suit." *Virginian-Pilot*, December 29, 2001.

———. "Letters Force Robertson to Get Out of Horse Racing." *Virginian-Pilot*, May 10, 2002.

Skale, Heather. "15 Minues with...Mark R. Warner." *Washington Times*, June 21, 1999.

Sluss, Mike. "Behind Every Winner Is a Mudcat." *Roanoke Times*, December 30, 2001.

———. "Capitol Asset." *Roanoke Times*, July 22, 2008.

———. "Democrat Looks to NRA for Assistance, If Not for Endorsement." *Roanoke Times*, July 21, 2001.

———. "Earley Asks Judge to Throw Out Car Tax Suit." *Roanoke Times*, May 11, 2001.

———. "Historic Building Renamed for Civil Rights Lawyer." *Roanoke Times*, October 29, 2005.

———. "Kaine Helps Break Ground for Civil Rights Memorial." *Roanoke Times*, February 20, 2008.

———. "Republican State Senator Endorses Warner in Governor's Race." *Roanoke Times*, October 17, 2001.

———. "Senators: Gilmore Plan May Not Be Constitutional." *Roanoke Times*, March 28, 2001.

———. "Some Members of GOP, Independents to Back Warner." *Roanoke Times*, June 29, 2001.

———. "Sparks Fly as Officials Try to Strike Budget Deal." *Roanoke Times*, May 4, 2001.

———. "2 Warners Endorse Election's Bond Package." *Roanoke Times*, October 31, 2002.

———. "Warner Wants GED Numbers Doubled." *Roanoke Times*, October 8, 2003.

———. "What Caused Budget Talks to Derail?" *Roanoke Times*, May 13, 2001.

Sluss, Mike, and Childs Walker. "Gilmore: Speed Car Tax Cut." *Roanoke Times*, January 11, 2001.

Sluss, Mike, and Isak Howell. "Gilmore Feeling the Heat on Budget." *Roanoke Times*, August 22, 2001.

BIBLIOGRAPHY

Smith, Doug. Interview by Will Payne. April 1, 2010.
Smith, Gabriela. Interview by Will Payne. November 16, 2010.
Springston, Rex. "Colleges, Parks Bonds Approved." *Richmond Times-Dispatch*, November 6, 2002.
Stallsmith, Pamela. "Veterans Director Selected." *Richmond Times-Dispatch*, August 8, 2003.
Stallsmith, Pamela, and Tyler Whitley. "State Funds Scholarships for Those Denied Schooling." *Richmond Times-Dispatch*, June 17, 2004.
Stefani, Alexis. *Audit of the Springfield Interchange Project*. Washington, D.C.: Federal Highway Administration, 2002, 3.
Stephy, M.J. "A Brief History of Camouflage." *TIME*, June 2009.
Stolle, Ken. Interview by Will Payne. April 8, 2010.
Stosch, Walter. Interview by Will Payne. May 4, 2010.
Sturgeon, Jeff. "Changes Coming to Home for Veterans." *Roanoke Times*, May 7, 2002.
———. "State Probes Nursing Facility." *Roanoke Times*, April 18, 2002.
———. "Veterans Center Seeks to End Its Insurance Woes." *Roanoke Times*, October 21, 2002.
———. "Virginia to Take Over Veterans Care Center." *Roanoke Times*, February 13, 2003.
Sturgeon, Jeff, and Mike Sluss. "Audit Details Misspending at Vet Center." *Roanoke Times*, August 8, 2002.
Szabo, Liz. "Robertson: Pilot's Report on Inquiry Is 'Wrong.'" *Virginian-Pilot*, July 22, 1999.
Taylor, Mark. "Hunting for Your Vote." *Roanoke Times*, October 19, 2001.
Thornton, Tim. "Tire Fire Left Man's World in Limbo." *Roanoke Times*, December 31, 2002.
Timberg, Craig. "Earley Free to Back Referendum." *Washington Post*, August 23, 2001.
———. "House Breaks with Gilmore, Overrides 2 Vetoes." *Washington Post*, April 6, 2001.
———. "Va. Campaign Strategies on Parade." *Washington Post*, September 4, 2001.
———. "Warner Takes Risk with New Strategy." *Washington Post*, July 22, 2001.
Timberg, Craig, and William Branigin. "Gilmore Fires Back in Clash Over Economy." *Washington Post*, August 22, 2001.
Trygstad, Kyle. "Warner Won't Run for Governor." Roll Call. November 20, 2012. http://atr.rollcall.com/virginia-mark-warner-wont-run-for-governor.
Ukrop, Jim. Interview by Will Payne. September 30, 2010.
Virginia Auditor of Public Accounts. *Virginia Veterans Care Center Special Report: January 1, 1998, to February 6, 2002*. Richmond, VA, 2002.
Virginia Department of Transportation. "VDOT Meets or Exceeds All Project Completion and Budget Goals for First Time." Richmond, VA, September 20, 2007.
Virginia Department of Veterans Services. *2014 Annual Report*. Richmond, VA, 2014, 4.
Virginia Health Care Foundation. *2014 Annual Report*. Richmond, VA, 2014, 3–7.
Virginian-Pilot. "A Baptism by Fire." April 7, 2002.

Bibliography

———. "Gimmick Justified to End Hiring Bias." December 24, 2005.
———. "Hire Me: John Warner." September 1, 1996.
———. "Hurricane Isabel: Around Hampton Roads." September 17, 2003.
———. "McSweeney and Byrne Protest Nomination Process to Sore Losers: Pack It In." April 19, 1996.
———. "Oceana's Brush with BRAC." May 23, 2006.
———. "Sen. Stolle's Courage on Car Tax Phaseout." February 3, 2001.
———. "State Digging Hole for Itself with 'No Car Tax' Pledge." January 12, 2001.
———. "VDOT Reports On-Time Rate for July 1– Dec. 31." January 19, 2006.
———. "Virginia Business Group Ruffles Capitol Feathers." May 21, 2003.
———. "Warner's Growing Popularity." June 9, 1994.
Virginia Public Access Project. "Mark Earley for Governor—Top Donors." 2002. http://vpap.org/committees/124080/top_donors.
———. "Ruble A Hord, III." 1999. http://www.vpap.org/candidates/4784-ruble-a-hord-iii.
Wakefield Ruritan Club. "Shad Planking History." http://www.shadplanking.com/planking_history.html.
Walzer, Philip. "College Group to Vouch for Students' High-Tech Skills." *Roanoke Times*, April 10, 1998.
———. "High-Tech Linkup Launched." *Virginian-Pilot*, February 17, 1998.
Warner, John W. Interviews by Will Payne. June 27, 2012; June 25, 2012.
———. "Senator Warner's Stance Toward Michael Farris." *Virginian-Pilot*, December 9, 1993.
———. "Speech Receiving the Washington Award." Lexington, VA, May 2, 2009.
Warner, Mark R. "Action Plan for Virginia." Alexandria, VA: Friends of Mark Warner, 2001, 67.
———. "Address to Families USA." Alexandria, VA: Friends of Mark Warner, January 24, 2008.
———. "Address to the Virginia Association of Secondary School Principals." Richmond, VA: Office of Governor Mark R. Warner, June 23, 2003.
———. "Address to Virginia Association of Superintendents." Alexandria, VA: Friends of Mark Warner, October 15, 2008.
———. "A Business Approach." *Virginia Law & Business Review* 1, no. 1 (Spring 2006).
———. "Education Reform: An Economic Imperative." Washington, D.C.: Center for American Progress, May 10, 2005.
———. *A Governor's Approach to Improving Secondary Career Education*. Washington, D.C.: Double the Numbers, 2005, 29–31.
———. "Health Care Coverage for Uninsured Children Should Be on the Agenda." *Richmond Times-Dispatch*, August 16, 1998.
———. *High School Reform: An Urgent Priority in a Changing Economy*. Washington, D.C.: Alliance for Excellent Education, 2004, 105–8.
———. "An Important Step Forward in Protecting the Innocent." Roll Call, July 22, 2014. http://www.rollcall.com/news/an_important_step_forward_in_protecting_the_innocent_commentary-235091-1.html.
———. Interview by Brian Lamb. C-SPAN. November 6, 2005.

Bibliography

———. Interview by Rodney Slater. "Homeland Security Beyond the Beltway." October 28, 2003.

———. Interviews by Will Payne. September 1, 2010; September 9, 2010; November 5, 2010; January 10, 2011; June 13, 2011.

———. "Mark Warner on Technology and America's Future." *The Globalist*, April 13, 2006.

———. "Remarks of Gov. Mark Warner to the 2002 DLC National Conversation." Washington, D.C.: Democratic Leadership Council, July 30, 2002.

———. "Restoring Trust." *Virginia Capitol Connections Quartly*, Summer 2005: 2.

———. "2002 State of the Commonwealth Address." Richmond, VA: Office of Governor Mark R. Warner, January 14, 2002.

———. *Virginia Excels: The Commonwealth's Response to "Show Me the Money."* Arlington, VA: American Legislative Exchange Council, 2005, 3.

———. "Virginia's Model for Community-Based Solutions to Real Problems." *Virginian-Pilot*, November 14, 1995.

Washington Post. "Gilmore Is Hanging Us Out to Dry." March 11, 2001.

———. "Gov. Gilmore's Empty-Till Plan." January 19, 2001.

———. "A Novice at Seeking Office." June 4, 1978.

———. "Senate: Miller vs. Warner." November 2, 1978.

———. "Warner Says Prosperity Eludes Some." March 17, 2001.

Washington Times. "Gilmore Vetoes Tax-Cut Foes' Bills." March 28, 2001.

———. "Latest Polls in State Races." September 27, 1996.

———. "Robb Captured 45.6 Percent of Votes." November 29, 1994.

Wasik, Bill. *Columbia Capital Corporation: Summer 1998*. Boston: Harvard Business School, 1999, 3–4, 6.

Wason, Judy. Interview by Will Payne. March 26, 2010.

Weatherford, Greg. "Getting to Yes." *Style Weekly*, March 2003.

Webb, Katie. Interview by Will Payne. April 5, 2010.

Wessol, Shay. "Methamphetamine: A New Drug Crisis Is Growing in Southwest Virginia." *Roanoke Times*, July 25, 2004.

Wharton, Tony. "Group Seeks IRS Inquiry of Pastors' Backing of Earley." *Virginian-Pilot*, July 3, 1997.

Wheeler, Garth. Interview by Will Payne. April 2, 2010.

Whitley, Tyler. "Boy Wonder to Long Shot." *Richmond Times-Dispatch*, October 29, 1994.

———. "Democrats Outgoing Chief Upbeat." *Richmond Times-Dispatch*, June 25, 1995.

———. "Final Vote Tally Gives Allen 9 of 11 Districts." *Richmond Times-Dispatch*, November 23, 1993.

———. "Five GOP Lawmakers Warn Warner on Taxes." *Richmond Times-Dispatch*, November 8, 2002.

———. "Former GOP Governor Holton Endorses Warner." *Richmond Times-Dispatch*, October 16, 2001.

———. "Gilmore, Warner Unified in N.Y." *Richmond Times-Dispatch*, November 9, 2001.

———. "GOP-Leaning Businesspeople Pick Warner." *Richmond Times-Dispatch*, June 29, 2001.

———. "'The Longest Job Application of My Life.'" *Richmond Times-Dispatch*, October 21, 2001.

———. "Mark Warner Gears Up Early." *Richmond Times-Dispatch*, June 1, 1998.

———. "North Had Role in Senate Race." *Richmond Times-Dispatch*, November 26, 1996.

———. "Republican Group Formed in Support of Beyer." *Richmond Times-Dispatch*, October 7, 1993.

———. "Senate Race Pits New Blood vs. Seniority." *Richmond Times-Dispatch*, November 3, 1996.

———. "State to Cut Jobs, Services." *Richmond Times-Dispatch*, August 20, 2002.

———. "Va. GOP Looks for Culprits." *Richmond Times-Dispatch*, November 10, 1994.

———. "Warner Talks of 'Duty' to Fight North's Senate Campaign." *Richmond Times-Dispatch*, March 26, 1994.

———. "Warner Victory Seen as a Model." *Richmond Times-Dispatch*, December 4, 2001.

———. "Warner vs. Warner." *Richmond Times-Dispatch*, October 6, 1996.

Whitson, Brian, "W&M Chief Blasts Budget Plan." *Daily Press*, January 5, 2001.

Whoriskey, Peter. "Democratic Cadre Tests Warner Vow of Bipartisanship." *Washington Post*, November 11, 2001.

Wilder, L. Douglas. "When the Dream Became Reality." *Virginia News Letter* 79, no. 3 (August 2003): 1–2.

Wilder, Sam. Interview by Will Payne. November 23, 2010.

Winegar, Garvey. "Animal-Rights Groups Seeking to Block Vote." *Richmond Times-Dispatch*, October 18, 2000.

———. "Returns Are In: Outdoorsmen Post Big Wins." *Richmond Times-Dispatch*, November 12, 2000.

———. "A Storm Is Brewing Over Proposed State Measure." *Richmond Times-Dispatch*, August 2, 2000.

Winston, Bonnie. "Farris Says Abortion-Cancer Link Is Ignored." *Virginian-Pilot*, July 30, 1993.

Woodley, Ken. Interview by Will Payne. January 15, 2010.

Woods, Jane. Interview by Will Payne. March 17, 2010.

INDEX

A

AAA bond rating 11, 60, 188, 193, 195, 214, 250
Allen, Governor George 38, 45, 47, 48, 52, 130, 131, 135, 139, 141, 146, 152, 153, 160, 169, 173, 198, 223, 259, 270, 284, 292
Americans for Tax Reform 62, 209
Andrews, Senator Hunter 25, 197, 199
Archer, Bob 15, 207, 208

B

Baliles, Governor Gerald 40, 62, 135, 270, 309
Base Closure and Realignment Commission (BRAC) 291, 292, 293
Baskerville, Delegate Viola 15, 266, 269, 270
Beltway snipers 273, 295, 296, 297, 298, 299
Bennett, John 15, 192, 193, 200, 201
Beyer, Representative Don 23, 42, 46, 47, 48, 139
biased-based policing 280
Blake, Peter 15, 257, 258
Blow, Bob 97, 99, 103, 104
Bloxom, Delegate Bob 15, 253
Bowen, Sandy 15
Bryant, Delegate Preston 15, 211, 212
Butler, Representative Caldwell 31, 32, 38
Byrne, Representative Leslie 46, 47, 52

C

Callahan, Delegate Vince 15, 142, 195, 209
car tax cut 131, 139, 140, 141, 142, 143, 144, 145, 146, 147, 148, 149, 150, 151, 152, 153, 154, 155, 156, 182, 187, 199, 205, 209, 224, 302
Chesapeake Bay 210, 228, 248, 249, 252, 253
Chichester, John 15, 147, 148, 149, 152, 194, 195, 196, 197, 198, 199, 207, 212, 257
Christian Coalition 48, 50, 51, 178, 179
Civil Rights Memorial 265, 266, 267, 268

INDEX

Clements, Janet 15, 294, 295
Clement, Whitt 15, 221, 225, 227, 232, 234
Cline, Michael 15, 273, 274, 286
Coleman, Marshall 40, 41, 42, 49, 50, 282, 283
Collis, Lisa 40, 108, 115, 136, 262, 265, 267, 278, 279, 284
Columbia Capital 59, 99, 100, 101, 102, 103, 104, 105, 106, 123, 257
Columbia Cellular Corporation 97, 98, 99
Cooke, Speaker John Warren 210
Cook, Sheriff Stuart 296, 298
Crouch, Bob 15, 282, 287
Crumley, Sherry 15, 157, 171, 173, 175, 176, 177

D

Dalch, Linda 15, 116, 117, 118
Dalton, Governor John 27, 31, 32, 33, 38, 182
Davis, Representative Tom 15, 23, 24, 46, 51, 52, 63
DeMary, Jo Lynne 15, 255, 256, 259, 260, 261, 263, 264
Democratic National Committee (DNC) 39, 72, 77, 78, 79, 81, 82, 107
Diamonstein, Alan 193
Dillard, Delegate Jim 15, 144, 210
DNA review 281, 282, 283
Dodd, Representative Chris 75
Durrette, Wyatt 15, 32

E

Earley, Attorney General Mark 62, 129, 130, 131, 134, 135, 136, 139, 145, 154, 160, 163, 169, 170, 171, 176, 177, 178, 179, 180, 181, 182, 183, 184, 283, 284
Earley, Mark 181, 302
Education for a Lifetime 256, 261, 264

F

Falwell, Jerry 47, 177, 179
Family Access to Medical Insurance Security (FAMIS) 215, 217, 218, 219, 220
Flaherty, Colonel Steve 15, 290, 291
Fleet Call Inc. 89, 90, 93, 94, 95
Foresman, George 15, 285, 286, 287, 289, 293, 294, 296, 297
Foundation for Virginia 201
Framme, Larry 15, 45, 134, 162, 171, 184
Fraternal Order of Police (FOP) 180, 181, 204

G

Galanti, Paul 15, 180, 240, 243
Gang of Five 196
Gilmore, Governor Jim 47, 64, 67, 128, 130, 131, 132, 135, 139, 140, 141, 142, 143, 144, 145, 146, 147, 148, 149, 150, 151, 152, 153, 154, 155, 156, 169, 173, 182, 183, 187, 199, 204, 208, 209, 215, 217, 224, 225, 231, 237, 239, 251, 255, 270, 274, 283, 284, 285, 286, 287, 302, 303, 304
Godwin, Governor Mills 26, 30, 31, 32, 33, 35, 36, 182
Grasso, Representative Ella 74, 75, 83

H

Hager, Lieutenant Governor John 16, 110, 130, 131, 139, 153, 154, 283, 284, 285, 286, 287, 288, 289
Henry, Mike 16, 133, 134, 137
higher education restructuring 257
Hill, Oliver 266, 267, 268, 269
Hishta, John 16, 24, 52, 55, 57
Holton, Governor Linwood 26, 27, 28, 29, 30, 31, 32, 48, 181, 270, 284
Homer, Pierce 16, 221, 222, 232

INDEX

Howell, Senator Janet 16, 144, 148, 198
Howell, Speaker Bill 207, 212

J

Jarding, Steve 16, 158, 159, 160, 162, 166, 170, 171, 175, 179
Johns, Barbara 266, 267, 268, 269
Joint Leadership Council of Veterans Service Organizations (JLC) 244, 245
Jones, Delegate Chris 211
Jones, John 14, 16, 151, 204, 205

K

Kaine, Senator Tim 134, 211, 221, 266, 267, 274
Keogh, Hugh 16, 207, 208
Kidd, Quentin 14, 16, 66, 305
Kilgore, Attorney General Jerry 135
Kington, Mark 16, 97, 98, 99, 100, 101, 102, 103, 104, 105
Kluge, John 271

L

Leighty, Bill 16, 274, 278

M

Magill, Susan 16, 38, 51, 54, 61, 64, 65
Marshall, John 16, 33, 274, 277, 280, 281, 288, 296, 297, 298, 299, 300
Marshall, Sheriff Mark 16, 275, 276
Massengill, Gerald 16, 148, 274, 275, 280, 290, 296, 297, 298, 299, 300
Matricardi, Ed 16, 129, 130, 131, 183
McAuley, Brian 89, 94, 95
McAuliffe, Governor Terry 12, 14, 16, 78
McMillen, Tom 82
methamphetamine lab busts 279, 280
Miller, Andrew 25, 26, 29, 30, 33, 34, 35, 36, 37
Miller, Jim 47, 48, 50, 51, 52, 55, 183

Mixer, Dave 16, 97, 98, 102, 103, 104, 105
Morgan, Harvey 210
Morino, Mario 16, 121, 122, 123, 124
Morris, Nigel 16, 123, 189
Murphy, Tayloe 16, 247, 248, 249, 250, 252, 253, 254
Murray, Jim 16, 85, 86, 97, 98, 99, 100, 101, 102, 103, 104, 105, 106, 257

N

NASCAR 89, 160, 166, 167, 169, 264
National Governors Association (NGA) 115, 262, 263
National Rifle Association (NRA) 169, 170, 171, 174, 181
Newman, Fred 16, 278, 280
Newman, Sheriff Fred 279
Newstrom, George 16, 190, 191
Nextel Communications 89, 93, 95, 97, 105
9/11 60, 177, 179, 283, 285, 286, 287, 289, 290, 294, 295, 298
Norment, Senator Tommy 16, 148, 151, 155, 196, 197, 198, 199, 212, 213, 214, 258
Norquist, Grover 62, 209
North, Oliver 49, 50, 52, 55, 56, 284

O

Obenshain, Dick 26, 27, 29, 30, 31, 32, 33, 34, 35, 51, 182
O'Brien, Morgan 16, 89, 90, 91, 92, 93, 94, 95
Oswalt, Debbie 14, 16, 108, 109, 110, 111, 112, 113, 114, 115, 218, 219

P

Partnership for Achieving Successful Schools (PASS) 259
Paylor, David 16, 248, 249, 250, 251
Puller, Senator Toddy 40

INDEX

R

Race to GED 264
Reinheimer, Peter 89, 90, 93, 94, 95
Republican National Committee (RNC) 26, 50, 131, 154, 182, 184
Rhodes, Delegate Panny 16, 182, 183
Ribicoff, Senator Abe 74, 75
Robb, Senator Chuck 42, 46, 49, 50, 130, 160, 173, 270
Roberts, K. Clayton 14, 16, 207
Robertson, Pat 51, 131, 177, 179
Robinson, Spottswood 266, 267, 268

S

Sabato, Dr. Larry 16, 22, 23, 43, 63, 135, 139, 149, 171, 183
Saslaw, Dick 16, 153, 198
Saunders, Dave "Mudcat" 162, 164, 165, 166, 167, 169, 170, 171, 173, 175, 176
Schewel, Mike 16, 293
SeniorNavigator 115, 116, 127, 294
Senior Year Plus 263, 264
Shad Planking 53, 57, 60
Shucet, Philip 16, 226, 227, 228, 229, 230, 231, 232, 233, 234
Sportsmen for Warner 157, 167, 170, 171, 173, 176
Statewide Agencies Radio System (STARS) 290, 291
Stolle, Senator Ken 5, 14, 15, 16, 147, 148, 152, 196, 197, 198, 199, 203, 205, 212, 213, 214, 287
Stosch, Senator Walter 16, 150, 152, 196, 197, 198, 199
Stottlemyer, Todd 16, 258

T

Taylor, Elizabeth 27, 31, 32
Tech Riders 120, 121, 127
TekXam 117, 118
Terry, Attorney General Mary Sue 40, 42, 45, 47

Tillett, Ron 146, 147
Turnaround Specialist Program 261, 262

V

Venture Philanthropy Partners 123, 124, 125
Virginia21 63
Virginia Chamber of Commerce 134, 207, 208, 283
Virginia Corps 294, 295
Virginia Department of Transportation 223, 224, 225, 226, 227, 228, 229, 230, 231, 232, 233, 234, 235
Virginia Department of Transportation (VDOT) 66, 221, 222
Virginia FREE 207, 208
Virginia Health Care Foundation (VHCF) 108, 109, 110, 112, 113, 114, 115, 127, 216, 218, 219
Virginia High-Tech Partnership 118, 119, 120, 127
Virginians for Warner 181, 182, 183, 201
Virginia Veterans Care Center 238, 239, 240

W

Wampler, William 38, 152, 196, 197, 199
Warner, Eliza 136, 265, 273
Warner, Gillian 136, 273
Warner, John 21, 24
Warner, Madison 136, 273
Warner, Marjorie 70, 73, 74, 114
Warner, Robert 70, 71, 72, 73, 74, 114
Warner, Senator John 16, 21, 22, 23, 24, 27, 28, 29, 30, 31, 32, 33, 34, 35, 36, 37, 38, 39, 46, 47, 48, 49, 50, 51, 52, 53, 54, 55, 56, 59, 60, 61, 63, 64, 65, 133, 180, 182, 183, 209, 250, 271, 292, 301, 303
Wason, Judy Ford 16, 31, 32, 63, 66, 182, 185, 201

Index

Water Quality Improvement Fund 253
Wheelan, Belle 16, 255
Wheeler, Garth 14, 16, 180
Wilder Commission 189, 191, 193
Wilder, Governor Doug 25, 39, 40, 41, 42, 43, 45, 46, 49, 59, 108, 109, 136, 139, 146, 152, 170, 189, 208, 228, 269
William & Mary, the College of 63, 131, 151, 258
Woodley, Ken 16, 268, 269
Woods, Jane 16, 217
Wynne, Dubby 16, 191

ABOUT THE AUTHOR

Born and raised in Richmond, Will Payne is the principal of Bull Moose Strategies, LLC. He led three "Virginians For" campaigns for statewide candidates for governor and the U.S. Senate and specializes in coalitions of Republicans, business leaders, elected officials, law enforcement, sportsmen and veterans. He is a 2001 graduate of the College of William & Mary and in 2005 was named a Fellow of the Sorensen Institute for Political Leadership at the University of Virginia. Will was appointed to William & Mary's Board of Visitors in 2014 and since 1997 has been involved with the university's club ice hockey team as a player, assistant coach and chairman of its booster club. He also serves on the board of Virginia21, a generational advocate organization providing nonpartisan information and support to young voters and students. Will is a partner with Commonwealth Outfitters, LLC, a hunting and fishing guide service

About the Author

based on the Eastern Shore, and is a co-founder of the Virginia Sportsmen's Foundation, a nonprofit, volunteer-based organization providing outdoor education to first-time hunters.

www.markwarnerbook.com

 /markwarnerbook

 /markwarnerbook

 /markwarnerbook